THE WORLD OF ICONS

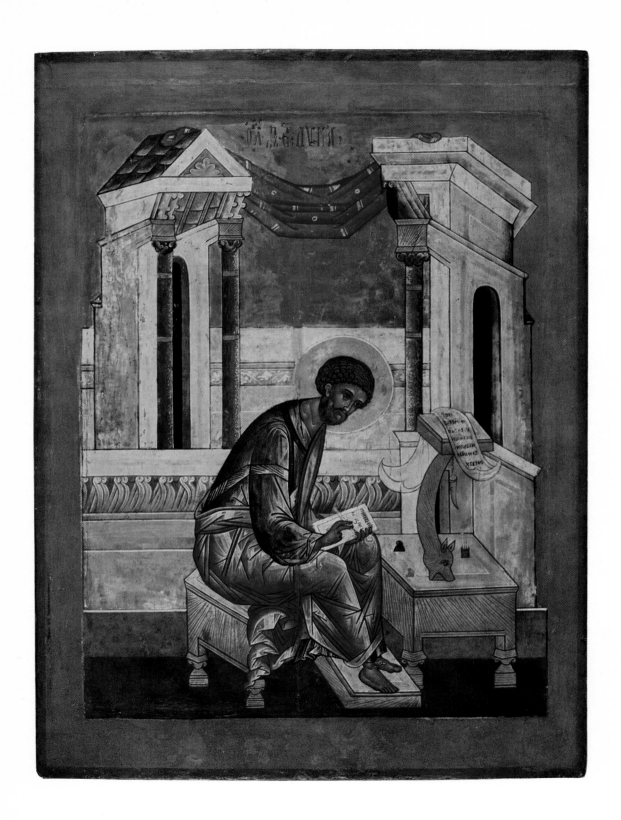

H. P. Gerhard

THE WORLD OF ICONS

HARPER & ROW, PUBLISHERS
New York, Evanston, San Francisco, London

The Frontispiece, a sixteenth-century Russian (Novgorod) icon, shows the Evangelist Luke (Ikonenmuseum, Recklinghausen)

Originally published by Verlag Aurel Bongers, Recklinghausen,
under the title *Welt der Ikonen*

Printed in West Germany

FIRST U.S. EDITION
STANDARD BOOK NUMBER: 06-433258-6

Library of Congress catalog card number: 70-162568

CONTENTS

Foreword 7

IMAGES AND IMAGE WORSHIP IN THE
EARLY CHRISTIAN WORLD 9

THE BEGINNINGS OF CHRISTIAN ART 41

BYZANTIUM AND THE BALKANS 55

RUSSIA 108

PICTURES INSIDE THE CHURCH 205

HOW ICONS WERE MADE AND DECORATED 208

SCHOOLS OF PAINTING AND DATING OF ICONS 211

Chronological Table 215

Notes 216

Selected Bibliography 222

Important Museum and Exhibition Catalogues 225

Indices 226

List of Coloured Illustrations 230

List of Monochrome Illustrations 231

MAPS 1 The Mediterranean 42

 2 Greece and the Balkans 56

 3 Russia 109

FOREWORD

During the past twenty years there has been an increasing interest in icons. Their devotees are not only drawn from the ranks of art-lovers: these painted panels have given many people a glimpse into the mysterious world of the Orthodox Church, whilst others have turned to them for information on cultural history and folklore. The present book has been published to cater for all these varied interests. It presents a clear and reliable, but at the same time concise, picture of the subject and traces the main lines of development. We have not set out to produce an exhaustive history of icon-painting, but merely a general survey, and the reader will, it is hoped, feel inspired to fill in the detail by studying specialised works on the great variety of individual topics discussed. A Selected Bibliography has therefore been included.

The Author is grateful to all those who have made this book possible and who have assisted in an active or advisory capacity. Special thanks are due to the directors and experts at the various museums and institutes and the private collectors in a number of countries who have given permission for their works of art to be reproduced.

H. P. G.

IMAGES AND IMAGE WORSHIP IN THE
EARLY CHRISTIAN WORLD

Christian art and image worship did not spring up suddenly without cause or reason. Like all other spiritual and creative activities they were influenced by earlier traditions. Although Christian art and culture introduced a new spirit, a new conception of the universe and a whole new set of values, their development was linked temporally and geographically with existing civilisations and existing cultural trends and characteristics.

Before we can hope to sort out the vast and complex question of pictorial art and image worship in the Christian community, we must try to ascertain the attitude of the non-Christian world in which they lived. Of special importance here are, of course, the three civilisations with which Christians had to contend from the very beginning in the course of their worldwide missionary activities. First of all, there was the Jewish civilisation — the background against which the salvation of mankind was enacted. There was also the Hellenistic culture of Greece, which played a vital part in moulding the outward character and spiritual life of the eastern Mediterranean area, and finally the civilisation of Rome, whose impact on the contemporary world showed a more material and political bias.

The JEWISH attitude towards images and image worship is based fundamentally on the ban imposed by the Pentateuch: 'Thou shalt not make unto thee any graven image, or any likeness of any thing that is in heaven above, or that is in the earth beneath, or that is in the water under the earth' (Exodus xx. 4). This version of the ban on images has been rigidly observed, but whether the generally adopted term 'image' is exactly in keeping with the meaning of the Hebrew word in the original text is doubtful. In Hebrew it would seem to cover something more in the nature of an idol than an image or picture. The Jews themselves even argued subsequently about the interpretation of this commandment and it was a frequent subject of debate and discussion. Other passages in the books of the Old Testament are not worded in such a sweeping manner. In the same chapter of the Book of Exodus we are told: 'Ye shall not make with me gods of silver, neither shall ye make unto you gods of gold' (Exodus xx. 23). We find the same idea in Deuteronomy: 'Cursed be the man that maketh any graven or molten image, an abomination unto the Lord, the work of the hands of the craftsman, and putteth it in a secret place' (Deut. xxvii. 15). It would seem that in these passages only the making of images of God, above all, sculptured, rounded images, is forbidden.

Thus images of God are quite definitely ruled out. A ban of this kind is perfectly understandable if we remember that the great creative achievement of the Jews was, in fact, their discovery of a purely monotheistic conception of God. They did not need God to be revealed to them in the form of an image, and rejected any attempt to attach Him to this earthly world. The

God of Israel was unapproachable and no likeness could be made of Him here on earth. He stood aloof from the events of this world and operated transcendentally from afar[1].

The command that no image of God should be made has never been questioned by the Jews. But the position is quite different with regard to the portrayal of other subjects. Several instances can be quoted from the books of the Old Testament: 'Moreover thou shalt make the tabernacle with ten curtains of fine twined linen, and blue, and purple, and scarlet: with cherubims of cunning work shalt thou make them' (Exodus xxvi. 1). In the Book of Kings we are told: 'And within the oracle he made two cherubims of olive tree, each ten cubits high' (1 Kings vi. 23). In Ezekiel's vision of the new temple we find an exact description of the cherubim in the inner temple:

'And it was made with cherubims and palm trees, so that a palm tree was between a cherub and a cherub; and every cherub had two faces;

'So that the face of a man was toward the palm tree on the one side, and the face of a young lion toward the palm tree on the other side: it was made through all the house round about.

'From the ground unto above the door were cherubims and palm trees made, and on the wall of the temple' (Ezekiel xli. 18—20).

In all descriptions of the Tabernacle, the Temple of Solomon and other holy places of the Jews, mention is made of sculptures, reliefs and also embroidered portrayals of angels and plants worked in a great variety of materials. But we never hear of any objections being raised by the people of those times.

Things seem to have remained unchanged until the period of the Maccabees, when the Jews came into fairly close contact with Hellenism, which revelled in images. There was every chance that Hellenistic ideas would infiltrate into the Jewish world, but this move was opposed and a strict and complete ban on images ensued. New temple buildings were designed without any images whatsoever, but this was not enough and even representational plastic friezes on shrines dating back to the earlier period appear to have been smashed. The strict interpretation of the ban on images even affected Jewish burial sites, where only pure ornament was used from that time onwards.

The lasting results of this change in attitude can still be detected in Roman times. Tacitus wrote in his *Historiae* that no statues of famous men were to be found in the Jewish area[2]. And Flavius Josephus, the historian of the Jewish people, gave various accounts in his works which show that this hostility to images persisted until the destruction of Jerusalem. In these descriptions we sometimes cannot help getting the impression that the religious feelings of the Jews were used as a pretext for their resentment against the Romans. Jewish complaints about the standards of the Roman legions in Jerusalem bearing the Emperor's picture might be understandable, but their wounded religious susceptibilities appear to have served more as an excuse when they actually demanded the removal of certain shields merely because they bore the Emperor's monogram. Be this as it may, the fact that the Roman governors gave way on both points shows

indirectly that the hostility to images had become deep-seated among the inhabitants of the capital and the Romans thought it advisable to spare the feelings of the highly sensitive population of Jerusalem. In other towns also, there was an uproar when the Emperor's picture was hung up in synagogues.

But the attitude to images was not so rigid in the provinces. There are repeated references in old documents to statues of Jewish kings and members of their families[3]. And in the Diaspora the Jews adapted themselves fairly quickly to an environment that was not hostile to images. In the Jewish Catacombs in Rome, for example, we find pictorial decorations of many different kinds: hunting scenes, pictures from mythology and Jewish history, animals, cupids and so on. The Jewish Diaspora in Mesopotamia was particularly well disposed towards images, as we can clearly see from the pictorial decoration in the synagogue of Dura Europos[4], dating back to the middle of the 3rd century A. D. In addition to fabulous creatures and animals and monumental figures representing leading personalities from the Jewish past and individual scenes from Greek mythology, we find various cycles from Jewish history, referring, for example, to Moses and Elijah.

Nor could the Jews in their own home country keep up their determined opposition to images after the destruction of Jerusalem and the loss of their independence. Conditions within the territory of the former Jewish state changed as they had done in the Diaspora. Even in the Palestine synagogues (for example, Ain Duk, near Jericho) images became quite usual in the 3rd century and the inhabitants appear to have accepted these decorated temples, as we do not come across any reports of demonstrations or protests. Of course, the most orthodox among them were not prepared to make any compromise and remained resolutely opposed to images. Their time came at the end of the 6th century and in the 7th, when the Jews as a whole reverted once more to their old hostility, which in its turn influenced the Islamic attitude towards images.

It is therefore true to say that the Jewish outlook on images — image worship was never practised — was not entirely uniform throughout. Decorations of this type, other than images of God, were permitted over long periods, but iconoclastic movements of tremendous violence kept recurring. Even in the Middle Ages, Jews in Europe proclaimed that images were superfluous and an impediment to worship.

The attitude of the GREEKS to images and their worship was quite different. Images of the gods and worship of them were accepted as a matter of course by the state and by the people, and this went on until the end of the Classical period. The belief that the image and the person represented by it were one and the same persisted among the ordinary people long after the various external changes in religious customs had taken place.

In Ancient Greece the idea of magic was very closely bound up with images and this arose perhaps from her contact with civilisations in the Near East. Any mortal who dared to gaze upon the unveiled image of a god was smitten with madness or blindness by those divine beings. We can

still see a vague tradition of this in the tales of Oedipus and in Homer. This idea of magic was linked with gruesome religious practices that lived on in the subconscious mind of the people long after they ceased to be performed.

The various accounts of images of the gods being flung down upon the earth by Zeus, i. e., images not made by human hands, also stem from these periods when the magical element was dominant. These images had stronger powers than images made from earthly material. Images of divine origin included statues of Athene in Troy and Athens and the celebrated image of Artemis at Ephesus, still referred to in the Acts of the Apostles as great Diana of the Ephesians.

When the magical element faded, the form of worship and the popular attitude to images changed. Fear was replaced by awe and reverence. The images had become identical with the gods, so people had to approach them with due reverence and lavish every conceivable attention upon them. The religious customs of that period included the bathing and anointing of images, and they were also crowned with garlands and given food. They often occupied a place of honour in the theatre and attended performances[5]. Critical minds in Greece felt that this new familiarity of the people with their gods tended to coarsen and vulgarise the old conception of them. They considered that the true essence of the divine being, i. e., the spiritual element, had been lost. 'God is all eye, all spirit, all ear. Yet mortals imagine that gods are born and have garments and voices and forms like themselves' (fr. 24 and 14). Thus wrote Xenophanes of Colophon[6], and he said elsewhere: 'But, if oxen and horses and lions had hands or could paint with their hands and create works like human beings, the horses would paint figures of gods that resembled horses and the oxen forms of gods resembling oxen and would fashion bodies having just the same form as their own species' (fr. 15). There is also quite an unmistakable note of criticism in Heraclitus of Ephesus[7]: 'And they actually pray to images of the gods there, which is just as if a person tried to carry on a conversation with a building, because they do not recognise gods and heroes for what they are' (fr. 5). Empedocles of Agrigentum[8] said: 'A man cannot bring the godhead close to himself and reach it with his eyes or grasp it in his hands . . .' (fr. 133), also 'It is not provided with a man's head on its body and it has not in sooth two branches rising from its back, or feet, or swift knees, or hairy private parts; a spirit, holy and superhuman, alone stirs within it and goes rushing with rapid thoughts through the whole universe' (fr. 134). Protagoras of Abdera[9] also expressed his doubts on the subject: 'As regards the gods, I do not indeed have any means of knowing if they exist or not, or what form they take, as there are things that prevent me from knowing this: their imperceptibility and the fact that human life is short' (fr. 4).

The criticism of the philosophers had its effect on educated men. They too felt that spiritualisation of the divinity was more fitting than the abuses then bedevilling religious practices. Once again they began to create a gap between the image of a god and the general public. The image was given a place apart in a residence of its own — the temple — and the priest presented himself as an intermediary between the god and the people. He it was who took delivery of the

garments and food brought as gifts for the god by devout mortals. But the real aim of these reforms was not achieved. The masses did not let themselves be led upwards into more spiritual regions. Instead they felt forlorn and abandoned now that their god had suddenly become remote and unapproachable. A dangerous gulf was opening up between the educated classes and the simple folk. Instead of being purified and elevated, the mass of the people sank back once more into the dark depths of superstition and the magical element began to revive.

Plato appears to have recognised the dangers inherent in this. He too regarded the images of the gods as being inanimate, but he believed that worship of the statues would be an inducement to the gods to be well disposed towards man and to bestow their favour upon him[10]. The appeal to the educated classes not to abstain from acts of worship even if they thought they knew the true nature of the gods was reiterated again and again as time went on, right up to the age of the Gnostics. After all, the mass of the people needed to have a representation of the divine beings that they could perceive with their senses.

The ROMANS, who probably had no images originally and even in historical times had a number of religious cults in which no images were used, based their evolution in this respect closely on the Greeks. Nor did their worship of images differ very much from Greek practices.

But certain changes arising out of the character of the Roman people are worth noting. The Romans were more practical and materially minded than the Greeks. Because of their down-to-earth way of looking at things they soon assigned definite duties to the images. These transformations did not go on for very long in the religious sphere and were more evident in private and social life.

In portraiture, the clearest characteristic is realism — a realism that was not afraid of revealing ugliness. The same sense of reality is also evident in historical pictures, which were used to decorate public buildings and were carried along in the triumphal processions of victorious Imperatores, so that the populace could share in those noble exploits exemplifying the greatness of Rome. Both types of image, the portraits of celebrities of the period and the informative historical pictures, fulfilled a clearly defined educational purpose. The image acted as the representative of the distinguished man or of the event.

This practice of assigning definite duties to images and also the representational role they were called upon to fill are very clearly reflected in one type of image belonging to the imperial period — the image of the Emperor. Under the influence of the Hellenistic images of rulers in the East, which had to be treated with the honour due to a god, an Emperor cult also came into existence in Rome. Augustus and his successor rejected that idea, but under Caligula the practice of treating the picture of an Emperor with the honour due to the gods became a legally established procedure. On the accession of a new Emperor his image was despatched even to the remotest provinces and the inhabitants were expected to show the same reverence towards it as to the Emperor himself. They approached the image with incense and candles and carried it ceremoni-

ously into the town, where it was acclaimed and garlanded and was set up in public places to indicate that the people acknowledged the new ruler. The basic idea underlying Roman imagery can clearly be seen in the case of the Emperor's image. It represented the person who was portrayed, but was not identical with him. And, as his representative, it was expected to perform the same duties as the person portrayed and had to be treated with the same reverence.

Roman criticism of images was more or less on the same level as that of the Greeks, the only exception being that the Emperor's image never gave rise even to the mildest hint of derision. Any attempt to mock or damage the image of the Emperor was regarded as lèse-majesté and was punished very severely.

To sum up the attitude of the Greeks and Romans, one could say that images of all kinds, even portrayals of the gods, were accepted as a matter of course and these images formed a part of their lives. There was never any hostility to images as such and criticism of image worship did not involve opposition to the actual images themselves. The Greeks flung themselves heart and soul into image worship, but the Romans adopted a more matter-of-fact approach. Their prosaic and politically orientated minds devised specific duties for the images, i. e., an educational or representational role and — although this point has not been particularly stressed — they were also used to adorn their lavishly appointed villas and palaces.

Around the beginning of the Christian era, if we exclude the geographically small area of the Jewish state, people lived in a world that was familiar with all kinds of images and accepted them as a matter of course. Christianity came into existence in a world that looked kindly on images, and it soon became clear that it too would have to come to a decision on the subject.

At first CHRISTIANS were, understandably, not interested in images, or they rejected them outright. Their country of origin, the land where Christ had lived and taught, was Jewish and at that particular time was fanatically opposed to images. On a campaign Pilate's successor caused his legions, who bore eagles adorned with the Emperor's picture, to make a detour and skirt Judaea in order not to upset or irritate the local populace[11]. So people who had been converted to Christianity from Judaism would have automatically rejected images as something reprehensible because of the traditional Jewish beliefs and would have regarded image worship as a form of idolatry. Non-Jews, that is pagans, who had been converted and had turned to a religion based on the spirit and on truth also looked upon images of the divine being as abominations and would have regarded this type of thing as a reversion to pagan practices.

During that first period of conversion the primary task to be accomplished was the spread of Christianity, and the creation of new communities and teaching of the spirit of the new religion. The Church at that time was not a well-knit organisation. Secondary questions, such as the use of Christian images, were extremely unimportant compared with this. Moreover, until the time of the Milan Edict of Tolerance (313) the Christians found themselves in a country where the standard form of worship conflicted with their own and they were persecuted again

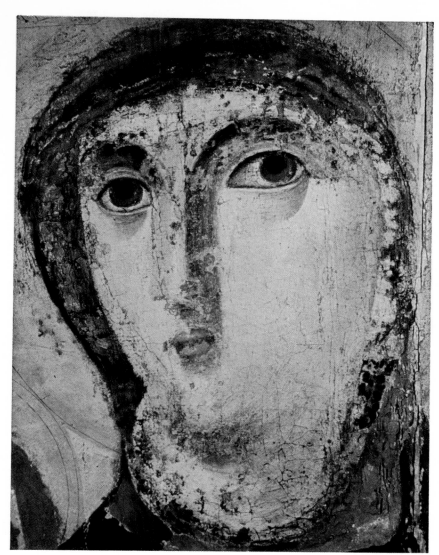

II The Mother of God and Child (detail).
Santa Maria Nuova, Rome, 6th/7th century

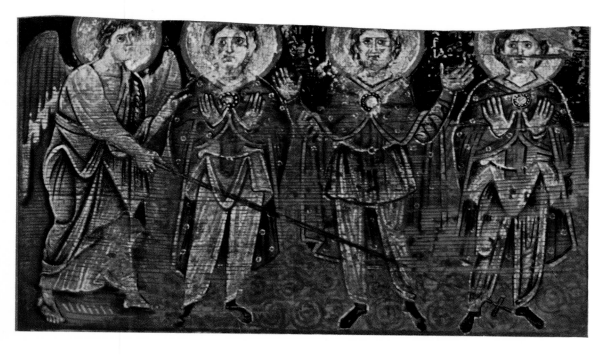

III
The Three Young Men
in the Fiery Furnace.
Palestine (?),
6th/7th century

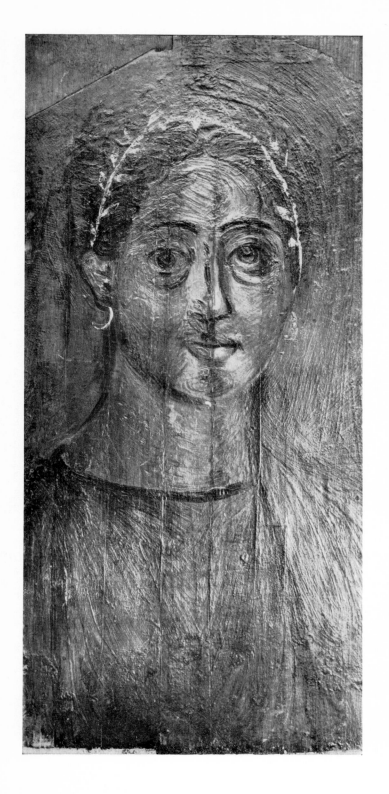

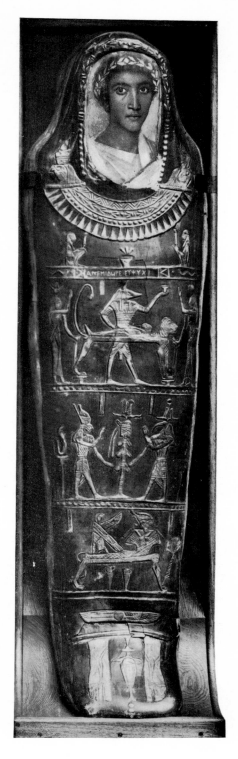

1 Mummy Portrait.
Faiyum, 2nd/3rd century

2 Mummy with Inset Portrait Panel.
Faiyum, 2nd century

and again through the years for religious and political reasons, either all over the Empire or in certain of the provinces[11a]. Christian images were not really necessary, as the books of the New Testament nowhere laid down that there should be any, so there were no factors compelling Christians to have an art of their own.

In the documents and comments handed down to us, the earliest leaders of the Church and the various writers make no mention of devotional images. It was images per se that Christians had to come to terms with — the images they saw in the world around them. The basic reaction shown by the overwhelming majority of them was a completely negative one — they rejected images. But even in these Early Christian polemics a certain distinction was made between images of different kinds. Pictures with a narrative content, the so-called *historiai*, were viewed with less hostility, and so were the symbolical pictures, or *symbola*. The full force of the attack was concentrated against the *charakteres*, or portraits. This term applied above all to idols, which symbolised a fraudulent delusion. This had to be combated because they were used in idol worship and so helped to consolidate paganism. The arguments used by the Church against idols are not very different from those of the Jews or the Greek and Roman philosophers and scholars. Stress was laid again and again on the inanimate character of the images and their natural process of decay. The miracles performed by individual idols were not denied, but these were ascribed not to the actual images, but to the activities of daemons, the forces of the underworld.

Images were not one of the main problems in Early Christian times. They are only referred to in connection with the general fight against paganism and reversions to paganism on the part of vacillating converts. So, quite understandably, the Christian Church had to concern itself with the persons who made these images — the artists. The Apostle Paul wrote: 'Let every man abide in the same calling wherein he was called' (1 Cor. vii. 20), but this statement did not apply unreservedly to artists. Tertullian (*ca.* 150 to 222) reprimanded the artist if he created idols, or images that could be turned into idols. According to him, it was the artist's responsibility if other people worshipped his images, even if the artist himself kept quite aloof from this. So it was very difficult, if not impossible, for an artist who had been converted to Christianity to pursue his profession. Tertullian indicated a way out, which would save the artist from dire distress: 'There is no art that is not the mother or the relative of some other art.' But these 'relatives' of art turn out, on closer examination, to be crafts. In his work entitled *De idolatria*, Tertullian compared the painting of an abacus with the production of an idol and the making of a cabinet with the carving of a divine image[12]. He did not have a very high opinion of art as such and spoke of the increase in idolatry since the Devil sent artists out into the world.

What Tertullian stated as a private individual is set out in similar terms in the early ordinances of canon law. The *Didaskalia ton Apostolon*, probably produced in the second half of the 3rd century, defines the general rights within the community of artists who paint with colours or make images. The *Apostolic Constitution*, of which a 4th century version has been preserved, although it is no doubt of earlier origin, clearly states that the production of idols

and membership of the Christian Church are incompatible. Its wording is based closely on Hippolytus (*ca.* 160—238): 'If a man is a sculptor or a painter, then he should be exhorted not to make idols. If he does not abstain from this, he is to be expelled!' Clement of Alexandria (Clemens Alexandrinus, *d.* 216) was probably referring to artistic works other than idols when he said that art could be honoured and respected. But he did see certain dangers arising if people admired art, and he warned them in the very same sentence not to let themselves be captivated by art as if it were the truth itself. He was not thinking of Christian images here — they were unthinkable as far as he was concerned. In the opinion of Clement of Alexandria, and of many of his contemporaries, only God the Father, the Creator of the whole Universe, had ever created an image, i. e., His own image in the form of the Logos. But man is a copy of the Logos and made to resemble Him by the gift of reason, so he is in that sense the image and likeness of God. Votive offerings presented by Christians to God could not therefore take the form of inanimate or perishable images made by the hand of an artist, but images of a different kind — the 'virtues created within us by God' (Origen, *ca.* 185—254). These virtues were immortal images, with which earthly images could not possibly be compared, even those displaying the highest artistic skill.

From all this it is clear that the image had no place in Early Christian life. It was of this world and could not possibly reveal the true world. We find this attitude confirmed when we look at the first portraits of Christ and the critical comments made about them. In Irenaeus there is a passage where he speaks of images of Christ, i. e., those to be found among the Gnostic sects: 'And they have some painted images and also a few made of other material and say that their form goes back to Pilate and that they were made at the time when Christ lived among men'[13]. The Gnostic sect known as the Carpocratians possessed images of Christ and also of Plato, Aristotle and Pythagoras. Even in the Lares shrine of the Roman Emperor Alexander Severus (222—235) an image of Christ stood beside Orpheus and Apollonius of Tyana. So the first portraits of Christ known to us belonged outside the Christian Church. And they were not used for religious worship — as is shown by the fact that they were set up beside leading philosophers — but were meant to honour a famous man.

The Christian Church rejected the idea of images and was fully convinced that it was right in doing so. This is evident from the replies made to criticisms of its unadorned places of worship. Towards the end of the 2nd century, when the Roman Emperors tended more and more to profess monotheistic religions and Christianity had recruited a considerable number of adherents throughout the Empire, Celsus criticised Christians, saying that they could not bear to look upon temples, altars or images. In reply to Celsus, Origen wrote about seventy years later that Christians and Jews were mindful of the commandment to fear God and serve Him alone. After referring to the prohibition of images in the Decalogue, he went on to say: 'They therefore do not merely abhor temples, altars and images, but are, if necessary, prepared to die rather than profane their conception of Almighty God by any forbidden act'[14].

At the beginning of the 4th century, when images seem to have become more numerous in the Christian communities, the Synod of Elvira laid down in Canon 36: 'Placuit picturas in ecclesia esse non debere, ne quod colitur et adoratur in parietibus depingatur'[15]. So the painting on church walls of objects intended for veneration and worship was forbidden. The Canon of Elvira has been interpreted in many different ways, but it is quite clear that the Spanish church assembly banned the use of images in churches within its sphere of influence. The hostility to images was confined here to their use in church, but it can probably be assumed that privately owned images were a common and well known feature of life by that time and quite popular. Perhaps we could regard the banning of images inside churches as a means of preventing the gradual introduction of image worship. If there had been images in the church where the congregation gathered for prayer, this might have served as a tacit encouragement to image worship. But the Canon made no reference at all to Christian images outside the church and thus tolerated their existence.

Just as the various written sources confirm that the Church on the western periphery of the Roman Empire had to decide where it stood with regard to Christian images, they also confirm that images were infiltrating into Christian life throughout the eastern areas of the Empire. Eusebius of Caesarea (ca. 263—340), the 'Father of Church History', as he has been called, described in his *Historia Ecclesiae* a sculptured group he himself had seen at Paneas, the subject of which was the Healing of the Woman with the Issue of Blood: '... Standing on a high stone... is the bronze statue of a woman bending down on one knee and stretching out her hands in front of her as if in prayer. Facing her is the standing figure of a man worked in the same metal, nobly wrapped in a cloak and stretching out his hands towards the woman. At the feet of the man a strange plant is growing on the column... This statue is intended to be a likeness of Jesus...'[16]. The Bishop explained that this group of figures was put up because the donors had formerly been pagans and were in the habit of offering thanks to their helpers and saviours in that way. In the same chapter Eusebius spoke also of icons of the Apostles Peter and Paul and even of Christ Himself, painted in colour. They had belonged to a woman and he had taken them from her, as he felt that anyone who possessed an image was still persisting in heathenish ways. We are therefore not surprised to learn that he refused a request made by Constantia, the sister of the Emperor Constantine, to send her an image of Christ. He informed the Emperor's sister that anyone who wished to have an image of Our Saviour before gazing upon His countenance in time to come should turn to the best painter of all — the Word of God[17].

Bishop Eusebius was definitely opposed to images and their worship, but his writings give us some indication of the social groups where images and image worship originated — among the ordinary people and apparently to a very marked extent among women.

Opposition to devotional images can also be seen towards the end of the 4th century. Asterius of Amasia (end of the 4th century) issued an exhortation not to paint Christ: 'Sufficient for

Him is the degradation of becoming a man, to which He voluntarily subjected Himself for our sake. Rather seek to carry the incorporeal Word spiritually in thy soul'[18]. Another man violently opposed to images was Epiphanius, Bishop of Salamis on Cyprus (367—440). One day when travelling through Palestine he wanted to pray in the village church of Anablatha and found inside it a painted curtain bearing a picture of Christ or a saint. He angrily tore the curtain to shreds, as it was contrary to Holy Scripture to hang up a picture showing Christ as a man inside a church ('Cum ergo vidissem et detestatus essem in ecclesia Christi contra auctoritatem scripturarum hominis pendere imaginem, scidi illud, et magis dedi consilium custodibus eiusdem loci, ut pauperem mortuum eo obvolverent et efferent')[19]. In a great many other polemical writings, only fragments of which have survived in each case, the fiery Bishop spoke out against imagery of every kind in the Christian Church. Christian art was blasphemous in his eyes.

As we can see, a large proportion of Church leaders stood out against religious images until the 5th century. But this very conflict against devotional images shows us at the same time how firmly they had taken root in the soil of popular piety. We ought not to look at this question of images in isolation: we must set it within the vast framework of what we can term the ethnical evolution, or in a certain sense the paganisation, of Christianity. This had made considerable progress since the 3rd century, or even earlier. The assimilation of pagan religious sentiments played a considerable part in the final victory of the Church. The veneration of the saints, the martyr cult, extending away back into the 2nd century, and the spread of the relic cult also encouraged the use of images by Christians to a great extent and paved the way for devotional images and image worship[20]. The Church adapted itself to the various trends existing in the community, although there was, of course, a powerful opposition who objected to materialisation of the faith in this way. Very large numbers of people had a leaning towards image worship around the beginning of the 5th century. Augustine (354—430) mentioned the many image worshippers ('Novi multos esse sepulcrorum et picturarum adoratores. . . ')[21]. He was also aware of the religious images exhibited in churches, but was restrained in his attitude towards them.

Side by side with all these dissentient voices, we can find worthy champions of images from the middle of the 4th century onwards. They include the following eminent Church Fathers from the East: Basil of Caesarea (Basil the Great, 330—379), Gregory Nazianzen (329—390), Gregory of Nyssa (d. after 394) and John Chrysostom (354—407), Patriarch of Constantinople. Basil often referred to images and many powerful arguments of his were quoted by the iconodules in the Iconoclast Controversy. At the end of his oration in praise of the Martyr Barlaam he appealed to painters ('zoographoi') to fashion a more perfect likeness of that hero of the faith and his martyrdom than he was able to do with words. And he actually demanded explicitly that the painters should show Christ 'the Arbiter' in the picture[22]. In another homily he said: ' . . . Orators and painters frequently depict soldierly deeds of valour, the former with the adornment of words and the latter with their brush, but both have spurred many men on to valour. What is conveyed to men's ears by the words of a story is also presented by painting and placed in silence before

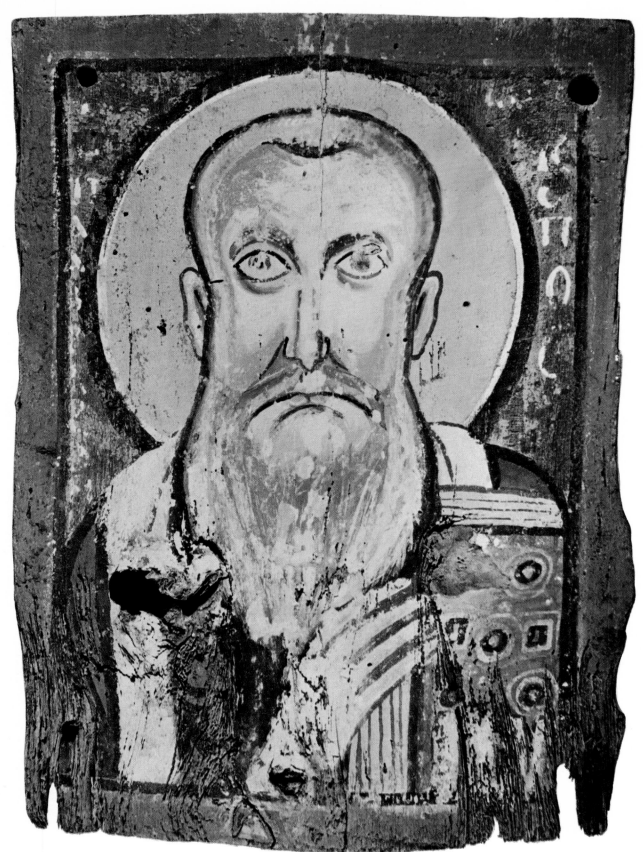

IV
Apa Abraham.
Coptic,
7th century

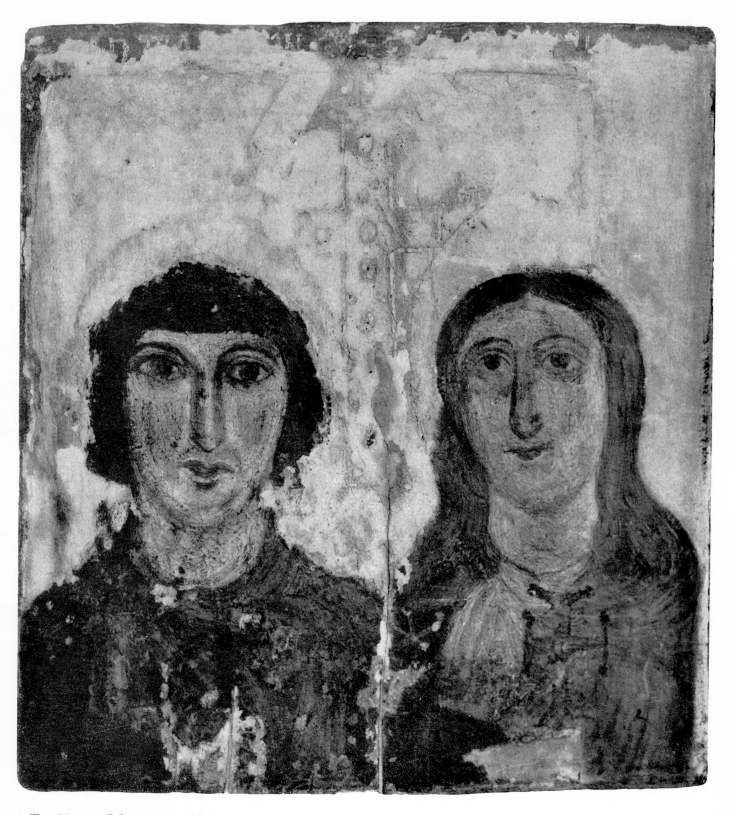

3 Two Martyrs. Palestine (?), 6th/7th century

their eyes... '[23]. In his sermons and treatises Basil often made comparisons with the Emperor's picture. We find an instance of this in his *Liber de Spiritu Sancto*, where he explained the oneness of the Deity in spite of there being the different persons of the Father and the Son. People referred to the picture of the King simply as the King, and yet there were not two kings. 'Neither the might nor the honour is divided. And, as the authority and the might ruling over us is all one — in spite of the King and his image — so also is the glorification that we accord to it, namely, to the might of the King and of his image, because the honour bestowed upon the image is transmitted to the person portrayed therein. What the image represents in the case of the King's image by virtue of imitation is represented in the case of God by the Son, by virtue of His nature. And, just as in the things that are produced by art the similarity resides in the form, so in the divine nature, which is not composite, the oneness is to be found in the common attribute of divinity' (cap. 18)[24]. The idea that the honour shown to an image is transmitted to the person who is actually represented played an important part in the case built up by the iconodules in the Iconoclast Controversy, although it was torn out of its context and was not perhaps used in its correct sense. Basil himself used it in the passage we have just quoted to explain the Trinity. But the idea that the respect or disrespect shown to an image was transmitted to the person represented by it occurs in another passage in Basil's writings, where he said that anyone despising human beings, who are made in the likeness of the Creator, commits an offence against the Creator Himself and will be punished accordingly. Here too Basil established a parallel with the Emperor image (*Comm. in Isaiam Proph.*, cap. 13). That images were also treated with scorn and disrespect, is shown by the fact that images of heretics, for example, Areios (Arius), were used to cover the floors of latrines in Constantinople[25].

Basil made an avowal of image worship in his letter to the Emperor Julian the Apostate, the authenticity of which has been called in question. He confirmed his belief in the apostles, prophets and martyrs and then went on to say: 'I also honour portrayals of them on their images and make proskynesis before them...' (*Epist.* 360). *Proskynesis* had not, of course, acquired its later and definitive meaning in Basil's day and quite often meant kissing or kissing one's hand to an object as a token of veneration[26].

Educational factors may have played a part in Basil's positive attitude towards images, but, be this as it may, his demand that Christ Himself should be painted certainly contrasted very sharply with the views of Eusebius and Epiphanius. Here we have the opposite pole to the puritanical point of view. Like Basil, Gregory Nazianzen also affirmed that the image of a saint was worthy of honour[27]. He acknowledged the pedagogic benefits of art and described the painter as the best teacher. Moreover, he praised the plastic works in the temple built by order of his father and commended them for being in no way inferior to nature.

Gregory of Nyssa, the younger brother of Basil, described the impressive character of an image showing the Sacrifice of Isaac, which moved him to tears. In a tribute to the martyr Theodore, he also gave an interesting description of the church: 'On entering a place like the

one where our gathering is being held today, containing the memorial to the righteous man and his hallowed remains, we are enthralled by the splendour of the spectacle before us; we see a house like a temple of God, a brilliantly executed and majestic building with beautiful decorations, in which the sculptor has carved animal shapes out of wood and the stonemason has polished the blocks of stone till they are as smooth as silver. The painter too has contributed the flowers of his art by depicting the heroic deeds of the martyr, his battles, his anguish, the savage figures of his tormentors, the assaults, the flaming furnace, the blissful end of the warrior and Christ the Judge in human form. He has expressed it all artistically in colour as if in a talking book, presenting to us vividly the struggles of the martyr and adorning the temple like a glorious meadow. Even a picture on the wall can speak without words and serve a highly useful purpose. In the same way the mosaic artist transforms the floor over which our feet pass into a teller of tales' (*Hom. in S. Mart. Theodorum*)[28].

John Chrysostom, 'of the Golden Tongue', leading orator of the Greek Church, thought that images encouraged piety. In a homily on St Meletius he praised the many people who had set up an image of the saint in public places and had put it on their household utensils and actually decorated their garments with it. He appealed to them always to keep it in front of them. From the later polemics of the iconoclasts we know that the custom of wearing Christian images on clothes persisted for centuries. In the well-known mosaic in the choir of San Vitale at Ravenna the Empress Theodora is wearing a robe with the Adoration of the Three Wise Men worked into the trimming[29].

So, side by side with all those who relentlessly opposed the use of images, we find numerous Church leaders who encouraged both their separate use and also the decoration of churches with them. The importance of educational factors should certainly not be underestimated here, as when Christianity became the established religion of the Empire, after the final victory, the conversion of pagans throughout its vast territories was the urgent and enormous task that the Christian Church set out to accomplish. We can therefore understand St Nilus the Ascetic (Nilus Sinaita, *d.* about 430) when in reply to an enquiry from the Eparch Olympiodorus regarding the painting of a new church, which was to include animal scenes of different kinds and a large number of crosses, he said that the eyes of the faithful would only be confused by it all. 'On the other hand it is fitting that a strong and manly spirit should set up a single cross in the sanctuary to the east of the holy of holies ... and fill the sacred temple on both sides with pictures from the Old and New Testaments by the hand of a distinguished painter, so that those unable to write or to read the Holy Scriptures may be reminded of the righteousness of loyal servants of the true God by contemplating their images, for they have exchanged earth for Heaven, preferring the unseen to things seen'[30].

The vast majority of images mentioned by the church leaders who were in favour of them took the form of scenes. In the memorial chapels of the martyrs, in particular, there were very often whole series of pictures showing the life and death of these much venerated saints. But

we must certainly not consider the high regard people had for this type of picture as amounting to image worship. Nor was Nilus thinking of this when he suggested to Olympiodorus that the church should be painted, as he expressly stated that the cross was in itself an adequate decoration for the smaller chapels in the building.

Portraits inside Christian churches appear to have been images of bishops originally, that is, if we exclude the portraits of Christ referred to earlier in connection with the Gnostics. These were not, of course, intended as objects of veneration for the congregation, but appear to have been based on the Emperor image. During the centuries of debate on matters of dogma we often hear of enthroned bishops having their own pictures hung and smashing those of their deposed predecessors. Information about the special purpose of bishops' pictures and when they first appeared is still thoroughly inadequate[31]. A certain Sulpicius Severus asked Paulinus of Nola (d. 431) for his picture so that he could hang it while Paulinus was still alive, together with one of Martin of Tours, in a baptismal chapel: the use made of bishops' pictures must have been rather similar. After hesitating and raising objections to begin with, Paulinus agreed, but not without giving him some special instructions. When a church dedicated to the Holy Martyr Felix was being restored, we also hear of Paulinus of Nola arranging for a large number of pictures to be painted on the walls, for educational reasons. By providing pictures and explaining them he hoped to divert the crowds who came flocking to commemorate the saint on his feast day from all the usual merriment and junketing, and make the festival a more seemly affair[32].

To the north of the Alps the existence of panel paintings ('iconica') was first mentioned by Gregory of Tours (540—594). In a church at Clermont there were iconica of the apostles. There was no question of worshipping these pictures[33]. Pope Gregory I, the Great (590—604), wrote a letter to the Hermit Secundinus, instructing him in the use of pictures of Jesus, Mary and the Apostles Peter and Paul which he had sent to him. He told the Hermit that he knew he did not hanker after the picture of Our Saviour in order to worship it like God, but he would be reminded of the Son of God and so his love would be strengthened towards the One whose picture he desired to see. Gregory added that we ought not to go down on our knees before the picture, but should worship the Person of whom the picture was intended to remind us[34]. At the end of the 6th century there was not yet a marked tendency towards image worship, nor was it allowed. Up to this time, images merely existed.

In the eastern parts of the Empire, image worship had in the meantime taken on a fresh lease of life. This was partly connected with the appearance of a completely new type of ascetic. In the 5th century — especially in Syria — stylites, or pillar saints, came into existence. The best known and most famous of these was Simeon the Stylite (d. 459), an ascetic who lived on a pillar for thirty years. People firmly believed that they were holy men and went flocking on pilgrimages to see them. As souvenirs of their pilgrimage they liked to take little clay statuettes or small plaques of St Simeon home with them, which were, they thought, endowed with the power of the saint and would protect them from all kinds of calamities[35].

From the 5th century onwards we can also see a vigorous effort being made to establish the true personal appearance of Christ[36], the Mother of God and the Apostles. So in the 5th century we come across the legend of the picture painted by the Apostle Luke. In the middle of the 6th century there is also an account of an image of Christ not created by human hands (acheiropoietic) at Edessa (the Abgar legend), and at the end of the same century we find evidence at Camulia in Cappadocia of a further acheiropoietic image of Christ[37].

The inevitable result of all these pictures flooding into the churches was an increase in image worship from year to year. As was to be expected, this became particularly marked in parts of the Empire where images had been indigenous in the pre-Christian era and were familiar to the local inhabitants — in Greece and western Asia Minor. Image worship developed in these areas in the 6th and 7th centuries and was now not only tolerated, but encouraged by the clergy. Images as such had long been an acknowledged fact of life. We hear of images appearing not only in the churches, but also, to an ever increasing extent, in all sectors of public and private life. But that is not all. References in the source literature to specific forms of veneration become more and more frequent. Mention is made of candles, incense, kissing and washing — and even proskynesis in the miracle of the Saints Cosmas and Damian. Images were borne in procession, just as the images of the Emperors had been, and churches were dedicated to particular images.

From here it was only a small step to miracle-working images, to the idea that mysterious forces operating within the image could grant the suppliant help and protection. There are repeated accounts of invalids being healed by the images themselves, by fluid gushing out of them or merely by water in which the images had been washed. The Saint himself appeared to the believers in the form they were accustomed to see in images and spoke words of comfort to them. It seemed natural then that a person who had been helped by the image should express his thanks to it; so the icon was decorated and encased in precious metal[38].

Later on, we find not only single individuals, but entire communities begging an image for protection. Travellers carried images about with them for their personal protection, and the army had an image carried in front of it in battle to bring it good fortune. Beleaguered cities relied on the protection of images — for example, Edessa put its faith in the acheiropoietic image of Christ, and Constantinople in the icon of the Mother of God.

Images were given the task of acting as representatives and the truth was affirmed in their presence with an oath. St Euphrasia, as we are told by John of Damascus in his third oration on images, recommended her child to the safekeeping of an image of Christ[39]. Images could also grant a merciful death. We learn of a man called Theodore who had slandered John Chrysostom and could not die in a state of redemption until he had venerated his icon[40]. Many more instances of the part played by images in popular life could be quoted here.

But, besides the miraculous help given by images, punishments and disasters were inflicted if they were treated with disrespect. Images damaged by the Arabs in conquered cities not only bled from their wounds, we are told, but this blood made the pagans seriously ill[41]. So images

V SS. Chariton and Theodosius.
Palestine (?), 7th/8th century

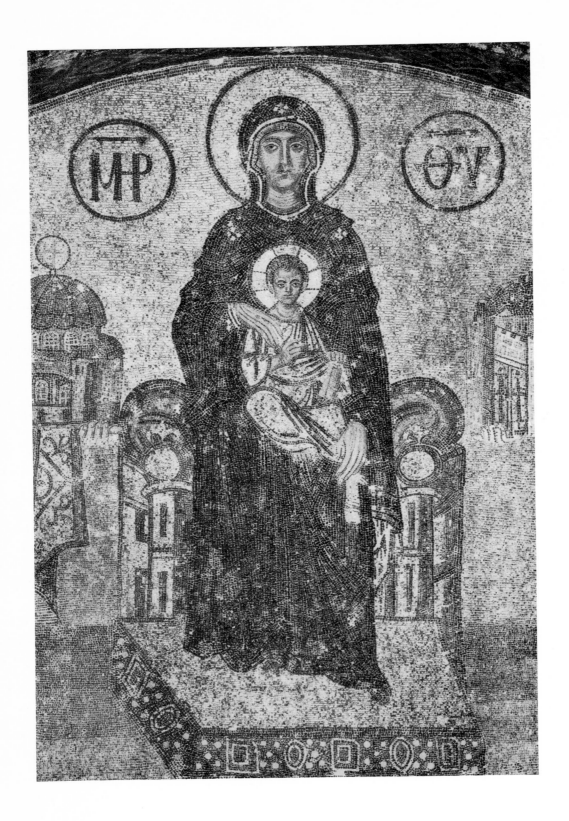

4 The Mother of God Enthroned (Wall Mosaic). Hagia Sophia, Constantinople, *ca.* 1000

were changing more and more and, instead of merely being objects of veneration, were having an active effect on the life of the whole nation. They were becoming more and more animate and alive — we even hear of images speaking — and an aura of the supernatural could be seen in the luminosity that was often supposed to surround these sacred pictures. As they became more and more important, the widespread worship of images increased accordingly. In the written material describing the life of St Maximus the Confessor we are told that the persons attending a synod, including the Bishop of Caesarea, went down on their knees before images of Christ and Mary[42].

The examples quoted from the east and west of the Christian world and the voices raised for and against images were relevant only to local areas. Although they do indicate an overall trend or pattern of development, no final verdict had been announced by the Church through the medium of a general council. A definite ruling on images was given for the first time at an ecclesiastical assembly in 691/692. It met in the Trullo Hall of the Imperial Palace and was intended to supplement the statements on dogma issued at the Fifth (553) and Sixth (680/681) Ecumenical Councils during Justinian II's first period of authority (he was the first Emperor to have a picture of Christ stamped on the reverse of coins). This was called the Trullan Council after the name of the hall, or the 'Quinisextum' because of its chronological order. These regulations are very interesting in many ways and show us what Christianity was like at that time. They give us deep insight into the popular customs of the period and reveal that pagan usages were still lingering on at the end of the 7th century[43].

Canon 82 is of particular interest in connection with Christian art: 'Certain holy icons have the image of a lamb, at which is pointing the finger of the Forerunner. This lamb is taken as the image of grace, representing the true Lamb, Christ our God, Whom the law foreshowed. Thus accepting with love the ancient images and shadows as prefigurations and symbols of truth transmitted to the Church, we prefer grace and truth, receiving it as the fulfilment of the law. Thus in order to make plain this fulfilment for all eyes to see, if only by means of pictures, we ordain that from henceforth icons should represent, instead of the lamb of old, the human image of the Lamb, Who has taken upon Himself the sins of the world, Christ our God, so that through this we may perceive the height of the abasement of God the Word and be led to remember His life in the flesh, His Passion and death for our salvation and the ensuing redemption of the world'[44]. So this Canon meant that the portrayal of Christ in human form was duly sanctioned and, in fact, demanded, and Christ's incarnation was used to justify and show the necessity for that particular form of presentation.

For the first time Christian images were following a definite path mapped out by the Church and were no longer subject to opinions and classifications relevant only to individual provinces. Canon 82 confirmed the ethnical evolution of Christianity as far as images were concerned; from now on, however, images were closely bound up with the Church. L. Ouspensky thought that we should interpret this event not as a 'penetration of pagan customs into the Church', but

as a process of 'churchification' — 'not the "paganisation" of Christian art, as has so often been asserted, but the Christianisation of pagan art'[45]. The assimilation of pagan customs was, of course, a process of 'churchification', but this churchification would probably not have taken place if it had not been absolutely necessary. The ethnical evolution of Christianity is an indisputable fact. But no serious assertion was made that Christian art had been paganised, because Christian art did not exist a priori. Christian art could only come into existence as a result of the churchification of pagan art. Perhaps the term 'churchification' is not a particularly happy choice and it might be more appropriate to say that profane art had been permeated by the spirit of the Christian faith. 'It does not really seem conceivable that Christian art could have been under general Church control from the very beginning. First of all, a Christian Church had to be formed and establish itself as a power over the masses, and the creative artist also became subject to this. The art flourishing in the early centuries in the individual communities purely on religious themes, and divided up according to the different groups of countries, was the real determining factor when Christian art came into existence.' That is the verdict of Josef Strzygowski on the beginnings of Christian art[46].

The stipulations of the Trullan Council were not binding upon the entire Church. The Pope, for instance, refused to acknowledge them. Many of the rules of that Council clearly show the great differences that had developed between Byzantium and Rome, between Christianity in the East and the West. And even the binding force of the rule about images, Canon 82, one of the 102 rules of that Church assembly was challenged barely a century later. The ensuing debate, that was to persist for many long years, flared up not so much because of the images themselves, but because of the superstitious worship of icons, which was extravagantly gaining ground among the ordinary people and the lower categories of monk. Ecclesiastical and political factors led to that great upheaval in the Church and the Byzantine Empire, recorded by historians as the Iconoclast Controversy.

The Iconoclast Controversy (726—843) did not stem from an act of pure despotism on the part of the Emperor, nor did it descend upon the Empire without warning, out of a clear sky. Before we can understand it, we must try to trace the political and spiritual undercurrents. Besides those who championed image worship there were always some, among the Bishops of Asia Minor, who opposed materialisation of the faith. They demanded again and again that God should be worshipped in a purely spiritual manner. The words used in John ('God is a Spirit' — John iv. 24) became the guiding principle of all those who saw image worship degenerating on all sides more and more into crass superstition. Moreover, in the 7th century there was a marked revival of antagonism to image worship from the Jews. The Christians were accused of idolatry, and in a whole series of writings by Archbishop Leontius of Neapolis on Cyprus, Anastasius of Sinai and others, which have been preserved completely or in part, the Christians stood up to the Jews and endeavoured to defend their point of view. Christian communities

outside the Church, for example the Paulicians, went back to the tradition of the Early Church and rejected images and image worship. A point we must not overlook is that the Arabs, who were then sweeping forward, did not allow images of human beings and a decree of the Caliph Yazid II in 723 ordered the removal of all images, even from Christian places of worship, inside his territory. In addition to this hostility to images and image worship from outside the Church, there was also — as we have mentioned — opposition to images inside the Church itself, and this should not be underestimated. The leaders here were the Metropolitan Thomas of Claudi-opolis and Bishop Constantine of Nacolia. Their central idea was that the spiritual worship of God ought to be preserved or restored. From a theological point of view, they felt that image worship and the pictorial representation of God were incompatible with Holy Scripture. They did not only refer to the Old Testament ban on images, but also obtained their arguments from the New Testament and from tradition. As the central point at issue was the portrayal of Christ, the theological debate was in a sense a continuation of the Christological disputes of the previous centuries. Arguments that had been voiced in earlier times were now reiterated. It was said that the divinity of Christ could not be shown in pictures as it was impossible to depict it. Even Christ the Man was clothed in His glory, or 'doxa', as His flesh was at the same time the flesh of the God Logos, and where Christ's soul was, there too was the godhead, and where Christ's body was, the godhead was present also. So, if an artist painted a picture of Christ, it was only a picture of Christ the Man. But this would mean that he had yielded to a false doctrine by separating the two natures which form an indissoluble state of oneness in Christ and so had become guilty of the heresy of the Nestorians. Or else he had combined the two natures and had also portrayed the divine nature of Christ, thus showing himself to be an adherent of the monophysite heresy. 'How can the foolish mind of the draughtsman be so presumptuous and dare to portray what cannot be achieved by art because of a miserable lust for profit and take it on himself with his unconsecrated hands to give a form to something that can only be believed in the heart and confessed with the lips?'[47]. That was the question asked at the Council of Constantinople in 754. Like Epiphanius and Eusebius, people even then stated that Christ was not to be copied in dead materials or in earthly colours and that matter simply remained matter. So the cult of images was really idolatry, bestowing on dead matter the honour that was due to God alone. The same could be said regarding pictures of the saints, as here too it was only possible to paint a picture of a human being, and never his celestial glory. As this could not possibly be portrayed, the pictures of the saints did not honour them in any way and were nothing more than an insult to them.

The objections raised by those who were hostile to images cannot be dismissed out of hand. They are certainly not another version of the imperial ban on images dressed up in a makeshift theological guise, as has been alleged. The supporters who had organised themselves into a group or — as would seem to be more likely — joined the movement purely as a result of their own personal convictions were probably recruited primarily from the educated classes.

As for the great mass of the people, they were becoming increasingly addicted to the superstitions surrounding images, which were then reaching a crescendo. But those who were against images — and they were not necessarily iconoclasts — could never have made their presence felt if they had not had the Emperor's authority to back them.

Leo III (717—741) came from the eastern part of the Byzantine Empire and had served for many years in the eastern provinces before becoming ruler of the entire Empire. He knew the Arabs very well indeed and was no doubt familiar with the ideas of those clergy who were striving towards a purely spiritual form of religion. The fact that one of the few periods when Jews were persecuted in the Byzantine state was during his reign is at least indirect evidence of the very considerable influence that must have been gained by the Jews — as we know, they protested violently against the Christians, who were in favour of images.

The first years of the Emperor Leo's reign were entirely taken up with the task of freeing the Empire from the Arab menace, for the Arab army and fleet had already reached the walls of the capital, Constantinople. As a result of his clever scheme of alliances and some enduring military successes the Emperor succeeded in liberating the capital and he also carried out a mopping-up operation in Asia Minor and managed to guarantee the security of the Empire. Leo III then turned to legislation and the reorganisation of the state. He showed himself to be just as great a ruler as regards internal affairs as when resisting enemies from without. But it was, in fact, a question of ecclesiastical and internal policy that plunged his Empire into a great crisis — the conflict known as the Iconoclast Controversy.

The dispute began in 726 when the Emperor Leo III spoke out publicly against images for the first time. Leo appears to have been under the influence of the Bishops of Asia Minor[48], who were hostile to images, and the final incentive came in the form of a natural disaster — a severe earthquake in which, it seemed to him, God had vented His wrath upon those who misused images[49]. The educational sermons in which the Emperor tried to convince the people of his hostility to images were soon followed by actions. By order of the Emperor, an image of Christ in the capital that was held in particularly high public esteem was removed. The reaction of the citizens showed how firm was the hold that image worship had upon them and also the extent to which the Emperor may have underestimated this. The furious bystanders slew the officer of the imperial guard. News of the Emperor's action spread like wildfire and parts of Greece soon rose in revolt, setting up a rival Emperor and sending a fleet against Constantinople. The Emperor succeeded in putting down the insurrection, but the unexpected reaction made him act more cautiously in future. At the same time it had showed the part of the Empire where image worship was most widespread — the Greek parent lands of the Byzantine Empire.

The Emperor carried on an extensive correspondence with the leading men of the Church and tried to win them over to his point of view. He met with opposition from the Patriarch of Constantinople, Germanus, and the Roman Pope Gregory II who was anxious to avoid a breach with the Emperor, whose help he urgently required against the Lombards, resolutely opposed

any attempt by the Emperor to interfere in religious matters and championed the cause of images. Gregory II and Gregory III actually condemned iconoclasm at Church assemblies.

Leo found that no one was in sympathy with his demands; only one course remained open to him — the issuing of an imperial decree and, after that, force. At an assembly of the highest dignitaries of the Empire the Patriarch Germanus once again refused to give his assent to the edict, so the Emperor was obliged to depose him and install a more amenable man in his place. Once the orders against images had acquired the binding force of law destruction of images and persecution of the iconodules began. The Popes in Rome — as we have already mentioned — did not recognise the decree against images as applying to their own area. When the Byzantine Emperor retaliated and Illyria and the southern Italian provinces including Sicily were placed under the jurisdiction of the Patriarchate of Constantinople the estrangement between Byzantium and Rome was deepened still further.

We cannot give a detailed description here of the complicated political events of the following years[50]. But it is important to remember that the son of Leo III, the Emperor Constantine V (741—775), whose succession was challenged by a rival claimant to the throne who favoured images, persecuted the iconodules even more zealously. Constantine went much further than his father and even demanded that worship of the saints should be abolished altogether. In his attempts to reform the Church he found that an imperial decree was not adequate for the purpose, so he tried to secure a decision in his favour by holding a Church council. The Council of Constantinople (at Hiereion on the Asia Minor shore of the Bosphorus, 754), the 'Headless Synod', as it was derisively called, because neither the Pope of Rome nor the Patriarchs of the East were represented, confirmed Constantine V's hostile attitude towards images. Sacred paintings in churches were now replaced by profane paintings and any icons which the iconoclasts could lay their hands on were destroyed. The bitter conflict between iconoclasts and iconodules reached an extraordinary peak of cruelty as the controversy approached its climax.

'The opposition who favoured images grouped themselves round Abbot Stephen of Mount Auxentius, to whom supporters flocked in ever increasing numbers from among the people. The Emperor's attempts to make the leader of the opposition give up the struggle failed and in November 756 Stephen died a martyr's death. In the streets of Constantinople he was torn to pieces by the mob, who had been goaded into a fury. The vast extent of the opposition to Constantine V's regime is shown by the fact that the Emperor had nineteen senior officials and officers executed in August 766 ... But it was the monks who resisted the destruction of images most strongly, so the persecution of image worshippers began more and more to take the form of a campaign against the monks. The heads of the most highly respected representatives of the monastic opposition fell, the prisons were filled to overflowing and mutilation and other acts of torture became an everyday occurrence. People began to emigrate on a large scale, moving, in particular, to southern Italy, where they created new centres of Greek culture by founding monasteries and schools'[51].

Constantine V was not content with mere iconoclasm. Towards the end of his reign his hostility to religious worship had increased to such an extent that he actually forbade invocations of the Mother of God and the saints. When he died in 775 the hostility to images and the persecution of iconodules had reached its climatx.

The picture of the two Byzantine Emperors Leo III and Constantine V that has been handed down to us is extremely distorted because of their iconoclastic activities. Leo III was certainly not the narrow and morose tyrant that he has often been made out to be. Diehl speaks of him as a clever diplomat, an excellent military leader and a good organiser, in short, a man with all the qualities of a statesman[52]. And his son Constantine V, a man with a split personality, tormented with passions, nervy and ailing, was also an Emperor well above the average. He was saddled with the contemptuous nickname 'Copronymus' by contemporaries who hated him and, after the Iconoclast Controversy was over, his body was removed from the Church of the Apostles. However, 'Memories of his successes in war and his heroic exploits outlived him, and when Byzantium was overthrown by the Bulgars at the beginning of the 9th century, the people in their desperation gathered at the tomb of Constantine V and beseeched the dead ruler to save the Empire from its terrible disgrace'[53].

Under Leo IV (775—780) there was a pause in the bitter religious conflict. A transitional period was beginning, during which the hostility to images was maintained, but all persecution of iconodules ceased. They were no longer punished by death. The Chronicle mentions only imprisonment and whipping — in one single instance. After the premature death of Leo IV the Empress Irene acted as regent for her son Constantine VI (780—797), who was a minor. The Empress, who was well disposed towards the iconodules and was confirmed in this attitude by an attempted insurrection supported by groups who were hostile to images, did her utmost to re-establish image worship. She set about this cautiously and sounded the ground by negotiating with the Patriarchs of the East and the Pope in Rome. They said they were prepared to support an ecumenical council for the restoration of image worship by sending authorised representatives to it. After replacing the Patriarch of Constantinople, who had been installed by Leo IV, by a man acceptable to her self, — her secretary — Irene made the final preparations for having the ordinances of the Constantinople Synod of 754, which had been hostile to images, repealed by the new council.

But the Empress had assessed the effects of the very protracted Iconoclast Controversy too favourably. Troops from the guard broke up the assembly of Bishops in the Church of the Apostles in Constantinople (786) and scattered the delegates by force of arms. Irene saw her mistake and in her usual energetic way made arrangements for a new council, whose success would be guaranteed. The mutinous regiments were moved out of the capital and sent on a campaign against the eternal enemy on the eastern frontier and were replaced by dependable Greek troops. Then she arranged for the council members to be convened once again, this time in Nicaea, where in 787 the VIIth Ecumenical Council met — the last of its kind in the history

5 The Apostle Peter.
 Byzantine, 6th century

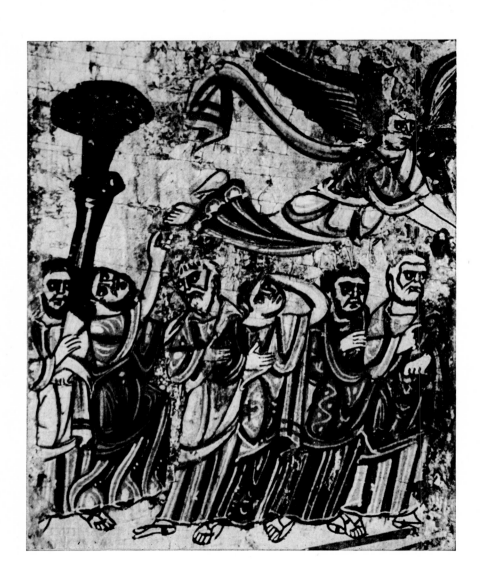

6 The Ascension (detail). Palestine (?), 7th/8th century

of the Christian Church. Under the chairmanship of the Patriarch of Constantinople, Tarasius, this Council, also called the Second Council of Nicaea, was brought to a successful conclusion in an astonishingly short space of time because the preparations had been so thorough. A factor of some importance which contributed towards the rapid and smooth course of the Council was the tolerant attitude of the iconodules, who, in spite of opposition from the monastic faction, were prepared to receive the iconoclastic Bishops back into the Church after they had abjured their false doctrine.

After a bitter conflict lasting over half a century a decision was reached about images and image worship at that Council. It was evident that the vast majority of the people and the clergy had been in favour of images and still were. This decision was unaffected by the repeated disturbances that broke out in the next fifty years. Again and again images were introduced into the battle cry of the various civil-war factions contesting the claim to the imperial throne, but Ostrogorsky rightly sums up the revival of hostility under the Armenian Emperor Leo V (813—820) as follows: 'The iconoclasm of Leo III and Constantine V was a spiritual movement of great inflammatory power, but the iconoclasm of the 9th century, stemming from political disappointments, was a decadent type of reaction'[54]. The iconodules were subjected to a final period of cruel persecution under the Emperor Theophilus (829—842), especially after John VII Grammaticus, a fanatical iconoclast, was installed on the patriarchal throne in 837. 'A grim reign of terror began once more. It was aimed primarily against the monks, as in the period of Constantine V, and involved acts of deliberate cruelty. A particularly cruel martyrdom was inflicted on the brothers Theodore and Theophanes from Palestine, on whose foreheads verses decrying images were branded with red-hot iron. They were afterwards given the nickname of "Graptoi". Theophanes was, in fact, a poet, well known for his verses in praise of images of the saints. After the restoration of the true faith he served as the Metropolitan of Nicaea, still bearing on his face the mark of his unique ordeal. But, although the Emperor and the Patriarch attempted to revive the iconoclastic movement by all the means at their disposal, it became increasingly evident that they were powerless in this matter. Even Asia Minor no longer supported the iconoclastic policy. It was confined to all intents and purposes to the capital and it was only through the determination of the Emperor and the few persons loyal to him that it continued to prevail there at all. Iconoclasm did not continue after the Emperor Theophilus, who died on 20th January 842'[55].

Irene had been responsible for the definite trend towards image worship at the Council of 787, and it also fell to a woman to bring this tempestuous chapter in Byzantine politics to a close. She was the widowed Empress Theodora, who was acting as regent for her six-year-old son, the Emperor Michael III (842—867). She and her advisers felt that what was most urgently required was peace within the Empire and, as a very important step in that direction, the restoration of image worship. A synod convened in Constantinople in 843 confirmed the practice of image worship and provided for the rehanging (Anastelosis) of images. That resolution is

commemorated in the Orthodox Church to this day in the festival marking the triumph of the true faith on the first Sunday of the great fast — the 'Sunday of Orthodoxy'.

The various political events in the Iconoclast Controversy, first moving in one direction, then in another, have been reviewed in sequence, and we should now mention the principles held by the iconodules, as they determined the dogmatic content of the icons and had very real effects on icon painting. The leading personality among the iconodules was John of Damascus (ca. 675—749), a cultured and well read apologist, whose strength lay in his gift of oratory and detailed knowledge of patristics rather than in the originality of his thinking. We get the impression that Damascenus did not miss a single quotation from the writings and sermons of the Early Fathers[56]. In his three famous orations about images he made repeated attempts to convince a large circle of hearers that image worship was right. He quoted the various arguments of his opponents and then proceeded to refute them in a clear, rational manner.

John boldly rejected any intervention on the part of the Emperor. 'No one will convince me that the Church is not governed by the written and oral ordinances of the Fathers, but by the edicts of the Emperors'[57]. He said that it was not the Emperors who proclaimed the doctrine, but the apostles and the prophets, and Christ did not transmit the power to forgive sins to the Emperors, but to the apostles and their successors. 'We obey you, oh Emperor,' he exclaimed, 'in matters concerning the interest of the state, in the payment of taxes and other sources of revenue. We fulfil our obligations, in so far as the administration of our affairs is entrusted to you. But, as far as Church ordinances are concerned, we have shepherds who proclaimed the Word to us and handed down the laws of the Church to us. We shall not therefore displace the old limits set down by the Fathers, but shall conserve the traditions in the form in which they were passed on to us'[58]. In all his orations John issued warnings to the Emperor and hoped that he would change his views. At the end of the third oration he then proceeded to excommunicate the Emperor completely and absolutely.

After John had rejected the Emperor's claim that he was entitled to lay down laws that were binding on both Church and State ('basileus kai hiereus eimi'[59]), he refuted the iconoclast assertion that the Old Testament prohibited the making of images. It was an undisputed fact that God the Father could not be portrayed, as nobody had ever seen Him, and the portrayal of God was strictly forbidden in the Old Testament. But many other passages in the Old Testament cancelled one another out, if they were examined separately. But the only true God, who never lied and could not contradict Himself, had composed the Old and the New Testament. One therefore had to search the Scriptures and observe the spirit of them. John of Damascus came to the conclusion that, in addition to the ban on portraying God Himself, which was unchangeable, the Jews had to be saved from idolatry, so the making of other images was banned too. This measure was adopted by God to educate His chosen people. But it had a time limit. When God became Man, this educational measure ceased to be valid. A new era had begun and the Old Testament, or Covenant, had been replaced by the New.

A particular passage was quoted from the New Testament as a proof of this: 'And the Word was made flesh, and dwelt among us, and we beheld his glory, the glory as of the only begotten of the Father, full of grace and truth' (John i. 14). And, referring to the parable of the tribute money (Matthew xxii. 16—21), John of Damascus reached the following conclusion: 'As the coin bears the picture of the Emperor, it belongs to the Emperor; give it therefore to the Emperor. And give the picture of Christ to Christ, for it belongs to Christ' [60].

John of Damascus rejected the tirades of Bishop Epiphanius against images, which were often quoted by the iconoclasts. In this he showed great cleverness, but was not entirely convincing. He began by expressing doubt about the authenticity of the various writings and statements that had been handed down. If they really were genuine, he thought that they might have been composed to deter the misuse of images, but if they definitely were intended to be hostile to images, then he had no hesitation in dismissing them as the voice of one single man in the College of the Fathers, which was of little significance when measured against the whole Church[61].

Having established that the views of the iconoclasts were refuted by the Holy Scriptures and by tradition, John of Damascus proceeded to work out the definition of an image. He described the essential characteristics of an image as follows: 'An image is a likeness that expresses the original in such a way that a difference remains between the two' [62]. In his third oration on images he went into greater detail: 'An image is a likeness of something, a representation or an impression, showing in itself the object imprinted' [63]. But the purpose of an image was to express something that was concealed. According to Dionysius the Areopagite (ca. end of 5th/beginning of 6th century) in his 'Celestial Hierarchy', an image is only a copy of the invisible, and contemplation of what is visible is capable of raising us up to view the divine[64]. Here we see Neoplatonic ideas appearing in a Christian guise.

We should bear in mind that an essential feature of images or icons (eikon) is similarity, reflecting the external form of the original. Anything that is not external, i. e., the soul, cannot be represented — that is the difference between the image and the original. Those who were hostile to images demanded that the image should be identical or consubstantial, but the champions of images held the view that an image had only to be similar — the difference between the image and the original lay in the substance. This emphasis on the similarity linking the image and the original had important consequences for Christian art in the East. It explains the iconographical consistency of the work — any possibility of change was virtually ruled out. Because of this, artists based their paintings on authentic images, the acheiropoietic portrayals of Christ or the Luke picture of the Mother of God, and were always anxious to find reliable sources revealing the true appearance of all the saints. This also accounts for the existence of painting manuals at the close of the Middle Ages.

The image was, moreover, supposed to be an impression of the original (ektypoma). This idea has been very aptly expressed by Theodore the Studite (759—826): just as the stamp on a seal makes an imprint and a body has a shadow, so each original has a copy. The imprint theory is

most clearly apparent in the legends surrounding the acheiropoietic images of Christ. They originated from an imprint and duplicated themselves miraculously, as in the case of the Camulian image of Christ in Cappadocia[65]. Being an imprint or reproduction of the original, the icon reveals the original to us. We have to look beyond what the physical eye can see and seek out the original by spiritual contemplation. This means that the original is spiritually present in the copy. It is not, of course, materially present, but its power and efficacy have been transmitted to it. Images are filled with grace and overshadowed by the Holy Spirit and they enable us to participate in the sanctity of the originals. In this way they transmit the sanctity contained in them and also become a mystery in themselves. The miracles performed by images have often been quoted as popular proof that these theories are correct.

We can portray not only what we ourselves have seen, but anything that has already been depicted or has appeared before[66]. In this way, pictorial versions of the Holy Spirit, the angels and also souls and devils can be justified. Although angels, for example, are incorporeal beings and are invisible to humans eyes, Divine Providence has depicted them in shapes and forms that we are capable of understanding. Angels have often appeared in human form and the Holy Spirit has on many occasions taken the form of a dove.

But this does not mean that we ought to make pictures of everything we possibly can. As both good and evil exist in the world, John of Damascus often stressed the fact that the intention of the man who paints the image is important when one is trying to decide whether a picture should, in fact, be painted or not. Images should be made with good intentions and for the glory of God or the saints, so that they can help to save souls and encourage all that is good.

A sharp distinction is made between the respect shown to an image and the worship due to God alone. We revere God by worshipping Him (*proskynesis tes latreias*), but only honour is shown to images (*proskynesis kata ten timen*). This also applies to the veneration of Christ's image, as it only reveals His human form. It must be remembered that the religious value of icons is based on their similarity to the original and they do not simply owe their special position to an act of consecration.

There is yet another feature of icons to be considered. At first sight it seems a purely external matter, but it does have a bearing on the religious use of the image. I refer, of course, to the inscription. John of Damascus stated that, after the death of a saint, the grace of the Holy Spirit was not only still attached to his soul, but also to his body and holy images, so it was still present and effective in the image. 'Images bear the name of the person depicted and are sanctified by that name, whether it be the name of God or of a saint'[67]. The Patriarch Nicephorus of Constantinople expressed this as follows: 'Just as churches are given the name of a saint, that name is borne also by their images in the form of the superscription, and they are sanctified thereby'[68]. The similarity to the archetype and the inscription, interpreted as a kind of epiklesis, were quoted as arguments against the consecration of images in church, and these arguments have also been put forward in recent times[69].

The resolutions of the VIIth Ecumenical Council applied to the whole of Christendom, but East and West plainly went their separate ways. The action taken by Charlemagne contributed in a great measure to the different course of development followed by the West. From a political point of view, he was strongly opposed to Byzantium, and besides this the contents of the Council resolutions were communicated to him, in translation — and a very inadequate translation at that.

His completely different attitude is recorded in the Caroline Books and was confirmed by the Frankfurt Synod of 794. Of course, Charlemagne did not manage to induce the Pope to turn down the resolutions of the Ecumenical Council, although he tried hard to do so. The *Libri Carolini*[70] state, amongst other things, that both the Synod of Constantinople (754), which was opposed to images, and the VIIth Ecumenical Council of 787 went beyond the bounds of religious truth. Worship and veneration appertained not to images, but to God alone. The purpose of images was to stir the hearts of human beings, teach Christians and adorn churches. As far as the faith itself was concerned, it did not really matter whether images existed or not, as they were not necessary, and the VIIth Ecumenical Council was ill advised in its decision to anathematise all who refused to venerate images. Images could not be compared with the Holy Scriptures, or the Cross or relics.

Charlemagne's successors remained true to these principles. An imperial assembly under Louis the Pious laid down in 825 that, as far as images were concerned (*in habendo vel in non habendo, in colendo vel in non colendo*), things should be left as they were and there should be no dissension about images[71].

In the Christian West, therefore, images were used to edify the faithful, educate the congregation and adorn the churches, but they were not bound up with the actual worship, as happened in the Orthodox countries, where the whole course of artistic evolution has been coloured by this virtually up to the present day[72]. As a result, artists in the West were free to exercise their individuality, although centuries were to pass before they finally broke away altogether from the Byzantine prototype.

THE BEGINNINGS OF CHRISTIAN ART

'The early beginnings of art among the Christians are veiled in obscurity. We cannot definitely say when Christians first expressed their religious ideas in an artistic form, or where or in what sphere of Christian life this took place'[1]. From a survey of images in Early Christian times and the objections raised by many leading thinkers and clerics we realise that art was not produced under Church guidance in the early centuries. The statement made at the VIIth Ecumenical Council that Christian art went back to the time of the apostles and was, in fact, started by the

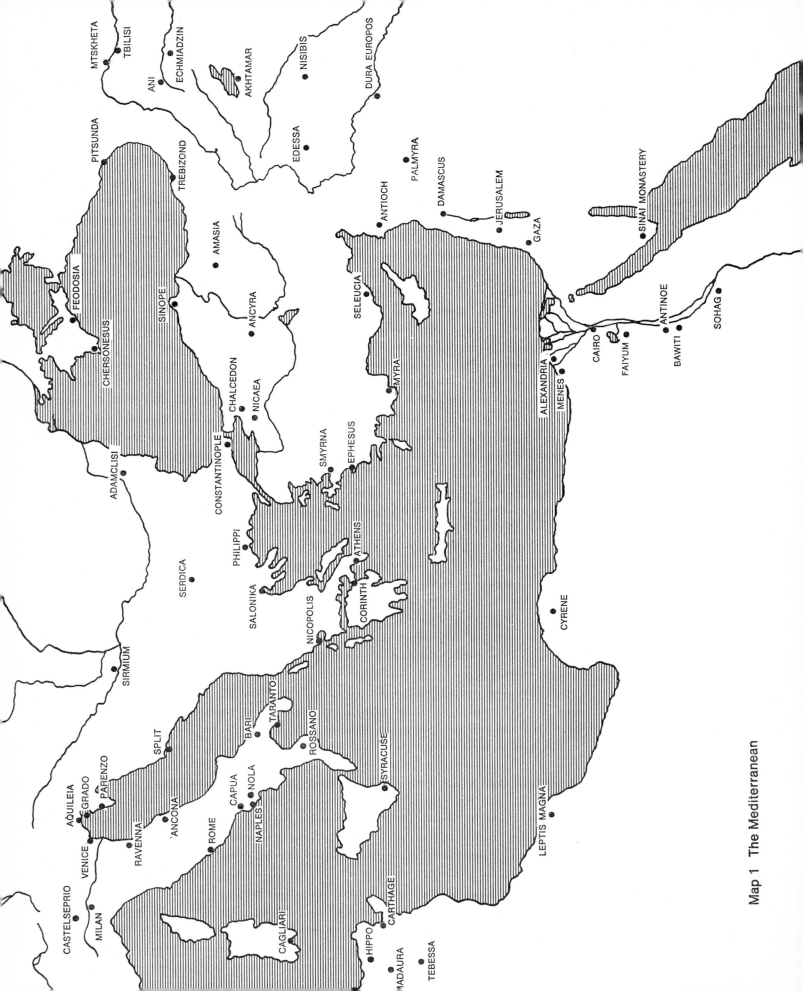

Map 1 The Mediterranean

apostles is not supported by the written sources or confirmed by the existence of artistic monuments.

In order to get some idea of the beginnings of Christian art we must therefore try to assess the various trends of development from the monuments that have survived. The form and the content of the works and their stylistic peculiarities and the themes portrayed definitely show that Early Christian art was conditioned by its surroundings. It took over elements from the existing styles and even pagan material. But the artists and the community managed to adapt both of these rapidly to suit the new faith.

The evolution of pagan art played quite unintentionally into the hands of the Christians. From the period of the Diadochi or even earlier, the old figural religion had been relapsing more and more into a state of decay and disintegration. The statues in the round of the individual gods had already lost the expressiveness shown in Classical times. New works had a more everyday quality, so in his treatise on the State Plato demanded that artists should be supervised by the State to ensure that their works were worthy of all the great ideas[2]. The close contacts that had been established with the religions and cultures of Asia in the period of Alexander the Great and, in particular, after his death, caused Hellenistic works to lose even more of their life and substance. Intellectual ideas were also finding their way into art, as we can see from the numerous allegories and personifications. In the following years relief work was introduced into the sphere of religion, which had been closed to it up to that point, and, after relief work, painting.

This pattern of evolution shows that art followed the spirit of the times, with its questing and enquiring approach. The ultra-refined civilisation and sophisticated luxury of the period of the Roman Emperors point to an inner vacuum, and peoply fully realised this. They knew the world too well ever to imagine that it could provide a true sense of fulfilment. They were vaguely aware of a spiritual and divine world behind the earthly one. Various schools of philosophy and mystical cults alleged that they knew the path to reach it and could supply the answers to all the ultimate questions, and it was left to Christianity to express them in a valid form.

From the end of the 2nd century, under the Severian Emperors, monotheistic ideas were actually fostered by the rulers. Oriental forms of worship were adopted in Rome and the Emperor Philip the Arab was reported to have become a secret follower of Christ. The savage persecution of Christians by Decius about the middle of the 3rd century was an indirect proof of the power of the new faith, which the Emperor tried in vain to suppress by force. Nor should we overlook the fact that the Emperors in the closing years of the 2nd century and during the 3rd often came from eastern or African portions of the Empire and tended, consciously or unconsciously, to foster the spiritual influence of the East, and to ignore the special position of Rome in favour of a more cosmopolitan imperial structure.

This new spirit was also evident in the sculpture and relief monuments of the imperial period, especially those created during the vital 3rd century, which marked a transition, with

the final remnants of the old period and the first features of the new period both in action and competing with one another[3]. The realism that had been such a prominent characteristic of Roman portraits up to that time was transformed and discarded and the spiritual element was intensified. An Antique feature retained by many images is the draping of the robes, but the details have been stylised in an ornamental fashion, as can be seen from the hair and beard, the arching of the eyebrows and the wrinkles on the face. The head is the supremely important part, as this is where spiritual intensity can best be expressed. In the period of Classical Antiquity the head was included in the harmony of the whole body and its posture and movement. Now it was given a significance of its own that would have been unthinkable in earlier times.

This new element is expressed in an even more tangible form in Severian reliefs. The Emperor is made to step right out in front of the beholder: 'The latter is no longer an impartial observer or spectator, but is taken right up to the ceremonial that is being enacted. A new and at the same time quite un-Classical relationship with the ruler and his image has thus been created. The artist has the task of portraying a purely representational entity, demanding respect. His task has changed radically and the prevailing tone is completely different too, so it can be appreciated that the Severian relief does not allow space for the figures in the Classical way any more. The figures of the Emperor and his family are lined up frontally and are added on, one after another, without any spatial connection between them. The figures fill the surface right up to the edge. There is no sense of space with life-like physical forms moving about in it, but a flat surface with figural symbols'[4].

What we have said here about reliefs applies to painting as well. The portraits in the fourth Pompeian style showed a pleasing lightness and spontaneity to begin with, but the individualised impressionistic features were gradually replaced, as time went on, by a representational and frontal approach.

This change in the manner of portrayal is always ascribed to Oriental influences. These had now extended beyond the provincial areas and were playing a dominant role in what was then the capital of the world — Rome. We often hear of these new-style sculptures and reliefs being ascribed to Oriental masters. There can be no doubt that eastern influences were indeed present, but, as has already been pointed out, they were not confined to art. Rome was now willing to accept them, as they were in harmony with the spiritual character of the period. The style and modes of expression used by these artists from the East were ideally in keeping with all the attempts to spiritualise the work and change over to allegorical symbolism, and to fit everything into a comprehensive intellectual system. The whole of life was being orientalised, so art could not very well be left out.

In the mystical scenes from the 1st or 2nd century that have been preserved in frescoes at Dura Europos[5] a flat frontal presentation of the subjects in rows is clearly evident. Conclusive evidence of the spiritualisation of sculptured faces is supplied by the finds at Palmyra[6], Leptis

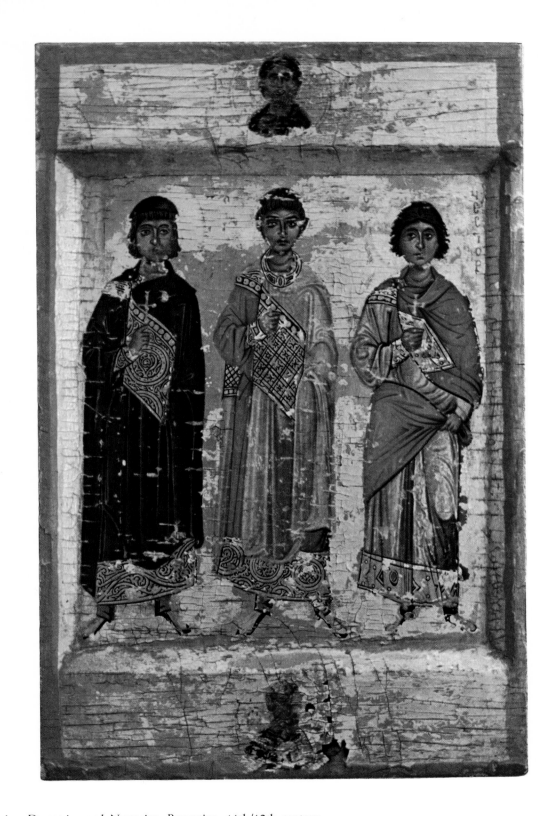

VI The Martyrs Procopius, Demetrius and Nestorius. Byzantine, 11th/12th century

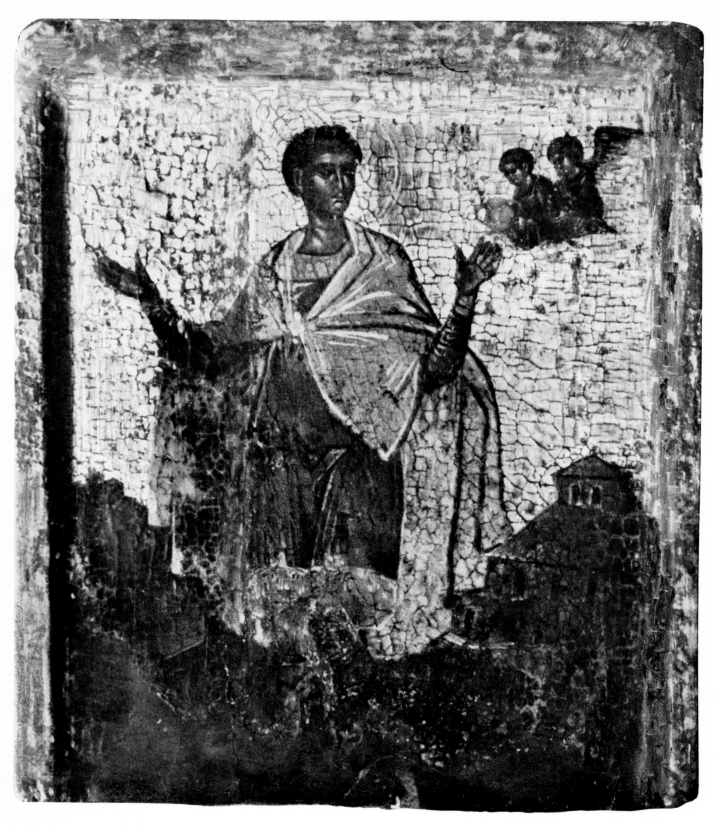

7 The Prophet Daniel. Byzantine, 12th century

Pl. 1, p. 16

Pl. 2, p. 16

Magna[7] and Antinoë[8], amongst other places. In painting, the new style can be seen in the hundreds of mummy portraits, mostly dating back to the 2nd and 3rd century, that have been found at Akhmim and in Faiyum[9]. All the portrait panels of the Egyptian mummies, which began to appear soon after the conquest of Egypt by the Romans, show pictures of persons who had died; only some of these would have been painted during their lifetime. The body of the mummy has remained purely Egyptian, but instead of the plastic face mask of earlier times we find a painted panel, which at first glance appears Hellenistic or Roman, as the facial features have been individualised and are in some cases quite realistic. But the portraits are not in keeping with contemporary painting. The eyes in these heads are far larger than the natural size and stare through the viewer into infinity. They are idealised and express a new spirit. This air of gazing into another world is completely different from the individualised portraits of Antiquity and at the beginning of the Late Antique period. 'Two centuries later artists in Rome were also making this type of portrait, which reveals that the artist, like the person portrayed, was fully aware of the fact that suprapersonal, transcendental power is more important than the individual features of an individual figure'[10]. The idealisation peculiar to the painters of mummy portraits also finds expression in the bright highlights in the eyes and is sometimes intensified by the gleaming gold used for the picture ground. That the hundreds of portrait panels found, all portraying persons who have died, include very few pictures of elderly men or women, such as we would have expected to see is also significant. The persons depicted are nearly all in their prime or bursting with youthful vitality. This too might be a manifestation of the spirit of Neo-Platonism, which dominated Egyptian thought and feeling for many years[11]. Most of the mummy portraits were produced by an encaustic method[12], i. e., they are paintings in wax colours treated with a hot spatula. There are also a few works in tempera[13].

Christians could express holy and divine subjects representationally or hieratically or with solemn ceremonial, if they wanted to put their faith into a pictorial form. The emphasis on spiritual things, the translation of matter into thought, the new meaning given to mythical scenes by converting them into symbols and the pictorial simplification achieved by confining oneself to what was absolutely necessary and essential were all fully in keeping with creative Christian art, and the Christian world was able to appropriate these elements from the changing pattern of Antique art in the first few centuries of the Christian era.

The first requisite was, of course, a desire to create works of art[14]. We cannot say to what extent a determined Christian urge to create works of art was present in the earliest Christian images that have survived, for example, in catacomb painting. In a study on official Roman and Early Christian art, Hauser writes: 'The difference lay solely in the fact that works of art intended for distinguished and well-to-do Romans were still obtained from real artists, who probably did not feel inclined to work for the poor Christian community — even if they were actually in sympathy with Christian ideas and would have made do with a reduced fee or none at all. The Christians demanded that they should take no further part in producing heathen

images of the gods. The more respected and successful an artist was, the harder it would have been for him to make that concession ... For the most part, work praised because it is supposed to show intentional simplification and supreme condensation, a purposeful attempt to heighten the effect and an idealised exaltation of reality reveals nothing more than poverty and inadequacy, an involuntary abandonment of natural form, and primitive bungling in the drawing ...' [15]. There was definitely 'a tug-of-war between what they wanted to do and were able to do' [16], but this did not become evident until the Church showed a definite artistic urge of its own. This could hardly have happened before the Milan Edict of Tolerance and probably came some time after this, when the Church had not merely accepted images, but had actually enlisted them in its service. By then, of course, the restrictions mentioned by Hauser no longer applied, and artists would, no doubt, have been perfectly happy to place themselves at the disposal of the Church.

We are hardly justified in assuming that an independent artistic urge of the kind we have mentioned was present in early catacomb painting. Even in cases where the painting followed different paths from those revealed by contemporary pagan, Jewish or Gnostic catacombs, it was still closely connected with the general symbolical tendency of the time. Simplification of the pictorial content does not in itself indicate a new artistic urge. Nor can this be deduced from the fact that fresh subjects were being introduced, such as scenes from the Old Testament, or that Hellenistic pastoral pictures were being given a Christian interpretation. Stylistically, all the renderings still came entirely within the range of artistic expression to be found in the art of the non-Christian world all around, and these forms were used without any qualms or hesitation. The subject depicted was converted immediately and, we might almost say, subconsciously by the beholder, so that the content was brought into line with the Christian faith. But it cannot be said that the artist gave the image such a definite spiritual slant with the artistic means at his disposal that it simply had to be regarded as a Christian image or, like the icons later on, a holy image.

The catacombs give us very little information about the first two centuries, and there is not much hope of making new discoveries and filling this lamentable gap. From the 3rd century onwards, a larger number of monuments have been preserved, but even they confirm the fact that Christian art deviated from its non-Christian environment more in the choice of subject than in the artistic mode of expression.

One difference between the catacombs and private villas that affected the method of painting was that the walls of the former did not provide large unrestricted surfaces positively demanding to be decorated. In contrast to the villas, the wall surfaces of the catacombs were pierced by arcosolia and loculi and so only limited areas were available for pictorial decoration. The decoration was therefore moved to the vaulted roof, and on the arches and wall areas, the restricted space available would certainly have been partly responsible for the reduction of the pictorial content to the absolute minimum required for interpretation of the symbolism. The roof painting

in the catacombs shows exactly the same geometric division of the surface and the same use of scrolls, flowers, vases, birds and other creatures to tone down the severely geometrical effect that we find in the private villas. The fact that the background was not tinted, as in the villas, but usually left white can be accounted for by the difference in lighting conditions.

Narrative or allegorical scenes were painted on the central section of the ceiling and in fairly large individual sections at the side. Even in the catacombs, the subjects used were quite often based on pagan models. Here we find the four seasons personified or represented by harvest scenes, as in the crypt of St Januarius in the 3rd-century Praetextatus Catacomb in Rome. Other items taken from the 'stock of symbols' used in Antiquity included the dove, a widely known symbol of peace, which in the course of time came to represent the redeemed soul in the Christian world; the duck, the bird of winter and so a symbol of death; and the peacock, which originally accompanied the soul of a dead Empress, but soon appeared in the burial places of Romans of lower rank, and was later introduced into Christian symbolism as an emblem of the Resurrection[17]. More examples could be added to the list.

There was also the mythological material of Antiquity. From this the Orpheus legend was introduced into Christian pictures in the 2nd/3rd century. Orpheus, who through the power of his music was able to gain control over the animal world, became a symbol of Christ, who stilled passions far more dangerous than the most savage animal[18]. Clement of Alexandria therefore referred to Christ as the 'new Orpheus'[19]. To make the Christian interpretation of the Orpheus scene clearer, the catacomb painters sometimes placed a lamb beside the figure of the musician, as, for example, in a roof painting in the S. Callisto Catacomb in Rome[20].

Since the days of Theocritus and his bucolic poems, writers had been extolling the idyllic rustic life in Greek and Latin. Popular genre motifs in the Hellenistic period therefore included impressionistic scenes from the lives of countryfolk and shepherds. They can often be seen in the catacombs as well and gave rise to one of the most popular Christ symbols of early times — the Shepherd and the Good Shepherd[21].

Conversion to Christian symbolism was accompanied by a reduction in the pictorial content. To begin with, even in Christian catacombs the resting Shepherd still held a syrinx, or pipe, in His hand and His flock consisted of a mixture of sheep and goats. Then He came to His flock with a lamb on His shoulders, which meant that He had quite definitely become the Good Shepherd. At a very early date He appeared without His flock, as His figure alone was sufficient to express the Christian meaning. This conception does not necessarily stem from the New Testament parable (Luke xv. 4—7; Matthew xviii. 12—14). Old Testament references to God as a Shepherd, as in Psalm 23, probably had an effect on symbolical concepts long before this — in a catacomb in Alexandria the text accompanying a Shepherd scene states quite explicitly that the Lord came to pasture, or feed, Israel, a term that is not unusual in the Old Testament and which reminds us of Ezekiel xxxiv.

The fish, symbolising the Messianic food, is also a Jewish symbol. It was adopted by the Christians and has been used to symbolise Christ since the 2nd century. It often has a special association with baptism. But we should not forget that much earlier in pre-Christian times, a fish in water betokened an Israelite belonging to the true faith. The fish symbol appears to have gained in popularity in the 3rd century because of the acrostic: Jesus Christ, Son of God, Saviour — or in Greek: I(esus) CH(ristos) TH(eou) (h)Y(ios) S(oter)[22]. The initial letters give us the word ICHTHYS = fish. So even Tertullian said that we small fishes had been born in water after the fashion of our 'ichthys' Jesus Christ — a reference to the beginning of Christian life through baptism.

The fish symbol often appears on the roofs of catacombs and occasionally also as a marginal decoration beside the Good Shepherd. But it is not just ornamented. In scenes with fishermen it clearly refers to the New Testament texts ('fishers of men', Mark i. 17, and Matthew iv. 19). In the S. Callisto Catacomb in Rome a scene with fishermen is placed in such a way as to establish a close link with the Baptism picture[23].

We find a good many Old Testament subjects in the catacombs from the very beginning. Daniel was placed between two lions in the Flavii Gallery of the Domitilla Catacomb[24] and can also be seen in the Vigna Massimo Cubiculum from the 4th century[25]. Subjects often recurring in catacomb paintings are: Noah in the Ark, shown as an opened box, with the dove and a woman in an Orans posture[26], or without her[27]; Jonah in the booth[28] or in a sequence of scenes[29]: falling into the sea, being swallowed by the whale, being spewed out and resting under the roof of the booth; David with his sling[30]; Adam and Eve beside the Tree of Knowledge[31]; the Three Young Men in the Fiery Furnace[32]; the Sacrifice of Isaac by Abraham[33]; the Miracle of the Spring of Water, performed by Moses[34]. Sometimes they are painted with Grecian lightness and elegance, reflecting a mood of cheerful serenity, against impressionistic landscapes, and Adam and Eve have certainly not been converted into stiff sexless symbols, but are shown corporeally as real nude figures[35]. As well as narrative pictures we also find some where the pictorial content has been condensed into a very abbreviated version — the Three Young Men dressed in Phrygian robes are all that is needed to symbolise Deliverance, and Abraham, Isaac and a bundle of firewood, and possibly a sacrificial animal, are sufficient to convey the idea of the Sacrifice of Isaac. So we have a juxtaposition of narrative accounts and symbols, as the artist was not bound by any absolutely rigid rule. In fact, both types, the narrative form and the condensed form, were viewed purely as a symbol by the community.

We need not be surprised to see such a large number of Old Testament scenes in the vaults of Christian catacombs, as the prayer texts recited during burial and commemoration ceremonies referred to saving acts of God, as reported by the Old Testament: Thus one prayer asks, 'Save, oh Lord, the soul of Thy servant, as Thou didst save Noah from the flood, Abraham from Ur of the Chaldees, Job from his sufferings, Isaac from sacrifice at the hand of his father Abraham, Lot from Sodom and the flaming fire, Moses from the hand of the Pharaoh, King of Egypt,

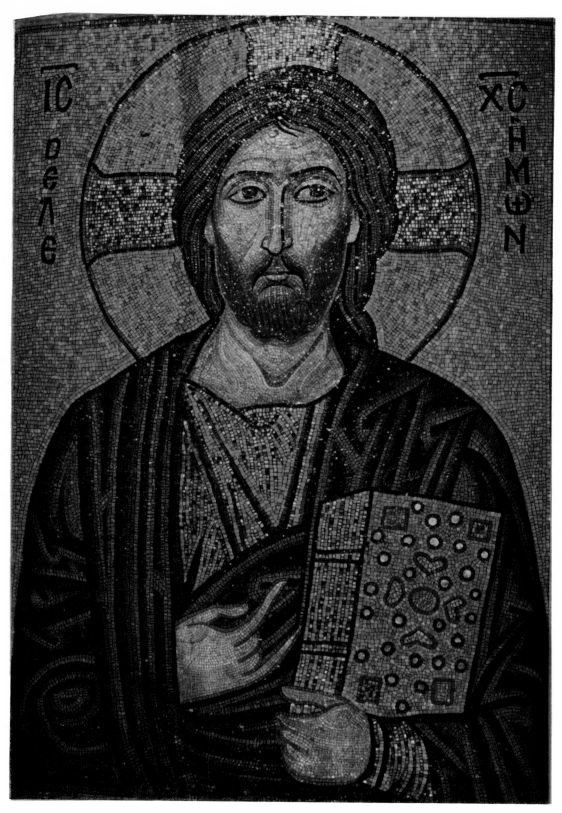

VII Christ the Merciful. Byzantine, 12th century

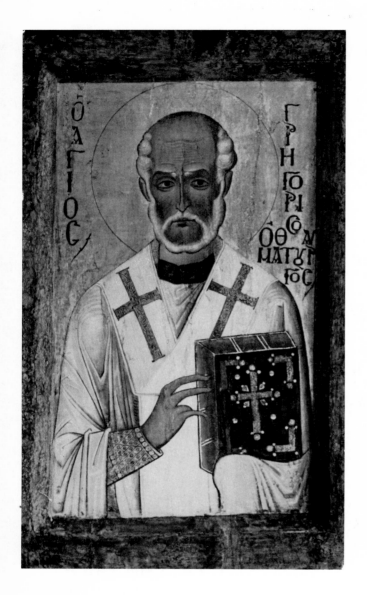

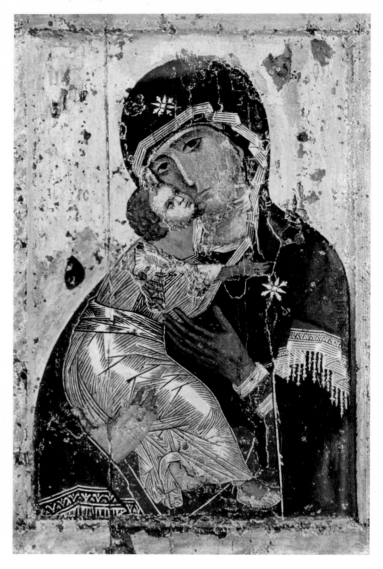

8 Gregory the Miracle-Worker.
Byzantine, 12th century

9 The Eleousa Mother of God of Vladimir.
Byzantine, early 12th century

Daniel from the lions' den, the three youths from the fiery furnace and the hand of the wicked king, Susanna from false accusation, David from the hand of King Saul and the hand of Goliath...' [36].

As well as the Old Testament evidence of help and rescue coming from God, two miracles of Christ were illustrated at an early date; the Healing of the Palsy[37] and the Raising of Lazarus[38]. The Healing of the Woman with the Issue of Blood came shortly afterwards. The man sick of the palsy is seen departing with his bed. Lazarus is painted twice — once as a mummy leaning on a wall of rock, then standing independently alongside it, with his arms folded over his breast. Christ, who performed these miracles, is omitted from many of the pictures. In the Catacomb of SS. Peter and Marcellinus, He appears impersonally as a miracle-worker with a magic wand[39].

Christ the Miracle-Worker ist also the object of the Adoration of the Magi. The earliest versions of this include a fresco over the dividing arch in the main chamber of the Cappella Greca in the Priscilla Catacomb, dating from the 2nd/3rd century[40]. The three figures, leaning forward, are hastening up to Mary, who is sitting feeding the Child. Mary also appears as a nursing mother in another picture from the same catacomb — in the Prophecy of Isaiah[41]. The Prophet is standing beside her and is pointing to a star shining over the Child. Of course, none of these early pictures were intended as portraits of Christ or the Mother of God. They were conceived purely as symbols and not as devotional images. Bearing in mind the prayer texts of the Christian communities, we could describe these catacomb pictures as painted prayers, put up to represent the supplications of Christians when the congregation was not in the room.

Catacomb painting introduced new subjects from the life and death of the martyrs. It was also given a local slant, as there were always new martyrs appearing alongside the earlier ones, and they were specially commemorated at the places associated with their life on earth and their sufferings. If we leave out of account pictures of martyrs that only appeared locally, it is surprising how even at a very early date the same subjects kept recurring throughout the Christian world in any given period — in Alexandria and in the distant Nile valley, in the Libyan Desert and on the coast of Africa, in Malta, Sicily, Sardinia and the Italian coastal towns. The largest finds have been made in Rome, but the compositions do not appear to have originated there. The prototypes would seem to have been brought in from some other centre, as motifs appeared in Rome and then disappeared or became schematised if they went on being used. Scenes in the catacombs at Cagliari[42] and others from a burial site near Alexandria (Wesher Catacomb)[43], that has not, alas, survived up to the present time, show similarities in style that cannot be purely accidental. So Alexandria has with good reason been suggested as one of the creative centres of the Christian world[44], although only a few paintings there have survived. Alexandria was also a flourishing centre of Hellenistic culture. In that city of flowers people delighted in the idyllic aspects of life, and landscapes and flowers were often chosen as subjects for pictures. Moreover, Alexandria was still a city of scholars in Christian times. Nor should we forget that, in pictorial art, prototypes containing Old Testament material were borrowed from Jewish manuscripts

and frescoes. Completely mature cycles from for example, the Synagogue of Dura Europos (middle of the 3rd century) clearly reveal the presence of a Jewish pictorial tradition based on the Books of the Old Testament. This, no doubt, also spread through the area in the form of miniatures from manuscripts, but none of them have survived from that early period[45].

Even if we manage to prove that Alexandria[46] was one of the homes of Christian pictorial art, we must remember that the prototypes all contained purely national features. This can clearly be seen if we compare the paintings of the Coptic Church in the upper Nile valley with others in the Libyan Desert, on Sardinia or in Rome and Naples. It is also likely that a community as large and respected as the Roman one would in turn have dictated the forms used within its own sphere of influence, just as Byzantium made an impression on the whole Christian world later on. Rome, after all, was still the capital of the world. But we must remember that our knowledge of this early period of Christian art is very limited and is based on pure chance. We are familiar only with what has survived and we do not know what future discoveries will reveal. We shall probably not unearth any really old material, but perhaps something will shed more light on the area of origin of the first Christian images.

What we have observed in catacomb painting is confirmed by a study of Christian sarcophagi[47]. They too prove to be closely related to non-Christian ones, but only a few have survived from the pre-Constantine period. The reason why there are not more Christian sarcophagi from that period is probably a material one — a sarcophagus was considerably more expensive than a burial place in the catacombs. Another point is that a Christian sarcophagus with decoration in relief was a greater threat to the safety of those left behind, who might as a result be identified and persecuted as Christians.

We see from the artistic work in the catacombs and the reliefs on sarcophagi that the non-Christian world all around provided subjects and forms which Christian artists could and in fact, did adopt, as the community at once transformed them into religious symbols. This is also evident in individual subjects. The first intentional pictures of Christ, for example, among His Apostles, present Him as a young god or hero. Even the pictures of an older, bearded man with a stern expression that replaced these idyllic portrayals of Christ in the 4th century were influenced by statues of the gods who dwelt on Olympus[48]. These borrowings from the non-Christian world did not by any means cease when the Christian Church became dominant. In fact, insignia denoting imperial power were then included in pictures of Christ[49].

Christ the Teacher is based on Hellenist portraits of philosophers. It was also a pagan custom to place the portraits of authors at the beginning of their books. The Christian world adopted this practice in the case of the Evangelists, whom we can observe in numerous miniatures of this kind in front of their Books in the New Testament, the various changes in the iconographical features being clearly evident. The angels, too[50], had their counterpart in ancient times in the form of the Nike statues. Many more items relating to all aspects of life could be added to the list of things borrowed or adopted by Christians from the non-Christian world around them,

but these examples are sufficient to underline the close connection between Early Christian and Late Antique art. It can be assumed that in the 4th century artists were busy working for Christians and pagans simultaneously, and that when paganism went into a rapid decline and faded into insignificance, they began to be associated more and more with the patrons who gave the highest rewards — the Church or the Emperor. But Christian subjects played an ever increasing part in their work, even if it was commissioned by an Emperor.

When, after withstanding the era of persecution, Christian art was able to emerge from the catacombs, it was soon confronted with a completely new task — it had to serve as a 'Biblia Pauperum' and help to educate the recently converted masses. This meant that, having condensed the Biblical scenes into concise symbols, the artist now had to make a more comprehensive picture, giving as detailed an account as possible and presenting the material in a clear, intelligible manner. We know that programmes of pictorial decoration were evolved later on for church interiors[51] and these fixed the size and scope of the subjects and their arrangement in the church. In this way a definite stock of subject matter began to accumulate and was soon distributed throughout the Christian world. The miniatures on manuscripts, which passed from workshop to workshop for copying, also encouraged this process.

But the collection of pictures that was being built up in this way was already associated with a new centre, which became the leading centre after Constantine the Great was converted, and which until its decline in the 15th century was envied and acclaimed as the focal point of civilisation. This was, of course, Byzantium, the small town on the Bosphorus which the Roman Emperor chose to be his new capital and which in the space of a few years rose unexpectedly to a position of great importance.

BYZANTIUM AND THE BALKANS

In 330 the Emperor Constantine the Great moved his imperial residence to the shores of the Bosphorus, to the spot where a small group of Greek colonists under their leader Byzas are supposed to have founded a settlement about the middle of the 7th century B.C. This was named Byzantium[1] in honour of their leader. The small town was in an excellent position, but, in spite of this, did not rise to fame. Now, when it was to be the centre of the world as it then was, it lost its old name and was given that of its new founder — Byzantium became Constantinople. And yet fate has been kind and has not allowed the name of the first settlement to sink into oblivion. It is permanently associated with the Byzantine Empire and Byzantine art and culture and has in this way come to symbolise the Greek nucleus, which, until the final debacle, set its stamp on what has been variously termed the Eastern Roman, Romaic or Byzantine Empire.

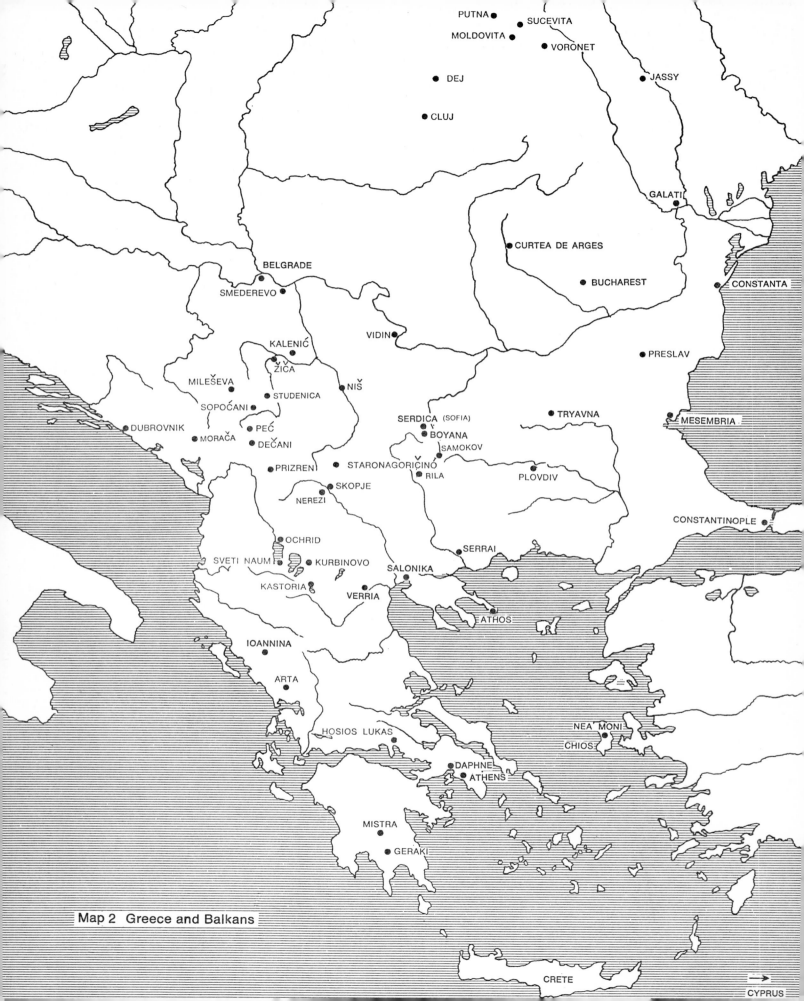

Map 2 Greece and Balkans

Constantinople developed very satisfactorily and even in the 5th century numbered half a million inhabitants. The political and economic position of the city at this junction of two continents very soon enabled her to become the focal point of the existing world and was responsible for the fabulous wealth which people in the West and among the Slav nations have never wearied of describing[2]. The inhabitants of the new metropolis were cosmopolitan in attitude from the very start — in fact, much more so than the people of Rome ever were.

'Greek culture, Roman political thinking and the Christian religion form the foundation of the Byzantine Empire. If we take one of these three things away, Byzantium as such is inconceivable'[3]. Of course, the synthesis of these three elements did not take place smoothly and was not by any means complete when the capital was shifted. There was a short-lived pagan reaction with Julian the Apostate[4] after the middle of the 4th century, but this particular episode proved that the future belonged to Christianity and that its victory was historically justified. Theodosius the Great followed this up by dealing severely both with the Christian sects and pagan forms of worship, thus consolidating the position of Orthodox Christianity.

The political events show a parallel with what was going on in the whole field of cultural activities and therefore in art. The interval between the Milan Edict of Tolerance and the reign of Justinian I (527—565) was a period of preparation and transition. Between the 4th and the 6th centuries, the trends evident in the various parts of the Empire were balancing out, and gradually acquiring what we normally describe as a Byzantine form in the capital. Influences coming from the East were not the primary factor moulding the Empire during these centuries and in the years to come. Until the downfall of Constantinople in the 15th century the influence of Antiquity remained dominant. It was very much alive in Byzantium and set its stamp on the Byzantine works of art produced in the various 'Renaissances'. The term 'Renaissance' can, of course, be misleading if we take it as meaning the same thing as the western Renaissance. In the West it denoted the discovery of something new, but in Byzantium it represented a gradual crescendo in a tradition that was going on all the time. The people of Byzantium never lost sight of the fact that they were the heirs of Classical Greece and that a heritage of that kind imposed certain obligations.

After the victory of Christianity, Classical features reappeared for a short time in the Christian art of Italy. The reliefs produced after those on the Arch of Constantine still showed a flat composition and rigid symmetry, and the whole lay-out had a spiritual quality. But in a few ivories from the end of the 4th and beginning of the 5th century we can see that the Hellenic influence had not died out. In fact, this revival of Hellenistic features, which was, no doubt, encouraged by the pagans in the Roman aristocracy, was also to have repercussions on Christian art. Many artists must have been working both for Christians and non-Christians. So narrative pictures, which were an everyday feature of pagan Rome, came to be used for Old and New Testament subjects at the beginning of the 5th century, and this strengthened the reaction against purely symbolic art[5].

In those days people everywhere in the Christian world were showing great interest in the lives and exploits of Biblical figures — an interest that extended to art and encouraged a narrative style. Ivories, for example those in the British Museum[6], give us some idea of this new form of art. We do not find a cross symbolising the Crucifixion of Christ, but a detailed account of the event. The figure of Christ on the Cross must be one of the oldest portrayals of Christ crucified. In addition to the cross and the figures at the side of it, on the left of the picture the Betrayer is also shown. Judas is hanging on a tree. The bag of money is at his feet and the pieces of silver are rolling out of it on to the ground. Of course, even in these scenes which reflect a Classical influence, there is one thing that we cannot expect to find — the artists did not study nature after the manner of the ancients. They based their work to a varying extent on known prototypes and endeavoured to copy them, but they could not break away from the main trends of the period. So we also find completely unclassical features in their compositions — thus the figures of Christ and Judas are not really hanging in a naturalistic manner. In other scenes it is evident that the tendency to create a flat, symmetrical effect has not been overcome. Later on in the 5th century the abstract approach became dominant once again. But these Roman works do reveal certain peculiarities of style that survived. 'Although new factors were always appearing, largely owing to Byzantine influence, this abstract geometric style remained dominant in Italian art'[7].

For over a century, from the end of the 4th century onwards, the western part of the Empire, and Italy in particular, followed a less peaceful course than the Byzantine East. Fresh waves of barbarians kept flooding into the various provinces and swept over the whole of Italy. As the local inhabitants were not strong enough to repel these constant attacks, they had to get protection from Constantinople. Cultural life came virtually to a standstill owing to these barbarian invasions, and the assistance granted by Constantinople meant that the western areas of the Empire became more and more dependent on her, and especially at the time of Justinian were reduced almost to the status of Byzantine provinces.

In the eastern portion of the Roman Empire two cities in particular had an important formative influence on Byzantine style — Alexandria and Antioch[8]. Alexandria, which had been founded by the Greeks, never abandoned or discontinued its tradition of Greek culture. Here there were established communities of Christians and they lived under more favourable political conditions than people in Italy, for example, who were constantly under the eye of the Emperor. When discussing catacomb painting, we mentioned what are supposed to be the special characteristics of Alexandrian art. Byzantine art perhaps borrowed its picturesque rendering[9] of landscapes and architecture from Alexandria, genre scenes which even had place in monumental art and in iconography. Alexandria contributed a graceful and almost playful lightness to the later imperial style of Byzantium, which began to take shape in the 6th century.

Antioch was not so decidedly Greek in character as Alexandria. It did, of course, display a marked Hellenistic influence and the Greek element rose to prominence, especially in the period

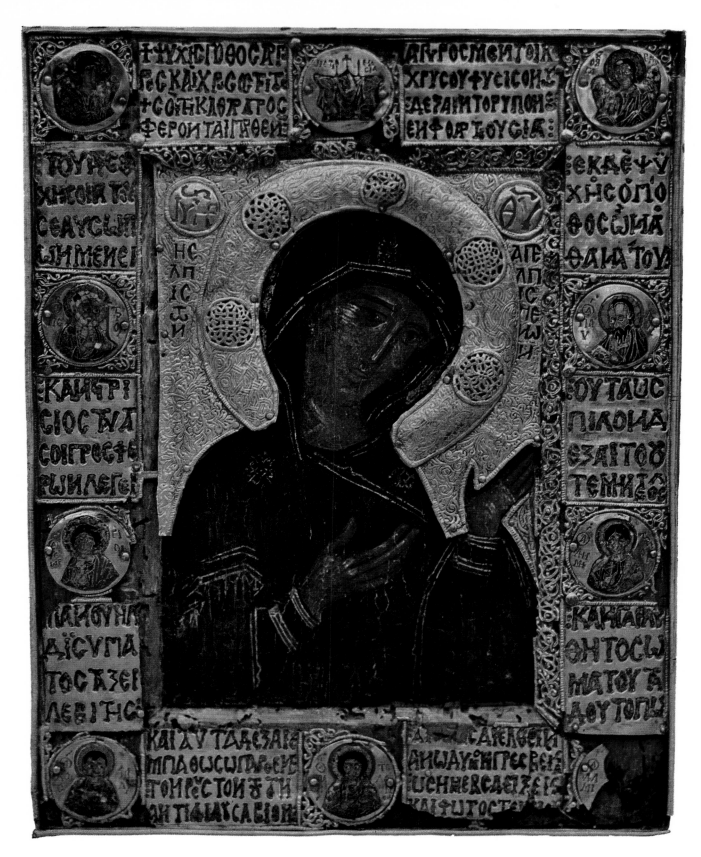

VIII The Mother of God Interceding. Byzantine, 1st half 13th century

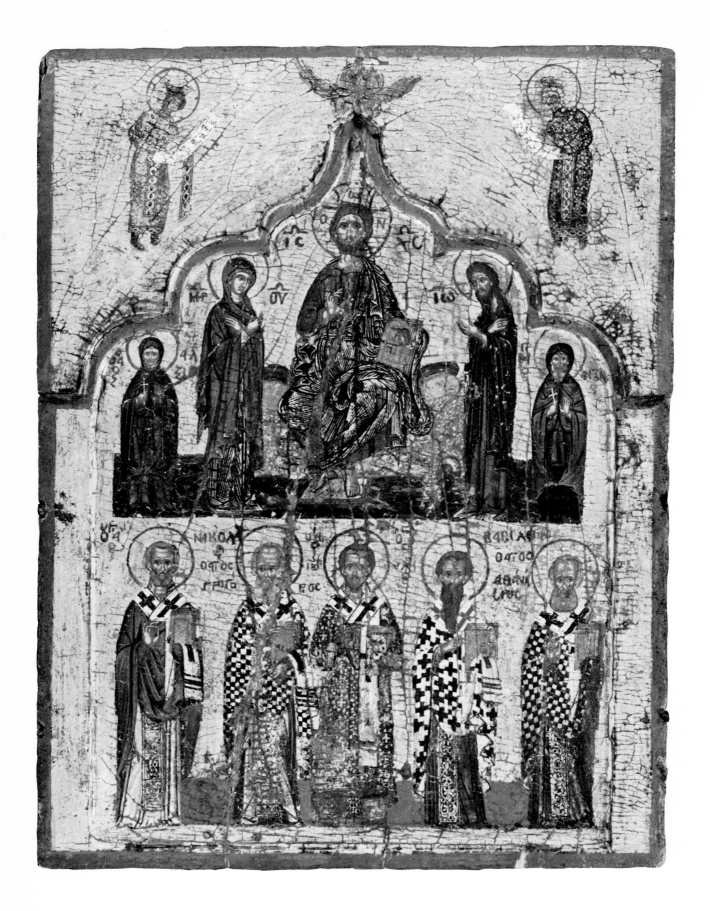

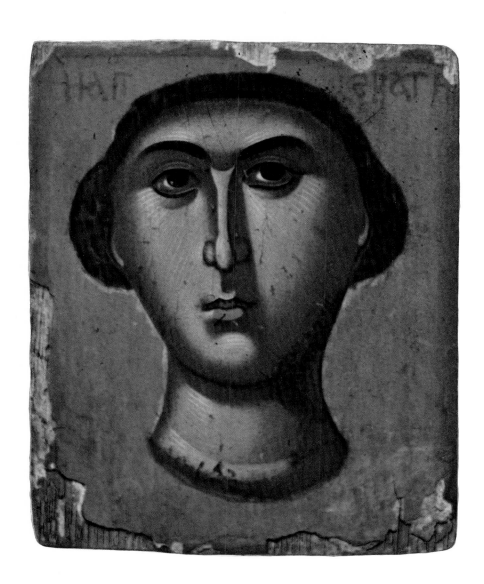

10 Deesis and Saints. Greek, early 16th century

IX The Martyr Catherine. Byzantine, 14th century

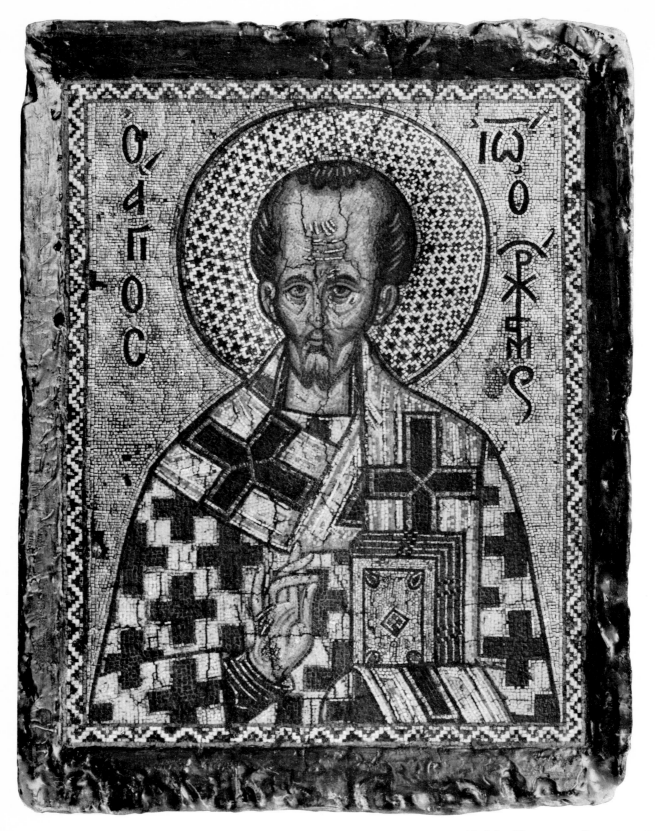

11 John Chrysostom. Byzantine, 14th century

of the Diadochi, but the city retained its dual character nevertheless. The educated classes spoke Greek and in the East, Antioch was referred to as a Greek city, not without good reason, but the Syrian language was kept alive among the ordinary people and also the feeling of belonging to the Syrian nation. So a curious hybrid culture, partly Syrian and partly Greek, came into existence in Antioch, and this prevented the city from rising to such great heights as Alexandria. 'Antioch was never a centre of learning or of art, at least not of serious and noble art.' That is how one writer summed up that city[10]. Soon after the victory of the Church, the native Syrian element increased greatly in importance. The Syrian language and Syrian literature showed a sudden and unexpected upward swing. The Semitic population of the hinterland had always had a passionate concern for all problems connected with religion and tended towards fanaticism and intolerance. This was still true in the Christian era. It was the scene of the most heated arguments about heretical doctrines and here too, numerous monasteries sprang up in the space of a few years and asceticism in every shape and form found a propitious breeding ground.

This upward surge of nationalism was accompanied by new art forms. Hellenistic and Roman elements were superseded by old native traditions. Close contact with Mesopotamia and Persia resulted in many new features being added to the traditional forms. A fair proportion of what are referred to as Oriental influences in Byzantine art found their way into imperial work via Antioch. Coptic characteristics, on the other hand, infiltrated into the art of the Christian East by way of Alexandria, the influence of the hinterland being imported through that great centre. Behind Antioch and Syria we are also vaguely aware of influences emanating from Sassanian Persia[11], whose power was in the ascendant, from the nomadic peoples of the Pontus basin and the vast areas of the East, all these influences being transmitted to Byzantium by way of Asia Minor.

Amidst this multiplicity of different forms and experimental types we can pick out two definite poles — the Church and the Emperor. The Church, which was gradually losing its hostility to images and, impressed by the glitter of the imperial court, did not want to be outdone in its attempts to glorify the Heavenly King[12], was faced with the task of creating spacious buildings for its large congregations to worship in and furnishing them in a worthy manner. So space was allowed for images inside church buildings — not for use in worship, but for decoration and to teach the faithful. The Emperor, for his part, was anxious to elevate his court above all others and underline his special position by surrounding himself with pomp and splendour and rigid ceremonial, so he attracted the leading artists to his court.

These efforts on the part of both Church and Court had a counterbalancing effect. Owing to the growing ability of the capital to attract artists and the concentration of power and wealth in Constantinople, the best masters tended to move to Byzantium even from centres on the eastern Mediterranean, and many others also tried their luck there. As always, metropolitan taste gave rise to more and more imitation and the idiosyncrasies of the different trends were smoothed out, so that an imperial form of art began to be created. There was a good deal of

give and take and a criss-crossing of different influences. As a result, provincial features began to appear in Constantinople and Constantinopolitan ingredients became mixed with the native idiosyncrasies in the remoter areas. This process went on for centuries. But from the time of Justinian I onwards the Byzantine element began to stand out more and more clearly. Imperial art had come into existence.

The Church must have wanted to ensure that pictorial decoration did not degenerate and lose all sense of moderation, and thus tried to give it a sense of direction and purpose. To begin with, as we have seen, this was left to the individual regions, but certain standardising tendencies arose from the influence of well-known church buildings, especially in the Holy Land. The number of pilgrims was rising year by year and in these Constantinian and Theodosian buildings in Jerusalem, Bethlehem, Nazareth, and other places, were pictures of sacred events that appear to have spread very rapidly in that particular form throughout the Christian world. The first signs of a definite Christian iconography were now evident. This means that important proto-types were created in Palestine. The great mass of different forms and types was then unified and consolidated into its final version in Byzantium[13]. The programme of decoration and pictures for church interiors was still fluid in this period when the search was continuing for a suitable type of building.

No icons (if we think of them in the present-day sense of panel pictures — a concept which did not exist at that time) have survived from that early period. We can only get an idea of the various stylistic and iconographical trends from the mosaics and frescoes and from descriptions of pictures that have been handed down to us, the *ekphrasis*. Comparison of 5th-century mosaics, such as the Ravenna mosaics in the Orthodox Baptistery or the Mausoleum of Galla Placidia, with those of the Justinian period in S. Vitale and S. Apollinare Nuovo clearly shows a movement away from the more elastic approach and the freer composition adopted in the Theodosian period towards a strictly representational version full of pomp and ceremony. The same thing can be seen if we compare the mosaics from the period of Constantine or Theodosius in Rome with those from the 6th century, for example, in SS. Cosma e Damiano. The Hellenistic character of the earlier period has given way to a mood of hieratic exaltation. A rich, full-bodied green and dark blue are used for the background and purple is included in the sombre colour scheme, which is enlivened by glittering gold and — especially in SS. Cosma e Damiano — is capable of producing very striking effects in conjunction with the white of the draperies. Unfortunately, there are no monuments surviving from that period in the capital city of Constantinople, but, judging by the importance of Ravenna during the period of Justinian, we can assume that they would not have been so very different. A contemporary writer, Paulus Silentiarius[14], has given us a description in verse of the sumptuousness of the Hagia Sophia in the Emperor Justinian's time. The powerful effect of this incomparable piece of architecture is presented in vivid and picturesque language. The decoration suffered at the hands of the iconoclasts and

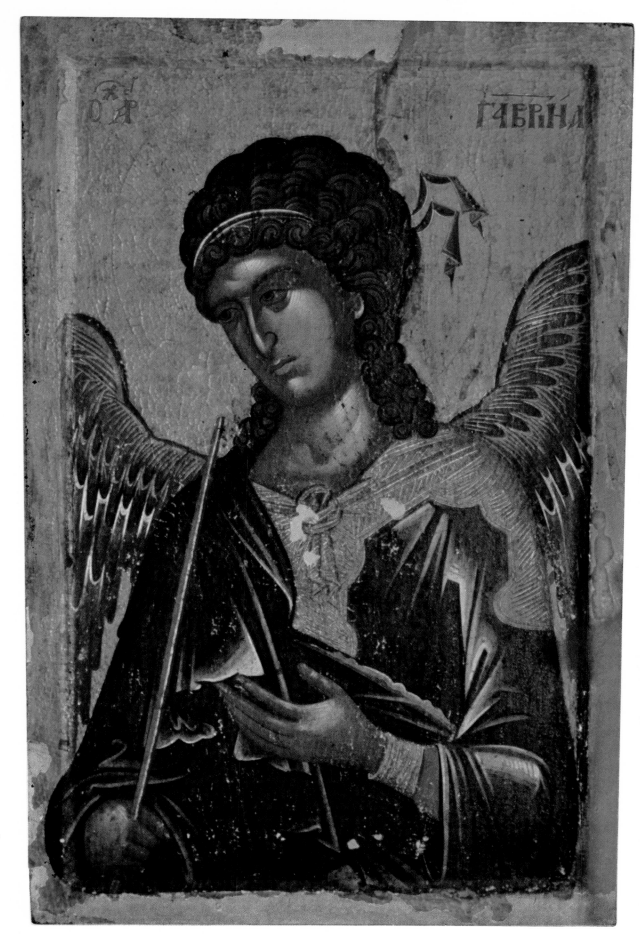

X
The Archangel Gabriel.
Byzantine,
late 14th century

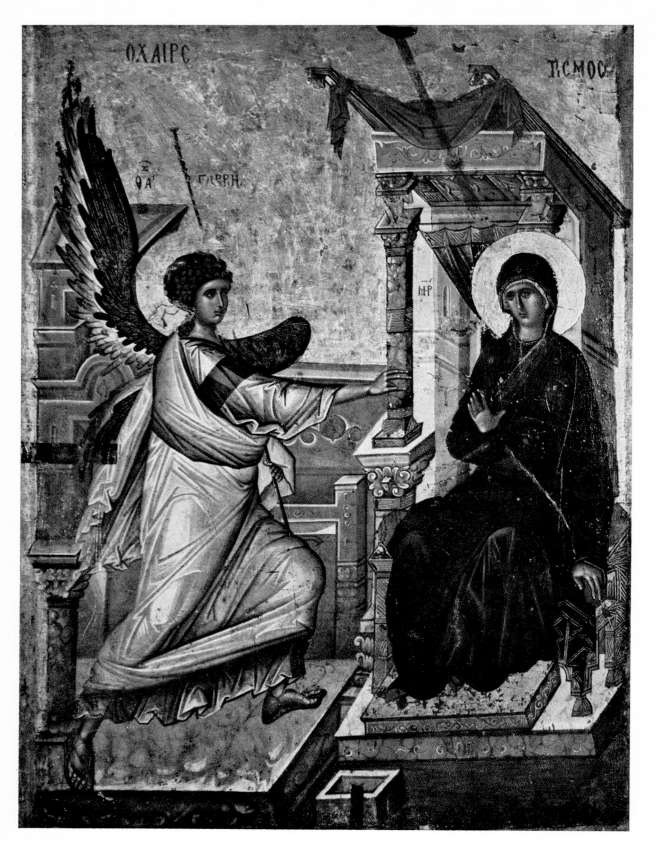

12 The Annunciation. Byzantine, 14th century

was later renewed. Numerous visitors from the West and also from the Slav countries spoke likewise of the fascinating effect of this later version.

The juxtaposition of Hellenistic and abstractionist features in this transitional period is also evident in the early monuments in the churches of Salonika (Hagios Giorgios, Acheiropoietos, Hosios David and Hagios Demetrios). A specimen of mosaic art from the era of Justinian that has remained almost intact is the apse mosaic from the basilica of the Monastery of St Catherine on Mount Sinai, probably fashioned by masters from the capital[15].

With Justinian I, who once again established an empire extending from Spain to the eastern frontiers and wiped out the barbarian peoples in the vanquished territories, came the beginning of the Golden Age of Byzantine art, as Kondakov has called it. Justinian, who was not himself of Greek origin, carried on the traditions of Rome by codifying the law in a standard form, but he also paved the way for the use of Greek as the state language by drawing up his Novels, or New Constitutions, partly in Greek. This policy led to the Grecianisation of the whole state only a few decades later.

Pl. 3, p. 22 The oldest surviving icons come from the period of Justinian. They were produced by different workshops and for the most part belong to the Monastery of St Catherine[16] on Mount Sinai, but they give us an interesting picture of the beginnings of icon painting. The first of these Sinai icons were discovered by the Russian Bishop Porfiri Uspenski in the 1850s in the Monastery of St Catherine. He took them home with him and they were placed in the Museum of the Theological Academy in Kiev. They have been reproduced on several ocasions and discussed in a scholarly manner[17]. G. Soteriou brought out various publications referring to these 19th-century discoveries and has since produced a comprehensive work dealing with the Sinai icons and presenting new pictorial material from that early period[18].

The Kiev group of Sinai icons includes a small panel portraying two martyrs, a man and a woman. Flat faces with broad noses, large eyes and fleshy mouths are presented in a rigidly frontal position. The two figures are holding crosses in front of their breasts and a larger cross appears in the background between their heads. In spite of a few later attempts at overpainting, the whole conception of the two saints gives us a good idea of provincial art in the 6th century. The faces express a certain amount of restrained emotion and this tones down the general impression of severity. Also the absence of sharp contours and the use of flowing gradations give the icon a painted rather than a graphic appearance. These peculiarities stand out clearly when we compare this panel with icons from the Coptic area belonging to the same period or slightly later on. The sharp contours and flatness to be found, for example, in the icon of Apa

Pl. IV, p. 21 Abraham from the 6th/7th century are completely different[19].

An icon from this early period produced by the encaustic method which has been cleaned

Pl. III, p. 15 for display is a picture of the Three Young Men in the Fiery Furnace, which was a popular subject. As the actual picture panel has been damaged, a small black-and-white photograph of the whole icon and its frame has been added for comparison. This gives us an idea of how the

whole picture has been built up. The predominant colouring of the icon consists of several shades of brown, contrasting with the blue of the draperies and the red of the flames. In the top third of the icon the brown of the background has been replaced by black, and this makes the faces and the haloes stand out from the rest of the picture. The haloes, too, have a brown edging which forms a gradual transition to the dark tones used for the ground. The names of the Three Young Men (Shadrach, Meshach and Abednego) are inscribed alongside the haloes. Most of the angel's name has disappeared. The Christian character of the picture, already evident from the haloes, is underlined by the cruciform staff held by the angel and lowered protectively in front of the figures of the Young Men. The trio are dressed in Phrygian garments and the clasps, like the garments themselves, are adorned with circular ornaments. The same circular ornament can also be seen on other icons from the same period in the Sinai monastery.

We cannot be absolutely certain about the place of origin of this icon, whose present location in the Monastery of St Catherine on Sinai gives us no indication of the workshop from which it came, owing to the meagre amount of material available for comparison. It does not display the characteristics of Coptic and Asia Minor work. The group of young men is not rigid in conception, but is presented with a slight sense of movement and rhythm, and the gestures are not uniform either. The Orans posture of the central figure is balanced by the two young men at the side slightly raising their hands in front of their chests, as in the icon of SS. Chariton and Theodosius. The sense of movement, the arrangement of the folds of the draperies and the striding figure of the angel suggest that the artist was not unfamiliar with the Classical period. The icon dates in all probability from the 6th century, and this impression is confirmed by the lettering on the contemporary frame, which reproduces the prayer from Daniel iii. It may have been fashioned in an eastern workshop under Hellenic influence, perhaps in Alexandria.

Pl. V, p. 27

The two icons of the Mother of God between SS. George and Theodore and two angels and of the Apostle Peter, discussed by Soteriou[20] and Felicetti-Liebenfels[21], must be ascribed to a different school, but the same period, i. e., the 6th century. These two encaustic picture panels reveal a cultivated hand and can be linked quite closely with Greek traditions because of the way in which light and shade have been modelled and also because of the expressive rendering of the faces. Felicetti-Liebenfels felt inclined to ascribe the Peter icon with certain reservations to an Alexandrian school[22], but Weitzmann stressed its connections with the monumental works preserved in Salonika and thought it likely that, in view of the harmonious relationship existing between Salonika and Constantinople at that time, the Peter icon might actually have come from Constantinople itself[23].

Pl. 5, p. 35

Another encaustic icon showing the Mother and Child takes us into the western portion of the Empire. This was discovered during restoration work on a devotional icon in Sta Maria Nuova in Rome. The possible date margin extends from the 5th to the 7th century. In contrast to the usual pictures of the subject, the Mother of God on this icon is holding the Child on her right arm. The Mother's face is highly expressive and is completely dominated by its large

Pl. II, p. 15

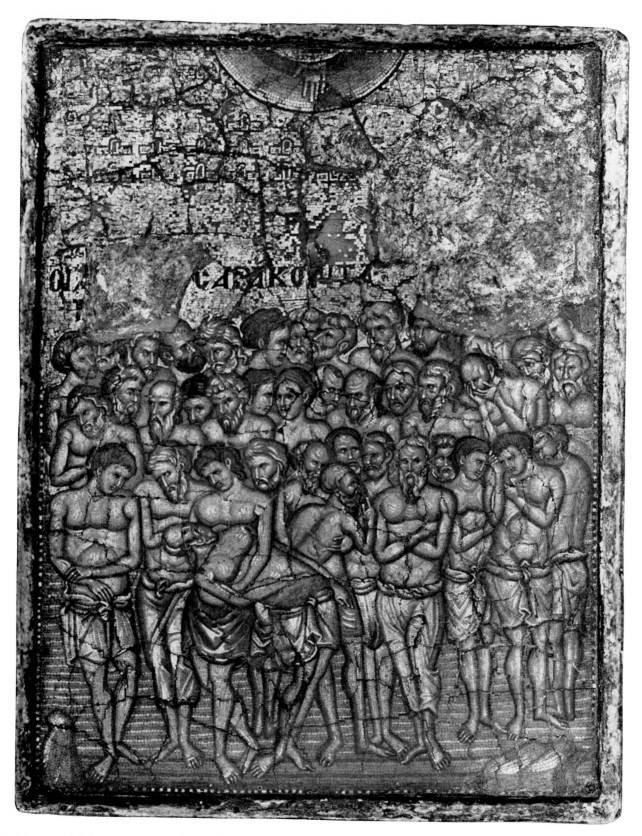

13 The Forty Martyrs of Sebaste. Byzantine, late 13th century

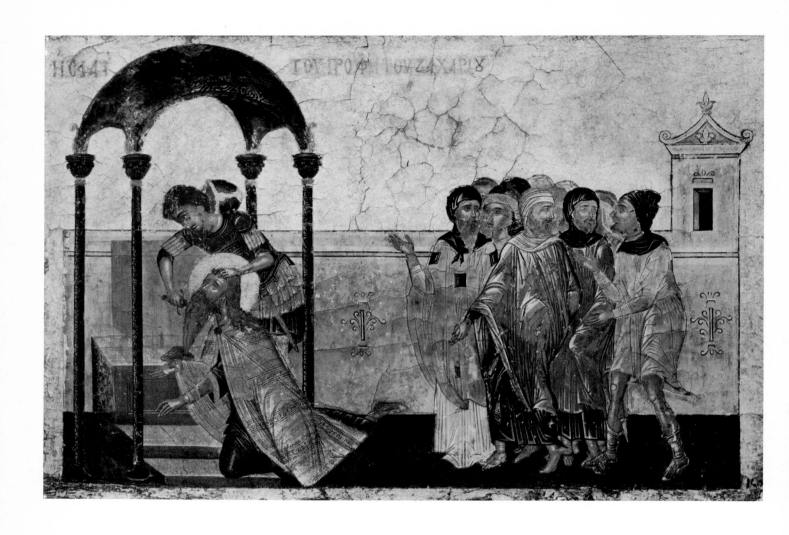

14 The Murder of the Prophet Zechariah. Greek, ca. 1500

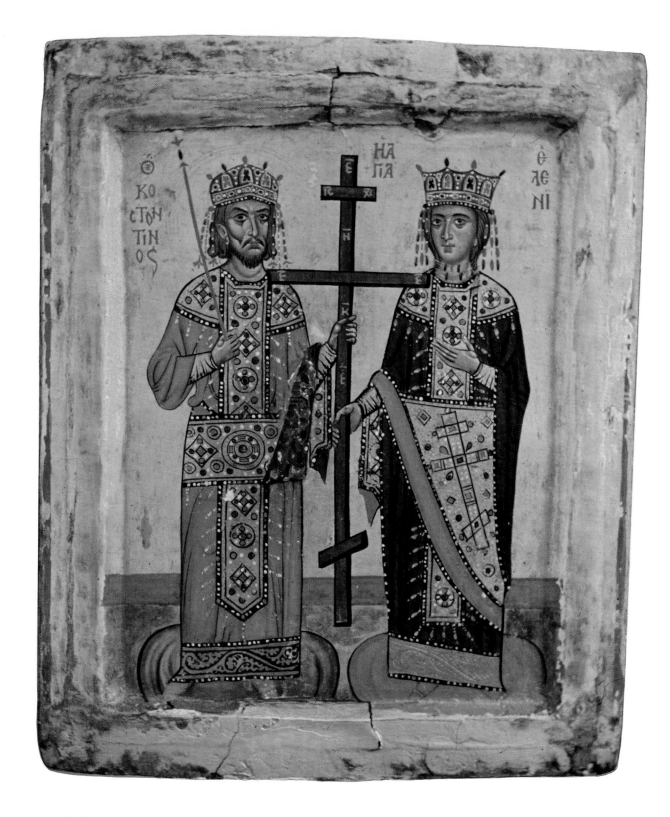

XI Constantine and Helena. Byzantine, 12th/13th century

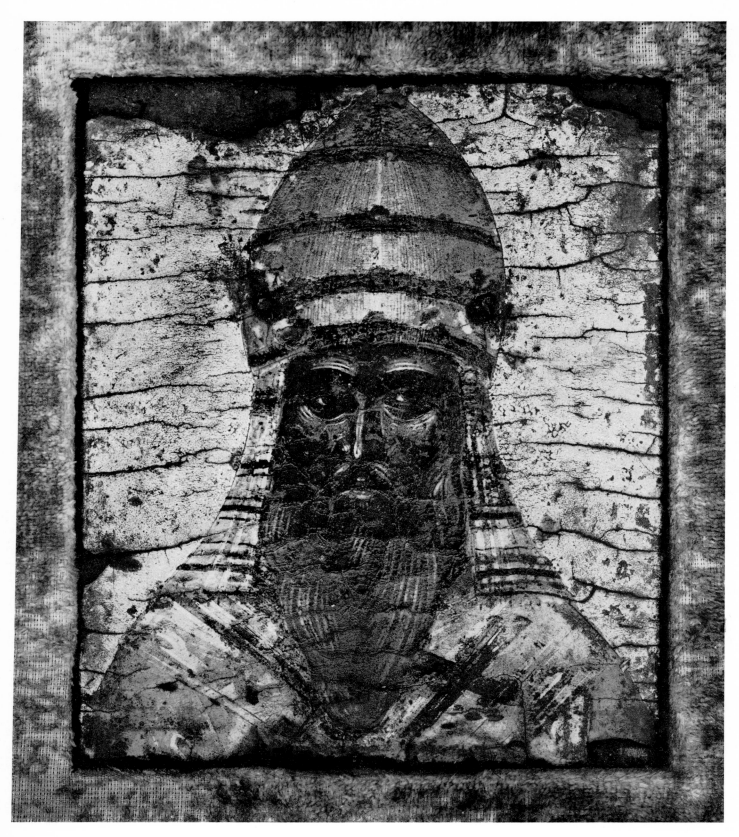

15 Cyril of Alexandria. Greek, late 16th century

eyes, whose gaze has been aptly described as 'Sibylline'[24]. Two small icons not entirely devoid of repainting belong to another group, but are also to be found in the Monastery of St Catherine on Sinai. Here the various features of popular art and a fairly primitive monastic style are more strongly pronounced. A small panel shows the Saints Chariton and Theodosius in separate compartments, one above the other. The pictures have a cinnabar-red edging and have been painted on to an almost black background. The sharply contoured heads are set off by their reddish-yellow haloes. The eyes of both saints look past the viewer. With just a few confidently placed strokes the painter has succeeded in individualising the saints' features, but they share a stern, ascetic expression produced by the downward lines of the mouth and beard. The draperies are broken up to a slight extent by powerful lines.

Pl. V, p. 27

In another panel, also considerably damaged[25], with pictures taken from the Festival cycle, the middle portion shows part of an Ascension scene. The Nativity of Christ comes above it on the original and below it a picture of Pentecost, the Descent of the Holy Spirit. The predominant colouring of the icon consists of different gradations of brown, and the background is in faded yellow ochre. The group of six apostles has been painted with a sense of lively movement and emphatic gestures on the part of the individual figures. A stylised tree is seen rising up behind the two figures on the outside. Hovering over the heads of the other apostles is an angel, holding the mandorla of Christ and bearing Him heavenwards. The whole of the right-hand side of the icon is missing, and the figure of the Mother of God, placed below Christ, has not survived either. Only the right half of her face and one hand raised in an Orans gesture have survived destruction. The severely painted faces, the linear ornamentation of the draperies and the flatness of the entire picture lead us to suspect that it came from a workshop in Asia Minor. There is a clear connection with the frescoes in Cappadocian monasteries and caves and also with later icons from the Anatolian area. We can assume the date to have been between the 7th and the 9th century.

Pl. 6, p. 36

Quite a number of features are common to most encaustic icons from this early period, in spite of the specific national characteristics of the various workshops. The technique used is highly reminiscent of the mummy portraits of Hellenic Egypt. The similarity to the Egyptian portrait panels — for example, those from Antinoë — is sometimes so marked that we cannot be quite certain whether these pictures are, in fact, Christian or non-Christian[26].

A great number of these early icons also have another purely external feature in common. They can be closed with a lid. The frame contains a groove in which a sliding bar can be inserted. This technical detail also tells us something about the purpose of these icons. They are usually small in size and were carried about on journeys, and the simple and practical closing device was a means of protecting them.

It is not surprising that so few pictures have survived from that early period. In the course of all the Christological controversies, the Near Eastern territories and Egypt lost their close connection with the imperial metropolis and soon fell into the hands of the Moslems after the

uprising of the Islamic peoples. Many Christian images must have been destroyed during that period of war and unrest. Even the remote Monastery of St Catherine on Sinai was only able to save its treasures down the centuries because the monks had been clever enough to claim that their monastery had been visited by the Prophet Mahomet. As a result they were able to display a guarantee of immunity bearing a seal from the Prophet's own hand. This legend will not stand up to historical scrutiny, but, thanks to the forgery, the Moslem rulers reaffirmed their protection of the Sinai monastery. However, the reasons for the wholesale destruction of images are not only to be sought outside the Christian world. In the 8th century the Iconoclast Controversy descended upon the Byzantine Empire and Christian images were systematically and relentlessly destroyed, especially under Constantine V Copronymus. As we have already mentioned, that was the time when the decorations in the Hagia Sophia were smashed. The same thing happened in many different places. Wall paintings were covered with whitewash, as can be seen from a miniature in the Chludov Psalter that has been handed down to posterity. Icons were smashed[27]. Of course, the perishable nature of the material used also caused a great many of these items to be lost or ruined without help from any outside agency.

But it would be wrong to look upon the iconoclastic movement, which went on, barring interruptions, for over a century, as a reaction definitely hostile to art itself. The Emperors who took up arms against the extravagant veneration shown to images removed these icons, but at the same time encouraged profane art that could not induce feelings of reverence. So once again we see Hellenistic garden pictures and hunting scenes and pictures of flowers and animals, and these also found their way into places of worship. This can be deduced from the complaints of the iconodules, who accused the Emperor of having transformed churches into aviaries and stables[28]. This action on the part of the iconoclasts led to a revival of stylistic and pictorial features from Antique and Hellenic art which was to be of great benefit to Christian art later on. Had it not been for iconoclasm, the iconographical prototypes that had just been evolved might, under the influence of the lower categories of monks and monastic art in general, never have advanced beyond their primitive early forms. So it is no exaggeration to say that the 'second golden age' of Byzantine art, the Middle Byzantine period, owed a great deal to iconoclasm.

The final victory of the iconodules resulted in even more fervent attempts to hold on to the images that had been saved, now that they were out of danger. The statements of dogma made at the VIIth Ecumenical Council represented a further important step forward with regard to establishing the various pictorial types. A definition was given of what an image really was and, as a result, these types became more closely connected with the authentic prototypes than ever before. We must also remember that the people who actually gave impetus to the iconodule movement were the monks, whose blood was often shed in the conflict. After the victory of the iconodules they rose to a position of pre-eminence and, because of Theodore, the strong-willed and enthusiastic Abbot of the Studion Monastery, who came to the forefront in the second

period of iconoclasm, the monastic influence became clearly evident in literature and art during the next few decades. This influence had a lasting impact in one field in particular, which to a large extent came within the domain of the monasteries — the production of manuscripts, that is, copies of Holy Books, legends and apocrypha. The miniatures from these provide us with a rich store of information about the various stylistic phases of Byzantine art.

After the iconoclastic period we therefore find two basic trends in art. One of these was the courtly style, the forms of which were laid down by the Emperor and the artists working in his service and consisted in a revival of Classical features, lifelike modelling and a realistic conception of the subject matter, especially as far as portraiture was concerned. On the other hand we find monastic art, aiming at something quite different — ascetic severity, adherence to the traditional stock of pictorial types and the transmission and expression of theological and dogmatic ideas in picture form. The interweaving of these two basic trends gave rise to the fascinating and often heterogeneous form that we refer to as Middle Byzantine art.

As in the Early Byzantine period between the 6th and the 8th century, which began with the powerful figure of the Emperor Justinian I, we also find a dynasty of rulers at the beginning of the Middle Byzantine period from the 9th to the 12th century, who led the Empire out of the turmoil of iconoclasm and all the external pressures up to new heights of greatness. Basil I, the Macedonian (867—886), was the first of the series of Emperors from that dynasty. While they were in control — and also under the Comnenes, who followed them after a brief interlude, — there was a new upsurge of artistic activity. This so-called 'Macedonian Renaissance' was greatly encouraged by the tendency to hark back to the days of Antiquity[29]. The Patriarch Photius and the humanist Psellus were typical representatives of the new movement towards Classical Antiquity. Here too we might mention Anna Comnena, the daughter of Alexius I, who described the life of her father in a fifteen-volume work and made interesting comments about the Crusaders at the Byzantine court. She introduced herself in impeccable Attic at the beginning of her book: 'Being not unlearned in the sciences, but particularly interested in the study of everything Greek, and not unpractised in rhetoric, familiar with the system of Aristotle and the Dialogues of Plato, and mentally strengthened by the quadrivium: geometry, mathematics, astronomy and music — for I must say how much the gifts of Nature and my own striving for knowledge, combined with God's grace and a favourable opportunity, have done for me — I wish in this work to record the deeds of my father, which do not deserve to sink into silent oblivion. . . .'

This humanistic tendency at the court and among the educated classes was offset on the ecclesiastical side by an endeavour to arrange and classify the traditional material. Simeon Metaphrastes, in the 10th century, sifted and arranged description of the lives of the saints and brought out a new version of them. It is also likely that the Church laid down stricter rules for art. A rigid form was given to the comprehensive programme of church decoration. Painting manuals stipulating the types and forms of presentation that the icon painters might follow have

not in fact survived, but it would be quite in line with Middle Byzantine tendencies if the first books of rules came from this period of Byzantine art, which has also been referred to as the 'liturgical period'.

Of the larger pictorial cycles from the Middle Byzantine period the mosaics from the Monastery Churches of Hosios Lukas near Delphi in Greece, in Phocis and at Daphne near Athens and the *'Nea Moni'* on Chios have survived. The south vestibule of the Hagia Sophia, displaying a large mosaic of the Mother of God between Constantine the Great and Justinian I, also known as the Great, comes from the end of the 10th century; other parts of the Hagia Sophia, including portions of the south tribune, belong to the 12th century. If we want to find other monuments of Byzantine art from this period we can also look outside the Greek area. In Russia the Cathedral of St Sophia in Kiev belongs to this epoch and in Serbia the frescoes of the Monastery Church of Nerezi near Skopje from the year 1164 are a distinguished example of Middle Byzantine monumental painting.

Pl. 4, p. 28

As regards panel paintings — icons — too, we can include Middle Byzantine monuments from the vast area which came under the influence of the Byzantine state. One of the best known and most beautiful icons of the Comnene period is the picture of 'Our Lady of Vladimir' (Vladimirskaya). As in the case of most icons, we cannot fix a definite date of origin, but the Russian Chronicles enable us to follow in detail its journeyings through Russia, so we can at least determine when the icon was already in existence.

Pl. 9, p. 52

The Russian Chronicles are agreed[30] that the Grand Duke Andrei Bogoliubski took the icon of the Vladimir Mother of God with him from Vyshegorod near Kiev when he shifted his Grand Ducal residence to Suzdal. The Chronicles moreover reveal that this icon, together with another icon of Mary which was also greatly revered, the Pirogoshcha, came from Cargrad (Constantinople) to Kiev. As the Grand Duke of Kiev Mstislav I laid the foundation stone of a Pirogoshcha Church in 1131 or 1132 — both dates are mentioned in versions of the Chronicles, but 1132 appears only in the Hypatius Chronicle — and this was completed in 1136, the date of arrival of the icons has been linked with that event[31]. The precise date of their first arrival is not reported in the Chronicles, but it would definitely come within the second quarter of the 12th century. In 1161 the Vladimirskaya was set up in the Uspenski Cathedral of Vladimir and reference was made in the Chronicle to its lavish adornment to mark the occasion: 'And more than 30 grivni of gold and silver, pearls and precious stones went into its making'[32]. According to the researches of V. Kliuchevski, the oldest account of miracles being performed by the icon of the Vladimir Mother of God would date from between 1163 and the 1180's.

From all the information in the Chronicles it is perfectly clear that the Vladimirskaya was definitely in Russia in the middle of the 12th century. The Chronicles give repeated descriptions of what happened to it subsequently, although we cannot be absolutely certain how the image fared during the various disasters. Thus under the year 1185, when referring to a great conflagration that ravaged Vladimir, the Laurentius Chronicle states that admirable icons were

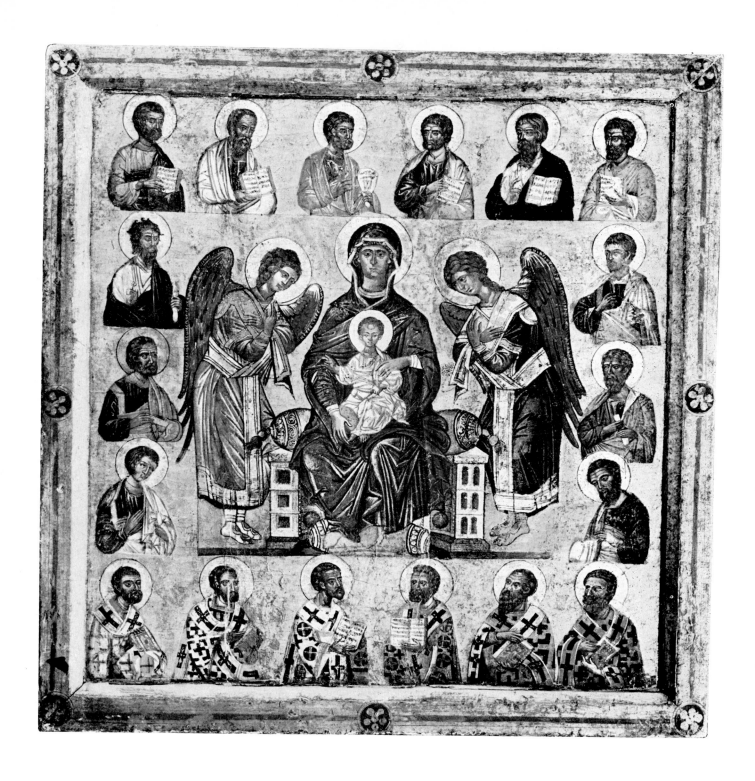

16 The Platytera Mother of God. Greek, late 15th century

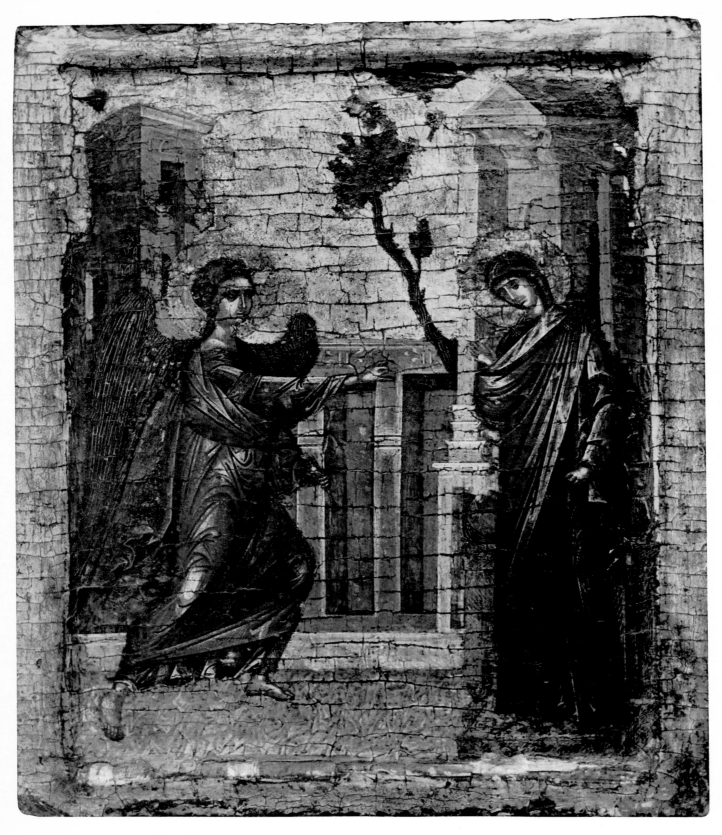

17 The Annunciation. Greek, 15th century

also destroyed 'which had goldsmith work, very valuable precious stones and large pearls on them and were set up in the golden-domed cathedral'[33]. As the fire was supposed to have started 'from up above', i. e., in the roof, it is possible that the miracle-working icon was saved. But, as it is also stated in the Chronicles that 'everything was burnt out' and 'the fire took everything and nothing was left after the conflagration'[34], and the miracle-working icon of the Mother of God was not specifically mentioned anywhere, Ainalov[35] came to the conclusion that the famous icon had also been swallowed by the flames. When Vladimir was taken by the Tartars, the Chronicle expressly states, however, that the icon of the Mother of God was despoiled. The Tartars 'robbed the magnificent icon of its decoration of gold, silver and precious stones and pillaged all monasteries and icons, which they smashed or took with them'[36].

As regards the subsequent fate of the icon, we know that it was brought to Moscow in 1395 to keep Tamerlaine away and, after returning for a time to Vladimir, it was finally taken there for good in 1480 and set up in the Uspenski Cathedral in the Kremlin. In 1918 and 1919 it was moved from there to the State Restoration Workshops in Moscow and was given a thorough examination. From the detailed description by Anisimov regarding the icon itself and the result of the examination it would appear that the removal of the layers of overpainting and the exposure of the oldest paint layer confirmed the dates and events enumerated in the Chronicles. We cannot therefore say definitely whether Ainalov's assumptions that the icon was probably lost in the fire or in the Tartar raid are correct. It would mean that the present icon is a new one, created in the first half of the 13th century[37]. We can, in fact, see a number of connections in colouring and expression between the Vladimirskaya and the famous icon of the Annunciation of Ustiug[38], which was made at the end of the 12th or beginning of the 13th century. On the other hand, a number of formal and iconographical objections raised by Ainalov in support of his theory are highly subjective and are now in some cases indefensible. Alpatov, Anisimov, Schweinfurth, Lazarev and others oppose the idea that the original Vladimirskaya was lost, and the results of the restoration work have supplied powerful arguments in their favour.

Restoration showed that only the faces of the Mother of God and the Child, and also His shoulder and the hand placed round His mother's neck had survived from the original painting. A schematic survey of the individual parts of the icon done during the various attempts at repainting is given by Anisimov in the monograph mentioned above[39]. In the course of these overpainting operations the outline of Mary's figure was altered. Another interesting point is that the faces have been preserved so well and have withstood the ravages of time better than the rest of the icon because the paint ground here is superimposed on canvas, whereas in the case of the figures and the remainder of the picture the chalk ground was applied straight on to the wood and so did not have such a secure base.

The Vladimir Mother of God belongs to the Eleousa type of icon (in Russian, *Umilenie*). Kondakov's theory that this type of image was produced under the influence of Italian Trecento painting is now out of date in the light of more recent information on the subject and does not

rule out the possibility that this image dates from the early 12th century. In colouring it presents a harmonious combination of golden, cherry-red, blue and ochre yellow tones. The faces of the Mother and Child, which belong to the original painting, have been done in various tones. The face of the Mother of God is in a 'warm olive shade passing over imperceptibly into pink and red'[40] and the Child's face has been done in brighter colours, i. e., a light ochre with olive-green shadows.

The overall impression we are left with in this icon of the Vladimir Mother of God is of the tender humanity with which the Mother and Child have been painted. The veiled, melancholy gaze of Mary looks out over the head of the Child to the eye of the beholder and the Child is nestling up against His mother's cheek and looking up at her. None of the known copies of the Vladimirskaya, not even the one ascribed to Andrei Rublev, expresses this peculiar quality of intensity and involvement. The Mother of God is not looking at the beholder, but at the Child or away over Him, into space.

Another masterpiece of Byzantine painting from the 12th century is the icon of St Gregory the Miracle-Worker, now exhibited in the Russian Museum in Leningrad. 'We are struck, above all, by the severity and deep feeling in the eyes, as they gaze sadly, but steadily, at the beholder'[41]. The artist enhanced the spiritual content of the icon by adding the high forehead, the long and extremely delicate nose, the small, tightly closed mouth, the emphasis on the eyes, which are stressed even more by the high, arching brows, and also by his successful combination of drawing and painting. The stylisation of the face, which gives this saintly figure a rather supernatural appearance, has been tackled with careful moderation and all exaggeration has been scrupulously avoided.

Pl. 8, p. 52

An icon of the three saints, Procopius, Demetrius and Nestorius, from the Monastery of St Catherine on Sinai belongs to the 12th or perhaps even the 11th century[42]. The saints, placed frontally, with their martyrs' crosses raised in front of their chests, are ranged in a carefully balanced group before the viewer. The blue-black upper garment of Procopius and the gleaming red of the gathered cape worn by Nestorius produce an impressive colour effect. The central figure of Demetrius, in whose draperies the radiance of the red is neutralised by the yellowish green cloak, is given the dominant position in the picture in spite of his restrained colouring. This is underlined by the two medallions, one in the top margin of the picture (Christ) and the other at the bottom (a male saint who cannot now be identified). The faces do not reveal the stylisation and the transcendental quality that was so evident in the icon of Gregory the Miracle-Worker.

Pl. VI, p. 45

A small icon of the patron saint of the monastery St Catherine (4½ x 5 in.), likewise from the holy foundation on Sinai, is also said to belong to the 12th century. The curious way in which she has been portrayed, with only the head and neck shown, the flat arrangement of the hair round the head, the severe drawing of the nose, the strongly emphasised lips and the highly

Pl. IX, p. 61

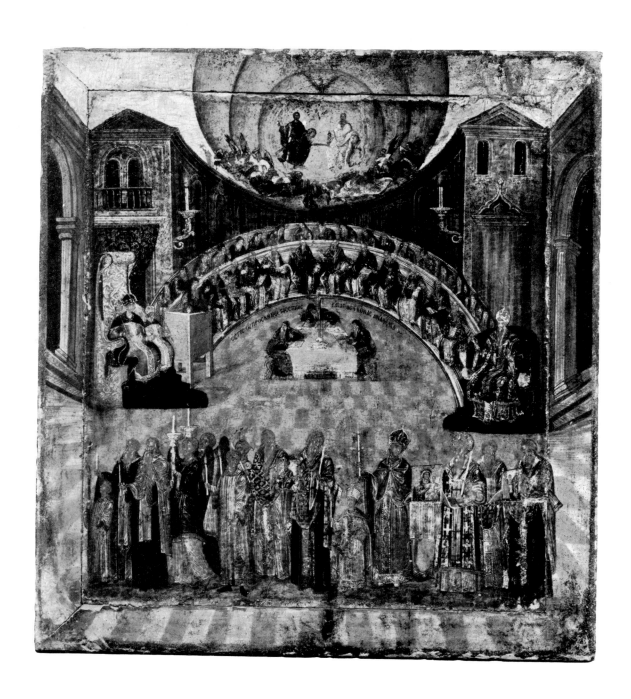

18 The VIIth Ecumenical Council. Greek, 17th century

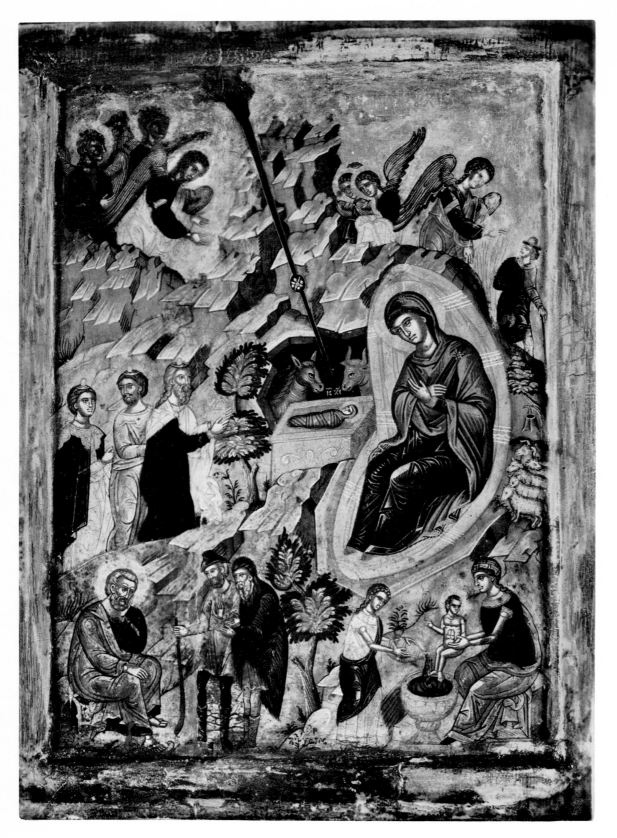

19 The Nativity. Viktoros, 17th century

individual marking of the lines of light for the eyes would seem to me, however, to indicate a later date, so it is more likely to have been made in the 14th century[43].

Pl. 7, p. 46
Another 12th-century icon, from the Byzantine Museum in Athens, is the Orans figure of the Prophet Daniel. In spite of its poor state of preservation, we can assume that, unlike the Vladimir Mother of God and the three saints Procopius, Demetrius and Nestorius, it was not a product of court painting, but belongs stylistically rather to the second Middle Byzantine type, the rigid monastic art form.

Pl. XI, p. 71
The icon of the Emperor Constantine and his mother Helena from the monastery on Sinai can probably be attributed to a workshop with a similar approach. From the powerfully drawn contours and the rich adornment of the draperies we can date it to the final phase of the Comnene period. A mood of courtly nobility and harmonious balance are the special features of a small

Pl. VIII, p. 59
icon of the Mother of God interceding, now placed on a side altar in the Cathedral of Freising. It dates from the first half of the 13th century and arrived as a gift for Bishop Nicodemus of Freising in 1440. The dedicatory inscription on the gilded silver border mentions the name of Manuel Disypatos, who was Bishop of Salonika from 1235 to 1261. The enamel medallions appearing on the gilded border reveal stylistic characteristics of the second quarter of the 13th century.

The small number of icons surviving from that early period are fortunately supplemented by a few mosaic icons[44], presented as costly gifts to monasteries or to honour some individual person. A number of these superb mosaic icons can be seen in the monasteries of Athos. A diptych from the first half of the 14th century, now in the Cathedral Museum in Florence[45], depicts twelve Festivals and is a well known piece that has been frequently reproduced.

Of the mosaic icons in Germany, that of St Nicholas from the Parish Church at Burtscheid, near Aachen, is unfortunately in a deplorable state and vital parts of the panel were overpainted during restoration in the 18th century, so that it is of little use to us here. One very valuable

Pl. VII, p. 51
work, however, is the mosaic icon of Christ the Merciful (*ho eleemon*), belonging to the Berlin-Dahlem Staatliche Museen.

Christ is conceived here as the Teacher of Mankind and the Gospel book in His left hand is shut. 'He is closely wrapped in a dark blue cloak which only reveals His golden robe with lights picked out in silver in the opening in front of His chest and at the end of His left sleeve. The top edge of this robe completes the circle formed round His head by the black and red outline of the nimbus, in which silver cross arms have been incorporated, so that it appears to have a double frame. The rigidly frontal placing of the face along the axis of the picture is accentuated by this, the axis itself being clearly marked by the long, narrow nose. This gives the face a touch of severity, although it has been quite delicately formed'[46]. The icon dates from the turn of the 11th century and is described by Wulff on the basis of both technique and style as 'genuine Byzantine work revealing a certain connection with the mosaics of the Cappella Palatina'[47].

The increased note of spirituality in the faces of the various saints, clearly evident in the idealised approach to icon painting (e. g., in the icon of Gregory the Miracle-Worker), is even more strongly marked in a mosaic icon of St John Chrysostom. This is a small panel (7 x 5 in) Pl. 11, p. 62 compared with the Christ mosaic (30 x 22 in). Here the face is made to appear even smaller owing to the high forehead, and the tapering cheeks give it an austere and ascetic appearance. The Patriarch's robe is adorned with red crosses and the omophorion with blue crosses, all edged with gold. The wide halo is also decorated with small crosses in blue, red and green, framed in gold. This mosaic icon belongs to the first half of the 14th century[48].

A scenic picture is presented on a mosaic icon created around 1300 and belonging, like the one just described, to the Dumbarton Oaks Collection of Harvard University in Washington. The Forty Martyrs of Sebaste form the subject of this icon. They are standing in three rows, one Pl. 13, p. 69 behind the other, with their martyr's crowns suspended above them. The hand of God is shown blessing them from a circular section at the top of the panel. From the remains of the inscription we can read: 'The holy forty . . . ' White is the dominant colour, with shadows in grey, green and blue, and the background is in gold[49].

With these last two mosaic icons we have reached the final flowering of Byzantine art — the Late Byzantine period, often referred to as the 'Palaeologue Renaissance'.

The Comnene era ended at the beginning of the 13th century which was to be a time of such momentous repercussions throughout the Byzantine Empire. In the very first years of the century, the knights of the Fourth Crusade seized the capital (1204), which was then subjected to all the horrors of war. When it was being sacked, many famous objects of veneration disappeared, including the acheiropoietic image of Christ that had been revered for centuries. The Byzantine Empire was never able to recover fully from this fierce attack or from the establishment of the Latin Empire. The hatred that had been building up against the 'Latins' was still very much in evidence during the Turkish siege and at an earlier stage caused the negotiations for a union to come to nothing. Three states emerged from the ruins of the Empire — the Empire of Trebizond under the Comnenes, Epirus, and the Empire of Nicaea, where the court of Constantinople had fled. From there Michael Palaeologus succeeded in winning back Constantinople in 1261. He upheld its status and under him the shrivelled Empire flowered again for the last time. A feature of this final phase of the Byzantine Empire that came out more strongly than ever before was the consciousness of being Greek — no doubt a side-effect produced by the long decades of oppression by the Crusaders, which had always been regarded as particularly humiliating in Byzantium. This reversion to all things Greek could not fail to have repercussions on art. 'The severity of the Middle Byzantine period has been abandoned and the underlying Hellenistic elements are becoming evident once more, moulded in accordance with Early Christian and Early Byzantine and probably also Antique models. The supreme importance of beautiful lines is stressed and persons engaged in their various activities are combined in a lively and natural manner'[50].

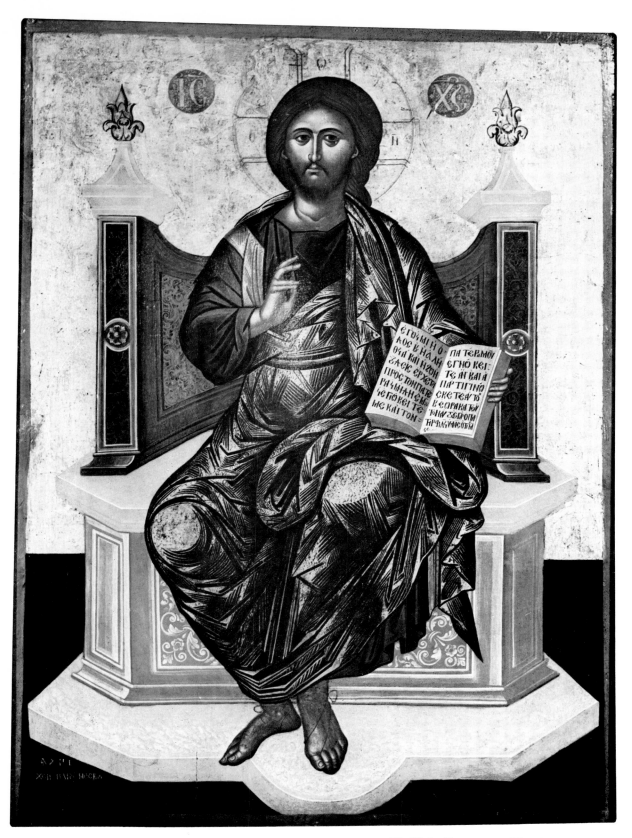

20 Christ Pantocrator. Elias Moschos, 1653

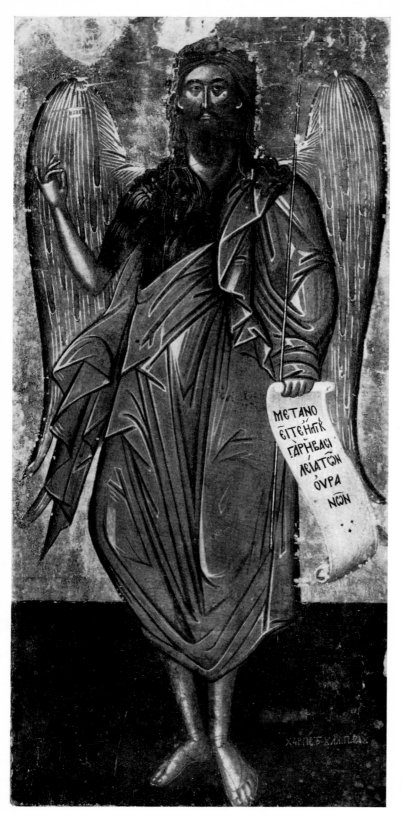

21 John the Baptist.
Petros Lampardos, 17th century

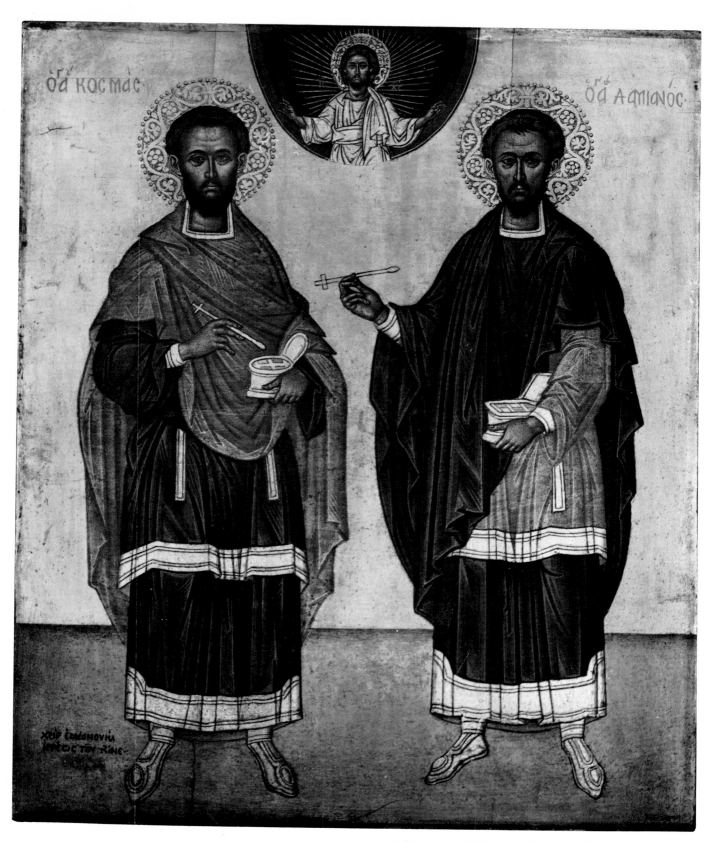

22 Cosmas and Damian. Emmanuel Tzanes, 17th century

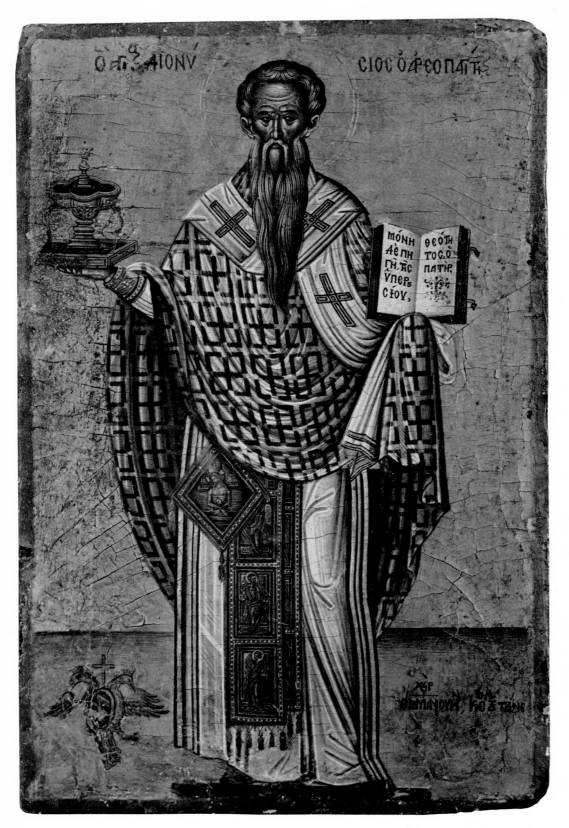

23 Dionysius the Areopagite. Emmanuel Tzanes, 17th century

The most mature example of these new trends is to be seen in the mosaics made in the Chora Church (Kahrieh Djami) in Constantinople around 1310. Here we certainly do find persons engaged in their various activities 'combined in a lively manner', and the background has also come to life again. There are glimpses of nature, trees and animals, and also more detailed architectural settings. The revival of interest in nature and the rediscovery of the dramatic factor go hand in hand with delicacy of presentation and elegance in the linework. The figures have become taller and more slender and the arrangement of the drapery folds is more disturbed and agitated, a common feature being the use of broken lines. There is also a certain degree of mannerism, especially in the conspicuously fluttering peaks and corners of the draperies.

Various explanations have been given regarding the origin of these new features. 'Some scholars, including D. V. Ainalov, who has taken up an intermediate position, support the so-called western theory and refer to the ... historical dealings between Byzantium and the West during the Latin occupation of Constantinople (1204—1261); others, in company with Strzy-gowski, speak of the eastern influences on Byzantine iconography, especially from Syria. The Hellenist theory, according to which the new movement is interpreted as a Renaissance, has many supporters who point to the active humanist studies that were particularly encouraged under the Palaeologue dynasty'[51]. A combination of several different factors was probably responsible for the formation of this so-called Palaeologue style. Even at the beginning of the 13th century we can detect a more emphatic and almost declamatory note in a number of monumental works, which would seem to indicate a departure from the Comnene style. The political situation after 1204 was favourable to the artists who were attempting to create new forms. Nicaea, the seat of the exiled Constantinopolitan Emperor, was not, of course, as important as the traditional centre, Constantinople, and probably regarded itself merely as a kind of staging-post on the road leading back to the old capital. So the centre of the Byzantine Empire was out of action for the time being as a formative and guiding force and the artist found himself thrown back on his own resources. He had to decide where he stood and work for the Frankish overlords or — as some preferred to do — go and seek out the Orthodox Slav princes of the Balkans. But, whichever course he followed, he gained a greater measure of artistic freedom than under the watchful eyes of the Emperor and the Patriarch, and he also became familiar with artistic forms diverging to a greater or a lesser extent from the traditions handed down to him. This process of evolution inevitably opened up new fields of knowledge and encouraged him to experiment boldly. He handled his subjects from this new angle with verve and vigour[52].

Icons revealing these new stylistic features include that of the Twelve Apostles, which has been reproduced more than once[53]. The Twelve, arranged in two rows one behind the other, show a lively sense of movement and the old hieratic alignment of figures has been avoided here. This feeling of restlessness is particularly evident in the four apostles in the front row, who are shown as full-length figures, and repetition has been avoided in their gestures. The Twelve therefore appear to be engaged in an animated conversation. The four apostles in the foreground

also round off the entire composition by their movement in turning towards one another. The highlighting of the faces and draperies serves to bring out the corporeality of the figures[54].

A picture of the Murder of the Prophet Zachariah, owned by the Statens Museum for Kunst in Copenhagen and dated to the 14th century, also displays a number of the stylistic peculiarities of Late Byzantine painting. From the point of view of colour it is dominated by gleaming red and blue tones, set against a shimmering gold background. The action appears to be divided up by the two halves of the picture, but a link is established by the prophet's foot, which is made to project backwards, and also by the ornament on the wall in the background scenery. A sense of drama is fully expressed both in the actual murder scene and in the animated movement of the group of people, who are painted in a natural manner with speaking gestures indicated. The presence of a larger group of people is suggested by the heads rising behind the five figures in the foreground and this helps to enhance the lively impression already given because the heads of the five are set against a loosely organised background and the rigid alignment that might have occurred if a plain gold ground had been used has been avoided. This icon seems, however, to take the existence of the Palaeologue style for granted rather than actually embody it. So the date should be amended (15th/16th century).

Pl. 14, p. 70

A number of good examples of Late Byzantine icons are to be found in the monasteries in the Balkans and also in Russian museums. Occasionally there is some doubt as to whether they really did come from the immediate Byzantine area, but, as a rule, the typical criteria of the Palaeologue period can be clearly detected, although it is not always certain whether a Byzantine master actually painted them or one of his pupils from the Balkan states or Russia. They include, for example, the icons from Ochrid[55] and from various monasteries on Athos, especially from the Chin, or order, of the Chilandari Monastery[56]. The nationality of the painters can seldom be established satisfactorily — a point that was of hardly any importance at the time when the icons were actually produced. This problem sometimes arouses a good deal of national feeling nowadays. The Macedonian area varied its political allegiance, but its predominant character in the 13th and 14th century was Byzantine. The well-known Annunciation from Ochrid, which was only restored to its true pristine beauty a few years ago after attempts were made to clean and conserve it, was definitely made by a Byzantine master from the capital as it is a noble and graceful piece of work. The figures from the Chin at Chilandari on the other hand reveal a greater sense of realism, so a monastic master from Byzantium may have been responsible there too.

Pl. X, p. 65

Pl. 12, p. 66

This Macedonian area emerges from fairly recent finds that have been made as an area with an artistic character of its own, whose features, however, diverge considerably from the so-called 'Macedonian School' of Millet[57] and the way in which it has been interpreted. The important contribution made by Salonika[58] and the Slavs[59] to the evolution and progress of painting in Macedonia has been recognised in the past few years and now stands out more clearly as a result of all the discussion. It is still too early to try to determine the true part played by these individual factors. With all the new discoveries made in recent years, for example at Kastoria[60],

Prespa[61] and monasteries in Bulgaria and Serbia, to mention only a few of the more important places, and the other finds that have been made, it will be possible for us to build up a more sharply defined picture of Macedonia as an artistic area.

Political developments in the 14th century and the loss of the greater part of Greek territory to the Turks were not without an effect on art. Mistra in the Peloponnese[62], the tone of the Despots, who after the middle of the 14th century were sons of the Byzantine Emperor (in fact, the last Byzantine Emperor, Constantine, was actually crowned at Mistra in 1449), had become a new centre of art and culture. The harbours of the Despotate may also have been stages on the route by which art found its way from the capital to Crete. Metropolitan features were appearing in Cretan art as early as the middle of the 14th century. Chronicles and old records confirm the migration of Constantinopolitan artists to Crete at the beginning of the 15th century. In the second half of the same century artists followed from Mistra, which was handed over to the Turks in 1460. So the island of Crete, which had been included within the sphere of influence of the Signoria of Venice since the 13th century, represented and perpetuated Byzantine art in the post-Byzantine era. Her masters worked in the monasteries of Athos and we find traces of them on Cyprus and in the remote Monastery of St Catherine on Mount Sinai[63]. The painters living there proceeded along quite different paths because of the absence of flourishing municipal centres, the oppressive burden of Turkish rule, the poverty and distress of the Church and also of the people living on the mainland of Greece. The trend was therefore towards folk art, powerful colour contrasts, simplification in the structure of the picture and often a highly expressive style.

Pl. 16, p. **77** An icon of an enthroned Mother of God, framed by a frieze of apostles, bishops and saints, probably belongs to the 15th century[64]. The figures appearing against the matt gold ground have been evolved in a more polished and formalistic manner — far removed from High Palaeologue art.

Pl. 17, p. 78 An Annunciation from the 15th century[65] is based on a frequently recurring model. A privately owned icon in Prague which differs only in unimportant details has been reproduced by Myslivec[66]. The same picture occurs as a marginal scene at the top left-hand corner of Plate 54 in the appendix to the Icon Catalogue of the Benaki Museum[67]. In the same catalogue a further icon of this type by John Kyprios (1581) is reproduced as Illustration 9A and there is one by Emmanuel Tzanfournari in Plate 17. The oldest pictures are the panel illustrated here, the Prague icon and the marginal scene, and they are all built up in a simple and impressive manner. From the point of view of colouring, our icon displays an extraordinary degree of refinement and harmony in its wine-red, greeny and yellowish tones set against the warm matt gold of the ground. In the case of the Kyprios icon the architecture is more complicated and the faces and the tree in the background are painted in a more natural manner. In the Tzanfournari version there is excessive stress on architectural details, genre motifs are introduced and the column capitals and ornaments reveal a definite Italian influence.

The increasing enthusiasm for narration is evident in an icon from the Statens Museum for Kunst in Copenhagen. This is described as Byzantine and no date is given. Its theme is the VIIth Ecumenical Council. Here too there is a clear indication of the course taken by icon painting in Greece after the fall of the Byzantine Empire. In the figures we find schematic drawing and standardisation of types. Under Italian influence architecture and ornament have become of prime importance and the pleasing combination of painting and linework has been lost. In spite of all the technical skill shown in the pictures, there is not such a free approach and, although the action has been added to and enriched, the movement is artificial and the artist quite often fails in his attempt to create spatial perspective. The Trinity in the triple sphere at the top of the picture is borne by angels based on Italian prototypes, and this icon probably dates from the end of the 16th century, if not the first thirty years or so of the 17th. An icon of St Cyril of Alexandria clearly reveals the changes in portraiture as time went on. This picture is more conventional and shows greater emphasis on the graphical side. The linear element is forcibly expressed in the lighting of face and beard. The probable date of origin of the icon which is in the Dumbarton Oaks Collection[68], is towards the close of the 16th century.

Pl. 18, p. 81

Pl. 15, p. 72

The tensions to which Greek painters found themselves subjected outside their own homeland are more clearly expressed in the works of the late 17th century. The Cretan masters of the 16th century were still closely connected with the Byzantine tradition. Their work is marked by clarity in the composition, a strict interpretation of the subject and a more markedly graphical approach. This is clearly evident in the middle portion of a triptych showing the Deesis and several saints and dating from the early 16th century. It displays balance in the structure of the picture and simple alignment of the figures.

Pl. 10, p. 60

In the 17th century Venice represented a vital formative stage in the artistic career of many Greek painters. The importance of that city and its Greek fraternity has recently been described most persuasively by M. Chatzidakis[69]. Michael Damaskinos[70], who painted vital parts of the iconostasis in the Church of San Giorgio for the Greek community in Venice in 1574, was probably the leading Cretan painter from the period around the turn of the 16th century. His work betrays a deeply sensitive understanding of Palaeologue art and he successfully produced a new version of Greek painting based on the spirit of his time. A more powerful rhythmical approach is certainly evident in his compositions, and the softer humanity expressed in his faces would appear to reveal a cautious introduction of Italian features. But the dominant factor is still Greek. More monumental in conception is an icon from the 17th century of John the Baptist, by Petros Lampardos. The powerfully disposed folds and the flat shading show a completely different basic conception of pictorial art, which recurs again and again until the 18th century, especially in pictures of individual saints. The prevailing tone is also Greek in the Pantocrator of Elias Moschos, painted in 1653. The ornamentation of the throne and the colours scheme with its subdued tones of red and green reveal that he was familiar with western pictures. The Nativity of Christ, a work by the painter Viktoros, reverts to the traditional treatment of the subject,

Pl. 21, p. 86

Pl. 20, p. 85

Pl. 19, p. 82

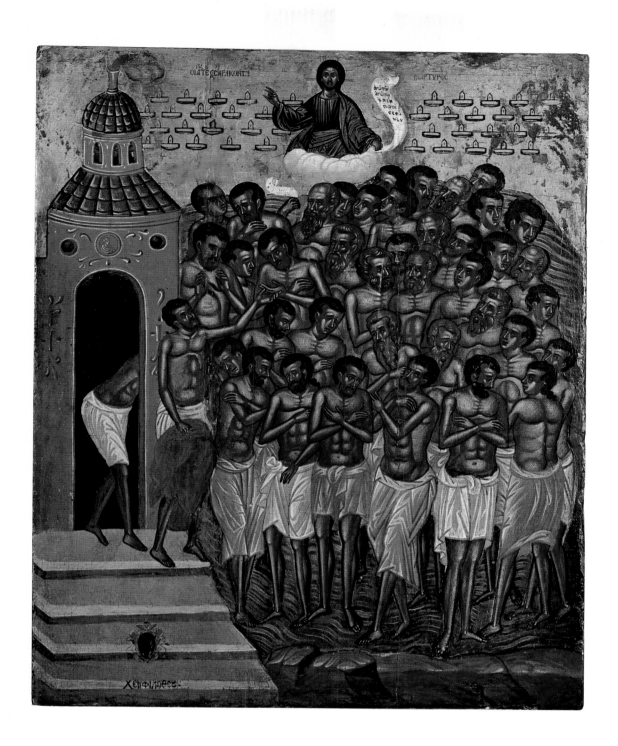

XII The Forty Martyrs of Sebaste. Philotheos Skouphos, 17th century

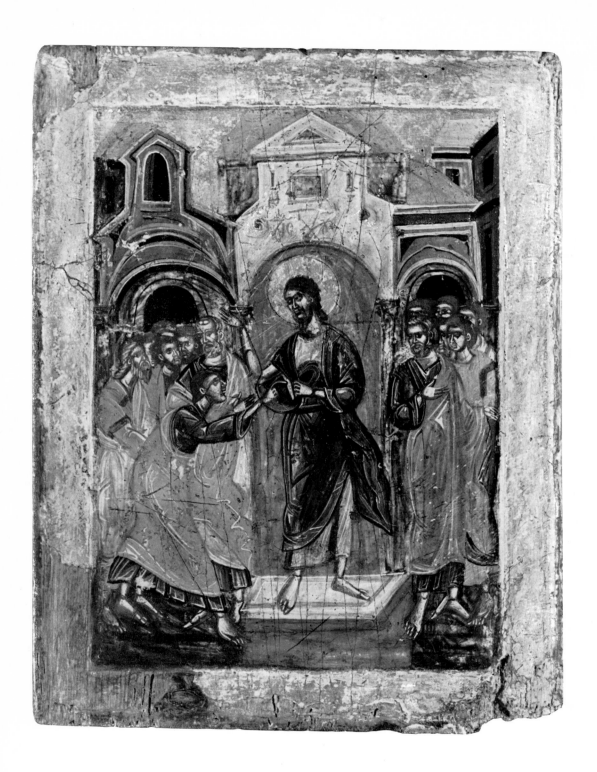

24 Doubting Thomas. Serbian (Peć-Dečani School), 17th century
25 Demetrius of Salonika. Serbian, late 14th/early 15th century

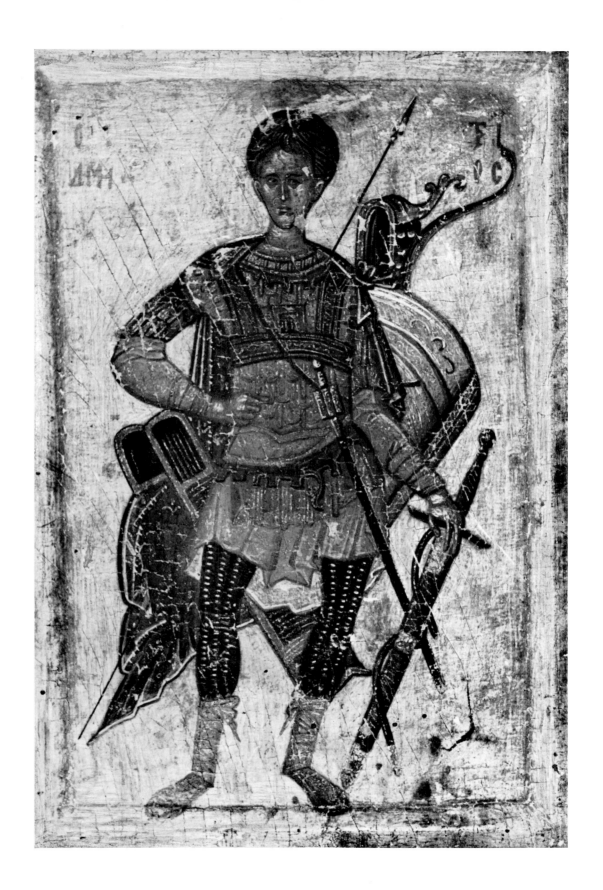

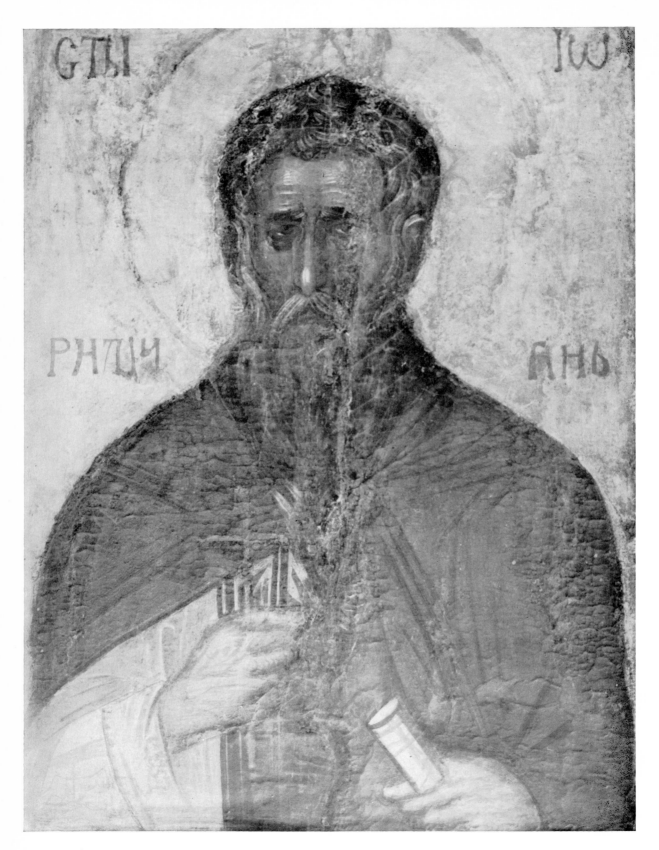

26 Ivan Rilski. Byzantine, 14th century

but the conception of the resting Mother of God, as shown in portrayals of the Nativity, has been modified to create an Adoration scene. Philotheos Skouphos, on the other hand, a contemporary of Lampardos and Viktoros, has built up his icon of the Forty Martyrs of Sebaste in a dramatic manner. A mood of restlessness and agitation among the Forty contrasts with the sublime calm of Christ Blessing, Who is shown on clouds between the four rows of crowns promised to the Martyrs.

Pl. XII, p. 93

Emmanuel Tzanes (1637—1694) was one of the most respected Cretan painters of his day. An icon of SS. Cosmas and Damian and another of St Dionysius the Areopagite give us an idea of his work. In the case of the doctor saints we can clearly see an attempt to create a devotional icon in the old spirit, but in the panel of Dionysius the Areopagite there is a definite lack of repose owing to overemphasis of the décor, the stylised drawing of the beard and the sharp lighting of the face, in spite of the severely earnest presence of the saintly figure. This restless mood stems from over-accentuation of the ornamental factor. In the draperies, the epitrachelion and the epigonation the cross patterns have lost their simplicity or have actually been replaced by scenic motifs. Emmanuel Tzanes is distinguished by great technical competence, fine and graceful brushwork and an excellent feeling for colour. The prevailing tone and structure of the pictures are Greek, but his work also reveals a harmonious incorporation of non-Greek influences.

Pl. 22, p. 87
Pl. 23, p. 88

When they lost their Cretan home, a vast stream of refugees surged over to the Ionian islands and into the coastal towns of Italy. Here some of the artists came more and more under the influence of Italian painting, and with the 18th century we find an ever expanding group endeavouring to paint in a purely western manner. Their work therefore comes outside the scope of icon painting.

As far as the BALKANS are concerned, the characteristics of icon painting in Serbia in particular have become more clearly defined in recent years. For a long time, mediaeval Serbian art was overshadowed by the fresco cycles in the numerous monasteries. The discovery of new icons and the sterling work done by the restoration workshops have now led to a detailed study of icon painting, and its various lines of development have, as a result, become more clear-cut[71].

Literary evidence of the existence of icons goes right back to the 11th and 12th centuries. But the number of relatively early original works is very small today. Among the oldest Serbian icons we can include the famous Mandylion known as 'la Sainte Face de Laon'[72], fashioned about the turn of the 12th century. The early Serbian icons appear to have adopted the monumental style of the frescoes and in general Serbian icons seem to be distinguished by a stronger note of realism and sharper modelling. The relatively close geographical connection with Byzantium and the steady influx of Byzantine works of art and also Byzantine painters set their stamp on Serbian painting until the fall of Smederevo (1459). So Serbian icon painting remained in close contact with the Byzantine pattern of evolution, but showed a preference for a more natural type of beauty and often greater simplicity of form as a result. As the centres of painting

at that time coincided very largely with the residences of the rulers and the ecclesiastical hierarchy, the pattern of development, as far as we can visualise it today, remained uniform, apart from the Dalmatian area[73], which was influenced by Italy.

The painters working in the Serbian monastery of Chilandari on sacred Mount Athos constantly maintained a close contact with the workshops of Constantinople, but in the monastery and on Athos they also got to know the products of foreign artists who were working there temporarily and of other schools whose icons were sent there as costly gifts. But, compared with Athos, which virtually remained a place of refuge even during the Turkish era, and managed to carry on an independent existence beyond the fringe of political events, the situation in Serbia itself was far less favourable. All the ups and downs of the Turkish wars and her loss of independence inevitably had a negative effect. The influx of emigrants from Constantinople, the Aegean islands and Bulgaria also left its mark on Serbian art. The general impoverishment of the country and the withdrawal northwards in the face of pressure from the Turks had a pronounced effect and a mood of ascetic withdrawal from the world became apparent in the icons and remained a characteristic feature until the 17th century. An icon from the Peć-Dečani School of the 17th century displaying Doubting Thomas is a clear example of this trend. Pl. 24, p. 94 Intellectual life, including painting, started to flower again with the renewal of the Serbian Patriarchate of Peć. Painters wandering through Serbia found helpers and patrons inside the Church. Italo-Byzantine and Russian icons sent to Serbia as gifts in the 15th and 16th century and the increase in western influence provided the artists with the necessary models and ideas, but they did not simply take them over in their existing state. Instead, like the Greek and Cretan painters of the early post-Byzantine era, they worked them into their own particular form of painting, which had been evolved from native tradition. Artists who, although receptive to new impressions, went their own individual way, were the masters Longin and Mitrofanović[74]. The latter painter, who worked not only in Serbia, but also in the Athos monastery of Chilandari, achieved a harmonious compositional combination slightly reminiscent of the Palaeologue period. Nevertheless there is just a hint of Italo-Byzantine art and the colouring of Russian icons.

The work of these masters was usually associated with the large monasteries, at Peć, Dečani and Morača. From the 17th century onwards there was also a more primitive form of painting directed at the peasant population, but often lacking the originality of true folk art. The more modest monastic workshops and urban craftsmen went in for this type of icon production to an increasing extent in the 18th and 19th century. 'From the early years of the 18th century onwards icon painting survived among the Serbians as a humble trade carried on by village masters, and leading artists trained in academies of art also began to do paintings for Serbian Baroque churches'[75]. Compared with the products of genuine folk art, in textiles and ceramics for example, the work of these village masters is of an inferior standard[76]. The characteristic feature of Serbian art in the 18th and 19th century was, on the whole, the conscious adoption of western Baroque style. But the introduction of western prototypes caused a gradual change

XIII The Eleousa Mother of God. Bulgarian, 13th/14th century

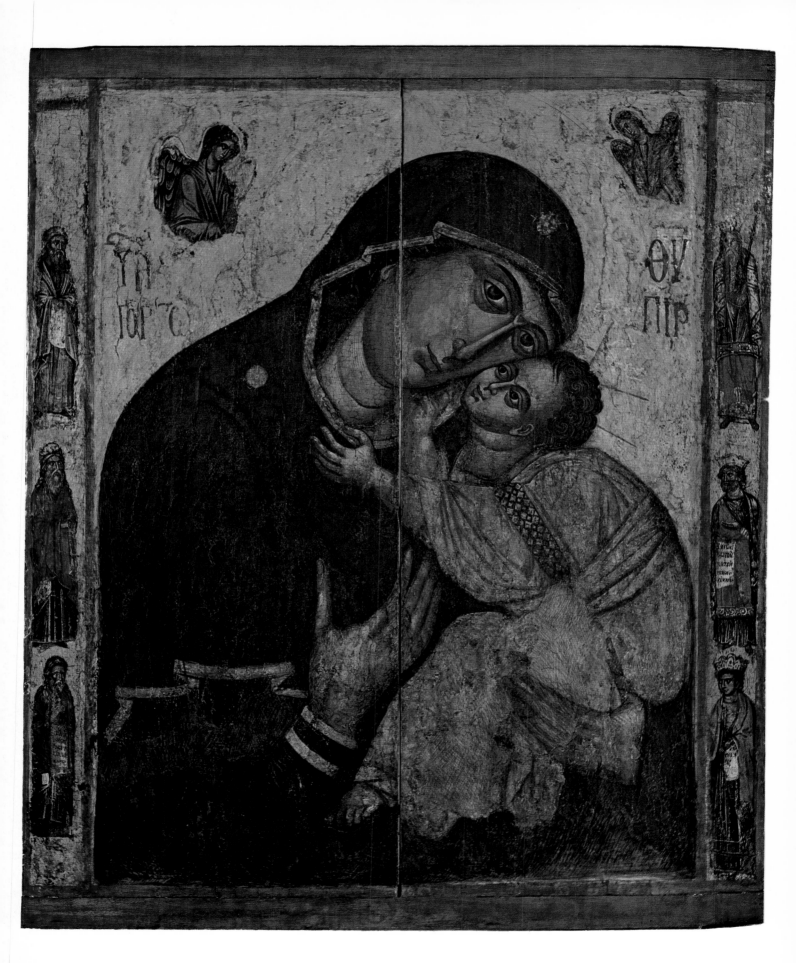

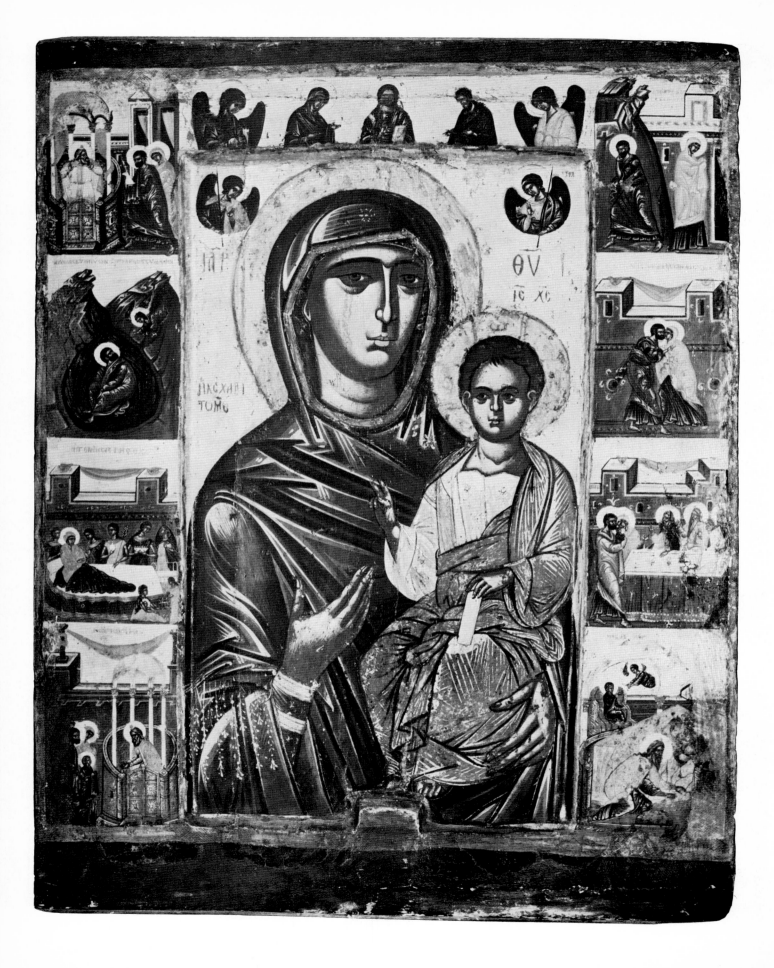

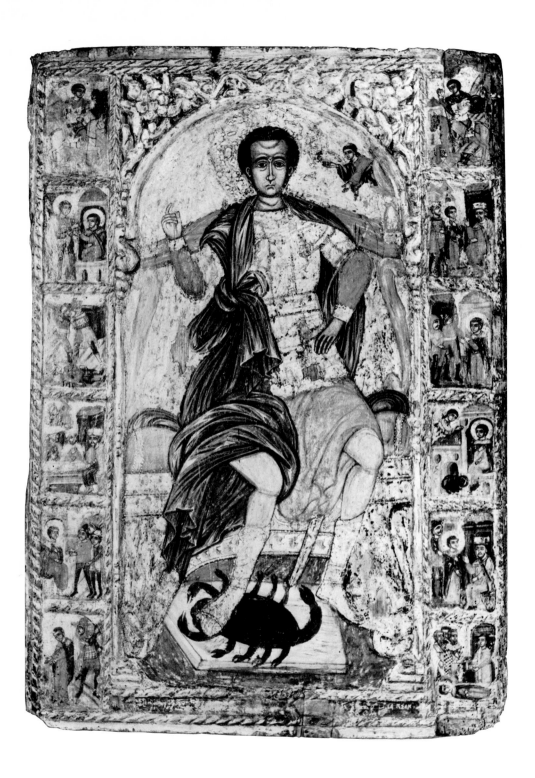

28 Demetrius of Salonika. Bulgarian, 17th century
27 The Hodigitria Mother of God, Bulgarian, 16th century

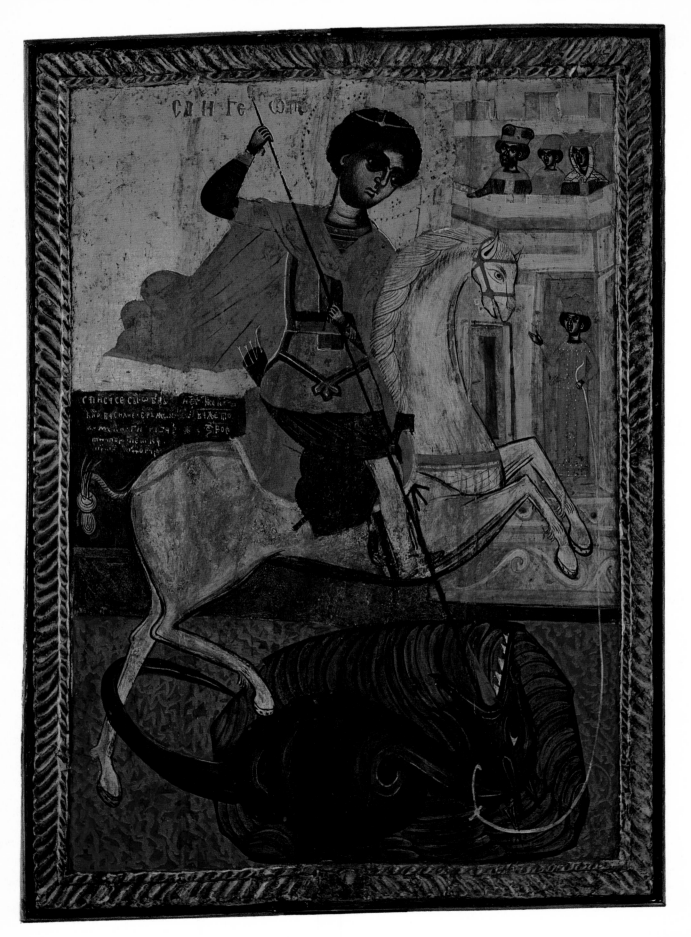

Pl. 12, p. 66
in icons and all that they once stood for, and so they became religious pictures in the widest sense. In this way a centuries-old tradition came to an end. The Byzantine Annunciation from Ochrid, a sample of Constantinopolitan art and one of the models for Serbian artists, which had perhaps as great an impact on them as the Vladimir Mother of God and other Byzantine icons on the evolution of Russian art, came at the beginning of the 14th century, whereas the icons

Pl. X, p. 65
from the Chin of Chiliandari, belonging to the end of that century, and probably made at another monastic workshop in Constantinople show a mood of solemnity and greater simplicity and restraint in the painting. The Serbian note is more in evidence in a small panel from the Museum

Pl. 25, p. 95
of Applied Art in Belgrade portraying St Demetrius. This panel dates from the beginning of the 15th century, and the positioning of the warrior within the tall rectangle of the picture shows that the composition has been carefully worked out. The fluttering corner of his cloak and the bow stress the diagonal, and this is emphasised in other ways as well — by the placing of the lance, the edge of the shield and the heavy sword. The quiver and the mace serve as hard accents bringing out the counter-diagonal. We see a powerful warrior who had little time for the courtly sophistication of a knight. The colours are bright and delicately graduated. The red and bluish green recall the colouring used by Russian painters of the same period[77].

In BULGARIA, too, interest was concentrated exclusively on monumental painting for a long time. The frescoes of Boyana, Turnovo, Bačkovo, and Berende, for excample, were reproduced[78] some years ago and are widely known. Since the time of Bogdan Filov, however, icon painting has been frequently brought to our attention as a result of the exhibitions held in western and central Europe and it has been discussed in several publications[79]. Quite recently Atanas Božkov brought out a detailed and comprehensive study covering the whole field of Bulgarian painting and clearly outlining its various aspects and the general pattern of evolution.

Bulgaria, too, was in close contact with Byzantium and her court based itself on Constantinople. Byzantine models provided a valuable guide for her painters. An important masterpiece of late 14th-century Byzantine art, presented by the Byzantine Empress to the Monastery of Poganovo and now in the National Gallery in Sofia, shows the Miracle of the Monastery of Latomou, with Mary and John on the other side. It is just one example of the many works of art from the Palaeologue period that reached the country. A resplendent blue is the dominant colour on the side showing the Mother and John and this makes the excessively elongated, slender figure of Mary stand out from the greenish gold of the background. The presentation of the vision on the other side is more expressive. Christ Emmanuel appears in sublime repose in an aureole with the symbols of the evangelists above the more animated scene depicted in the bottom half of the picture. A rocky terrace, bare of vegetation, is built up in rugged, irregular stages round a rippling lake. Ezekiel, standing by the water's edge, is gazing up excitedly at the manifestation of Christ, whilst Habakkuk is sitting on the rocky ground. He is utterly withdrawn and lost in reverie and is obviously meditating on the vision[80].

XIV St George and the Dragon. Bulgarian, 1667

A portrait icon of St Ivan Rilski from the 14th century is in complete harmony with Palaeologue art. It is also related to a number of icons from Serbia, for example, that of St Nicholas from Dečani and the icon of John the Evangelist from the Deesis tier at Chilandari[81]. Pl. 26, p. 96

The artist who made the double-sided icon from Nessebar with Christ on one side and an Eleousa Mother of God on the other in the second half of the 13th century used a soft consistency in his painting. In this way he achieved a prevailing tone of lyricism, expressively reinforcing the feeling of tenderness that is so characteristic of the Eleousa type of picture. If we make a comparison between this Eleousa icon and another icon of Mary of the Hodigitria type with scenes along the borders from the life of the Virgin, now housed in the Museum of Church History and Archaeology in Sofia, we can clearly see the transformation that took place in Bulgarian icon painting. The Hodigitria icon, from the 16th century, has been executed in a harder manner with a denser application of paint, sharper contrasts and a livelier interplay of colours. The same thing happened in Bulgaria that had already occurred on the Greek mainland and in Serbia: the loss of autonomy and the heavy Turkish yoke served to restrict the scope of art. The formal tradition was preserved, but the old, familiar subjects were treated in a less inspired manner. Features of folk art came into prominence. The delight in ornament even became evident in the treatment of the painting boards. The raised edges of the pictures bore carvings in simple relief, and in icons with portraits of the saints or scenic pictures along the marginal strips the individual compartments were divided from one another and from the central figure in the middle compartment by carved arches or mouldings. Scroll reliefs also became commoner in the haloes. An icon of St George and the Dragon, dated 1667 and exhibited in the National Gallery in Sofia, and an icon of St Demetrius of Salonika with scenes from his legend, likewise belonging to the 17th century and coming from the Monastery of St Demetrius in Boboševo, clearly illustrate this trend. Pl. XIII, p. 99

Pl. 27, p. 100

Pl. XIV, p. 102

Pl. 28, p. 101

Subsequent phases of development do not reveal the charm and delicacy of the great eras that were now past. The compositions became simpler and were often reduced to the bare essentials. Strong and even loud colours often contrast harshly with one another. In the 18th century and sometimes in the 19th this plain form of art was typical of the painting families in Tryavna and Samokov, whose works can still be found in large numbers in remote regions of Bulgaria. But, apart from this rather more popular trend, there are also icons reflecting the influence of Baroque engravings and oil paintings of western origin and forming the basis of icon work bearing a western stamp and painted in a realistic manner. In these works, too, scope was found for decoration in the various drapery details and the lavish ornaments on the medallions bearing inscriptions[82].

A systematic and concentrated study of icons has been carried out in RUMANIA in the last few years, although there has been no comprehensive publication on the subject since Iorga[83]. The Moldavia area with its rich monasteries and flourishing municipal centres, situated at the

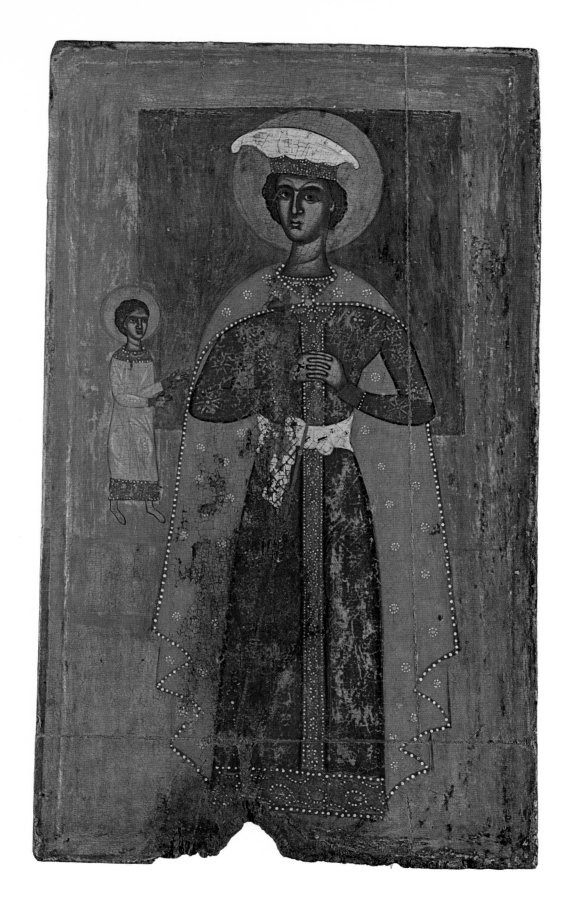

XV Demetrius of Salonika.
 Rumanian (Moldavia),
 16th century

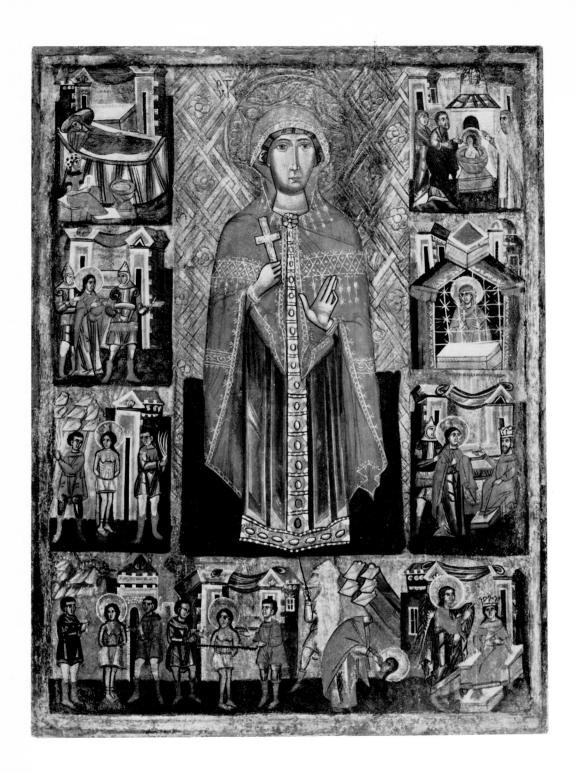

29 The Martyr Paraskeva. Ruthenian, 16th century

meeting-place of many roads running in all directions, remained for centuries the goal of many fugitives from the Christian Balkan states which had been incorporated in the domains of the Sultan. Here art reached a high peak of excellence in the 15th and 16th centuries, as is shown by the external frescoes on the Moldavian monasteries, the rich embroidery, the illuminated manuscripts and the repoussé work in precious metals dating from that period[84]. An example of icon painting from the Moldavia area in the closing years of the 16th century, now housed in the Ikonenmuseum in Recklinghausen, is the representative picture of St Demetrius of Salonika. Pl. XV, p. 105 In the sumptuous attire of a logothete, with his hands resting on a richly ornamented staff, he is presented as the ideal warrior and prince. The icons from the Maramuresh region and part of Transylvania are flatter and more rustic and often more sombre in colouring, as far as we can judge today. The close ties connecting the former principalities of present-day Rumania and the region of the Dnieper and the Carpathians, which was Polish until the middle of the 17th century and then came under Russian rule, had some bearing on this. A great number of icons were brought to Rumania by traders from workshops in southern Russia, especially in the 18th and 19th centuries, and were used as models in the local painting villages and monastic workshops for the numerous objects that they themselves produced. Icons of a special kind evolved after Transylvania had been incorporated in the Danube monarchy, painted on the reverse side of glass[85]. These naive and gaily coloured glass pictures were originally painted by peasants in their spare time in winter to decorate houses and churches, but roving merchants carried them all over Rumania and even now they are regarded as impressive examples of popular religious art in the Orthodox world.

Icon painting in the area occupied by the present-day Ukraine, south-western Poland and eastern Slovakia displayed a remarkable degree of continuity until the 17th century. Research into regional schools of painting is still in its infancy. Important centres were apparently situated in the area of Lwów (Lemberg) and Przemyśl and their influence radiated out westwards beyond the Carpathian Mountains. The icons from this area are stylistically related to Novgorod on Lake Ilmen and Pskov and also to Bulgaria. Characteristic features of the early period are rich colouring, dynamic movement of the figures, the use of geometrical or plant ornaments scratched into the gold ground and — just as in Cyprus and Bulgaria — an arrangement of scenes from Pl. 29, p. 106 the life of the particular saint depicted along the two vertical margins and also above the bottom edge of the picture. But the middle compartment is not completely enclosed by the marginal scenes — a trend so popular in Russia. Towards the end of the 17th century there was a greater influx of features from folk art and the influence of western art became stronger. This is evident in the iconographical details and the more natural rendering of persons and scenery. It must be remembered that the Catholic Church was a near neighbour and efforts were being made to form a union with Rome. Even icon frames reflect the growing impact of influences from the West[86].

RUSSIA

There was an interval of about one hundred and fifty years between the establishment of the first Varangian states on Russian territory and the adoption of Christianity, in 988. Although not the first states to be founded, they were the first to achieve any degree of permanency. Of course, Christianity reached the country before Grand Duke ('Great Prince') Vladimir of Kiev, who was later regarded as a Saint 'equal to the apostles', made arrangements to have his people baptised. From old records we learn that the Patriarch of Constantinople, Photius, sent a bishop to the 'Rhos' about 860, but we do not know where he subsequently had his residence. However, even as early as 945, Kiev possessed a church dedicated to the Prophet Elijah, and the Grand Duchess ('Great Princess') Olga, grandmother of St Vladimir, was baptised some time between 955 and 957, while on a visit to Constantinople. The conversion of the Grand Duchess was, however, a purely personal matter and had no political repercussions and no effect on her own family. In fact, her son Svyatoslav remained a pagan. The Russian people were indifferent, or even hostile, to the Christian religion. After being baptised, the Grand Duchess Olga asked the German Emperor Otto I to send a bishop to the Rus of Kiev. The Emperor accordingly arranged for a monk called Adalbert from St Maximin in Trier[1] to be ordained for the purpose, but his stay in Kiev was a brief one (961 to 962). Opposition from the heathens forced him to leave the city. Also, when the Grand Duke Vladimir gave the order for the people of Kiev to be baptised, the Chronicle made the astute and pertinent comment that 'his piety was allied with power'.

We can regard 988 as a landmark in the history of Russia and her civilisation, for that was the year when the Rus of Kiev was joined to the Christian peoples of eastern and south-eastern Europe. The Slavonic script created by the Greek brothers Cyril and Methodius[2], later known as Church Slavonic, and their translation of the New Testament, which was completed about 860, were also responsible for the rapid conversion and instruction of the Russian people, who soon became familiar with the new religion when it was presented in their own language. A golden age was dawning in Russia.

It would be interesting if we could examine the Christian culture of Russia in the light of her pre-Christian heritage, but that cannot be done in the field of painting. Very little of the pre-Christian art of Russia has survived — too little to give us a proper idea of its main characteristics. This applies to architecture and plastic art and, above all, to painting. Occasional meagre references in chronicles from Russia and elsewhere are our only source of information, at least as far as painting is concerned. So we cannot but feel rather doubtful when V. N. Lazarev, who has written excellent articles for the new edition of the *History of Russian Art*, says at the beginning of the chapter on 'Painting and Sculpture of the Kiev Rus'[3] that 'pictorial representation was well known in pagan Russia' and a few lines farther on asserts: 'It is hard

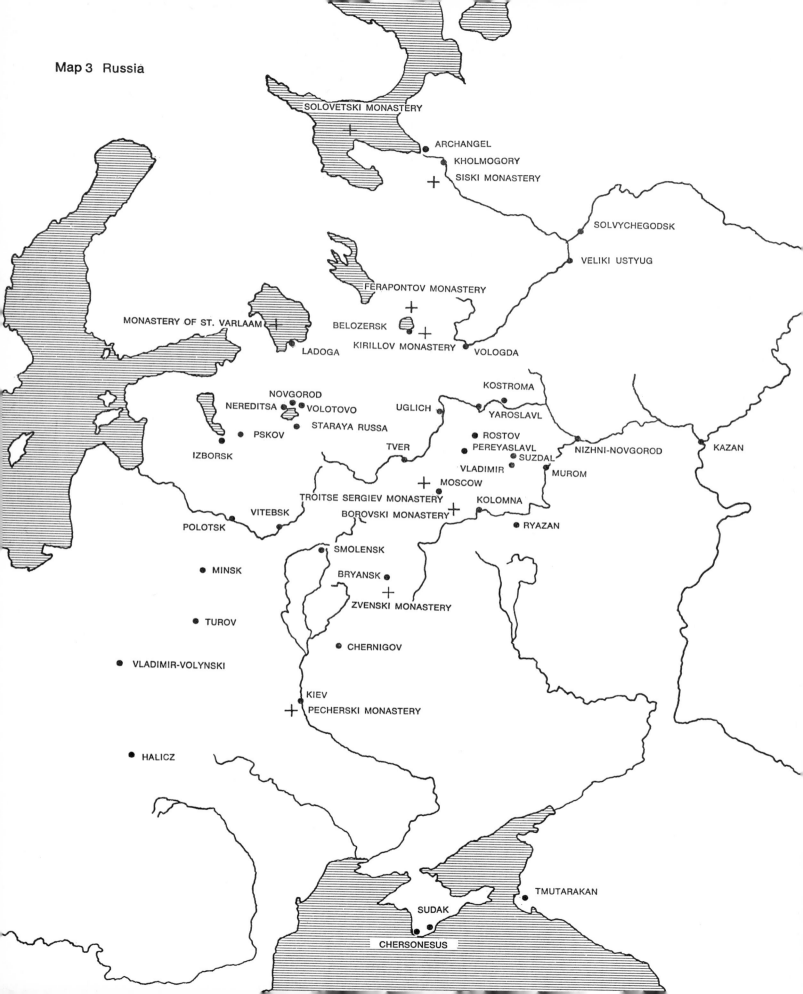

Map 3 Russia

SOLOVETSKI MONASTERY

ARCHANGEL
KHOLMOGORY
SISKI MONASTERY

SOLVYCHEGODSK

VELIKI USTYUG

FERAPONTOV MONASTERY

MONASTERY OF ST. VARLAAM

BELOZERSK
KIRILLOV MONASTERY
VOLOGDA
LADOGA

KOSTROMA

NOVGOROD
NEREDITSA VOLOTOVO UGLICH YAROSLAVL
STARAYA RUSSA ROSTOV
PSKOV TVER PEREYASLAVL
 SUZDAL NIZHNI-NOVGOROD KAZAN
IZBORSK VLADIMIR MUROM
 MOSCOW
TROITSE SERGIEV MONASTERY KOLOMNA
VITEBSK BOROVSKI MONASTERY
POLOTSK RYAZAN

SMOLENSK

MINSK BRYANSK
 ZVENSKI MONASTERY

TUROV

CHERNIGOV

VLADIMIR-VOLYNSKI

KIEV
PECHERSKI MONASTERY

HALICZ

TMUTARAKAN

SUDAK

CHERSONESUS

to say to what extent the old pagan tradition was carried on by Kiev painters who had embraced Christianity, as not a single example of pagan painting has been preserved.'

Although he supplied an interesting piece of evidence in the shape of a quotation stating that people in pagan Russia prayed, and depicted their gods in human form, it is doubtful if these portrayals could be classified as paintings. They would be more likely to have been carved representations — statues of the gods fashioned in wood or stone[4]. We have reliable information that such statues did, in fact, exist, for example in the passage in the Chronicle about the conversion of Kiev, which mentions the statue of the god Perun crashing down into the Dnieper. In view of the complete lack of paintings from pagan Russia and the very meagre documentary evidence, which is open to varying interpretation, we cannot subscribe to Lazarev's assumption that there was a continuous tradition of pre-Christian and Christian painting in Russia: 'Although this pagan painting followed certain well-established practices which must have had an important effect on the subsequent evolution and development of the Kiev School, on the whole it undoubtedly showed a high degree of imperfection.'[5] It is hard to believe that a relatively imperfect form of painting could have had a decisive impact on the Kiev School and so, to some extent, on the whole of Russian art.

So long as we have no real proof of the existence of pagan painting — and there is little hope of new discoveries being made in that field — we must regard it as a completely unknown quantity. It is also quite possible that this art form may not have been very important. In any case early Russian wall paintings and the few surviving icons do not contain any special stylistic features that we might feel tempted to attribute to a heathen painting tradition. But the very absence of any ancient painting tradition (if we reject Lazarev's theory) makes the artistic genius of the Russian people seem all the more fantastic. In an amazingly brief space of time they somehow managed to produce superb original paintings and timeless interpretations of Christian subjects.

Primitive forms of a different kind were probably taken over from the pre-Christian era and introduced into the Christian art of Russia. I am referring here to the great wealth of decorative shapes that we find in ornamental borders and initials on manuscripts and also on the buildings, draperies and weapons depicted in frescoes and icons. The ornamentation remains the same, unaffected by religion or the political situation. We even find it right back in Russia's prehistoric Tripolye civilisation and the basic forms have survived up to the present time. Slavonic or specifically Russian ornaments and certain favourite colours also found their way into the art of Christian Russia.

We are faced with yet another problem when studying the beginnings of icon painting in Russia, and that is the very small number of early Russian icons that have survived. Owing to the ravages of war and, above all, the Tartar invasion of the 1230s, the early examples of Russian pictorial art were destroyed, leaving only a few meagre remnants, and quite a number

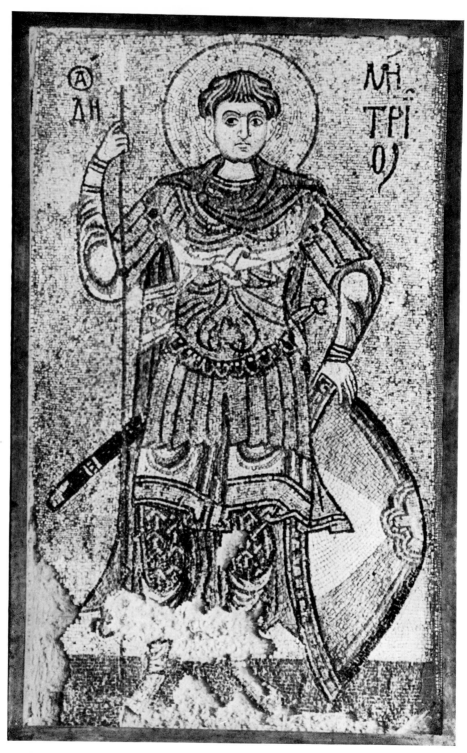

30 Demetrius of Salonika (Wall Mosaic).
 Monastery of St Michael with the Golden Roof, Kiev, late 12th/early 13th century

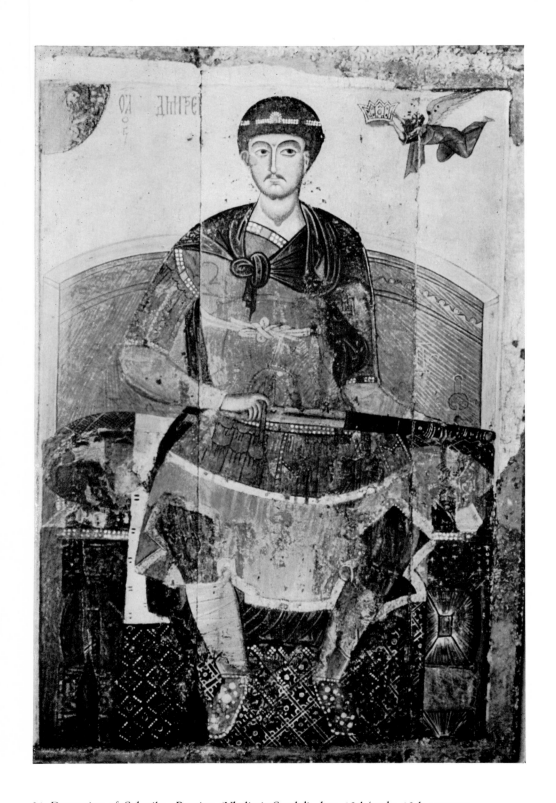

31 Demetrius of Salonika. Russian (Vladimir-Suzdal), late 12th/early 13th century

of these surviving works were lost in the civil war that followed the October Revolution and even more in the Second World War.

So, when examining Russian icon painting, we cannot ignore the early mosaics and frescoes. The actual pictures included in them and the style and technique that were used give us valuable insight into the influences that helped to shape the original Russian paintings. Although the Byzantine influence is predominant, there are also clear connections with the Balkans and occasionally with the Christian kingdoms in the Caucasus.

The Rus of Kiev and their princes were determined to preserve their autonomy and independence vis-à-vis Byzantium and prevent the Metropolitans, usually Greeks, from exerting any influence. This doubtless explains why the Grand Duchess Olga, although she had been baptised in Byzantium, asked the German Emperor to send them a bishop. Under Yaroslav the Wise, St Vladimir's son and successor, a Russian became Metropolitan of Kiev for the first time in the history of the Russian Church. He was called Ilarion. It is worth noting that at the time of his installation they were at war with the Byzantine Empire. Once this disagreement had been settled, no further mention of Ilarion appeared in the Chronicles. He was succeeded by yet another Greek. But Ilarion is credited with a famous oration, a 'Treatise on the Law and Grace'[6], vigorously proclaiming Russia's rejection of Constantinople.

The links with the Balkans were forged in quite another way. Bulgaria had already adopted Christianity in the 860s, so a large amount of Christian literature was available there in translation. Because of the close linguistic connections, the Russian clergy used these Bulgarian manuscripts and had copies made of them. In all probability, the various miniatures and ornaments were often reproduced as well and so became widely known in Russia. There were certainly close connections between Ochrid, the ecclesiastical centre of Bulgaria, and Kiev, although M. D. Priselkov[7] is probably going too far when he suggests that it actually came under Ochrid's jurisdiction.

Holy Mount Athos had already begun to play a significant role for the Rus of Kiev in the 11th century. The legend of Antoni, the founder of the Pecherskaya Lavra (Cave Monastery) of Kiev, is closely connected with Athos. It was on Athos that he was blessed and given instructions for his work in Russia. In the 11th century, Russians acquired the monastery of Xilurgia on Athos, but it was soon unable to cope with the influx of Russian monks. The Byzantine Emperor, Alexius I Comnenus, therefore placed a larger establishment, the Panteleimon Monastery, at the disposal of the Russians. On Athos the Russians entered into close contact with Bulgars and Serbs and became acquainted with many art forms belonging to their Slav relatives. Athos had a special importance for the Slavs, as it served as a bridge between the Orthodox peoples and had an influence on ecclesiastical art which stemmed not so much from its own creations, but in a much more permanent and enduring way from the fact that artists were able to see on Athos a great profusion of icons and frescoes representing a wide variety of periods and styles. Athos also fulfilled that same important function in the centuries to come, when the

Ottoman Empire expanded and all direct links were severed between Russia, the Balkan Slavs and Byzantium.

The problem regarding the immediate prototypes used by the Russian painters, i. e., the non-Russian icons which came to Russia after the people had been converted, is also an important one, and it can be settled fairly satisfactorily. According to an account in the Chronicle, Vladimir brought icons, crosses and other church furniture back from the campaign which he undertook in the Byzantine Crimea before he was baptised. This collection of gifts and booty came from the town of Korssun (Chersonesus), near present-day Sebastopol. They would probably have included Constantinopolitan icons, and others from towns on the Black Sea coast of Asia Minor. The Greek clergy who came to Kiev and Russia to convert the people no doubt brought a large number of icons with them, and still more were sent to the Grand Duke of Kiev and the other Russian princes as gifts from the Emperor or the Byzantine court, as we can see from the various stories and the occasional references to them in the Chronicles. We must also remember that from the 12th century onwards icons were brought back by the many pilgrims who travelled to the Holy Land and in this way Oriental and Syrian models found their way into Russia. So a wide variety of influences were at work in Russia, both as regards style and technique. The paintings and mosaics used to decorate the newly built Russian churches were of particular importance however, and also served as models outside their local area.

After he had returned from the Crimean campaign and the people of Kiev had been baptised, St Vladimir built Kiev's first stone church in 989. This was the Desyatinnaya Church (Church of the Virgin of the Tithe), consecrated in 996. It collapsed in 1240 when Kiev was captured by the Tartars because too many citizens had crowded inside it. When a part of the foundations was uncovered in the second half of the 19th century, remains of mosaics and frescoes were found. The mosaics, forming part of the church floor, contain a linear style of ornament. Of the frescoes, only a small fragment showing a portion of a saint's head has been preserved[8], but this fragment is extremely interesting in that it differs in style and technique from the paintings in the Cathedral of St Sophia in Kiev, which was built only thirty years later.

Nor was the basilica style adopted in the Desyatinnaya Church in keeping with contemporary building trends in the Byzantine capital. In those days it was only used in Eastern areas and the Balkans, especially in Bulgaria. The painting of the fresco fragment also differed from the methods employed in Constantinopolitan art. It is flat, clumsy and archaic with sharply marked shadows. The prominent, wide open eyes are reminiscent of the encaustic icons dating from Early Christian times and the Hellenistic mummy portraits from Faiyum.

The Chronicle reports that Vladimir arranged for builders and artists to come from Byzantium and decorate the church and it also mentions the name of one of the masters, Nastas Korssunian (Anastasius of Chersonesus). But we have every reason to suppose that the builders and painters who worked in the Desyatinnaya Church had their spiritual home in the Balkans. N. P. Sychev's

XVI All Saints. Greek, 16th century

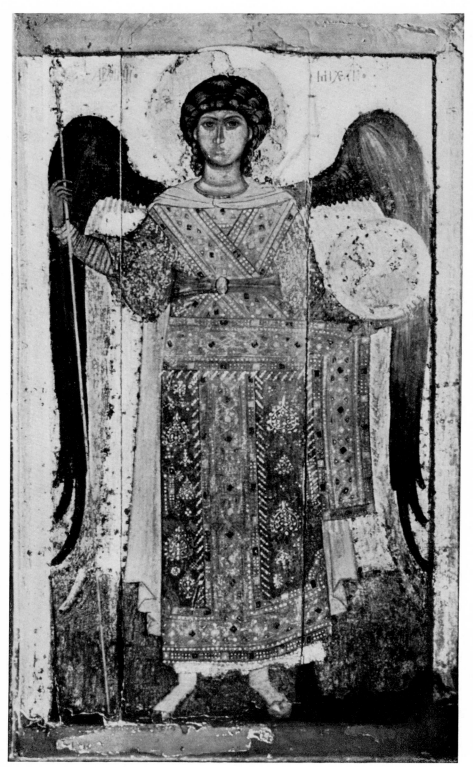

32 The Archangel Michael. Russian (Yaroslavl), late 13th/early 14th century
XVII The Holy Trinity. Russian (Moscow), 15th century

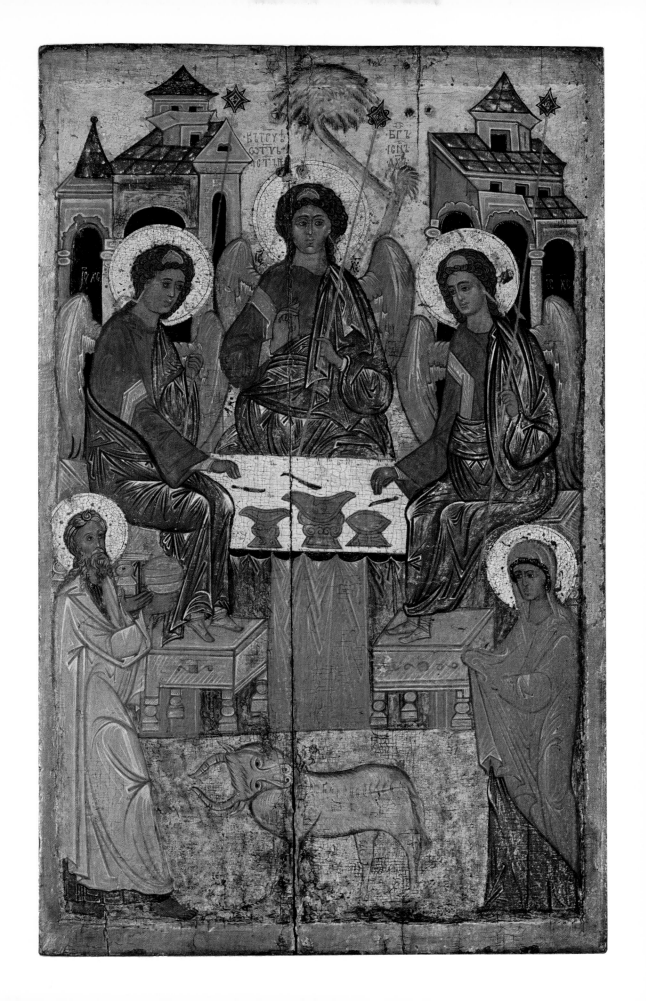

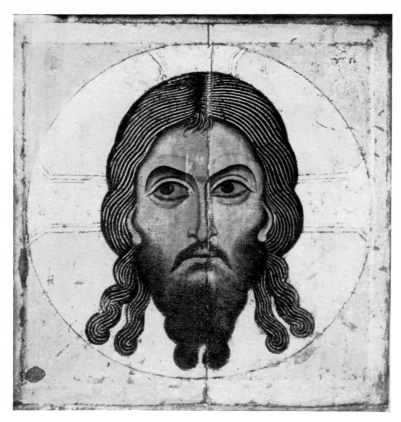

33 The Image of Christ
Not Made by Human Hands.
Russian (Novgorod), 12th/13th century

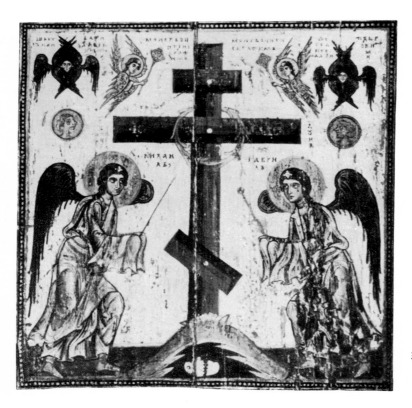

34 The Adoration of the Cross
(reverse of Illust. 33).
Russian (Novgorod), 12th/13th century

theory that the artists employed in that church came from Salonika seems quite a sensible one. Salonika played an important part in the art of the Balkans. It had ties with Ochrid and, through Ochrid, with Kiev, which has on occasion been referred to as the Russian Salonika[9].

The mosaics and frescoes from the Cathedral of St Sophia[10] in Kiev create a completely different impression. That building was probably started in 1017 and was consecrated initially in 1037 and a second time in 1050, after a few structural changes had been made to reinforce the walls. It was Vladimir who actually planned the great cathedral, but his son Yaroslav carried out the work. By this time, the principality of Kiev had become consolidated and was a power known and respected even in the West. Yaroslav aimed at making Kiev a second Constantinople. Not only the Cathedral of St Sophia, but many other monuments built by Yaroslav, for example, the Church of St Irene and the Golden Gate, are named after famous places in Constantinople. The Cathedral of St Sophia was meant to glorify the illumination of pagan Russia by divine wisdom (Sophia). This was the meaning behind the mosaics and frescoes, which were based almost entirely on contemporary Byzantine models as far as the programme of pictures was concerned. But the combined use of mosaics and frescoes was unknown in Constantinople; there the mosaic decoration in the churches came right up to the marble slabs on the walls. The paintings on the towers containing the staircases that led up to the gallery did not merely celebrate the illumination of Russia. They served a profane purpose by illustrating the power of the Grand Duke. Scenes from the Hippodrome in Constantinople were used to decorate these towers — pictures showing circus games of all kinds. The imperial tribune was painted too, with the *basileus* and the *basilissa*. Unfortunately, the frescoes are very badly damaged, so it is no longer possible to identify these exalted personages. But we can assume that they are Byzantine rulers and not the Grand Duke and his consort in imperial attire. The vast programme of paintings and mosaics inside the cathedral would certainly not have been completed at the same time as the actual building, but probably extended into the second half of the 11th century, or perhaps even the early 12th century.

The masters working in the Cathedral of St Sophia were undoubtedly Byzantine. Both the building and the pictorial decoration express a mood of lofty exaltation, dignity and severity, and both are monumental in character. The composition of the whole of the internal decoration follows a definite principle that leaves nothing to chance. The saints are shown in a frontal position in rows, with no suggestion of movement. Firm and definite outlines are drawn round the figures. Their facial features have been accentuated to heighten their spirituality and their robes are draped in an almost Antique manner. The colours in the mosaics are quite enchanting. The robes of the apostles glow against the rich gold background in vivid shades of violet, green and blue. On the large mosaic the praying figure of the Mother, the *'Nerushimaya Stena'* ('Unshakable Wall'), is clothed in a dark violet mantle bordered with gold over a whitish blue robe. The haloes of all the figures are made to stand out by the use of blue, green, red and brownish lines which blend harmoniously into the colour structure of the entire composition.

Unfortunately, all the frescoes are in a poor state of preservation and the repainting in oils done in the 19th century has not been completely removed. V. N. Lazarev refers to these frescoes and mosaics, which do not represent the work of a single master, and his concluding remarks are as follows: 'The frescoes in the Cathedral of St Sophia in Kiev are particularly interesting from the point of view of the history of Russian art because some of them were undoubtedly the work of Russian masters. To carry out this large-scale programme of decoration the Greek masters must have made use of local labour. In this way a school of Russo-Byzantine masters was formed, which with the passing of the years began to acquire a more and more definite and clear-cut character of its own. This would account for the distinctively Russian quality evident in a great number of frescoes, from which a straight line of development can be seen running on to the Neredica paintings. In all these frescoes Russian types have been substituted for the old Greek ones and certain features quite alien to the Byzantine style are now evident. Instead of the rather tense psychological approach peculiar to Byzantium we find the faces being treated in a more natural manner. They have lost their extremely severe expression and the figures have become squatter and more definite. In place of the old Byzantine treatment of colour we find a linear manipulation of form, with amazing skill shown on the graphical side.'[11]

The paintings in the Desyatinnaya Church and the Cathedral of St Sophia are generally referred to as belonging to the 'First Kiev School'. The so-called 'Second Kiev School' is closely connected with the Kiev Cave Monastery and includes the first canonised Russian icon painter known to us by name, Alimpi.

The Kiev Cave Monastery, founded by Antoni (Antonius) and Feodosi (Theodosius), grew rapidly and soon became an important centre of Christian culture in Russia. About a hundred Russian hermits had settled around the Cave of Antoni by 1058. In 1083 construction work began on the main church of the monastery, the Uspenski Church (Church of the Assumption). According to a report in the Kiev Paterikon, Byzantine masters from the Blachernae district of Constantinople were given the task of decorating it. They brought relics with them and also materials and equipment. Unfortunately none of the original painting has survived, but we have descriptions of the pictures included in the decoration programme and these provide indirect proof that the painters were of metropolitan origin.

Chapter 34 of the Paterikon of the Kiev Cave Monastery tells of a certain pious monk. He was not the first icon painter in Russia, but he stands out clearly as an individual because of the legend that has grown up around him. The Chronicle states quite explicitly that Alipy helped the masters from Constantinople to decorate the Uspenski Church and that he learned a great deal from them. After a miracle involving an image of the Mother of God he became a monk. From then on he devoted himself to the painting of icons and the restoration of old pictures. He worked for the sheer love of it and not for the sake of financial gain. His earnings were divided into three parts — one he gave to the poor, the second to his monastery, whilst

the third was used to purchase the materials for his work. It is said that a second miracle was associated with his death. The dying master was unable to complete an icon that he had been commissioned to paint, in spite of all the earnest entreaties of his patron. Then the radiant figure of a young man appeared before him and set to work on the painting. He finished the icon in three hours and disappeared with it that evening. Next morning the picture was found to be in the church, and when the astonished abbot, hearing of the miracle that had occurred, entered Alimpi's cell and asked him how the icon had been painted and by whom, 'he (Alipy) told him what he had seen, namely, that an angel had painted it. "And there he stands and would fain take me with him!" And, so saying, he gave up the ghost.'[12]

The painter's personality must have made a great impression on his contemporaries, judging by this whole legend, and many other Russian painters must have served their apprenticeship with Byzantine or other foreign masters, as he did, and then worked independently in Russia.

Constantinopolitan artists must also have been responsible for decorating the Mikhailovski Monastery (Monastery of St Michael with the Golden Roof) in Kiev. The mosaics in that monastery are also ascribed as a rule to the 'Second Kiev School'. As for the actual church, recent research[13] has shown that it was the cathedral of the Dmitrievski Monastery, built in the middle of the 11th century. When the church was pulled down, parts of the mosaic decoration found their way into the Cathedral of St Sophia in Kiev. A mosaic depicting St Demetrius of Salonika[14] can be seen today in the Tretyakov Gallery in Moscow. These mosaics differ stylistically from the ones in St Sophia because of the greater emphasis on linework. They have more balanced proportions and the figures of the saints are more sharply differentiated. The eyes are no longer abnormally large. Even in the Cathedral of St Sophia their special characteristic was their size. The ornamental pattern of lines gives the figures a sense of rhythm and there are no large expanses of paint — in contrast to the work in the Cathedral of St Sophia. The mosaic decoration used at Daphne would lend itself admirably for comparison, if we wanted to find something similar. The mosaics are tremendously rich in colour, especially in the use of intermediate tones. The harmonious overall effect of these meticulously graduated nuances shows that the artists were in superb control of the entire colour scale. 'The malachite green cloak with its shimmering blue and white band, the blue hose, pink sleeves and grey boots and the bright shield framed in bands of reddish brown — all these colours are combined with great delicacy and sensitivity and lend a special note of solemn dignity to the picture (of St Demetrius) ...'[15]. Unfortunately, very little of the cathedral frescoes has survived. Russian masters probably shared in the work, although Byzantine artists played the leading part. From the remnants preserved, Lazarev feels we can conclude that the ornamentation was of popular origin, which would mean, indirectly, that Russians had been involved in the painting[16].

The mosaics in the Mikhailovski Zlatoverkhi Monastery are the last examples of that art form in Russia. Economic conditions and the splitting up of the territory into small principalities prevented any costly projects from being undertaken, and the lines of communication with

Pl. 30, p. 111

Constantinople, where the materials could be obtained, were cut off almost completely by the Polovtsy nomads. Frescoes took the place of mosaics, and cycles displaying great artistic skill have, in fact, been handed down to us from mediaeval Russia. Was a special 'aesthetic approach on the part of the Kiev painters' [17] responsible for this change from mosaics to wall paintings? That is a question we can — and must — leave open.

The frescoes of the Kirillov Monastery, dating from the end of the 12th century, must be regarded as the first example of monumental painting in Kiev. In the choice of subject they show connections with Serbia — some of the saints were held in special esteem in the Balkans. The paint has been put on with a bold brush, there is uniformity in the figures and architectural settings, with frontal presentation, and great emphasis is placed on the drawing.

Other examples of early Kiev wall painting, including the oldest monuments in the Mikhailovski Church, attached to the Vidubitski Monastery, have not yet been completely exposed and cleaned, so we can only wait for the results of this work. As far as icon painting by the Kiev School is concerned, we unfortunately find ourselves at a loss. Nothing has been preserved from the 11th and 12th centuries and panels like that of St Nicholas from the Cathedral of St Sophia, formerly dated to that early period, have turned out after restoration to be works from a later age. There must certainly have been a great many icons in Russia in those early Christian times[18], but we know nothing about the style of the Kiev painters and have little prospect of ever finding out what it was like.

We can assume that icon painting in Kiev, and in Russia as a whole, must have followed the same general pattern as monumental art. Here too Byzantium supplied the teachers and the original prototypes. Further inspiration would have come from Salonika and the Balkan countries, with which close contacts were maintained. But, although these painters adopted the form and technique used in their models, they very soon adapted them and introduced forms and interpretations of their own, so that the 13th, 14th and 15th centuries became the golden age of Russian icon painting displaying its own distinctive characteristics.

The Mother of God of the 'Pecherskaya' type[19], also known as the Zvensk Mother of God and formerly ascribed to Alipy, dates from the second half of the 13th century. But the picture of the Mother of God Enthroned, with the founders of the Pecherskaya Lavra standing by her side, was probably a copy based on the icon of St Alimpi. The most striking thing about it is the predominantly Greek character of Mary and the Infant. No Byzantine prototypes were available for the figures of the two saints with their highly individual faces. Here we can detect a softer note which may well represent the Russian facet of the picture. The colouring of the panel is dominated by gleaming shades of blue.

But the political situation began to deteriorate for the Kiev Rus, and the state collapsed. Princelings made war on one another and there were raids by nomadic peoples from the steppes. The population was decimated as a result and many of the inhabitants abandoned the fertile land on the fringe of the steppes and moved into the safer country to the north and north-east.

　　　　　　　　　　XVIII Christ's Resurrection (Descent into Hell). Russian (Novgorod?), 14th century

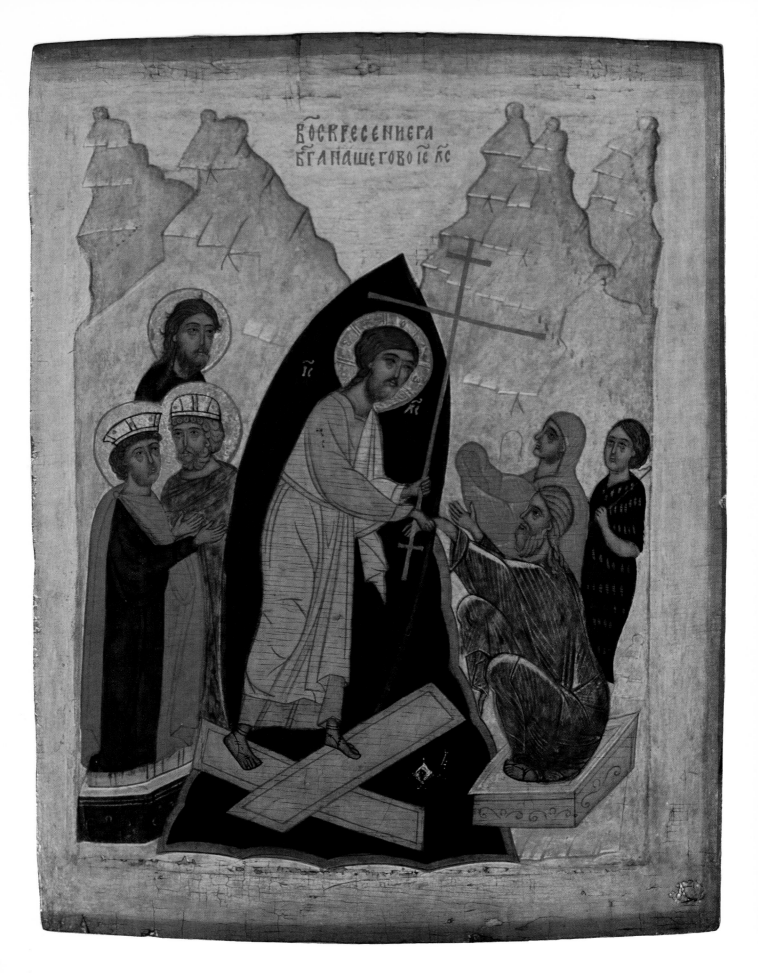

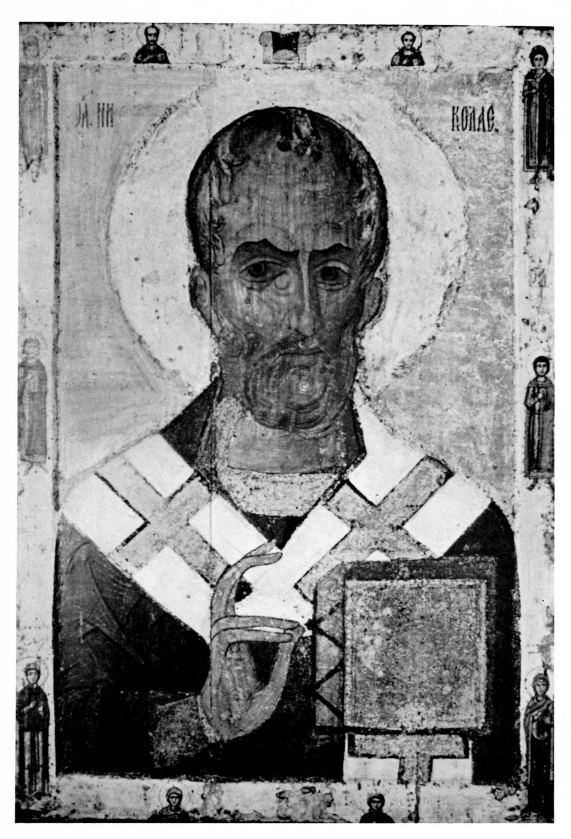

35 Nicholas. Russian (Novgorod), 12th/13th century

Kiev, 'the mother of all the Russian cities', was dwindling in importance and after the middle of the 12th century, when she was destroyed by the Russian princes in the civil war, the centre of power shifted decisively towards the north-east. Russia's new focal point after the decline of Kiev was Vladimir-Suzdal. The Grand Duke now ruled in the north. New and flourishing towns had sprung up in the area, and there one could meet Caucasians and Greeks, and even Germans and Italians. Vsevolod, the brother and successor of Duke Andrei Bogoliubski, whom we have already mentioned in connection with the icon known as the Vladimir Mother of God, had spent his young days in Constantinople and never lost his affection for that great metropolis. So we must look at the painting of Vladimir-Suzdal against that historical background.

The Vladimirskaya, a masterpiece of Byzantine art, had come to Vladimir through the agency of the Grand Duke Andrei Bogoliubski. Another icon, commissioned by the Duke himself after a 'manifestation' of Mary in 1158, and referred to as the 'Bogoliubskaya'[20], is unfortunately very badly damaged. The half-length figures of the Deesis (Christ between Mary and John the Baptist, and Archangels) are painted along the top of the icon. The actual picture shows the Mother of God standing with her arms raised in supplication and a scroll in her hand. She is turning towards the half-length figure of Christ Blessing, painted in the top right-hand corner of the picture. As the icon is in a very poor state of preservation, we cannot determine with any exactitude whether the painter was Byzantine or Russian. The head of the Mother of God is highly reminiscent of the Vladimirskaya and of Byzantine works. On the whole the Byzantine influence remained dominant in art, and under the Duke's successor, Vsevolod, with his strong attachment to Constantinople, this influence grew still further. So Byzantine masters were commissioned to paint the frescoes in the Cathedral of St Demetrius. Those in the Church of SS. Boris and Gleb at Kideksh and in the diakonikon of the cathedral in Suzdal, which were uncovered after the Second World War and have only been reproduced in part, may, when work on them has been completed, make a further contribution to our artistic knowledge of the area.

A few icons give us a more detailed insight into icon painting in Vladimir-Suzdal than would have been possible only a decade or two ago. The 'Deesis' group[21] transferred from Vladimir to the Uspenski Cathedral in Moscow must be regarded as the oldest monument. A youthful Christ Emmanuel is portrayed here between two angels who are turning towards Him. The icon reveals only the head and the top of the shoulders of these figures and is unusual in shape. The board on which it is painted is broad and not very high and was perhaps used to decorate an altar screen, an early version of the later Russian iconostasis. The angels' faces have the same expression of gentle melancholy as we see on the Vladimirskaya. Comparison with angels portrayed in the Cathedral of St Demetrius has led Lazarev to date this icon to the end of the 12th century. Another Deesis, also from the Uspenski Cathedral in Moscow, shows Christ between the Mother of God and John the Baptist and has the same layout, but it is quite different in style. The figures are less soulful and there is less skill in the brushwork. This icon has been dated to

the beginning of the 13th century and, with reservations, has also been attributed to the School of Vladimir-Suzdal.

This last Deesis, especially the head of Christ, shows a certain similarity to the Demetrius figure on an icon from the Cathedral of Dmitrov as far as the method of painting is concerned. Pl. 31, p. 112 This panel has suffered damage too. It is of electrum[22] and the expression of solemn majesty on the face of the saint is accentuated by the heavy symmetrical lines used to draw the eyes, nose, beard and mouth. The upright posture of the warrior sitting on a throne with his drawn sword laid over his knees underlines the fearless character of the martyr. During restoration, a symbol revealing that it had been the property of the Grand Duke Vsevolod was found on the back of the throne, so it must date from the end of the 12th or beginning of the 13th century. Rather confusing attempts at repainting in the 16th century have distorted the general appearance of the icon. Another icon of the Mother and Child, exhibited in the Vladimir Museum and showing the Metropolitan Maxim kneeling at the feet of the Mother of God, is also connected with Vladimir and probably dates back to the 13th century. Unfortunately, this too is a mere fragment, but the few surviving remains of the Mother's head are thought to be reminiscent of the Ustiug Annunciation and are extremely beautiful[23].

The well-known doors of Suzdal Cathedral with their engravings (1230—1233) are also interesting examples of 13th-century Russian art. They provide us with information about some unusual iconographical subjects which have not survived from that early period in other places, and they also present a pleasing combination of ornament and drawing in the composition. Linear form dominates the work, and this encourages the strong tendency towards ornamentation that we find expressed again and again in the art of Vladimir-Suzdal in a great many reliefs and miniatures and also in the icons.

As the Russian provinces became further split up (Vladimir-Suzdal suffered with the rest), a number of local schools also made a name for themselves. They gave a freer interpretation of the formal standards borrowed from Byzantium, and there was a strong flavour of popular art and an air of freshness that made their work come curiously alive. The first of these local centres was Yaroslavl, which had its golden age in the 13th century. From 1218 it was the headquarters of an independent principality in which a great many churches were built in the first quarter of the 13th century. All this building activity naturally had a stimulating effect on painting, because the new churches had to be decorated. An example of Yaroslavl painting is the icon of 'Our Lady of the Sign'[24] (Znamenie) from Yaroslavl, a standing figure of Mary with the Christ Child floating in an aureole in front of her breast. An archangel has been painted in each of the top corners of the picture. As it came from the Monastery of the Transfiguration of Christ (Spaso Preobrazhenski Monastery), its date of origin has been fixed as the beginning of the first quarter of the 13th century. Mary is standing in the Orans posture on a purple cushion against a gold background. The symmetrical composition emphatically conveys the impression that this was a devotional icon. The monumental character of the icon is also reflected in the way in which

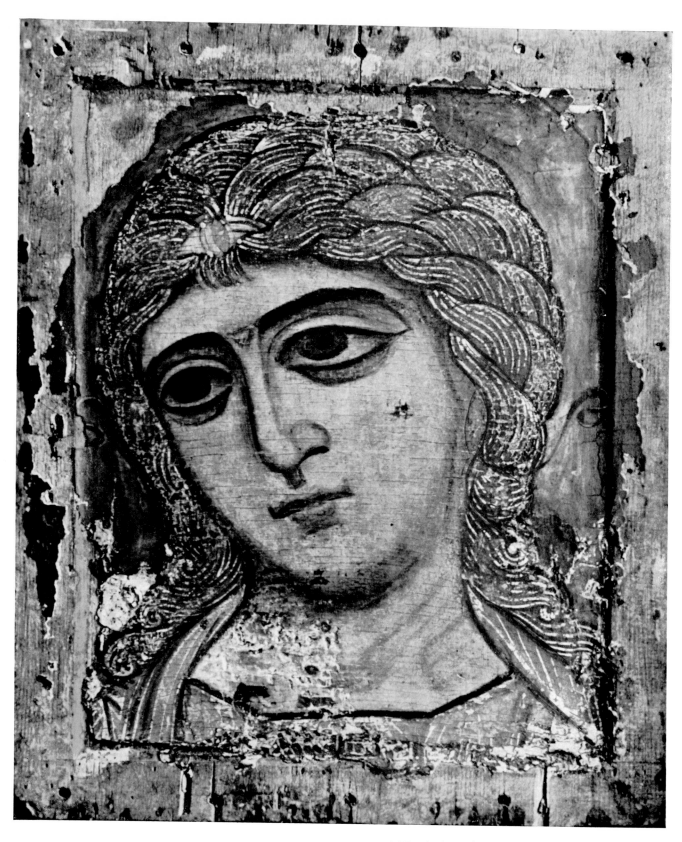

36 The Archangel Gabriel. Russian, 12th/13th century

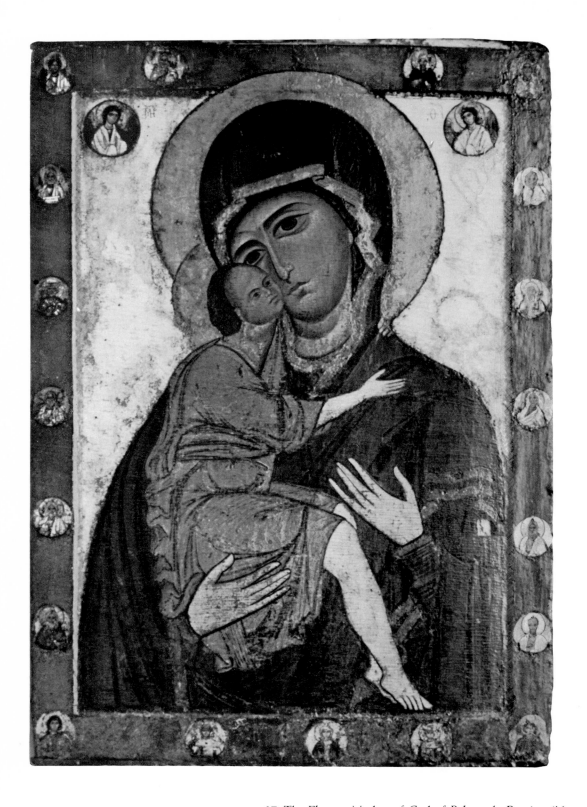

37 The Eleousa Mother of God of Belozersk. Russian (Novgorod), mid-13th century

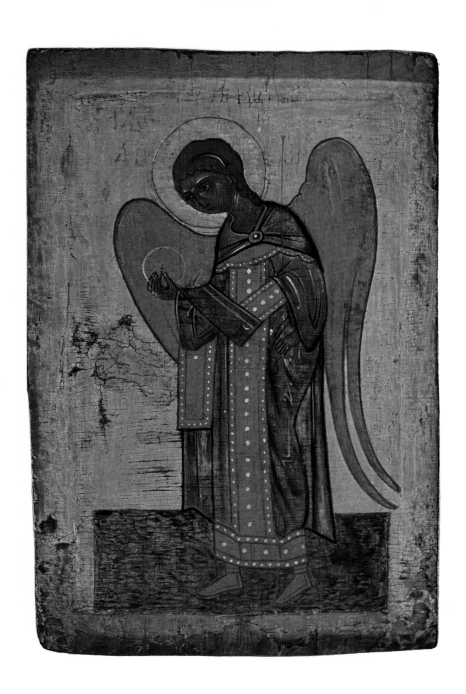

XIX The Archangel Gabriel. Russian (Novgorod), late 14th century

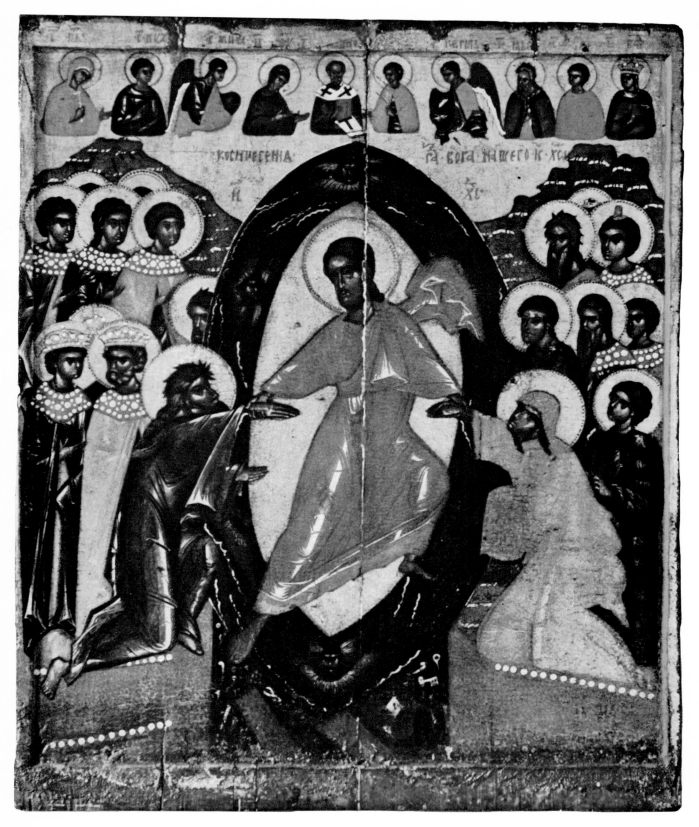

38 Christ's Resurrection (Descent into Hell). Russian (Pskov), 14th century

it was painted. We no longer find delicate little gold lines on the draperies, but flat gold strips are used instead to break up the blue robe. The draperies are richly adorned with dots and circles, which clearly shows that the love of ornament was still very much alive in Yaroslavl. We are struck by a minor iconographical peculiarity. The Child's arms, which are stretched out sideways as if giving a blessing, extend beyond the edge of the aureole. Gay colours are the keynote of this panel — blue, red and white, combined with gold.

An icon attributed by Ainalov[25] to the Novgorod School also shows a link with the Yaroslavl School of painting. The ornamentation is almost exactly the same as on the Yaroslavl Znamenie and also includes pearl borders and circular patterns. This icon portrays 'The Redeemer with the Golden Hair'. There are also similarities in the vivid and almost harsh colour scale. 'The blue ground gives way to a white edging framed in red ... The Cross is green with a gold frame running round it and red outlines. The golden hair is interspersed with fine brown lines. The chiton is in a delicate cherry red showing different gradations of colour and with white accents marked on the folds and angles. The mantle is dark blue, indeed almost black, with expanses of blue coming in between.'[26]

Pl. 32, p. 116 Among the other monuments of the Yaroslavl School, we might mention an icon of the Archangel Michael. It belongs to the end of the 13th or beginning of the 14th century. The full-length figure of the archangel is in a frontal position and his red robe is richly decorated with gold ornaments. The dreamy face in a greenish tone with red applied to the cheeks shows a relaxation of the old painting standards and this, together with the curiously bright colouring, suggests that it was produced in the Yaroslavl workshop.

Two other icons belong to the Yaroslavl group of paintings — the pair of Tolgo icons portraying the Mother of God (Tolgskaya I and Tolgskaya II). The difference between them is that the Tolgskaya I[27] shows a full-length figure of the Mother of God Enthroned, whereas the Tolgskaya II[28] really presents only part of a figure — in fact, a half-length version. They come from the Tolgski Monastery near Yaroslavl and are both Holy Mothers of the Eleousa type (Umilenie). The intensity of feeling is greatly heightened in these panels and their colouring is confined to sombre tones which form a delicate harmony against the leaden background, intended to represent silver. The ornaments and the throne, which is mounted on a pedestal, have been painted in the same colour as the ground. The sharp white lights make the facial features stand out in relief. In the Tolgskaya II we find the same colouring and the same leaden-tinted silver background. But the lighting of the faces has been done in a completely different way. In the Tolgskaya I the touches of white have been applied as sharp and definite lines, but in the second icon they are flatter and lighter and have been applied in a more painterly fashion.

Examination of other Yaroslavl icons, for example, a Mother of God of the Feodorovskaya type, confirms the love of ornament and shows another characteristic that we see in an icon with scenes from the life of St Nicholas (from Bolshie Soli) belonging to the 14th century: the realistic touches present in the small subsidiary scenes, which are crammed with action. When

Vladimir lost her privileged position and Moscow came into the forefront as the leading Russian principality, there was a transfer of artistic traditions from Vladimir to Moscow and we find it difficult to differentiate between early Moscow painting and the final stages of painting in Suzdal. Two icons belong to this transitional period. One of them shows the Archangel Michael with the kneeling figure of Jesus Navin at his feet[29]. This second figure has also been referred to as Joshua[30]. The colouring is sombre and there is strong vertical emphasis in the proportioning of the figure. The armour and draperies have a profusion of gold lines, and gold is also used for the ornaments on the archangel's clothing. This icon is similar in colouring and ornamentation to a picture of Boris and Gleb[31], also dated to the beginning of the 14th century. The two sons of St Vladimir are standing facing the viewer in a frontal position with martyrs' crosses and swords in their hands. They are dressed in national costume with heavily ornamented caftans and cloaks. There is a solemn and almost sad look on their faces. The icon is extremely beautiful from the point of view of colour. The figures of the two princes stand out sharply against the gold background. The colours used for the saints' caftans and cloaks have been reversed, which is a fairly regular practice among the angels in Deesis groups. Boris has a gold ornament on his cloak and Gleb a silver one.

A general appraisal of the icons painted in Vladimir-Suzdal and Yaroslavl that we have discussed here shows that the Byzantine element is very evident in the early monuments, and we can only attribute the works provisionally to individual schools of painting on the basis of certain minor distinguishing features. Byzantium and the East and also the West made their influence felt at the court of Vladimir and eminent dukes, for example, Vsevolod, nicknamed 'The Big Nest', had been educated in Constantinople and never lost their profound respect for that city. So it would not have been unusual to find Byzantine masters working in the Vladimir area. Icons like that of Demetrius (from the Dmitrov Cathedral) reveal a very close connection with contemporary Byzantine art and the same applies to the Tolgo icons of the Mother of God. The part played by Russian artists in creating the various pictures that have survived is therefore very difficult to assess, although the icons in the Yaroslavl group have certain things in common. But we must remember that between the middle of the 13th and the middle of the 14th century, in the transition period when painting passed from Vladimir to Moscow, the style was aristocratic, compared with that used in Novgorod. We see lavish and artistic ornamentation and exquisite colours, and the faces of the saints are not stiff and rigid, but are imbued with human feeling.

Two icons from the Hann Collection are, according to the Catalogue[32], to be ascribed to that period. They are a picture of the Trinity and one showing the Adoration of the True Cross, in reality an 'All Saints' icon. The latter, described as a 14th-century work, Byzantine or belonging to the early Vladimir-Suzdal School, in the Korssun style, is attractive because of its vivid colour scheme, with strong shades of red and blue encased in a gold background. Under the actual picture a wall can be seen running along the bottom with bushes and half-length figures of saints,

Pl. XVII, p. 116

Pl. XVI, p. 115

XX George, Clement and Menas. Russian (Novgorod), late 14th century

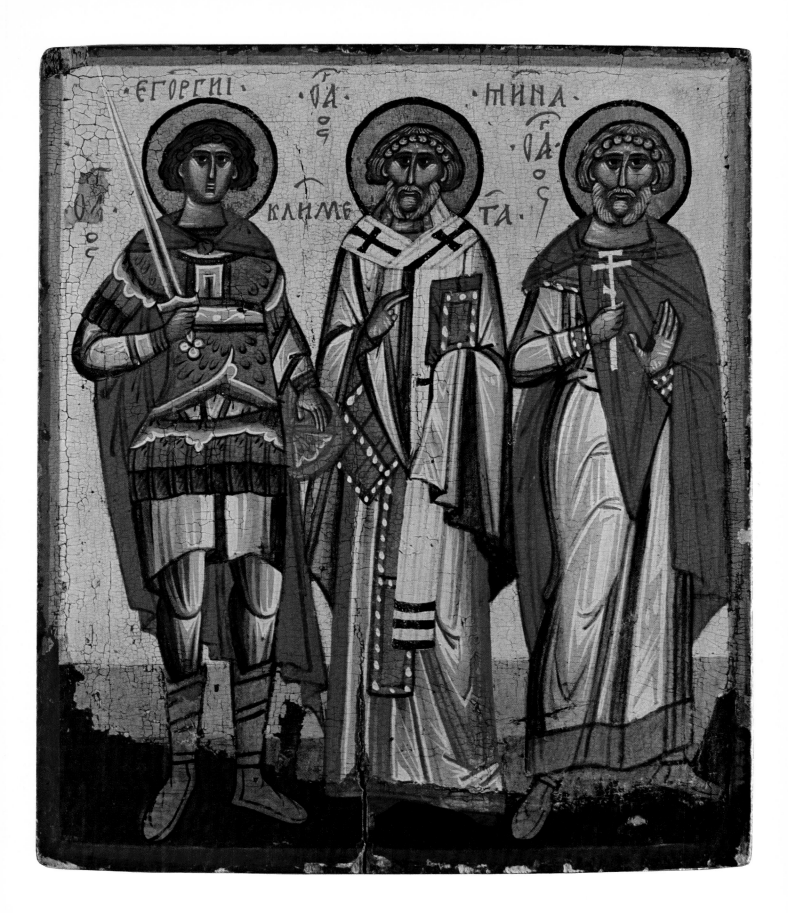

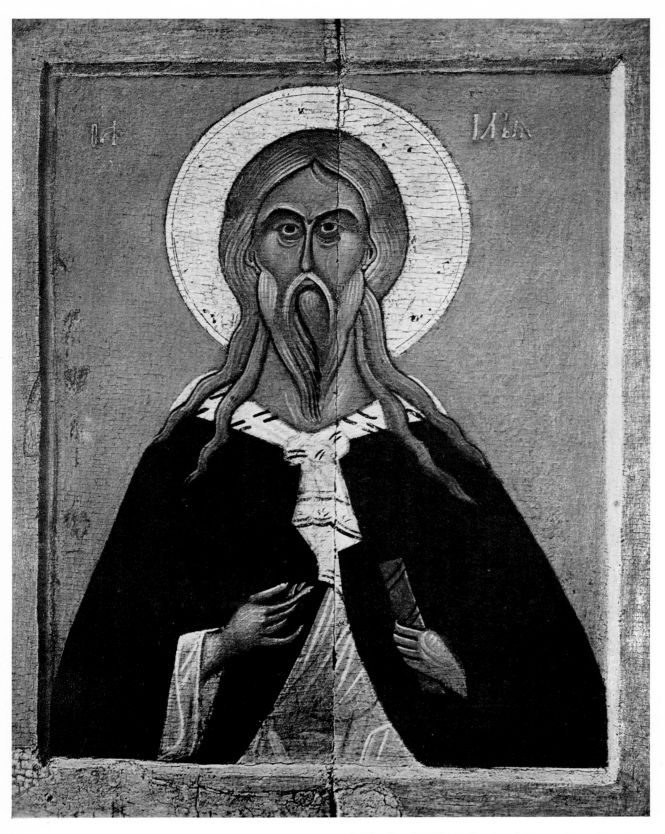

39 The Prophet Elijah. Russian (Novgorod), 15th century
XXI Demetrius of Salonika (detail). Russian (Novgorod), 15th century

40 St George and the Dragon. Russian (Novgorod), late 14th century

the middle one representing a Mother of God with the Child. A cherub guards the entrance to this idyllic garden. A frieze containing peacocks and other birds and plants, with a fountain in the middle, is also situated under the main picture in an icon depicting the Nativity of Mary, reproduced by Kjellin[33]. This icon has been attributed to Novgorod and dated to the end of the 15th or beginning of the 16th century. Of course, the frieze here is purely decorative, whereas the idyllic garden scene is related to the subject of the main picture. Among the special characteristics of Suzdal painting that we see in this particular icon, we can include the colouring, the profusion of devices used to break up the draperies, and the gold decoration on the platform and the throne of the apostles at the top of the picture, which is linear rather than ornamental. The feeling of life and movement among the apostles reminds us of frescoes in the Cathedral of St Demetrius in Vladimir, but the complex pictorial effect produced by this whole icon is quite unequalled anywhere in Russia. A trace of an omikron with an aspirate (*spiritus asper*) has survived from the inscription[34], but this does not mean that the icon was necessarily of Greek origin, any more than one can conclude that an early icon bearing a Russian inscription must have been the work of a Russian painter. The lively presentation of the groups of saints with all their varied gestures, the animated line of apostles and angels, painted quite freely and not in a rigid frontal pose, the mood of restlessness created in the icon as a result, although this is toned down to some extent by the compact grouping, and, last but not least, the frieze at the bottom of the picture reveal that the panel must have come strongly under the influence of post-Byzantine painting. We can therefore say that it was probably made in Greece sometime in the 16th century.

Pl. XVII, p. 117 The other icon from the Hann Collection, portraying the Trinity, is also described as being in the Moscow, or possibly the Vladimir-Suzdal, style and has been dated to the 14th century. It is very similar to 15th-century Moscow icons in the linear drawing of folds, the sparing use of highlights and the tall, slender shape of the figures. It must therefore belong to the end of that century — not to the 14th century.

Novgorod had a happier history than any of the other Russian dukedoms. The Tartar onslaught passed it by and the whole area escaped the ravages and devastation of war and plundering expeditions. We therefore have an excellent opportunity of studying the gradual evolution of Russian art in Novgorod, up to the time when Ivan IV caused the final downfall of that once flourishing city. At some unspecified point in history the Rus of Kiev managed to consolidate their position and a dazzling centre of Russian life and culture was established in their midst. War brought both success and failure, then they had to contend with mounting pressure from the nomads of the steppes and in the end the area was torn by dissensions among the minor princes and finally laid low by the Tartars. That was when Novgorod developed into a flourishing centre of commerce and also came to occupy a rather unique position in Russia because of her type of government. Novgorod was a principality of a very special kind and was referred to as Great Novgorod because of her vast possessions in the north and north-east of Russia. She did

not allow unpopular rulers to remain in power, but forced them to relinquish their high position and appointed more acceptable overlords in their place. In Novgorod, unlike other parts of Russia, the municipal population always played an important role and their representatives met regularly in the *vyeche*, a kind of municipal assembly, to discuss and resolve the problems of their city-state. As a result, the citizens had a more stable position here than under the feudal conditions in the other Russian principalities, and they managed to retain that position and have a more lasting impact than elsewhere. So art was influenced by two sets of patrons — the Grand Dukes and the Church on the one hand and the proud citizens on the other.

Nor should we overlook the fact that Novgorod is situated in the north-west of Russia and because of her trade was able to keep in closer and more permanent contact with western Europe than any other Russian principality. These trading connections brought Novgorod into the Hanseatic League and opened the door to the whole world. Because of the trading houses of the German merchants and their continual contacts with the people of Novgorod, the principality gained a far greater knowledge and awareness of the lands beyond her frontiers. So it is in Novgorod, above all, that we detect an influx of Western motifs and Western characteristics. They never became dominant, but provided ideas and inspiration and, like everything alien or exotic, were rapidly assimilated.

As in Kiev, painting in Novgorod began in the 11th century. Close links existed at that time with Kiev, so it is possible that masters from Kiev worked in Novgorod, although this was not necessarily the case. There are supposed to be architectural connections between Novgorod and Kiev, but there is generally another explanation for these. Both cities were linked up to the same central point, Constantinople. She provided the architects who directed building operations in Kiev and also in the other Russian cities until an adequate number of Russian architects were available. There is no proof that the masters who taught the Novgorod painters came from Kiev[35]. In fact, there is little support for the idea that painters from Kiev worked as teachers in Novgorod in the 11th century, as they themselves were still mostly learners and the very few who had completely mastered their art could not possibly have spread their influence over the whole vast land of Russia. In any case, there was plenty of work to do in the Kiev area and this would have taken up all their energy. So it is quite clear that the masters who painted St Sophia in Novgorod must have been called in from Constantinople, although our written evidence of this fact only comes in a late version of the Chronicle. The very minor differences between the Kievan and the Byzantine masters, often affecting the content of the picture, are regarded as peculiarities of the fresco painters of Kiev. But these discrepancies did not, on the whole, signify any real departure from the Byzantine form of painting, and they make us rather chary about attributing the earliest Novgorod frescoes to Kiev.

It is possible that, in addition to the Byzantine painters, there were perhaps even Western painters working in Novgorod, judging by the frescoes in the Church of the Nativity of Mary in the Antoniev Monastery, which remind us to some extent of Romanesque frescoes. Antonios,

XXII Royal Door from an Iconostasis. Russian (Novgorod), late 15th century

41 Three Bishops. Russian (Novgorod), late 15th century
XXIII The Annunciation. Russian (Novgorod), 15th century

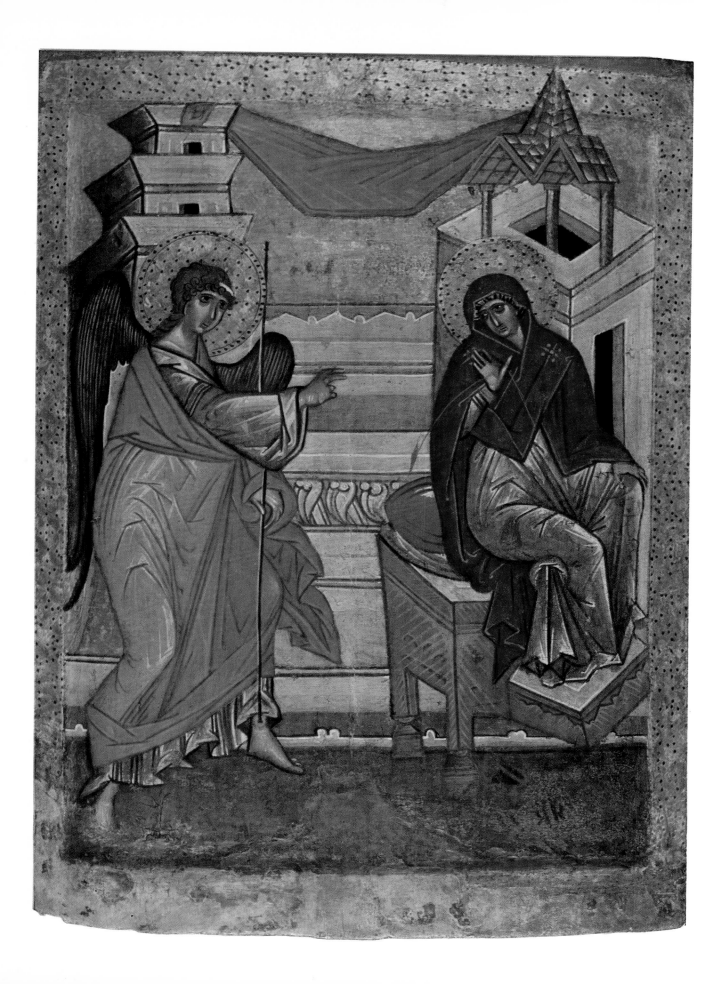

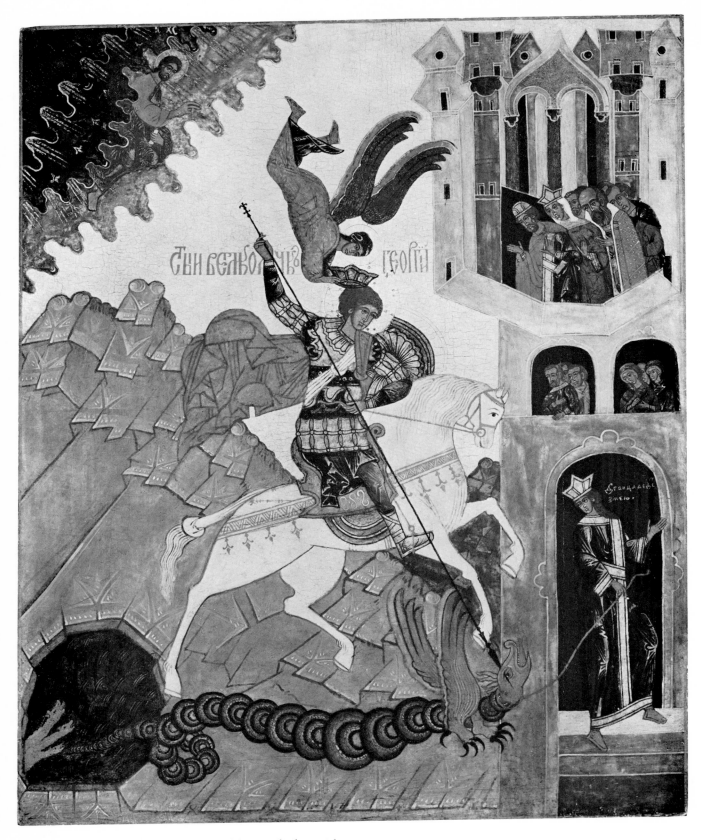

42 St. George and the Dragon. Russian (Novgorod), late 15th century

nicknamed 'the Roman' (*Rimlyanin*) had not mastered the Russian language when he arrived in Russia, and Western works of art, including enamels from Limoges, arrived there with him. A commercial city like Novgorod, whose doors were open to the whole world, received artistic ideas and inspiration from many different quarters and no doubt made use of them.

These are some of the reasons why the wall paintings in Novgorod from the early 12th century show no uniformity of style. In fact, it would have been amazing if they had. Nor is there any consistent style evident in later wall paintings. The frescoes uncovered at the end of the forties in the village of Arkazhi, inside the Church of the Annunciation (dating from 1189), were executed in a vigorous manner and the highlights were applied as sharp accents, sometimes in a stylised form — a procedure that was apparently very popular with fresco painters in Novgorod and made the faces more expressive. There are similarities between the Arkazhi frescoes and those in the Church of St George at Staraya Ladoga[36], so they have also been dated to the 1180s. The frescoes in the Church of St George are more uniform in style and are lightly painted, and the contours of the figures are clearly defined. The vivid palette used is reminiscent of folk art.

Both fresco cycles show a connection with the famous paintings in the Church of the Redeemer at Nereditsa (1199), whose destruction in the Second World War represents an irreparable loss. The art of Nereditsa is severe in character, with its main emphasis on the next world[37]. A solemn sense of rhythm pervades the compositions running along the walls. The heavy figures with their large heads add to the monumental effect and the mood of lofty solemnity. Green shadows contrast effectively with white highlights and at the same time add their own special values to the bright colour scale. The Nereditsa cycle was executed by several artists, each one with a particular style of his own. In spite of this, the overall effect is consistent, showing a painterly rather than a graphical approach. Links with the Caucasus can be observed in the iconographical details, as in the portrayal of saints who were specially venerated in the Caucasus (Rhipsime and [?] Nina). This is quite possible when we consider the family ties of the Duke of Novgorod. There are also a few western European touches, which can be accounted for by Novgorod's close trading contacts with that area. But the dominant influence is that of Constantinople, although quite a number of the compositions are peculiarly Russian in character and give us a foretaste of the great era of independent painting that was about to begin in Novgorod.

The first icons from Novgorod appear at the end of the 12th and the beginning of the 13th century. The earliest and most important example is an icon showing an image of Christ reputedly

Pl. 33, p. 118

not created by any human hand ('*Spas nerukotvorni*'). The theory that it was made in Novgorod is corroborated by the palaeographical characteristics of the inscription on the reverse side of the icon, showing the Adoration of the Cross; also by the close stylistic similarity between the

Pl. 34, p. 118

angels in that picture and the frescoes on the dome of the Church of the Redeemer at Nereditsa and the rough copy of the picture appearing in a manuscript from the year 1262, where the two sides of the icon are combined and the angels can be seen approaching the image of the Redeemer. Subdued colouring has been used for the face of Christ, with fine white lines to

indicate the hair. The whole painting breathes an air of solemnity and a note of mild severity is added by the large and deeply accentuated eyes. The back of the icon, showing the Adoration of the Cross, is in a darker key and has been painted in a vigorous and less restrained manner. The two sides of the icon are the work of different masters. The artist responsible for the obverse side was still strongly influenced by Byzantine models, but the other remained independent and unattached. The Adoration of the Cross is based iconographically on an old Palestinian proto-type, allowing a certain degree of freedom in the interpretation[38].

The well-known and frequently illustrated 'Ustyug Annunciation'[39] is quite similar in style to this icon. It originates from Novgorod, coming either from Ustyug, from which it derives its name, or from the Monastery of St George, which would seem very likely according to other sources of information. We shall not deal with the interesting iconographical details here, but must strongly underline the fact that this icon is one of the most outstanding artistic works from Novgorod, achieving supreme subtlety both in the actual painting and in its intellectual content. The dark colouring obtained with yellow, blue and cherry red is combined with the gold of the ground to create a restrained type of harmony, with which the silver nimbus of Christ is in perfect accord.

An angel's head from a small icon, presumably belonging to a Deesis group, is very similar to the head of Gabriel in the Annunciation. The hair, which is stranded with threads of gold, is painted in the same way as in the Ustiug Annunciation and the Head of Christ, but this face is imbued with a much deeper spiritual quality. The gentle, melancholy eyes, the delicately curved nose and the fine mouth give the angel a curiously wistful look of happiness. This angel icon also comes within the transitional period between the 12th and the 13th century. Some of its features belong unmistakably to Novgorod in spite of all the evident connections with Middle Byzantine painting.

Pl. 36, p. 127

Written sources quite definitely confirm the very real links with Byzantium. They also inform us that a Greek called Petrovich was painting in Novgorod in 1196. These three icons with their pleasing combination of Byzantine and Russian characteristics should perhaps be attributed to his workshop.

A number of icons from the 13th century give us a fairly exact picture of the evolution of painting in Novgorod. These icons include one of St Nicholas with subsidiary figures of other saints placed round the edge. The painter has exaggerated the height of the saint's forehead and given him an elongated face, so conveying a mood of lofty spirituality. This picture does not portray Nicholas the kindly helper, but Nicholas the theologian, a thoughtful man brooding on distant things. The subdued colouring is in keeping with this mood. The reddish brown draperies, brightened with silver lines, are painted against a silvery background. The face is yellowish with a hint of olive green and the wrinkles are marked in a reddish brown colour. The figures set along the edges are in strong contrast to the main part of the picture and stand out

Pl. 34, p. 126

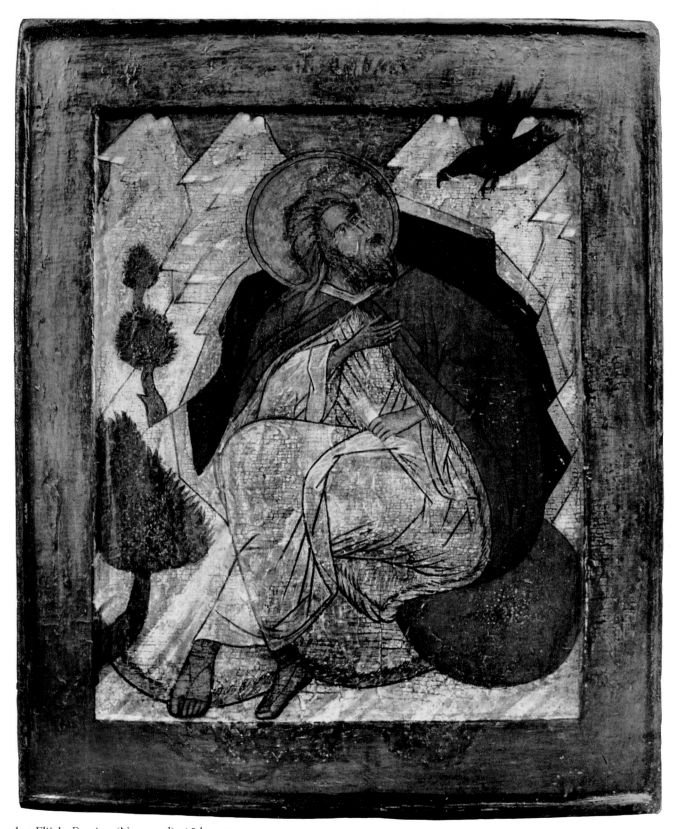

43 The Prophet Elijah. Russian (Novgorod), 15th century

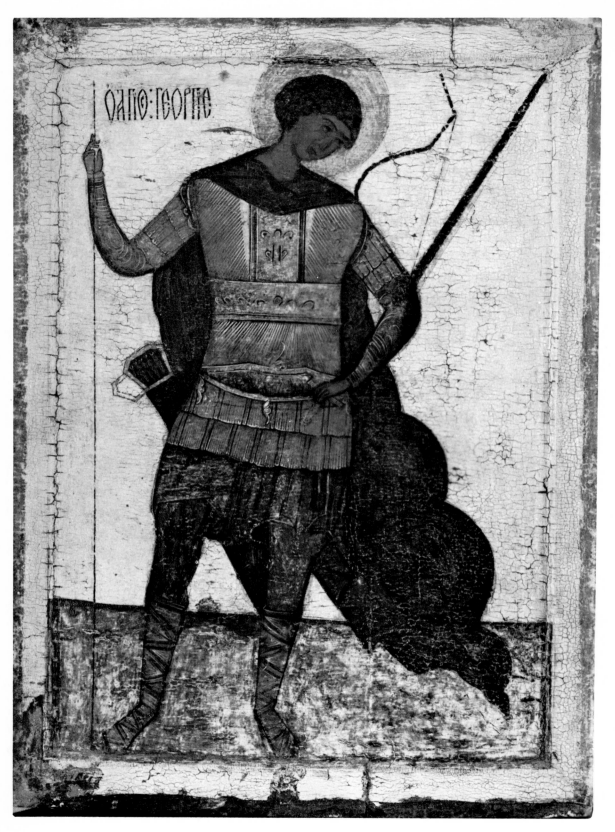

44 The Martyr George. Russian (Novgorod), 15th century

XXIV Nicholas Appearing to Mariners in Distress (detail). Russian (Novgorod), 15th century

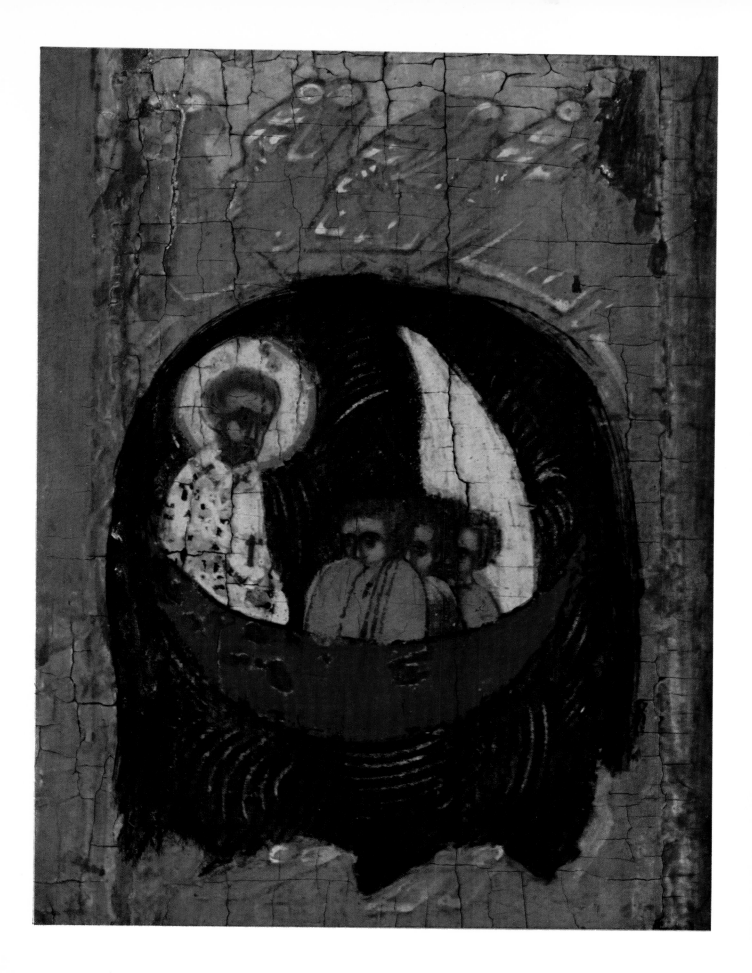

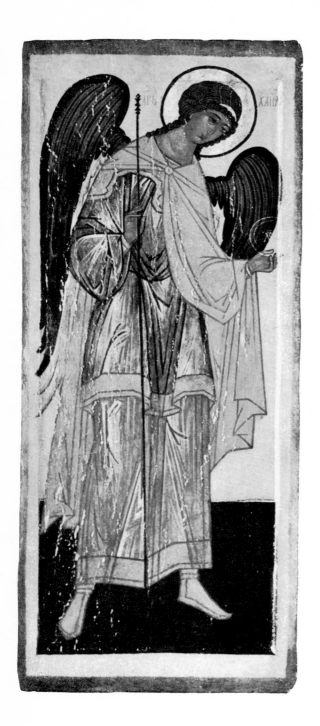

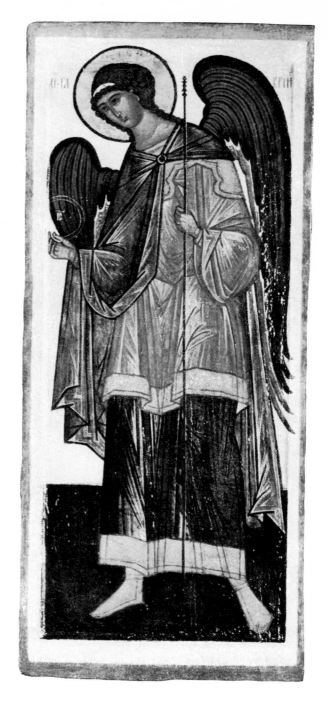

45 The Archangel Michael.
 Russian (Novgorod), late 15th century

46 The Archangel Gabriel.
 Russian (Novgorod), late 15th century

harshly against a white background. The special thing we notice about the saints, including Boris and Gleb, and the draperies, is the use of rich, gleaming colours.

This fondness for colour effects can be regarded as a special feature of the work from Novgorod. Colour still remained the dominant characteristic in the years to come, when this school had reached its peak of achievement, and makes the icons of Novgorod quite unmistakable. In addition to this emphasis on the painterly, or pictorial, side of the work, we find that the saints are losing their rather severe expression. There was already a hint of this in the icons produced at the turn of the 12th century with their warm undertones of tender feeling and humanity. We now repeatedly find a gleaming red ground. The colour scheme is becoming purer and brighter, the types more realistic and the composition simpler. The use of subtle nuances and of light and shadow is declining. Brilliant cinnabar, rich emerald green, harsh white and crude yellows have become the popular colours. How lucky it is for us that Novgorod at least was spared from the Tartar hordes and we are able to study the progressive development of Russian icon painting at an important centre. Icon painting in Vladimir-Suzdal was still completely overshadowed by monumental art. What the large cathedrals mainly required was not icons, but an impressive mural decoration in keeping with their vast size. In all probability, just when icon painting was gaining in importance in these eastern territories because of the many smaller churches being built, new attempts to carry on the old traditions were cut short by the Tartar onslaught and the long period of oppression, by the depopulation and general impoverishment of the region and the recurring threat of raids by the nomadic hordes. But Novgorod gives us a complete and continuous panorama of painting and makes us sincerely lament the absence of all the works that could not be painted or were lost because of the ordeals that the rest of Russia had to undergo at that time. The special status enjoyed by Novgorod because of her favourable position also extended to the provincial areas, but we are not completely certain about the works of art produced in those areas. From one of these centres, Belozersk, comes the icon of the Belozersk

Pl. 37, p. 128 Mother of God. It belongs to the Eleousa type and so is a Mother of God of Pity, revealing the tender humanity that was to become such a characteristic quality of Russian icons. Red haloes on a white ground, a blue frame with pictures of the prophets and medallions of the two archangels set against a background of pink and light blue — here in short, we find a gay, bright colour scale and something of the simple charm of folk art. This icon would belong to the mid-13th century.

In the 14th century the special features and peculiarities of Novgorod began to assert themselves even more strongly and the icons painted then looked completely typical of their area. This is basically true also of 15th-century work. The iconographical prototypes were really coming to life. There was a strong suggestion of this in the Belozerskaya icon and this trend continued and progressed. The figures were also becoming more slender and better proportioned. Static poses were being abandoned and they were often shown in the very act of moving. Contact with Byzantium remained close and under her influence artists were able to find suitable ways of

expressing these new trends. The figures in the frescoes have become more graceful and the heavy heads have been replaced by smaller ones. But at the same time we can also detect the influence of icons on fresco painting. Bold lighting effects were giving way to the more sensitive and subtle shading usually found in icons.

In the 1370s a new artist appeared in Novgorod — a man who was to have a powerful influence on painting both there and in Moscow. This was Feofan Grek (Theophanes the Greek)[40], probably a Cretan who reached the Russian Empire via Constantinople. The stations along his artistic route can be ascertained from a letter to Kirill Belozerski written by a man who knew Theophanes well. From this we learn that he worked in over forty churches, including three in Moscow and others in Constantinople, Chalcedon, Galata, Kaffa (Feodosia), Novgorod and Nizhni-Novgorod. The letter-writer admiringly referred to the fact that nobody had ever seen him use a model. His pictures were designed and executed with a sure hand. Epifani Premudri, the writer of the letter, also mentioned that Feofan Grek painted miniatures, a fact reported in the Chronicles. Characteristic features of his painting are his muted tones and the vigorous strokes he used to model his figures. Powerful lighting effects were produced on the flesh tint with white, grey, red and a bluish tone, not always applied to the raised parts, but sometimes to shadow areas. They do not obey the laws governing the distribution of light and shade and so do not merely model the figures, but endow them with a peculiar dynamic quality. In 1405 Feofan Grek and Andrei Rublev were both painting icons in the Cathedral of the Annunciation in Moscow. The central portions of the Deesis group were done by Theophanes: the Archangel Gabriel, the Apostle Paul, Basil the Great and John Chrysostom. Feofan seemed born to create monumental works of art, so for the Deesis series he chose a size not usually found in Russia up to that time — the icon panels are over two metres tall and over one metre broad. There is freedom in the composition of the figures and the faces show a painterly, rather than a graphical, approach — both characteristics of a fresco painter. But some new features are evident in his art. The figures are endowed with a certain melodious rhythm and the pure, neat lines of the drawing have never been surpassed. The colouring and the light effects on the draperies also reveal the hand of a gifted and inspired master.

An artist of that calibre naturally had many pupils and a great number of imitators. If we exclude the fresco cycles attributed to him or seemingly inspired by his work (there are widely divergent views regarding the frescoes in the Church of Feodor Stratilat (Theodore Stratelates) and those in the Church of the Assumption at Volotovo), we also find a few icons associated with the name of Feofan. These include the well-known icon of the Mother of God of the Don, showing on the reverse a picture of the Dormition of the Mother of God. The latter appears to Pl. 47, p. 151 be connected with the paintings in the church at Volotovo[41], which are in a more popular style. The apostles' faces are filled with emotion and highly expressive and also give us deep insight into what Feofan's painting was really like. The architectural setting has been reduced and

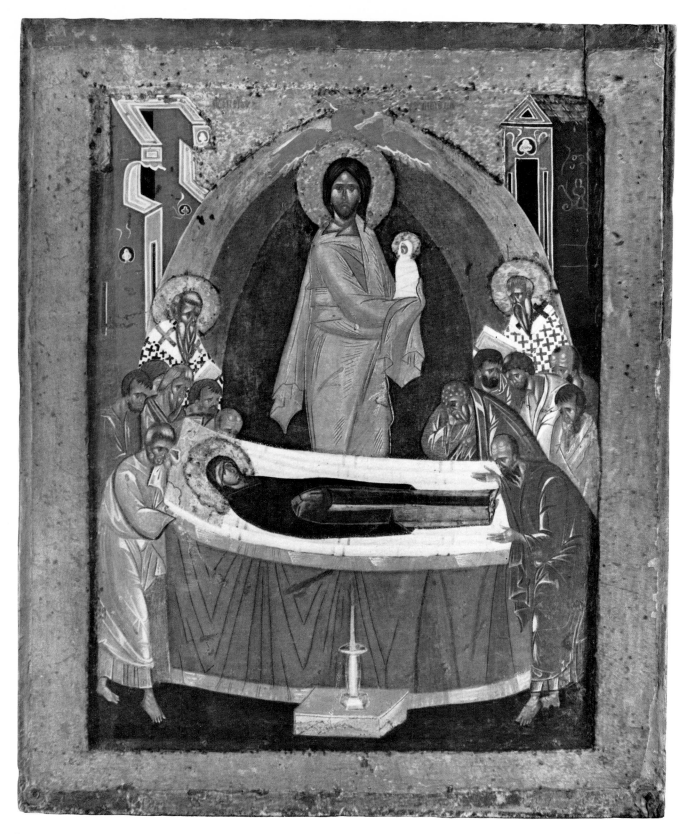

47 The Dormition of the Mother of God. Feofan Grek, late 14th century

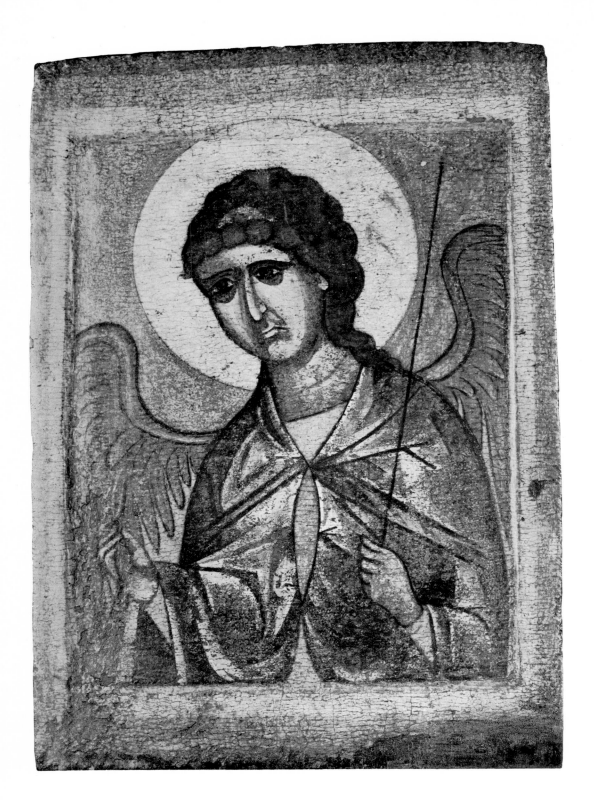

48 The Archangel Gabriel. Russian (Novgorod), late 15th century

simplified by the artist. In the picture of the Mother of God and Child we find a poetic interpretation of the theme of tenderness.

With Feofan Grek, the master of monumental painting, and the frescoes of Kovalevo, wall painting in Novgorod came to an end. Pictures were now becoming synonymous with icons and this tendency was being greatly encouraged by the development of the iconostasis and the increasing number of small churches. As people became more prosperous, they found it necessary to decorate private houses, and icons were also ideal for that purpose. Three icons from the

Pl. XVIII, p. 123
Pl. XIX, p. 129

Hann Collection have been ascribed to 14th-century Novgorod: one of Christ's Descent into Hell and two of the Archangels Gabriel and (presumably belonging to the same Deesis group) Michael[42]. All three icons appear more archaic than quite a number of works from that century. The picture of Christ's Descent into Hell is simple in structure — the rocky background setting plunges down towards the centre into a deep ravine, with the blue-black mandorla round Christ extending into it in severe contrast. It is adapted to follow the direction in which He is moving and so is leaning slightly over towards the right-hand side of the picture. The gestures of the figures are meagre and economical. Contrasting with the blue-black of the mandorla we have the gleaming red draperies worn by Eve and David. As icon painting in the 14th century had not yet a definite and standard style, we tend to find icons of different types standing side by side. The icon of the Archangel Gabriel, also popular in style and with sharp outlines which make the reddish brown wings in particular stand out against the ground and emphasise the squat figure of the angel, shows a distant resemblance to the frescoes in the Church of Feodor Stratilat. The sharply defined lights on the curving eyebrows and the white dots on the dalmatica also reveal close connections with a favourite form of decoration used in the Pskov icons. The bluish green tone is another feature reminiscent of Pskov painting[43]. A few panels with a red ground, including

Pl. 39, p. 134

a half-figure icon of the Prophet Elijah[44], come at the end of the 14th and beginning of the 15th century and are powerful paintings rooted in popular art. The curiously sloping shoulders, of which there was some suggestion in the earlier work, became more ar less a typical characteristic of pictures produced at the end of the 14th century.

Pl. XXI, p. 135

A half-figure icon of St Demetrius could also be attributed to this group of expressive artists who believed in simplification. The manner of painting the face and draping the garment and the slight asymmetry are repeated in the frescoes of Kovalevo[45], painted in the 1380s. The saint's hand gripping the archaic cross is similar to that of Elijah clutching his scroll. This icon should therefore be dated to the early 15th century.

Pl. XXIII, p. 141

An icon of the Annunciation, painted like a number of icons put at about the turn of the 14th century, also belongs to the 15th century. The faces show simplification in the painting of the nose and a sharply defined shadow round the small mouth and are closely related to the pictures on the icons of Paraskeva-Pyatnitsa and Anastasia[46] and the two-tiered panel with pictures of Nicholas, Elijah, Paraskeva-Pyatnitsa and Blaise[47]. A dark pattern of short, broad strokes has been marked on the green ground plane, as in the icon of the Praying Citizens of Novgorod

153

(1468)[48] and the Three Young Men in the Fiery Furnace (end of the 15th/beginning of the 16th century)[49], both in the Novgorod Museum. We appear to find a simplified form of the linear pattern used in the icon of the Annunciation recurring with greater frequency towards the end of the 15th and even in the early 16th century, for example, in a quadripartite icon with scenes from the Passion[50] and the icon showing SS. Macarius, Onuphrius and Peter[51]. The simple architectural setting, quite unimportant in itself, the economical gestures of the Mother of God and the angel and the presence of just a few sharply emphasised folds are all typical of Novgorod painting at that time. This icon should therefore be dated to the 15th century.

Another icon in an archaic style, showing the Archangel Gabriel, is described by the Fogg Pl. 48, p. 152 Art Museum as 'Russian, 12th—13th century', but this is probably too early a date. So few works have been preserved from these two centuries and none of the icons from the early period that have so far come to light bear any resemblance to this Gabriel as far as the painting is concerned. The economical presentation of the subject, the expressive face of the angel and the incisive way in which the draperies have been broken up all suggest that this panel should probably be dated to the closing years of the 15th century.

A favourite saint in Novgorod, apart from Boris and Gleb, Florus, Laurus and Elijah, was St George, who was repeatedly portrayed by icon painters in his role of dragon-killer. One of these Pl. 40, p. 136 pictures of St George, belonging to the 14th century[52], has only a single landscape detail on the left of the picture, a stylised tree round whose trunk the dragon's tail is coiled. At the foot of the trunk a jagged black cavity represents its den. There is a dotted pattern running along the dragon's back and the saint has run it through with his lance. The figure of Christ Blessing appears in the top corner of the picture. The graceful drawing of the horse gives only a hint of the stylisation that was so common later on. Another icon, attributed to 15th-century Novgorod, has added a great deal to the simple content of the picture. The landscape at the back rises up Pl. 42, p. 142 to form crags and on the right about a third of the picture is given over to the subsequent chapter in the legend, following the actual fight with the dragon. The rescued daughter of the king is pulling the monster into the city, from whose walls the populace and the king and queen with their noble retinue have been watching the contest. The complicated towers rising up behind them have been painted with a loving eye for detail. Two special features of the icon are the crowning of the saint by an angel flying steeply down towards him and the oddly shaped segment of the heavens, with Christ appearing among the spatially conceived layers of cloud and blessing the saint. It is unusual to find George turning his back on the figure of Christ Blessing. The entire composition is highly complex, and the impressive simplicity which so attracted us in the older icon has been lost completely. This fondness for detail, however, which can be seen in the décor behind the king and queen, and the strong narrative quality of this icon is more suggestive of the 16th century than the 15th century, which was a period when minor details were omitted in order to make a picture more vivid and expressive.

Pl. 44, p. 146 In an icon showing St George as a warrior, but not fighting the dragon, he is leaning on a spear and is turning away with his head on one side. The weight-bearing leg is emphasised by bending the hips. The sword in his left hand is not lying in the crook of his arm, but has been brought through between his arm and his body and is pointing steeply upwards. A billowing cloak is swinging out in a wide peak towards the bottom right-hand edge of the picture and serves to counterbalance the lower part of his body which is slanting in the opposite direction. This icon belongs to the Novgorod Museum and has been dated to the period around the 15th Pl. 43, p. 145 century. We see the Prophet Elijah gazing at the raven in another icon from the closing years of the 15th century[53]. The composition of the picture is simple and impressive and the figure of the prophet is thrown prominently into relief by the black mouth of the cave. Elijah is sitting there, pensive and detached, looking up at the raven, whose wings the painter has spread right over the ground of the picture on to the border. The soft, flowing edges of the rough skin cloak are wrapped round the prophet.

We can see very clearly how even in the small details of a scene from the life of a saint the painters from Novgorod aimed at formal simplicity and contrived to make the picture more expressive and compelling by emphasising the general outline. An example of this is the rescue Pl. XXIV, p. 147 of storm-tossed mariners depicted in an icon of St Nicholas from the end of the 15th or beginning of the 16th century[54]. On the watery expanse, where the waves are indicated by a few opposing sets of parallel lines, we see a small sickle-shaped boat with a vivid white sail. Red crags mark the edge of the sea. The sailors, cowering down in fear and dread, are begging for mercy and their helper, St Nicholas, is towering up in front of them, his great head encircled by a red-rimmed halo of shining gold, and he seems to be radiating a mood of profound peace and serenity. Using very little detail, the artist has successfully reproduced the legend, combining his talents as a painter and a draughtsman.

The icon painters of Novgorod always achieved their special effects by the use of colour. This came first and everything else was subordinated to it. The radiant quality of rich, unmixed Pl. XX, p. 133 colours — brilliant cinnabar, golden ochre and lush green — was a keynote of their work, but they also enjoyed using delicate gradations of pink, violet, lilac and silvery green. They juxtaposed them to produce contrasts, but also managed to blend them harmoniously together to express a more restful mood.

The search for new forms that went on in the 14th and early 15th century was followed in the second half of that century by the use of firmly established iconographical types and a general change in appearance. The figures had formerly been squat, but were now becoming taller and Pl. 45, p. 148 slimmer. This transformation is clearly evident in the icons of the Archangels Michael and Gabriel, Pl. 46, p. 148 which have come from a Deesis tier and belong to the end of the 15th century[55]. The tall, slender figures are leaning forward gracefully, their hands turned towards each other and holding discs with the logogram of Christ. The basic colours of their draperies are used alternately, with an interplay of blue and red. The folds are now being drawn more carefully, without any sharp,

angular brush strokes, and there is also greater mobility and variety in the lighting. The curving tops of the wings sweep harmoniously up behind the shoulders and combine with the outer frame of the haloes to form an arch. There is a striped pattern on the wings and the draperies have wide borders, but the amount of ornamentation is negligible.

Large, slender figures are also a typical feature of Christ's Descent into Hell, a big panel that is monumental in character, although presented in the form of an icon. The composition of the icon is carefully balanced and the figure of Christ in His blue-green mandorla is given prominence as Lord and Redeemer of the World. A diagonal line runs upwards from the resurrected Adam over Christ's right arm and shoulders and the billowing edge of His cloak to the mountain crags in the top right-hand corner, which represent a continuation of this same line. The two groups of prophets and saints supply an effective frame for the central scene. As regards colour, the white robe of Christ with matt brown lines to indicate the folds and powerfully drawn contours is set off boldly by the blue mandorla. The halo, on which the gold has faded, frames a long, narrow head. The face is kindly and serious, with red added to heighten the flesh tint and a few short strokes of light to bring it to life. This icon probably belongs to the 16th century. Two large calendar panels divided into ten tiers and showing the saints and feast days for the entire church year come from roughly the same period. The year begins on the left-hand panel with 1st September, in accordance with the old calendar. The exact sequence of days is broken only on the right-hand panel because the events of the Passion, the Resurrection, the Ascension and the Descent of the Holy Ghost, which are not tied to any definite date, happen to fall within that particular half-year. So in the two middle tiers the artist combined the events of the New Testament coming between the Raising of Lazarus and the Feast of Pentecost, thus giving the picture its own special focal point. Elsewhere he kept strictly to the proper chronological order. He produced some very delicate brushwork and showed consummate skill in making each of the figures appear highly individual. In this way he created a painted *podlinnik* and his two panels of the Saints and Feasts commemorated in the church year could be used as a model by other painters.

A more precise type of painting in which a great deal of the breadth and expressiveness of the High Period in Novgorod has been lost and the linear side has become more prominent can also be observed in an icon of the Nativity dated to about 1500 and owned by the National Gallery in Oslo[55a]. The pensive face of Joseph, the Mother of God gazing wistfully into the distance and the love of ornament that can be seen in the draperies and the gifts of the Three Magi, and also in the lighting of the garment of skins worn by the old shepherd in front of Joseph, are all features of this transformation which marked the final phase of Novgorod art and paved the way for the mixed style — a Novgorod-Moscow hybrid — that was becoming more and more typical of the 16th century.

The icon of St Nicholas, surrounded by scenes from his life, gives clear evidence of this transformation. The almost calligraphically fine painting and drawing and the complicated pattern

Pl. 50, p. 159

Pl. XXV, p. 158

Pl. 51, p. 160
Pl. 52, p. 161

Pl. 49, p. 157

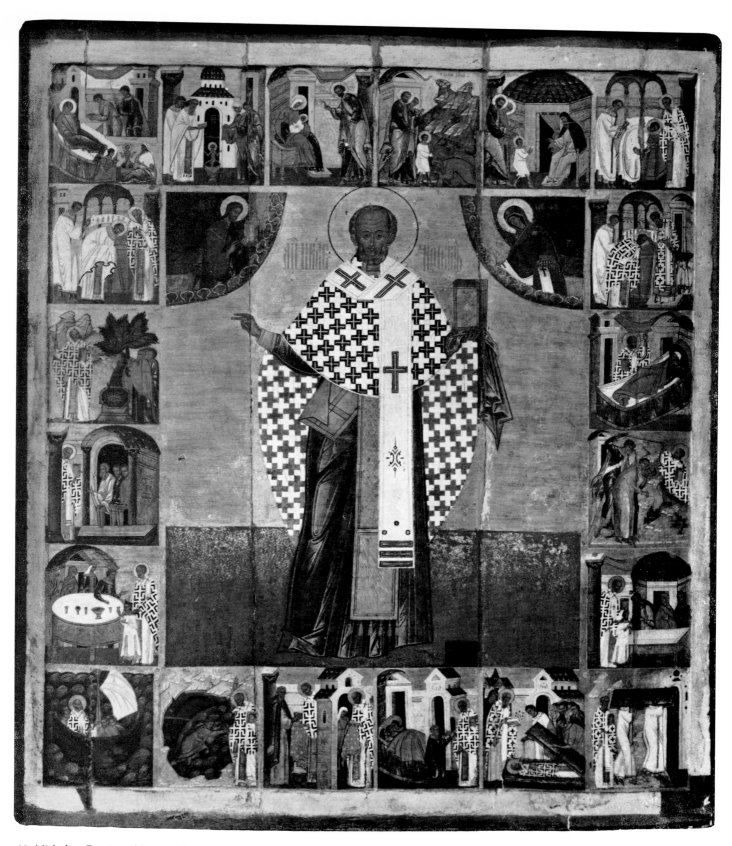

49 Nicholas. Russian (Novgorod), *ca.* 1500

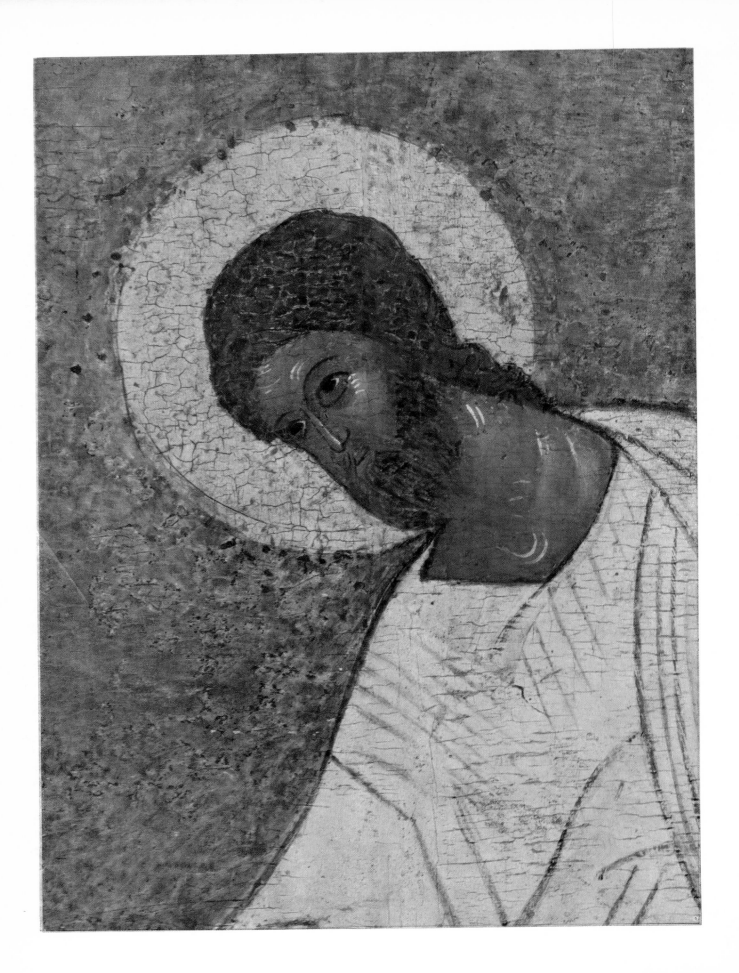

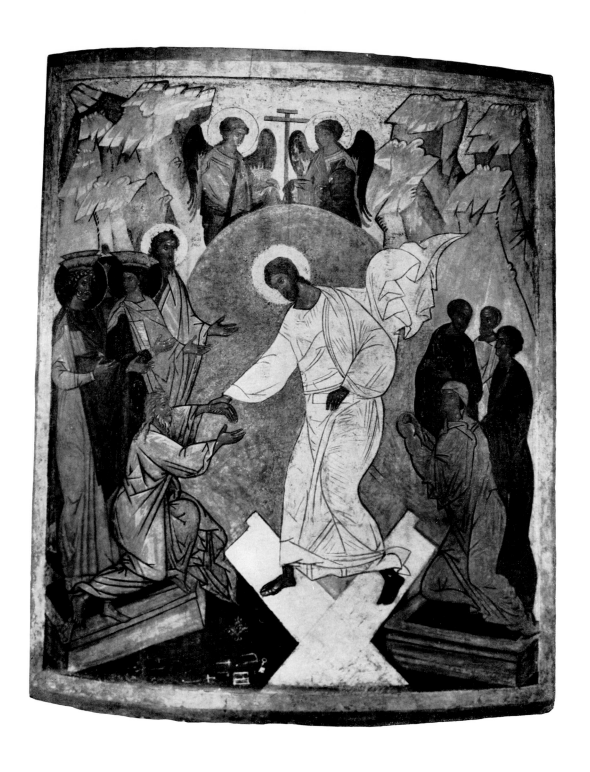

50 Christ's Resurrection (Descent into Hell). Russian, early 16th century
XXV Detail from No. 50

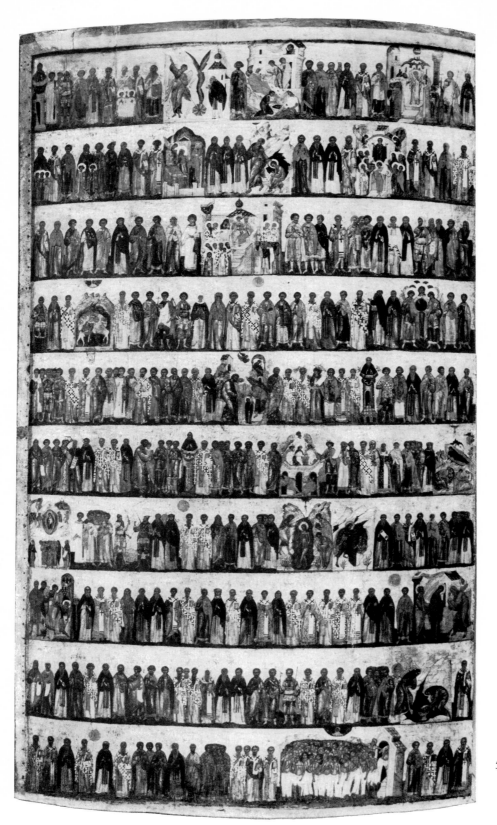

51 Calendar Panel of the Church Year
(1. 9. to 14. 3.).
Russian, late 16th century

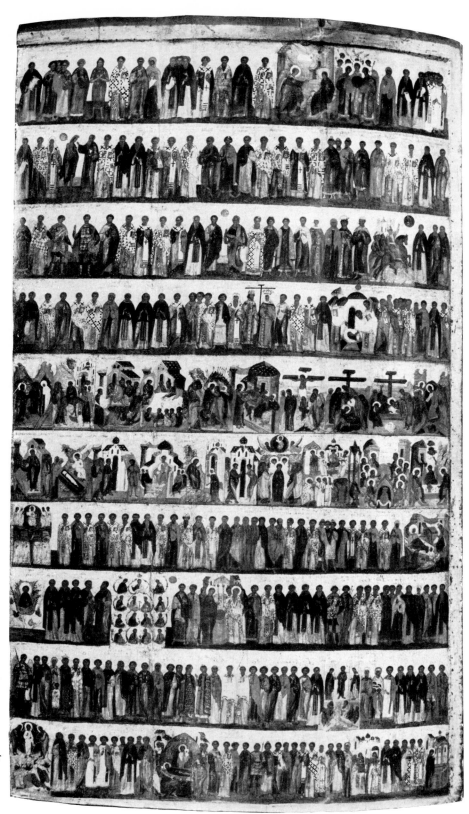

52 Calendar Panel of the Church Year
 (15. 3. to 31. 8.).
 Russian, late 16th century

53 The Martyr Nikita. Russian, 16th century

on the bishop's vestment show once again that the true Novgorod style has been abandoned. We

Pl. XXIV, p. 147 can see this clearly if we compare the small scene depicting the rescue of the mariners in distress, which appears at the bottom left-hand corner, and the coloured picture showing part of another St Nicholas icon. The stirring simplicity of the latter is in sharp contrast to the calligraphic rendering of the sea that we find here. Although there is nothing incomplete or inconsistent in the composition of the boat and her crew, we sense a mood of restless agitation not felt by the 15th-century painter and not in keeping with his aesthetic principles.

We are, however, aware of a static quality of repose in a tall, narrow icon dating from the
Pl. XXVII, p. 167 early 16th century. It shows St George as the patron saint of warriors. His nobly formed head and slender, sinewy body and the delicately shaded colours give this panel a graceful air of courtly elegance. Here too we are struck by the new importance given to the decoration on the saint's armour and boots and by the elegant ornament that has found its way into Novgorod art and is here inscribed on the martyr's fiery red cloak.

Pl. 53, p. 162 In a small icon of St Nikita, who is shown slaying the Devil, while an angel places a martyr's crown on his head, the archaic features of Novgorod painting have been retained. The tendency to make the subject more complex can be seen in the allegorical portrayal of Hell as a two-headed monster trying to seize hold of the saint, with the Devil standing on its right head. Nikita is restraining him. Ornamental work, still flat and not really extravagant in any way, appears on the throne and also on the cloak, which is swinging out in a mass of folds behind the saint's body to form a bold arc. The actual ground of the picture has been recessed and a new frame has been added with the artist's brush. He has, in fact, painted yet another frame in the shape of an unsymmetrical circular arch, sweeping round to form three curves. This tendency to make the subject matter more complicated is a peculiarity of Novgorod art mainly in the closing years of the 15th century and, above all, in the 16th. The use of drawing to break up the armour and the simple ornament appearing on the saint's armlet and crown and also on the two cushions covering the throne point the way ahead to the late 16th century, in which we find frequent evidence of the formal use of drawing. This icon should therefore be dated to the early 16th century.

Pl. 54, p. 165 The small icon of St Varlaam of Khutyn is another example of the mixed style, based on features from both Novgorod and Moscow, that we so often come across in the 16th century. The painter made a mistake in the inscription and began the saint's derivational epithet with the character equivalent to 'Ph', instead of 'Kh'. The Saint is raising his arms in prayer to Christ in the typical posture of a humble monk and in the top left-hand corner of the picture Christ can be seen turning towards him and blessing him from the segment of a circle thickly studded with stars. The panel can be attributed to the second half of the 16th century, and its palaeographical peculiarities also support this dating. An increasing number of Russians were being canonised in the 16th century, with the encouragement of Moscow, and as a result, more pictures of Russian saints were appearing in icons.

In the 16th century Novgorod lost her importance as an artistic centre. The city never recovered from the terrible onslaught she had to endure under Ivan IV, known as the Terrible, and she was reduced to the status of a provincial town. But her artistic tradition became merged with the Moscow style and we can look upon this as the legacy bequeathed by Novgorod to icon painting in Russia.

Pl. I, frontispiece

Novgorod's sister-city of Pskov had a lively artistic life of her own. The architects of Pskov, for example, were so famous that they were summoned to construct buildings for Ivan IV in Moscow and the surviving frescoes and icons from Pskov are of high artistic quality and show determined individuality. A picture of Christ's Descent into Hell from Pskov is a typical specimen Pl. 38, p, 130 of her painting. Christ is standing on the Gates of Hell and the effect is one of vigorous movement. He is seizing Adam and Eve by the arm and lifting them out of the grave. The prophets and patriarchs and John the Baptist are standing in two rows behind the central group, and their alignment in this manner serves to stress the austere character of this panel. At the top of the picture a frieze of saints is arranged like a Deesis and, although these half-length figures have just been added as an extra, they make the general composition seem rather less tight and rigid, as their movements are related to the central figure. Pskov icons are, as a rule, in a sombre key, with a predominance of dark green in a shade only found in that city. The ornamentation on the draperies and the edges of the coffins in the icon illustrated here consists of glaring white dots. Glistening white highlights illumine the mountain crags which form the setting and also the dark faces of the figures.

In addition to the important centres well known to us because of the many works still in existence, other large towns in Russia must have had icon workshops too. Unfortunately, as far as icon painting in central Russia is concerned, in the cities of Tver and Smolensk for example, so few pictures have survived that we cannot identify the style belonging to their workshops. Occasional references to icon painters in the Chronicles merely confirm the fact that art also flourished in those areas. In the case of Smolensk we know that St Avraami painted an icon of the Last Judgement as early as the 12th century, but we have no idea how it was made or what style he adopted. As for the northern towns, such as Vologda and Kolomna, there are too few clues, especially in the early period, so it is impossible for us to establish the existence of definite schools of painting.

It was the emergence of Moscow as a power which brought the various Russian provinces together, but in the 12th century she was still relatively unimportant. After the Tartars had attacked and ravaged the little principalities, the princes of Moscow managed to win the highest position in Russia for themselves, thanks to their political skill. Ivan Kalita (1328—1330 and 1332—1341), nicknamed 'Money-Bags', was the man mainly responsible for Moscow's rise to power. Under Dmitri Donskoi (1361—1389) the Russians gained their first victory over the Tartars and this gave a tremendous fillip to nationalist feeling, but did not alter the fact that the Tartars were in control and officially retained their supremacy until 1480.

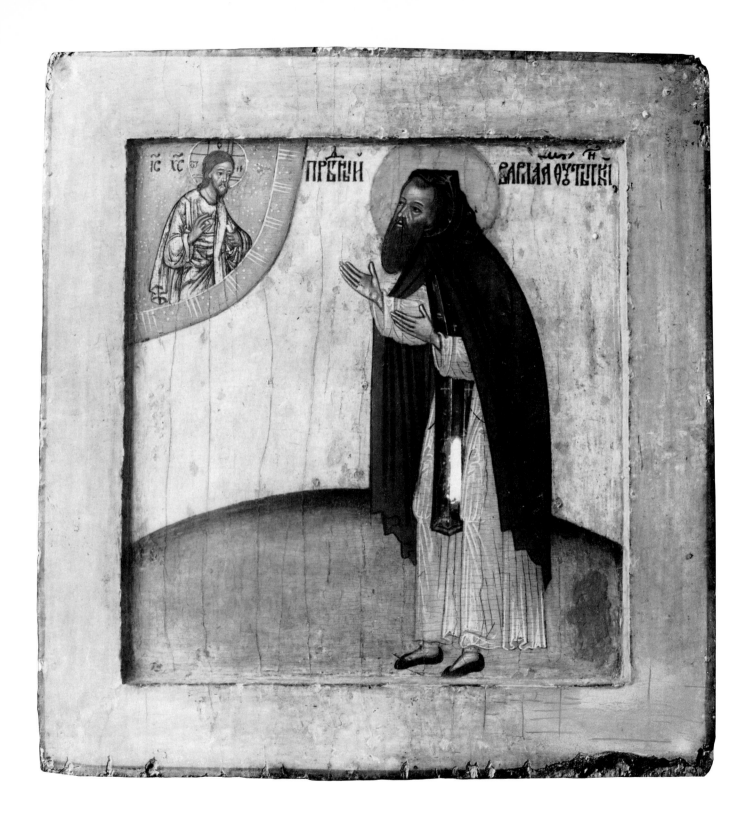

54 Varlaam of Khutyn. Russian, late 16th century

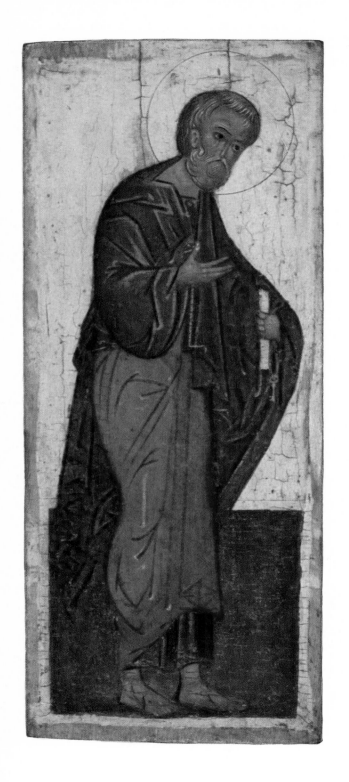

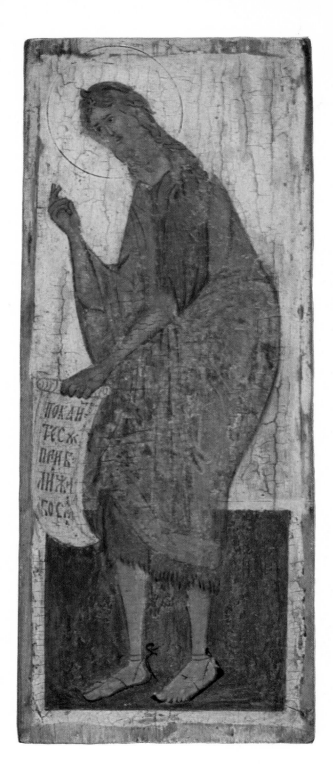

XXVI The Apostle Peter.
Russian (Moscow), early 16th century

XXVII John the Baptist.
Russian (Moscow), early 16th century

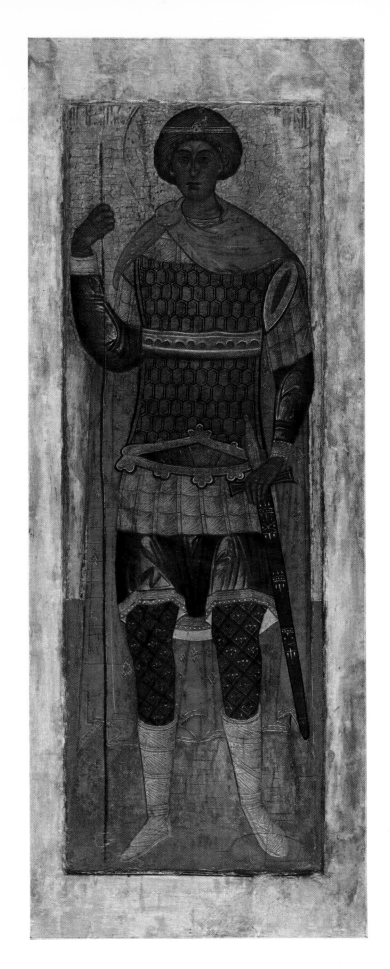

XXVIII The Martyr George.
Russian, 16th century

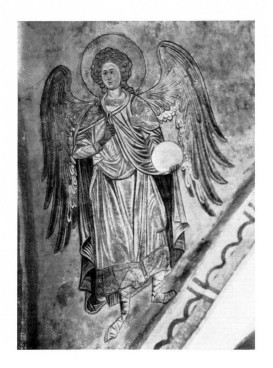

55 Archangel. Fresco in the Castle Chapel, Lublin 1418

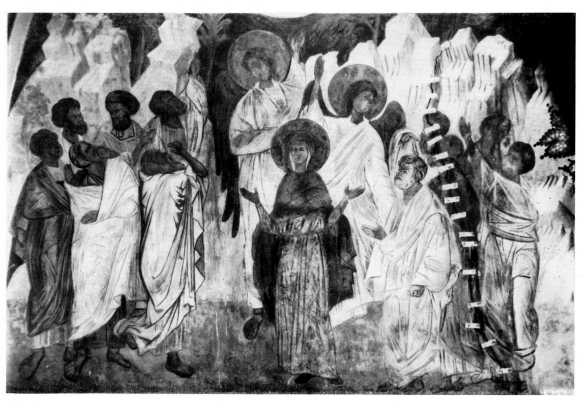

56 The Ascension (detail). Fresco in the Castle Chapel, Lublin, 1418

The absence of any art or culture of her own caused Moscow to develop in close association with Vladimir-Suzdal, the former seat of the Grand Duke. This imitative phase persisted into the 14th century. Few specimens of Muscovite art from before that date have been preserved and even they cannot definitely be claimed as original works from Moscow. This state of affairs continued until the end of the 14th century. But we must remember that, when Khan Tokhtamysh attacked Moscow in 1382, the churches of the Kremlin and all their treasures were destroyed by fire. The icon of the Tolgo Mother of God has been ascribed to Moscow, but there are stronger indications that it was the work of masters from Yaroslavl, or perhaps even Byzantium. Except in the minor arts, there is no early Muscovite work for us to study. Icons from the 13th and early 14th century that are thought to be connected with Moscow differ in style and sometimes even contain definite rustic touches, so we cannot establish any direct link with later Muscovite painting. They are merely chance finds and they do not have the standardised appearance that we see in the later work.

Close contacts with Constantinople were still maintained at the court of the Grand Duke and the residence of the Metropolitan. Even in the 14th century the Metropolitans were often Greeks. So we are not surprised to discover that masters were fetched from Constantinople about the middle of that century to paint the Metropolitan Church in Moscow. The Late Byzantine style of the Palaeologue Renaissance may have reached Moscow in that way. There are also several reports in the Chronicle of Russian groups of painters working in Moscow at the same time. Some of these, although Russian by birth, were pupils of Greeks. It is easy to understand how Moscow, the new centre of all Russia, began to lead a more active artistic life as a result of her political importance. The early Moscow icons from the 1340s reveal the many influences at work there. The creators of these icons still had a link with the archaic work of the past, but they were already groping their way forward into new fields of Byzantine painting[56]. Examples of Muscovite painting only started to become more numerous about the end of the 14th century, after the Battle of Kulikovo, when a great number of envoys were passing to and fro between Russia and Constantinople. Foreign masters also came to the Russian metropolis from Serbia and Greece, and these included the celebrated Feofan Grek, who had previously worked in Novgorod. He apparently reached Moscow around 1395 and set about painting the Church of the Nativity of Mary with various colleagues and pupils. He decorated a total of four churches in Moscow. The eminent Greek found a great number of pupils and followers in Moscow, just as he had done in Novgorod. Because of him, we observe an odd combination of Greek and Russian features in Muscovite icons, which reveal both the static element present in Russian painting and the dynamic qualities of the Palaeologue style.

But we also find that other influences, apart from Feofan Grek, moulded Muscovite painting in the 15th century, and new notes were added to the artistic range. For example, a great number of icons connected with Moscow copy forms used in Serbian icon painting. Serbian and Bulgarian emigrants, including artists, had settled in Moscow, which they looked upon as a kindred Slav

area, to escape the Ottomans oppressing their own native lands. Icon painters in Moscow could therefore find plentiful sources of inspiration. But there was still a special preference for Greek art at the end of the 14th century, and Greek artists painted a number of important icons, including the Annunciation in the Troitse Sergiev Monastery.

The greatest exponent of Russian icon painting, the canonised artist Andrei Rublev[57], was also busy around the turn of the 14th century. He was better than anyone else at producing consummate works of art which were based on Greek models, but unmistakably Russian in character. Generations of icon painters modelled themselves on his style, but never managed to equal him.

Andrei Rublev was probably born about 1360. From Abbot Nikon's account of his life we learn that he lived to a venerable age. He died some time between 1427 and 1430. A study of the general character of his work would appear to show that his own particular form of painting evolved mainly during the 1380s and the 1390s. Rublev's name appears for the first time in the Chronicle under the year 1405, when the Cathedral of the Annunciation in Moscow was painted by him in cooperation with Feofan Grek and an old man called Prokhor from Gorodets. As Rublev's name was mentioned last, he was probably the least well known of the three. In 1408 he and an icon painter called Danilo (Daniel) were mentioned together in conjunction with the decoration of the Cathedral of the Assumption in Vladimir. Here too his name came second. He appears to have worked with Danilo for some considerable time. Another joint labour was the painting of the Church of the Trinity, attached to the Monastery of Troitse Sergiev, in 1422. They died not long afterwards. That is all the definite information we have about Rublev's life. We are not told anything further about his origins or his artistic development. Rublev was well known and respected as a fine painter in Moscow during his lifetime, but his fame did not spread to the whole of Russia until after his death. His icons were held in high esteem. This is evident from the references in certain old documents and also from the fact that the Stoglav Council exhorted artists to paint from old models, i. e., in the manner of the Greek masters or Andrei Rublev.

Many icons used to be attributed to Rublev in former days, but it was impossible to gain a true idea of his artistic achievement until after the discovery of the famous Trinity icon in 1904. A systematic study of all the works linked with Rublev's name was launched at the State Restoration Workshops in Moscow in 1918. One of our main difficulties when trying to assess his creative work is that we cannot definitely claim any painting as a piece by his colleagues Prokhor or Danilo. It is only in the Trinity icon that we can actually see Rublev's style, and it was overpainted three times. So it is very difficult to ascribe the other works accurately to any of the individual artists who were painting together. All three appear to have come from the painting workshop which we know to have existed at the Troitse Sergiev Monastery. In the 1390s, which represented a milestone in Rublev's artistic career, he came under the influence of Feofan Grek. Independent work by Rublev would appear to have started during that period, at Zvenigorod.

In the iconostasis at Zvenigorod, created around the turn of the century, Rublev already showed himself to be a master who had evolved an individual style by his own efforts. Characteristic features of this are his bright, gay colours, clear drawing and faces heavily charged with emotion. A few Festival icons, unfortunately in a very poor state of preservation, are included in the work he did jointly with Feofan Grek and Prokhor in the Cathedral of the Annunciation in Moscow and should undoubtedly be ascribed to Rublev. They have a unique quality of gentleness, as seen in the 'Nativity of Christ'[58]. The angels bending over the manger containing the Holy Child give the whole picture an atmosphere of warmth and intimacy. In the 'Baptism' the Angels are shown bowing down humbly before Christ. The moving tenderness conveyed by that posture can also be seen in the 'Presentation of Christ in the Temple', where the elderly Simeon is reverently taking the Christ Child in his arms. All these works reveal human feeling and this has taken away the severity that we often associate with icons. A connection can be found between the angels in the icons just mentioned and those in the Trinity icon. After the wall paintings in the Cathedral of the Assumption in Vladimir had been cleaned, it was possible to identify the pictures made by Rublev because of their all-pervading mood of gentleness. Apart from these, the main items produced by Rublev when he was working in Vladimir were a few panels on the iconostasis. He was probably responsible for designing the overall composition. Twenty-seven of the icons from that iconostasis were found in a village near Vladimir, where they had come after being sold at the end of the 18th century, when the cathedral in Vladimir was given a new iconostasis. Study of the icons in the Deesis tier shows that they were set out in the typical Rublev manner — with perfect drawing of the outlines. The figures have been done in his favourite rhomboid shape, i. e., they are broadest in the middle of the body and taper off considerably in the upper and the lower parts. This gives a sense of lightness and we feel that their feet are not really touching the ground. The colouring of the icons in this Deesis tier is also typical of Rublev. The fact that he was working with Feofan Grek may have induced him to heighten the monumental effect of the Deesis icons in that mighty cathedral by all the means at his disposal. The individual panels are 3·14 m. high and are over a metre larger than Feofan's panels in Moscow. As far as we can see, in view of the poor state of preservation, Christ, John and Paul are the most impressive paintings on this iconostasis. They have been ascribed to Rublev himself, whereas the other panels were probably the work of his pupils.

A copy of the icon of the of Vladimir Mother of God is also connected with Rublev. It was painted to replace the old miracle-working image when it went to Moscow in 1395. This copy certainly belongs to the beginning of the 15th century, but we have no definite proof that it was connected with Rublev. Igor Grabar attributes it to Rublev, but Lazarev thinks that, in spite of all its tender humanity, this work lacks Rublev's delicate touch. The most mature work by Rublev is the icon of the Trinity, painted for the Troitse Sergiev Monastery between 1411 and 1423 and known all over the world. This icon is intended for devotional contemplation and is quite devoid of movement or action. The viewer is aware of the silence of the angels. The striking

thing about these angels is their profound spirituality and the feeling of tender humanity that is so typical of Rublev and is so perfectly expressed in this work. The angels seem to be absorbed in their own thoughts. They are not looking outwards at the viewer or any of the other angels. The circle is used as a kind of leitmotif throughout, but Rublev is not afraid to break the rhythm of his circle and interpolate a vertical house. By shifting things around at the bottom of the picture, he makes it all symmetrical once more and the whole composition seems wonderfully elastic. The figures have been treated like silhouettes, with lines and splashes of colour used as the main artistic forms of expression. In his flat, rhythmical presentation of the subject Rublev reveals a particularly close link with the traditions of Russian icon painting. An attractive feature of Rublev's icon is its colouring. The pleasing combination of colours and smooth, perfect lines lend pure, harmonious beauty to the picture. 'Rublev would not appear to have chosen his colours in glaring sunshine, but on a bright summer's day with a clear flow of light, when the most obscure and delicate nuances light up, as it were, and begin to shimmer in soft harmony. It is interesting to note that hardly a single shadow can be found in Rublev. If he introduces a dark patch or a fairly concentrated colour, he does so merely to underline the brightness of the adjacent tones. Because of this colour concept Rublev's palette is not only bright, but curiously transparent' [59].

Apart from the Trinity, no work by Rublev has survived from the second decade of the 15th century. But the icon of the Baptism of Christ [60] from the iconostasis in the Cathedral of the Trinity in the Monastery of Troitse Sergiev dates from the second half of the 1420s and was probably painted by this very important master.

Rublev's principles of composition were followed for many years, as can be seen from three small panels for a household iconostasis depicting the Apostles Peter and Paul and John the Baptist. These three small icons are also a typical example of the way in which work was divided out within the various painting associations in Russia. We are struck by the fact that the two apostles do not show the same delicate refinement as John the Baptist or the fine line-drawing which is so evident, for example, in the shaping of John the Baptist's back. We can therefore assume that the master painter in the group was responsible for the central figures in the Deesis, including John the Baptist. The two apostles reveal the hand of a different artist who was certainly capable of highly competent and expressive work, but could not achieve the sensitive refinement and elegance so characteristic of John the Baptist. In that icon we can detect an intimate colour harmony in the meticulously graduated tones of green and the use of ochre also shaded in green. The rhomboid form used in the composition is closely reminiscent of Andrei Rublev's typical stylistic device.

There is also a theory that a fresco group painted in 1418 in the Chapel of the Trinity at Lublin Castle [60a] was inspired or influenced by Rublev and his works. These wall paintings are certainly very important examples of Christian art in which Greek iconography has been handled in a Western manner. But the external similarities to Rublev's style that we can observe in the

Pl. XXVI and XXVII, p. 166

Pl. 55 and 56, p. 168

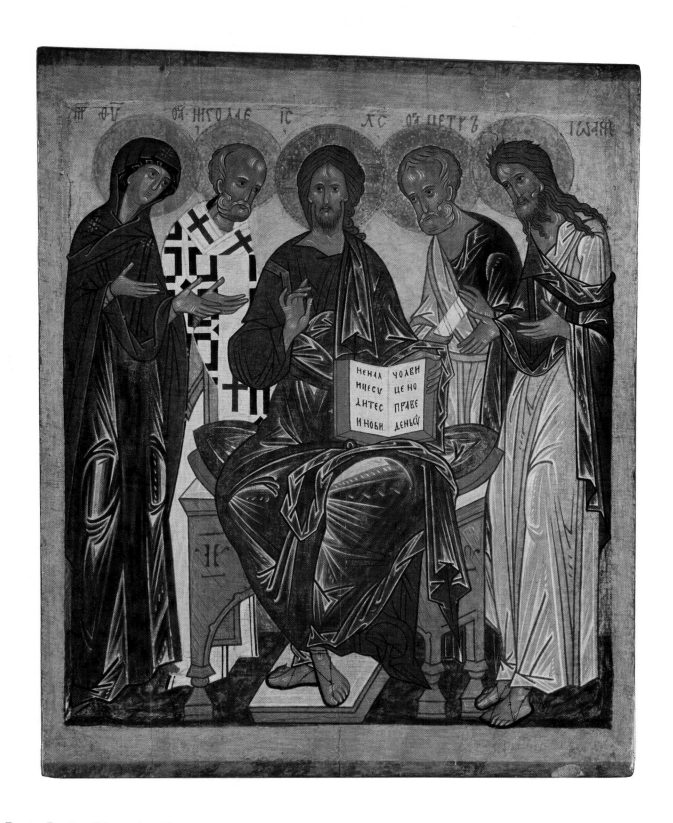

XXIX Deesis. Russian (Moscow), 16th century

57 Zosimus and Savati of the Solovetski Monastery. Russian (Moscow), *ca.* 1600

figures in these frescoes —they are really minor and the link is rather artificial — cannot blind us to the fundamental difference in their pictorial content. In the Lublin frescoes there is a predominant note of realism that is far removed from the very unworldly atmosphere of Rublev's work. These frescoes reveal great artistic ability, but we are surely not justified in looking for close links with Rublev and his school, although it would be interesting to study the method of an artist trained to copy the leading Russian master and also in contact with western Europe.

A more likely theory is that these paintings were produced by an artist who had left the Balkans and gone off elsewhere, because of the troubled times in which he was living, and on his way east had come into fairly close contact with the art of western Europe or Bohemia. So he was able to combine artistic forms from both parts of the Christian world very successfully. But perhaps we can regard the Lublin frescoes as a connecting link, revealing the numerous ways in which creative ideas reached the Empire and influenced the new concepts and creations of Russian art during the 15th and, in particular, the 16th century. A great number of non-Russian masters worked in Russia later on, but we very seldom find out how they reached the Eastern Empire. We merely know that they worked in Russia. The Lublin frescoes tell us something about a staging-post on that route that deserves careful examination.

The work of another famous artist also reminds us of the style of Rublev. He is master Dionisi, whose fresco cycle in the Ferapontov Monastery (*Therapontos*)[61], painted in 1500, has survived in entirety. No doubt other churches were painted by him too, and there are also a few icons by him, for example, at Volokolamsk. Some of his most typical frescoes are very similar to those in the Cathedral of the Assumption in Vladimir, on which Rublev worked. Dionisi's form of artistic expression reveals a change that had already begun to appear in the 15th century. The bright patches of light still being used by Rublev do not occur in Dionisi, who laid great emphasis on lines. Drapery folds are strongly marked by Dionisi, but he is also expert in the use of delicate lines which convey no more than a subtle hint and enhance the spiritual quality of the picture. His colouring is also exquisite and reminiscent of the illusionism we find in the Late Byzantine style.

Pl. XXIX, p. 173

In the icon painting of Dionisi's period there is often a greater use of linear effects. A Deesis icon with Peter and Nicholas (Moscow School, 16th century) is an example of the introduction of linear devices into what is otherwise a painterly piece of work. The finely drawn heads and the deep spiritual intensity and involvement stamped on the faces are typical of Moscow icons from the second half of the 15th century. In contrast to Rublev's faces, which seem to radiate a divinely inspired mood of deep spirituality, the figures here are reaching out intellectually towards the supernatural, although they still remain attached to earthly things. Our panel also shows another characteristic of Moscow icons from the closing years of the 15th century that was not present in Rublev: a strong emphasis of the vertical plane where the figures are concerned.

Pl. XXXI, p. 183

The Eleousa Mother of God in the Hann Collection is described as Moscow work from the 16th century. The calligraphically fine lines on the Child's hair, the delicate ornament on His

chiton and the linear division of the draperies make this icon truly unique. The Christ Child has also been given a very prominent forehead. The care with which the painter modelled the leg that Christ has crossed under His body reveals a conscientious eye for detail.

New iconographical forms were introduced into Russian art in the 16th century. The state had firmly established its authority by this time and Moscow was the leading centre of Orthodox power. After the fall of Constantinople more Russians were canonised and portrayed as saints. Here the wishes of the Russian Church coincided completely with those of the Tsars.

The deliberations of the Great Moscow Council, or Hundred Chapters Synod[63], give us some idea of how the spiritual life of Russia between the end of the 15th and the second half of the 16th century[62] was affected by the cataclysmic fall of Constantinople and her capture by the infidel, and by the formation of heretical sects and the general search for something new. During those decades following the decline of Constantinople, the other Rome, people were looking for a new foundation, new principles on which to build. This searching, enquiring spirit is reflected in literature and in the formulation of false doctrines and also brought new features and a note of uncertainty into icon painting. So the Hundred Chapters Synod (Stoglav) laid down in 1551 that icon painters should not follow their own taste or whim, but should keep to the established types.

This is probably a suitable place for us to stop and think about all this from the point of view of the icon painter and to examine the changes in his duties and position down the years. For St Alipy, working in the Cave Monastery of Kiev in the early days of Russian icons, painting was just one of the many jobs to be done in a monastery. The main thing was not to be idle. The icon painter of that period could be compared with the scribe who copied out the manuscripts required for the services or for the monastery library. He had been trained according to his gifts and aptitudes and was then issued with work to do. Later on, when these artist monks were no longer able to meet the increasing demand for icons (icon painting as such was, of course, never confined strictly to those in holy orders), lay painters roamed through the country in groups and it became necessary to subject them to closer supervision, as they did not all reach the high standards laid down for them by the Church because of their highly respected professional status. The pronouncements of the Stoglav Council are therefore extremely illuminating as far as the 16th-century icon painters are concerned. They tell us about the various deficiencies that would appear to have been common in those days. The Synod's reply to a question from the Tsar (Chapter XLIII) deals first of all with the moral and ethical prerequisites that were accepted as a matter of course and then goes on to refer at great length to artistic training, abuses, etc., and states most emphatically that only artists should be allowed to paint icons. We are reproducing that very informative chapter in full, as the much quoted passage about the moral conduct that was expected of an icon painter gives a very one-sided picture if taken out of its context.

'By order of the Tsar, the holding of divine service and, above all, the sacred icons and the icon painters in the capital city of Moscow and in all cities of the Metropolitan should be super-

vised by the Archbishops and Bishops, who must make sure that everything is done in accordance with the sacred rules. They should lay down the duties of the icon painters and inform them of the rules to be followed when painting the carnal form of Our Lord God, Jesus Christ Our Redeemer, His Mother most pure, the heavenly powers and all the Saints who have at all times pleased God.

'The painter should be filled with humility, meekness and piety; he should shun frivolous talk and amusement. He must be peaceable by nature and know no envy. He must neither drink, nor rob nor steal. Above all, he should be extremely careful to safeguard his spiritual and physical purity. If he is unable to live in chastity, he should take a wife and marry according to the law. He should pay numerous visits to his spiritual fathers and inform them about his way of life and, in keeping with their commands and instructions, fast and pray, cultivate purity and modesty and keep all shamelessness and turbulence far from him.

'He should show conscientious care when painting the pictures of Our Lord Jesus Christ, His pure Mother, the holy Prophets, Apostles and Martyrs, both male and female, the venerable women, the princes of the Church and the venerable fathers as likenesses in the manner that has been handed down. Directing his eyes towards the works of older painters, he should take the best icons as his models. If these contemporary painters live faithfully according to the instructions given them, if they meticulously carry out this work which is pleasing to God, they will be recompensed by the Tsar and the leaders of the Church will watch over them and show more respect to them than to ordinary men.

'These painters must take pupils, supervise them, instruct them in piety and purity and conduct them to their spiritual fathers. They must teach them in accordance with the instructions of the Bishops about the kind of life — quite divorced from shamelessness and turbulence — that befits a Christian.

'The pupils should follow attentively the teachings of their masters. If, by the grace of God, one of the pupils shows artistic aptitudes, the master should take him to the Bishop. The latter will examine the icon painted by the pupil and see if it is a true picture and likeness. He will thoroughly investigate his way of life and determine if he is leading a pure and pious life, in no way disorderly, as laid down by the rules. He should then bless him and exhort him to live a pious life and pursue his hallowed profession with tireless zeal, and he will award him the badges of honour agreed upon with his master, which are withheld from ordinary men. Thereafter, the Bishop shall exhort the painter not to show preference to his brother, or to his son, or to any other relative. But if, by the will of God, a man is without artistic aptitude, if he is a mediocre painter or does not live according to the rules accepted by him, and his master nevertheless declares him to be expert and competent, displays work by another person and asserts that the pupil painted it, the Bishop will after thorough examination impose the appointed penalties on that master, so that others will take fright and be warned against following his example. The pupil, however, will be absolutely forbidden to paint icons.

'If, by the will of God, a pupil is endowed with certain aptitudes and lives according to the rules accepted by him, but the master in his envy belittles him to deprive him of the honour that he himself enjoys, then the Bishop will after examination impose the penalties prescribed upon that master, but the pupil will be given great honour.

'If one of these painters conceals his God-given talent and does not permit his pupils to play their proper part, he will be condemned to eternal punishment by God, like the man who hid his talent (Matthew xxv. 14 ff.). If one of these masters or one of the pupils does not live according to the rules accepted by him, if he becomes a drunkard and lives an impure and disorderly life, the Bishops will then suspend him and forbid him to paint icons, remembering with awe the words of the Prophet: "Cursed be he that doeth the work of the Lord deceitfully!" (Jer. xlviii. 10)

'As for those who until now have painted icons without art, according to their whim and in their own way, carelessly and without creating any likeness, their works should be taken from them and sold at reduced prices to simple and ignorant people in the villages. But the painters themselves should be exhorted to take instruction from experienced masters.

'Any person who by the Grace of God can paint and can reproduce form and likeness should paint. But, if God has withheld that gift from him, he should be forbidden to paint icons, so that he will not insult God with his ineptitude. Anyone who goes against that prohibition should be punished and condemned by the Tsar. If such people say to you: "This craft is our livelihood and earns us our daily bread," pay no heed to their reply, as it has been inspired by ignorance and they do not believe that they are guilty of any sin. But none of these persons should paint icons — God has given men many different crafts, apart from icon painting, to provide them with food and guarantee a livelihood. But pictures of God should not be entrusted to those who degrade and distort them.

'The Archbishops and Bishops must supervise the icon painters in all cities, villages and monasteries within their dioceses and personally examine their work. Each one must select the most important painters in his diocese and give them the right to supervise their fellows, so that no clumsy or crude painters will be included among them. But the Archbishops and Bishops must personally inspect the painters to whom they have entrusted this supervisory task with the utmost strictness. These painters should be treated with special consideration and be given special badges of honour. All people, both high and low, must honour them and hold their venerable art in esteem.

'Each Church leader in his diocese must watch carefully and with unwearying attention to ensure that good icon painters and their pupils reproduce the old models and abstain from their own whims and imaginings and do not form the image of God in any daring manner. Although Christ, Our God, appeared in a fleshly guise, His divinity eludes the painter. St John of Damascus said: "Do not portray the godhead: do not distort it, ye blind men, as it vanishes from before your eyes and cannot be pierced by your gaze. When reproducing the fleshly covering, I bow down with complete faith and give praise to the Virgin Who bore Our Lord." If a painter who

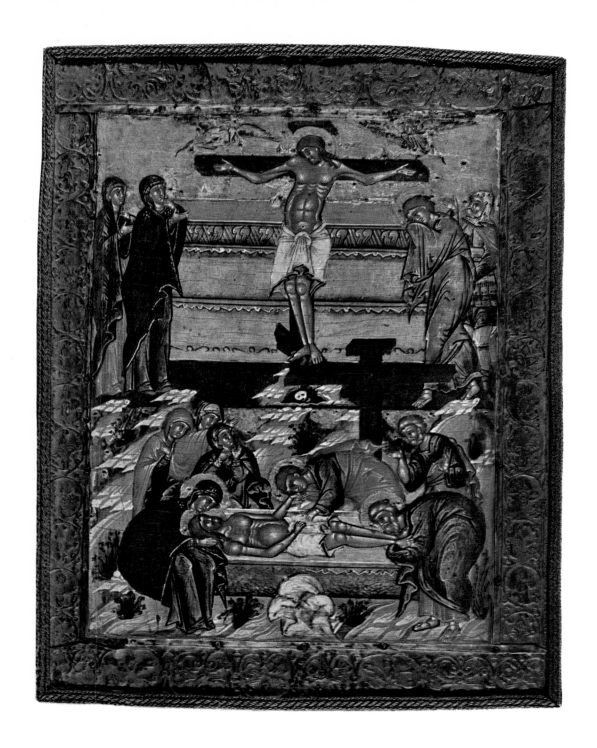

XXX Christ's Crucifixion and Burial. Russian (Moscow), *ca.* 1600

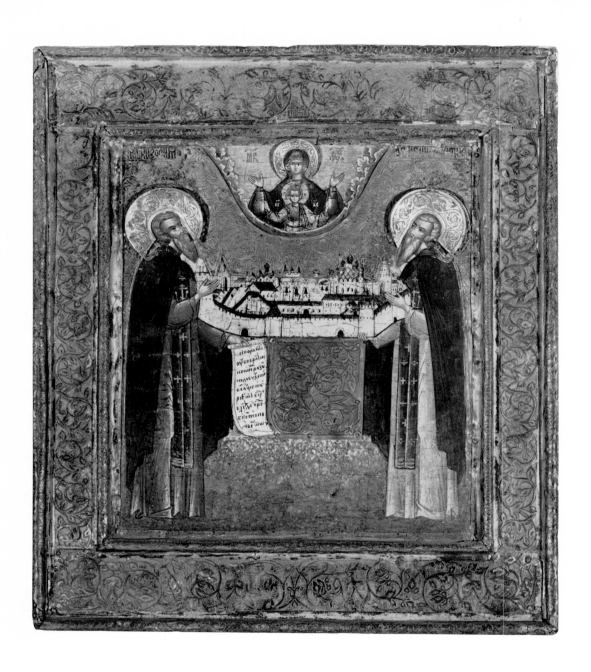

58 Zosimus and Savati of the Solovetski Monastery.
Russian (Moscow), late 16th/early 17th century

has been taught by skilled and expert painters conceals the talent given to him by God and does not instruct any pupil in his art, then he will be condemned by Christ to eternal punishment like the man who buried his talent. So, painters, teach your pupils diligently and do not cunningly hold anything back, or eternal punishment will descend upon you!'

The order requiring badly painted icons to be sold at reduced prices to ignorant villagers throws some light upon what was then a usual practice in the icon trade. But the reply to question LXXIV gives us still more information about the traffic in icons and certain prevalent abuses.

'One sees monks and nuns, poor people, women (beggars) and other lay folk wandering through the country and the towns, estates, provinces and villages and along the roads. They are roving aimlessly about, carrying holy icons. Certain among them, confused by visions and possessed by demons, are looked upon as prophets and collect money for the building of churches, and others in order to purchase the release of prisoners. They appear at markets with their icons. It is a scandalous sight. Persons from other lands and followers of ohter religions are astonished when they see these folk wandering about with their holy icons.

'The Scriptures tell us to show to all things divine the honour that is due to them, and one Passage says: "Cursed be he who doeth the work of the Lord deceitfully." The Tsar should publish a ukase against this abuse and have it loudly proclaimed in the market-places that persons of that kind are forbidden to carry holy icons about with them. Those who collect money for the release of prisoners or for other purposes should appeal to devout persons in God's name, but they must on no account appear publicly with icons in their hands. If anyone goes against this ban, his icons will be taken from him and placed in some holy church. But the malefactors will be driven from the town, so that others will be discouraged by their punishment from carrying on similar practices.'

From all this we can reconstruct a picture of what the icon painter was like at that time and possibly on many occasions in previous centuries too. However, the increasing demand for icons and the need to fulfil that demand led, of course, to a lowering of these standards. Other contributory factors were the new subjects for icons that were appearing towards the end of the 16th century and the political upheaval at the beginning of the 17th, which made it virtually impossible to supervise the painters.

At a synod held in 1553/54 the *dyak* Ivan Mikhailovich Viskovati[64] accused icon painters of breaking away from the iconographical canon when they were repainting the Moscow churches that had been destroyed by fire. For example, he objected to Christ being portrayed as a lamb, and not in human form. He regarded the use of symbols as a threat to the teaching value of icons among the uneducated classes. In his opinion any portrayal of the invisible deity encouraged 'chicanery' and he vehemently attacked pictures illustrating the theme: 'And God rested on the seventh day from all His work.' He objected to pictures of the Crucifixion in which Christ's body was covered by the wings of cherubim, because this represented a 'Latin heresy'. He

sharply attacked clothed figures of Christ on the Cross, a version introduced from Greek art, because Christ did not need to cover Himself up before the eyes of the world. He was afraid of 'cunning and trickery', believing that the unorthodox iconography that had found its way into icon painting was dangerous for the people. The complicated mystical and didactic icons, in particular, could not be understood by the simple believer.

The reformation of icon painting which Viskovati was striving to bring about was opposed by the Church assembly. They sided with the icon painters who had a leaning towards the narrative side of art. There was no Byzantine model for pictures of this type. So the Russian artist had a free hand and could present his subject-matter as he wished.

The snub given to Viskovati clearly illustrates the change that had occurred in icon painting. Viskovati was certainly not an 'obscurantist' or a narrow-minded simpleton, but, in fact, quite the reverse. He occupied a position of importance in the diplomatic *prikaz* of the Tsar, i. e., the foreign affairs department. It was because of his serious concern for the Orthodox faith that he felt obliged to do what he did.

As the middle classes became increasingly prosperous, icon painters produced more and more icons to adorn private houses. The wishes of their patrons had to be respected, so the work they had to carry out was now quite different. Owing to the fairly close contacts between Russia and the rest of Europe, painters were becoming familiar with prints and engravings of Biblical and legendary subjects and were finding models and inspirational material that had not been available to them in the old days. The people now commissioning icons did not just want a devotional picture. During that period, everyone was searching for the answers to a number of vitally urgent questions and these could only be found in religion. Narrative icons presenting an account of events and not intended for use in worship proved to be very helpful. Another point to remember is that the 16th century was the period when 'portrait icons'[65] made their appearance, that is, pictures of secular dignitaries. They were painted in the same way as the old familiar icons, because no other kind of painting was known, but they had, of course, quite a different purpose from icons. So icons which told a story and pictures with iconographical details added to them did not seem as strange as they might have at that time.

From the end of the 15th century we can find icons in Russia that violated one basic principle of icon painting. Unity of time and action had previously been essential in icon painting. Now there was often a relaxation of that principle, with icons showing a whole sequence of events. A state of being, rather than a subject or action, is portrayed in an icon of the Moscow School painted around the turn of the 15th century. It is a symbolic picture of Christ known as 'The Unsleeping Eye'. Christ is resting between the Mother of God and the Archangel Michael. Both Pl. XXXII, p. 187 are watching over Him and Michael is holding a cross, the symbol of redemption, above the young Saviour. The lively background setting on this panel would have been quite unthinkable a few decades previously. The trees and birds of paradise, which add to the symbolism of the picture and are at the same time artistic devices playing their part in the composition, lend a note of

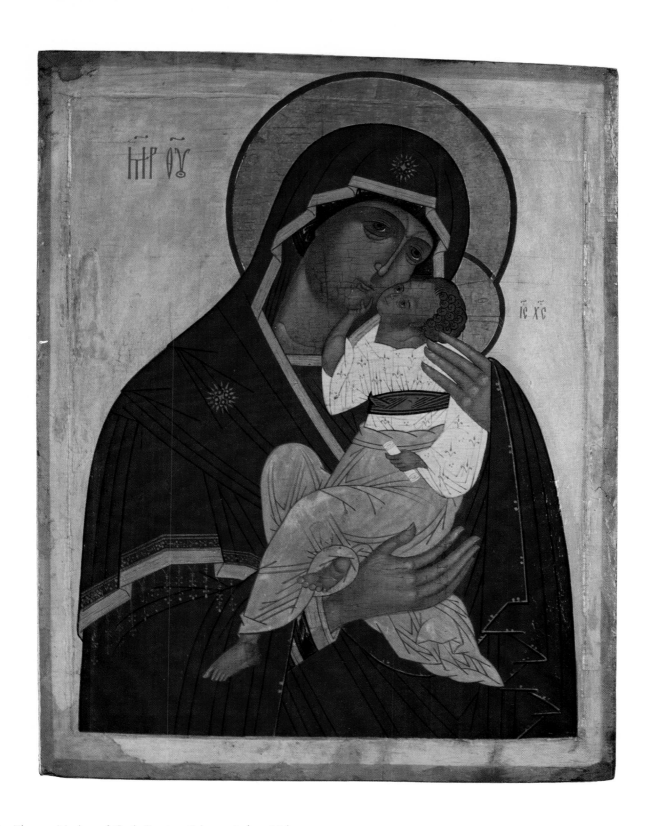

XXXI The Eleousa Mother of God. Russian (Moscow), late 16th century

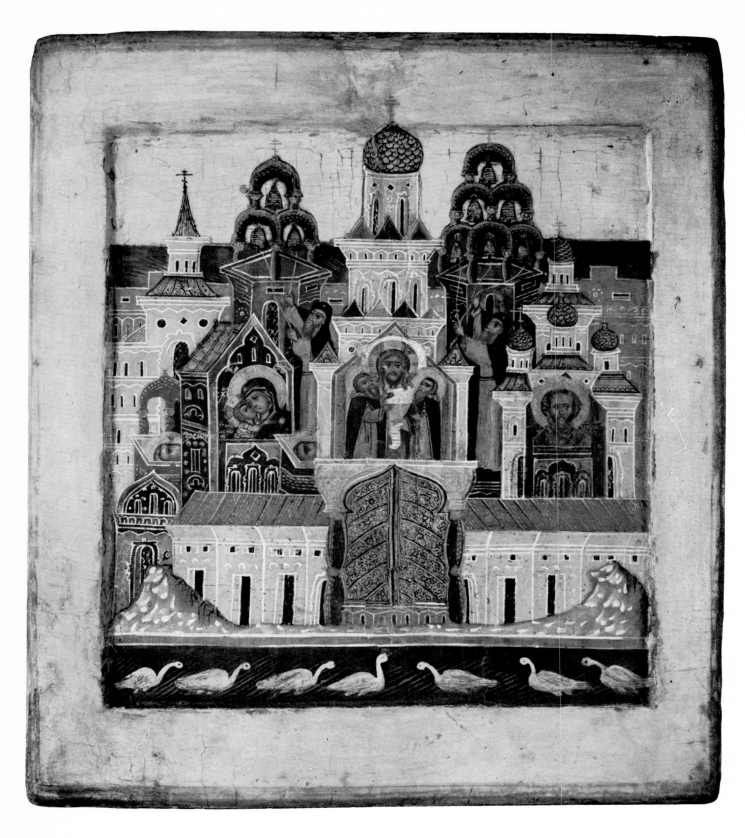

59 Zosimus and Savati of the Solovetski Monastery. Russian (Moscow), mid-17th century

animation that is lacking in earlier icons. But movement is curbed by the emotion that seems to radiate out from this picture. The whole atmosphere is profoundly poetic and this not only helps people to believe, but also makes an appeal to their emotions. The fondness for ornament and detail that was evident in Novgorod and Moscow from the end of the 15th century can be seen here and has set the tone of the entire picture. The icon of the Unsleeping Eye speaks the language of symbolism and allegory. One of the literary sources is the devotional tract of the Physiologos[66]. The viewer is encouraged to study the composition and try to grasp the meaning behind it. But in this respect the panel differs from a true icon, which is merely intended to take us back to the original. Viskovati fully understood this change in purpose, as can be seen from the arguments he used at the Council.

Pl. XXX, p. 179

In addition to narrative icons of this type, there are others combining two related subjects with only a hint of a horizontal division to separate them. An example of this is an icon painted in Moscow about 1600 and depicting the Crucifixion and Burial of Christ. Here the reason for uniting the two scenes is obviously to be sought in their content, in the connection between the Crucifixion and the Burial. But in other combinations the common denominator does not stand out so clearly, as for example in an icon from the Hann Collection dating from the same period. There the Mandylion and the subject: 'Weep not for me, Mother!' are presented together in the same picture. Christ in the Tomb, with His mourning Mother embracing His body, is a subject from the Passion and there is no intrinsic relationship between this and the Mandylion, unless we imagine that the painter was influenced by the West and regarded the Mandylion and

Pl. 57, p. 174

the *sudarium*, or kerchief of St Veronica, as being identical. Icons of Russian saints[67] were becoming commoner at this time because of the country's new feeling of supremacy in the Orthodox world. The artists who painted them were to be found mainly, although not exclusively, at monastic painting centres. Two saints very often depicted in Russian icon painting were Zosimus and Savati from the Solovetski Monastery in the White Sea. They are generally presented showing the humble demeanour of God-fearing abbots raising their arms in prayer to Christ, Who, as here, is shown in a circle segment at the top of the picture, pronouncing a blessing. The icon was painted around 1600, entirely in the old spirit. The absence of frontal posing in icons of this type should not be regarded as a deviation from the old canon.

Pl. 58, p. 180

In the 17th century, Russian saints and founders of monasteries were thought of in close connection with their work. Icons of many of these persons show them placed in front of their monastery. Zosimus and Savati are particularly good examples, of the way Abbots and founders of monasteries recommended their work to the protection of God or the Mother of God. In one icon Zosimus and Savati are holding up a model of their monastery with its multiplicity of towers,

Pl. 59, p. 188

and our Lady of the Sign is shown in a circle segment at the top of the picture, granting the saints' requests. In another icon they were so completely amalgamated with the group of monastery buildings on their island in the White Sea that the icon seems to be a picture of the monastery rather than of the two highly revered saints. Dominant features of this picture are the lofty walls

and the church towers with their multiple structure. The two saints are standing behind the walls in front of the main doorway. But the artist has also shown their inanimate bodies in the reliquary shrines inside the main monastery church. A decorative strip of water with swans indicates the remoteness of the island monastery and perhaps symbolises the peacefulness to be found in that isolated place[68].

The period around the end of the 16th and beginning of the 17th century was a difficult one for Russia. The future of the Empire was in danger and the capital, together with the 'false' Demetrius, fell into the hands of the Poles. This period is closely associated with the name of the Tsar Boris Godunov. A few icons were painted during those years and they have recently been bracketed together as works of the Godunov School. The wall paintings in the cathedral of the Novodevichi Monastery in Smolensk have been linked with that school. The subjects portrayed in them are the 'Akathistos' and the miracles of the 'Mother of God of Lydda'. In spite of the clarity of the composition and the quiet gravity of the figures, they differ fundamentally from the frescoes produced at the beginning of the 16th century. They no longer reflect the sense of inward repose or the stability or shining spirituality so typical of the earlier period, but display a liking for worldly pomp and splendour. The external trappings are given more prominence than the spirituality that lies within. There is a glittering array of bright colours and muted tones. The painters have broken away from the old models or have adapted them to suit their own times. Contemporary costume has been used to replace historically accurate garments and accoutrements. The architecture is largely based on the Russian style at the time of Godunov. We are also struck by the fact that the personal idiosyncrasies of the various painters are quite easy to identify. Each one had his own individual approach and did not trouble to adapt his style to keep in line with the other painters.

Typical icons belonging to the Godunov School are those from the Festival tier on the iconostasis of that same monastery cathedral (Novodevichi) in Smolensk, which, like the wall paintings, were executed in 1598. They display the same characteristics as the frescoes, in that we find that indigenous types of building have been introduced into what is in itself rather clumsy architecture. The two icons of SS. Boris and Gleb from the Pafnuti Borovski Monastery, now exhibited in the Tretyakov Gallery in Moscow, have also been attributed to the Godunov School. One of the two panels, St Gleb[69], has been reproduced, so we have been able to form some idea of what that school was like. In spite of the painter's technical ability these pictures, too, lack the spark of life and inspiration that we notice in earlier works.

Apart from the Godunov School, we find another, quite different, stylistic trend in evidence around the turn of the 16th century. It can be seen in a considerable number of very subtly painted icons possessing tremendous artistic and aesthetic charm. These belong to the Stroganov School. The archaising tendency of the Godunov painters, evident in some of the frescoes, merely showed that it is possible to control the form of a work, but not the spirit. This could not lead icon painting along new paths. In fact, there was no future in it. But real works of art — quite

XXXII Christ, the Unsleeping Eye. Russian (Moscow), ca. 1500

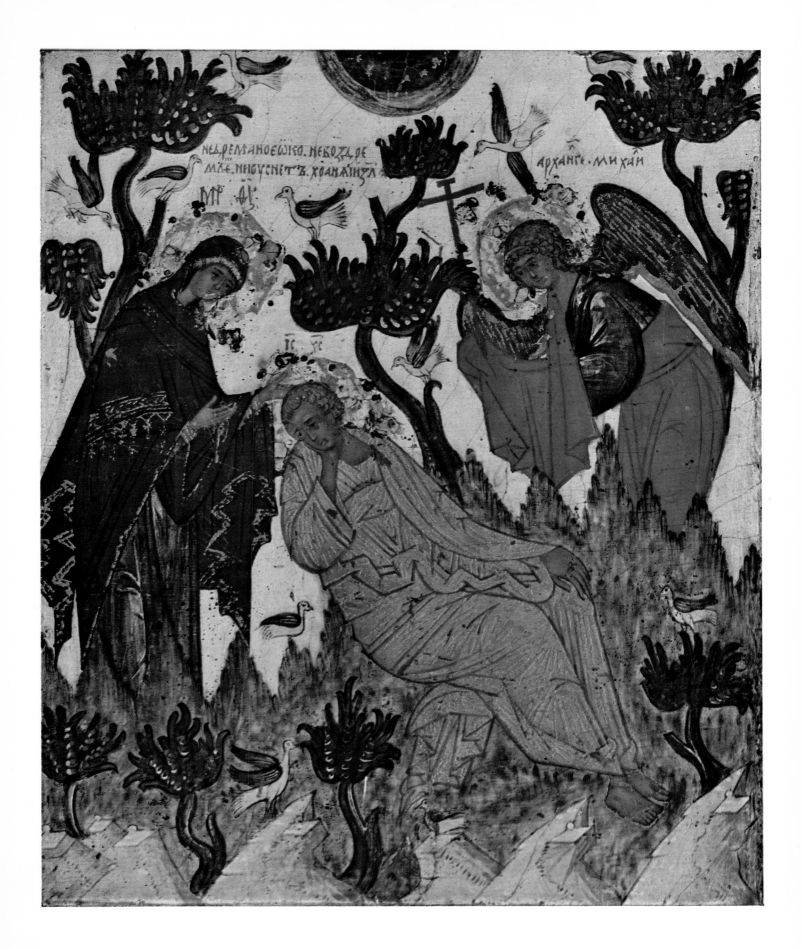

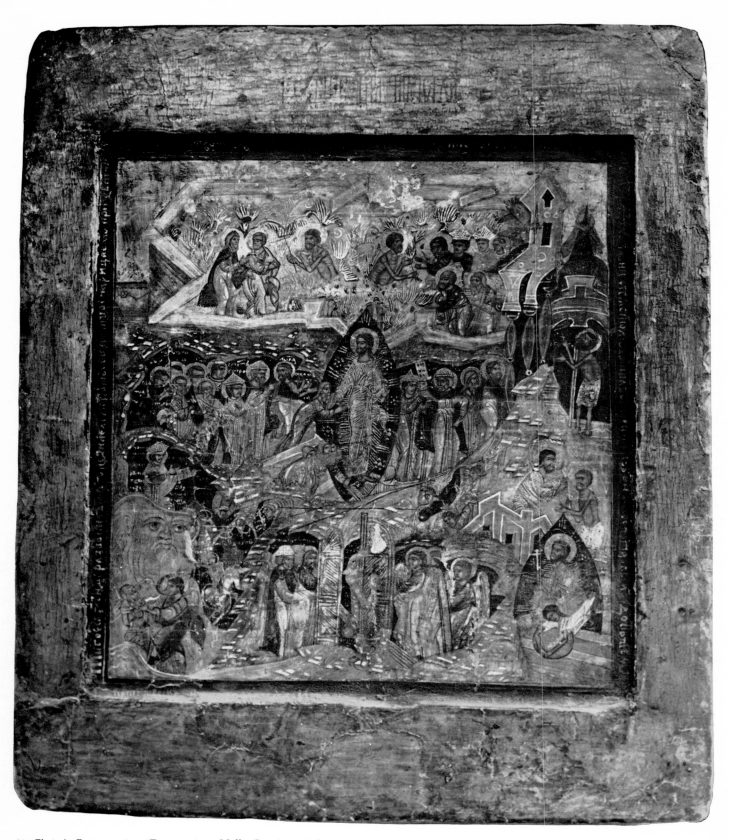

60 Christ's Resurrection (Descent into Hell). Russian. 17th century

different, however, from those produced when Russian icon painting was at its height — were created by the artists who have been associated with the name of Stroganov, the great Russian trading house, and will doubtless remain associated with that name in the years to come, whether there is any proper justification for this or not.

Opinions are divided concerning the origin of the Stroganov School. This term was used first by collectors, who in 19th-century Russia came chiefly from the ranks of the affluent Old Believers. Many panels, done in a very characteristic manner, reminiscent of miniatures, bore the seal of ownership of the Stroganov family, so icons painted in this very popular style came to be referred to as 'Stroganov icons'. A systematic study of icons was made in the last century and the knowledge and experience of the collectors was turned to good account. So the term 'Stroganov painting' was no longer confined to the collectors' world, but was now used to denote a School of artists: 'A special style came into being at the beginning of the 17th century. It was created and popularised by icon painters who have become known as the Stroganov painters. They would appear to form a special School noted for its accurate drawing and carefully executed work. The cradle of this School was in Solvychegodsk, where the famous Stroganovs had their home' [70].

This view was not left unchallenged. It was pointed out that the mere fact that a number of icons happened to bear the mark of the Stroganovs, who were known to have been extremely wealthy and might well have commissioned a great deal of work, was not sufficient proof that they had set up a private painting workshop of their own where icon painters produced items exclusively for them. Moreover, certain of the painters who were supposedly members of the Stroganov School had also worked in Moscow in the workshops of the Tsar. Likhachev, for example, thought there was no proof that the Stroganov School ever existed as the Stroganovs would have been wealthy enough to order icons to be painted for them in the Tsar's workshops. Muratov contradicted Likhachev and, in fact, stated the exact opposite, i. e., he suggested that the Tsars had made use of the icon painters attached to the Stroganovs' trading firm and had commissioned icons from them. And there was another point that worried people in the midst of this whole controversy. Where had the icon painters of the 'Stroganov School' come from? Were they from Moscow or Novgorod?

The Stroganov family originated in Novgorod and moved to Solvychegodsk in 1470. Fedor Lukich Stroganov, a man of wealth, was the ancestor of the merchant family that was to become so important in the years to come. His prosperity came from the salt deposits in the region. His sons and grandsons added to that wealth, but were also interested in art and a number of them, for example Maxim and Nikita, actually painted icons themselves. The Stroganovs did a great deal to establish settlements and built many churches. They also took a special interest in providing suitable decorations for the churches of Solvychegodsk, where they had their home.

By the mere fact that they were patrons of the arts, the Stroganovs undoubtedly had an influence on icon painting and, as they were familiar with its problems and actually dabbled in

this specialised art themselves, it is surely not wrong to use the term 'Stroganov School' for a group of painters who certainly reflected their own particular taste, even if some of them did also belong to the Tsar's School in Moscow. It is very likely that, in addition to these excellent artists associated with the Stroganovs, there were simpler workshops of a craftsman-like character. These would have been responsible for painting icons for the numerous village churches in the area, but, unlike the great masters, the names of these artists have not been handed down to us.

It has been quite rightly stated that the Stroganov School followed various trends and the work of a number of the artists closely resembled Muscovite painting of the 17th century. But there are certain stylistic features that tend to recur in Stroganov painting and are characteristic of pictures painted in this highly decorative manner, after the fashion of miniatures. So in the new edition of the *History of Russian Art* the term 'Stroganov School', which has already acquired a definite connotation, has been retained.

We can be grateful to the Stroganovs not only for collecting and commissioning icons, but for adding to our knowledge of Russian icon painting at the turn of the 16th century — as art collectors they were in the habit of noting down the artist's name on the icon. So it is possible for us to study the work of some of the Stroganov painters and learn more about the connections between the Stroganov painters and the Tsar's School in Moscow.

The painters of the Stroganov School had a different conception of art from the painters at the beginning of the 16th century. The works of these new masters lack the balance and repose we found in icons from the period after Rublev and Dionisi. They strike a very delicate, sensitive note. An icon of the Archangel Michael, forming the central panel of a triptych with Pl. XXXIII, p. 191 saints of house and home, displays the main characteristics of this new school. It was produced in the period after 1600, when the Stroganov School was still flourishing. This is a meticulous piece of work, delicately drawn. Sensitive linework has been used to sketch in all the details of the angelic figure, and the cloud under Michael's feet and the two bushes which provide the background interest have all the grace and charm of a miniature. An artist with such an intuitive appreciation of all the fine points of drawing and composition must have welcomed every opportunity of adding ornament and decorations. The Archangel's glittering gold armour and wings have been most delicately drawn and are also patterned with slender gold lines which give an astonishingly pleasing effect. The drawing of the head and face reveals the same almost calligraphic touches.

It is quite obvious that the artists working on these pictures were intent on creating aesthetic effects. Their aim was not merely to produce a devotional icon, but to give the viewer something on which he could really feast his eyes. The advantages of this type of art with its strongly graphical bias were, of course, only fully evident in pictures where the subject matter was complicated. We see this confirmed in another icon from the early 17th century, portraying Divine Wisdom accompanied by a whole host of figures. The artist of this picture has not Pl. 61, p. 192 merely painted the two side figures in the Deesis group and the angels over Sophia, but has

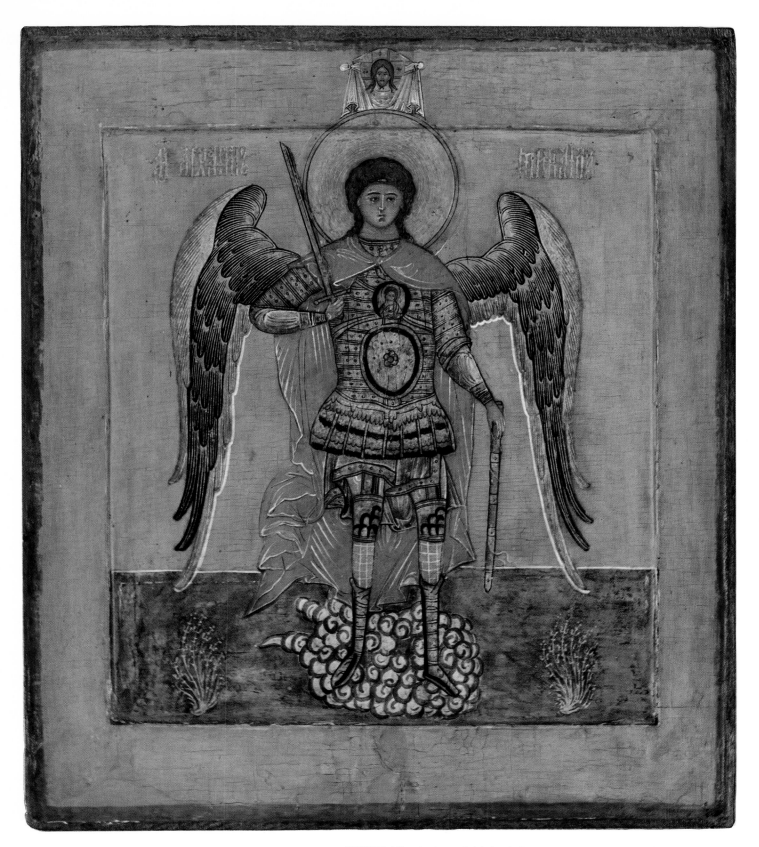

XXXIII The Archangel Michael. Russian (Stroganov School), 17th century

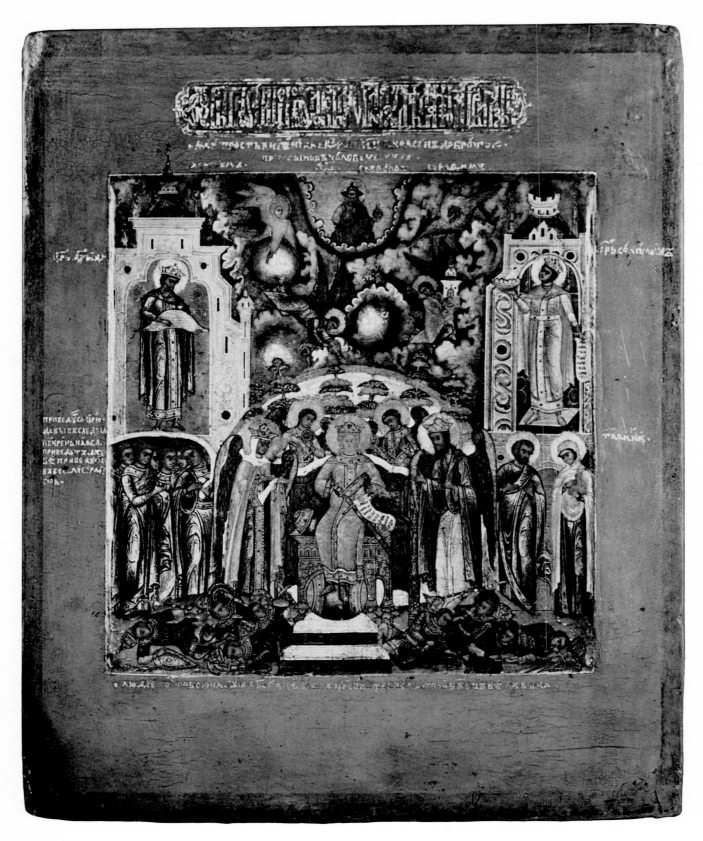

61 Sophia, Divine Wisdom. Russian (Stroganov School), 17th century

enlarged the pictorial content and accentuated the narrative element by adding saints and angels and making the trees in Paradise appear behind the throne of Sophia. But even this was not enough. The space between the throne of Sophia and God the Father, Who is suspended over the fiery angel with the globe of the Cosmos and is giving a blessing, has been filled in with stylised ornamental clouds, all very carefully shaded. There are also two angels flying towards Sophia. Because of the cruciform nimbus she can be taken to represent Christ. The two inside compartments of the icon are also filled up with two groups of saints, one above the other, with King David and King Solomon at the top. A great host of warriors is assembled round the throne of Sophia and the inscription in gold along the bottom of the picture says that they illustrate the might of God to which men must yield. As we might expect, the artist was also aware of the ornamental possibilities of the inscription. The gold letters of the title have been formed into a harmonious pattern on a gleaming red ground.

Pl. XXXIV, p. 195 Another dramatic scene is shown in the icon that depicts the Beheading of John the Baptist. Once again we are struck by the fineness of the drawing and also the exquisite colours, which give this little panel a strong aesthetic appeal. The background for the action is provided by John the Baptist's prison, which is guarded by a Russian palisade and is of a soft red colour with sober ornamental lines appearing in the architecture. John the Baptist is bowed in prayer to God, with his arms raised, waiting for the fatal blow to be struck. The chalice in which his head is to be laid is standing on the ground in front of him. A young man is coming slowly up to him with a kind of skipping step and is drawing his sword out of its scabbard. This detail alone tells us that he is the executioner. In other respects this figure is so graceful and fragile and has such a gentle expression and moves so charmingly that we would not think him capable of holding such a gruesome office. The artist's delight in all things precious and ornamental caused him to mark thin gold lines even on the skins clothing the ascetic John, and God the Father can be seen surrounded by very fine gold rays. He appears in the circle segment at the top right-hand corner of the picture, but this is no sedate figure giving a benediction. He is hurtling through the air towards John the Baptist, blessing him as He flies along.

Pl. 62, p. 196 The icon of the Saints Boris and Gleb, sons of St Vladimir, who were put to death by their brother and are Russia's earliest Christian saints, has been painted in softer tones. Between the two brothers we see an artistic bush with tendrils reminiscent of the icon portraying the Archangel Michael. On the robes of the Grand Duke's sons the painter has been able to indulge his love of ornament to the full.

Pl. 64, p. 198 The Stroganov painters loved producing vivid pictures covering only a small area. Work of this kind can be seen on a little domestic altar. The sixteen small compartments with pictures taken from the life of Christ and, above all, the Mother of God, obey the rules relating to the portrayal of Feast days. The rounded tops of the two altar wings, which present narrative material, have given the artist scope for a freer rendering and he has contrived to set out his compositions in a lively, vivid manner.

Although the icons of the Stroganov School specially stress the aesthetic side, the final effect is not one of cold, polished perfection. We can often sense really deep emotion. Seriousness and melancholy of a special type are stamped on the faces of the figures, for example, the Archangel Michael and John the Baptist in the icons illustrated here. Feeling has been presented, as it were, in a concrete form in the facial expression and also in the postures and events.

Stroganov icons are not intended for a large hall or even a church. Because they are of small to medium size they need to be examined at close quarters, although we must not be so preoccupied with the content that we fail to notice the exquisite fineness of the work. They appeal not only to the pious (who are less concerned with the painter's artistic skill), but also to all those who are able to appreciate the form in which the subject is presented to them.

The icons of the Stroganov School were aimed, consciously or unconsciously, at a very definite group of people — all those who were interested in aesthetic enjoyment and did not merely want a religious picture in their homes, but who wished to have something beautiful to look at. So the Stroganov painter was really working for the cultured classes, the court and the rich merchants, or, at least, those who had not lost their feeling for beauty. And it is surely no mere accident that the painting at the Tsar's court in Moscow and the painting of the Stroganov School coincided in many respects, and that the painters of one School worked for the other, also that both patrons — the court and the Stroganovs — two roughly similar circles, had a very high regard for this new style. It has been said that the miniature-like style of these artists led icon painting down a blind alley and that they looked at their work too much from a purely formal and external point of view. But this criticism is rather one-sided. Their painting is, of course, based on a completely different conception of art, but we do not find this only among the artists; it was also typical of the people who loved and respected that particular type of work. Times had changed and people were altering their way of life. Manners were becoming more refined and, apart from the wearisome everyday routine, life gave scope for gaiety and social activities.

The most important exponent of this new method of painting was Prokopi Chirin. He was highly thought of by his contemporaries annd by those who came after him and towards the end of his life he became master of the *Oruzheini Prikaz*, the leading workshop of the Tsars. He was so greatly respected that Nikita Stroganov considered it worth mentioning that the drawing at least on a certain icon had been done by Prokopi Chirin. But he gave no indication of the artists who had subsequently painted the icon[71].

Prokopi Chirin died in the 1620s. His work was closely linked with the house of Stroganov, who gladly commissioned paintings from him in preference to all others. But he probably also worked for the court of the Tsar at the end of the 16th century.

On an icon of Nikita, the Warrior Saint and patron of Nikita Grigorevich Stroganov, we find the following inscription: 'In the summer of 1593 this icon was painted in Moscow by Prokopi, the icon painter from Novgorod. He decorated the icon with repoussé silver and gilded

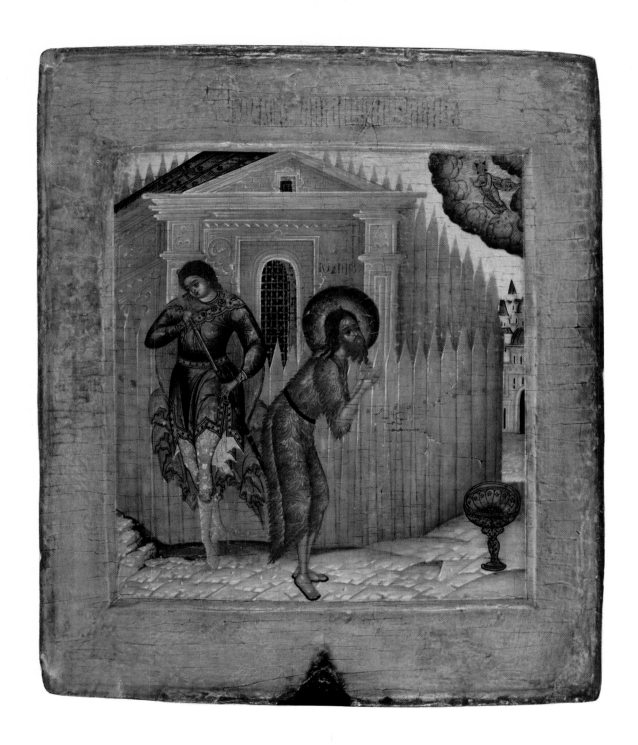

XXXIV The Beheading of John the Baptist. Russian (Stroganov School), 17th century

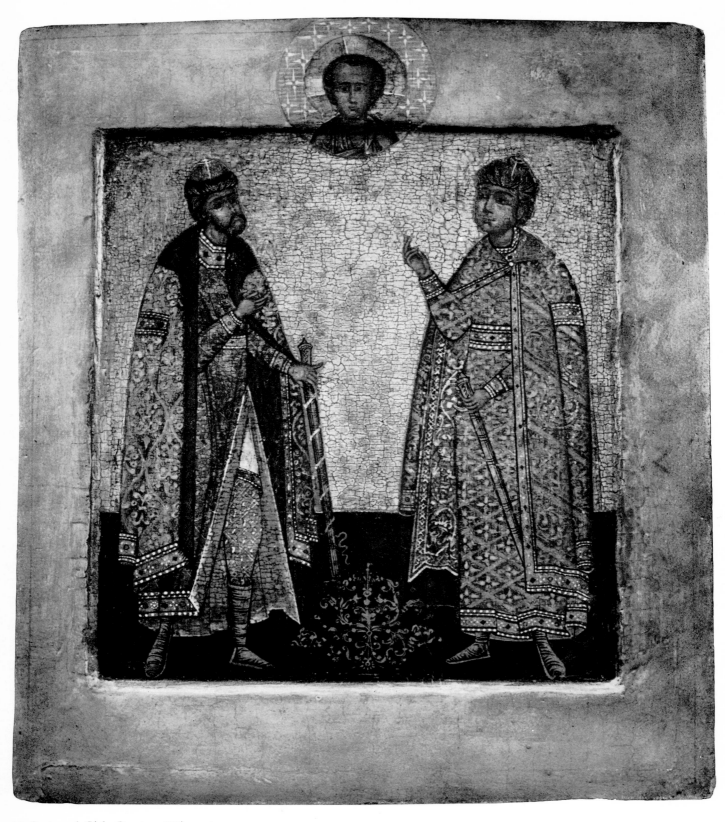

62 Boris and Gleb. Russian, 17th century

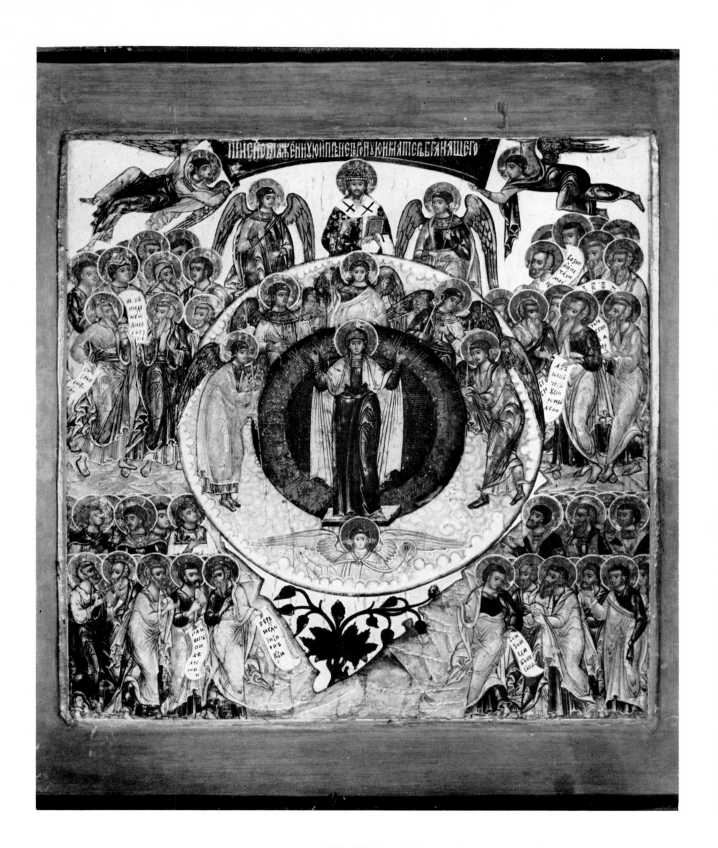

63 'The Whole of Creation Rejoices over Thee.' Russian, 17th century

64 Two Wings of a Domestic Altar. Russian (Stroganov School), 17th century

it and adorned it with pearls and precious stones. 1597, the 15th day of the month of September. Nikita Grigoriev, son of Stroganov' [72]. As this icon is stylistically in keeping with the works of Prokopi Chirin, we can assume that the Prokopi from Novgorod who painted the icon in Moscow was none other than Prokopi Chirin. There is only a slight difference in the colouring.

Another famous Stroganov painter who often worked with Chirin was Nikifor Savin. He came from an old family of painters, including two who worked for the Tsar's School and also for the Stroganovs. We still have a record of the prices paid by Nikita Stroganov for work by Nasari Savin — 22 roubles in one case and 50 roubles for a Petrovskaya Mother of God — an extremely large sum for those days.

Nikifor Savin often tried to add life to his pictures and reverted to scenes from nature. For example, he painted trees with realistic trunks and not just suggestions of trees or symbols, such as we found in the old icons. Nikifor Savin even painted individual twigs and leaves. There is variety in his pictures and an unusual amount of tiny detail in the background. We find animals, such as lions and deer, living on the river banks and birds sitting on the trees. He has painted real landscapes and has set out to make them look as natural as possible. Russian icons had never presented nature in this way before.

The Stroganov School was already past its peak by the early 1620's. The artists who produced these detailed, miniature-like paintings had always been very closely connected with the Tsar's workshops and a number of their stylistic devices survived there — devices that would not have struck the Muscovite artists as being in any way unusual as they had often worked together or for both patrons.

In the 17th century another type of picture was also highly thought of and became very common — icons painted by the 'continuous' method. In these, the narrative element comes out strongly and is, in fact, the dominant feature. The quiet repose of the old devotional icons could not be present in a panel which was meant to tell a story. We see this clearly in a version of Christ's Descent into Hell, done by the 'continuous' method. Round the actual Descent into Hell, which was formerly the sole subject of the picture, we find a comprehensive series of scenes. These have not been separated off in any way, so they simply run into one another. The story spans the period from the Crucifixion and time of mourning to the Resurrection and so on to the central theme of the Descent into Hell. Paradise, a garden in which the righteous can be seen strolling, has been included in the border of scenes running along the top. The good thief is standing at the gate. He appears in a further scene in the garden, where we see him receiving a friendly welcome from the patriarchs. As a contrast to Paradise, Hades is shown at the bottom of the picture. It is no longer just hinted at and symbolised by the gates of Hell burst open and laid over each other in the form of a cross. The whole story of the victory of the angels over the devils has been painted with a great relish for detail. We see the knocking at the gate of Hell, the mouth of Hell and the terrified devils — in some icons the angels are shown raining blows upon them. The gestures of the dead express a mood of joyful expectation, as they walk towards

199

the shattered gate of the gloomy underworld. In many icons the slanting edge running round the picture ground is decorated with a line of prayers referring to the Resurrection of Christ and praising the Redemption of Mankind.

Similar examples of the continuous method of painting can be seen in pictures of various saints. Surviving panels of this kind very often depict the Prophet Elijah, also regarded in Russia as the patron saint of the weather[73]. The legend of that celebrated penitent Mary of Egypt is also presented quite frequently in 'continuous' form.

Pictures of this kind are more than plain narratives. They provide instruction and edification as well. Symbolism was almost entirely absent when icon painting was at its height, but was now finding its way into art. Panels of this kind were very common from the middle of the 17th century and in the 18th as well and have, in fact, been described as mystical and didactic icons. A favourite picture of the Mother of God in that late period was of the type known as the 'Burning Thornbush' — the bush that could not be destroyed. There is a picture of Mary Pl. 65, p. 202 inside an eight-pointed star. The spaces between these points are occupied by angels set against a cloudy background and Old Testament visions are grouped round the picture. These visions are linked with the coming of the Redeemer and extol the Mother of God. Very often icons with an instructive or a mystical and didactic content of this kind have many lines of lettering running along the margins of the picture. These refer to and explain the adjoining scenes. Another type of icon glorifying the Mother of God and paying homage to her is entitled: 'The Whole of Pl. 63, p. 197 Creation Rejoices Over Thee.' It shows the Mother of God in an attitude of prayer between the choirs of saints and angels.

But, just when these particular types of pictures that had been little known earlier on were becoming quite common, another change of a completely different kind was taking place. Old subjects were being reshaped, and models and ideas for interpreting the traditional material were being imported from Western painting, with which the Muscovites had become familiar through the foreigners' suburb in Moscow. The more lively and natural approach of Western art and its use of realistic scenery could be seen in woodcuts and engravings. A group of artists, the most important of whom was Simon Ushakov (1626—1686)[74], adopted the new forms of expression and the various artistic devices from the West and tried to combine them with the traditional method of painting. Ushakov lived in a period of tension, when Nikon was busy reforming the Church. This caused the Russian Orthodox Church to split up into two groups — the True Believers, or supporters of the State Church, and the heretics, or Old Believers. Ushakov tried to proceed along new lines in icon painting, but was unsuccessful. We find a delicate and harmonious combination of icon painting and Western influences in a version of the Image of Christ Not Made by Human Hands. This new note is introduced discreetly in the presentation Pl. XXXV, p. 201 of the strands of hair, the modelling of the face and the extremely fine floral ornament on the linen cloth.

 XXXV The Image of Christ Not Made by Human Hands. Russian, late 17th century

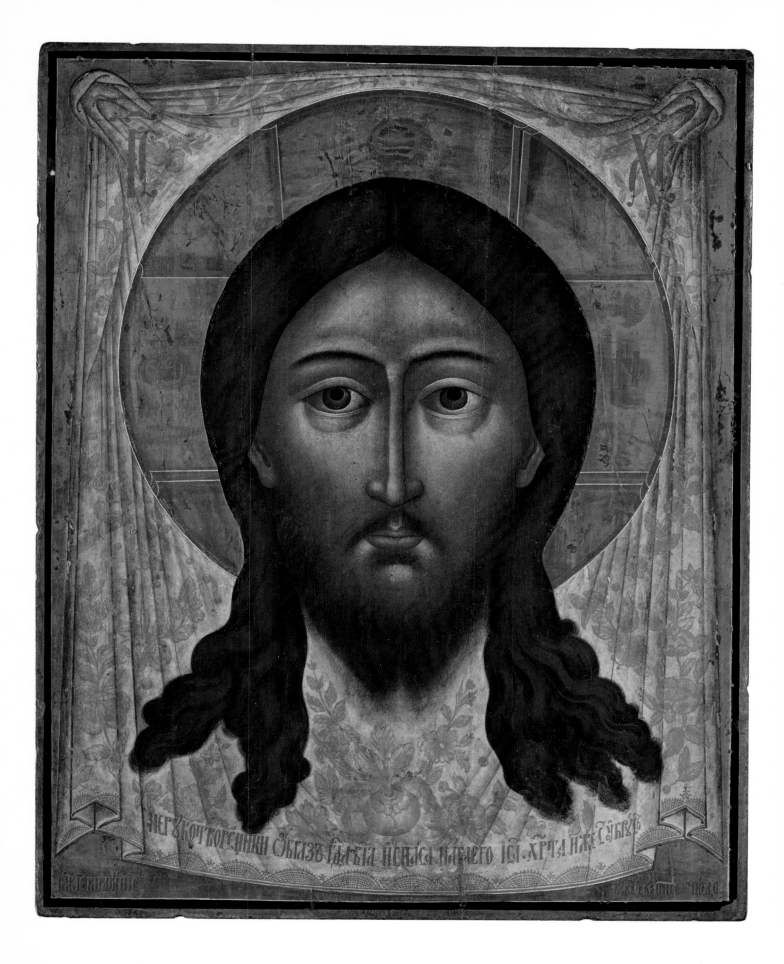

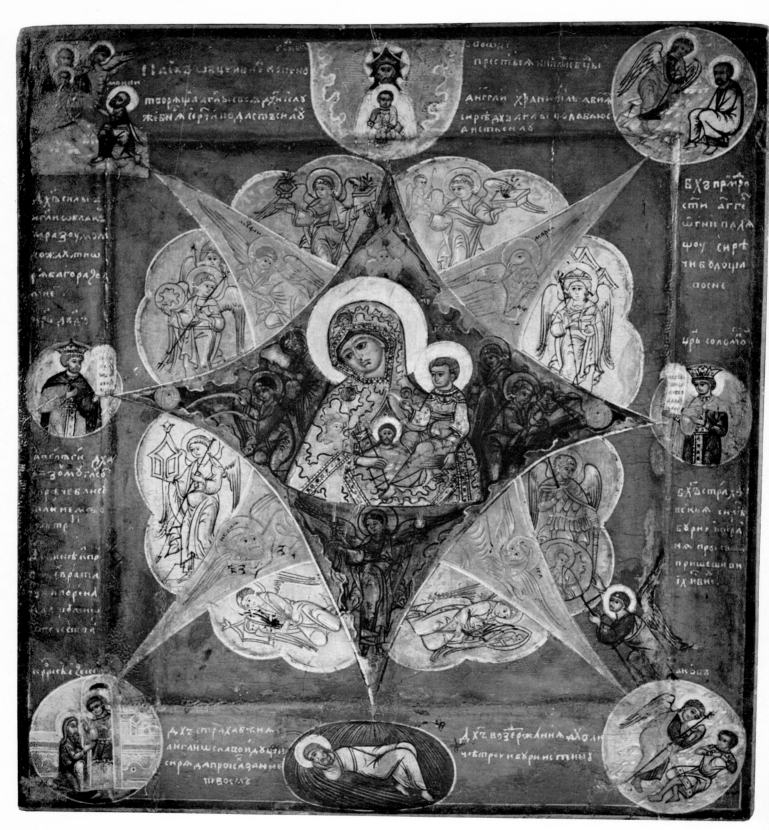

65 The 'Burning Thornbush' Mother of God. Russian, late 17th century

These innovators, like so many of the artists searching for new paths to follow, were far from being free-thinkers. They were loyal supporters of the Orthodox faith and were merely trying to remould the old compositions and present them differently. They wondered why the faces had always to be painted dark. They also wanted to show a seated figure of the Mother of God in the Nativity icons because she felt no pain or weakness. This group of men did not regard tradition as a mechanical process of carrying on the forms that had been handed down to them — they were aware of an inner thread of continuity. They therefore tried to direct the old type of icon painting into new channels. But they were unsuccessful, because icons occupied a very special position, somewhere between art and religion. They had their roots in religion and, when that connection was severed, something vital was lost and the icon as such was no longer viable. The cataclysmic changes taking place in the world and the gradual drift away from religion, with which the whole life of mediaeval man had been bound up, led to a decline in icon painting. The harmony between life, religion and art had ceased to exist and, unless there was a combination of all three, icon painting could not be a living art. There was rigid retention of empty form, as imposed by the State Church from the middle of the 17th century, after the Moscow Synod. We find evidence of this in a worried postscript added by Joachim, Patriarch of Moscow and All Russia, to his will in 1690. It clearly expresses the uncompromising reactionary thinking of the Church leaders: 'I request and beseech the Tsar's Most Serene Majesty to command that holy images of Christ Jesus, God in human form, and the Holy Mother of Our Lord and all the Saints should be painted in the traditional Greek manner, like the old miracle-working icons, and on no account after the fashion of those new-fangled Latin and German pictures, which are both irritating and unseemly. They reflect the sensuality of these heretics and offend against our Church tradition. Should icons of this type be found in any church inside the Empire, it is imperative that they be thrown out, for the heretics paint the Holy Virgin, the helpmate of honest Joseph and Mother of Christ, with her head uncovered and her hair adorned. They also paint many other holy women with their heads uncovered and holy men according to the usages current in each individual country. But it was never the custom to have such pictures in the Greek or the Russian Church and even now they are not recognised. For we believe that the Most Holy Mother of God remained a Virgin even after the birth of Christ. Our Church therefore cannot and will not countenance these new pictures under any consideration.' The Church body that had to deal with the complaints of the *dyak* Viskovati over a century before stated quite explicitly that anything brought in from outside the Greek or Russian Church was not necessarily to be considered heretical *a priori*. But the lines written by the Patriarch Joachim reveal a reactionary approach and a harsh rejection of the new and creative spirit of enquiry.

The reforms of Peter the Great, which grafted the European way of life on to the Russian, prevented any further attempts at reshaping the art of icon painting. Members of the new society regarded Western elegance as the only model worth aspiring to and were captivated by the very different magic of the Rococo style, so they soon viewed that restful old branch of art with a

66 Preliminary Sketch of an Icon with the Image of Christ Not Made by Human Hands. Russian, 17th century

rather contemptuous smile. They began to be ashamed of their old original forms of expression and preferred the humanised pictures of the 'new' world they had discovered rather than their own creations. Many painters tried to master the new technique rapidly and forget the old one. But the religious painting produced during the next few decades is generally experimental and imitative in appearance.

The art of icon painting degenerated and became merely an occupation for pious monks who did not attempt to produce great works of art, but devoutly painted pictures to please the religious. In a few painting villages in the province of Vladimir, such as Palekh, Kholuy and Mstera[75], guilds of icon painters actually went on producing work in the same traditional way right up to the 20th century. But even in these villages icon painting did not really survive in the true sense. Even the later works of the Palekh painters are saturated with sweetness and sheer sentimentality, although in the early days, around the beginning of the 18th century, we are still reminded in some of their pictures of the delicate stylishness of the Stroganov icons. However, by about the beginning of the 20th century these icon villages already had an extensive sales organisation, with representatives to market their pictures. In this way, a form of art that was both powerful and profound and seemed to reach out towards the other world came to an end, bogged down by the commercialism of our earthly life.

PICTURES INSIDE THE CHURCH

As the iconostasis changed and developed, icons came to occupy a very special place inside the church building, and so wall paintings declined in importance and were supplanted. The towering iconostasis with its many tiers of pictures caused people to look towards the altar niche and the most important pieces of monumental art were concealed behind its complicated structure. So frescoes could no longer be regarded as the central feature of the church.

In this way the iconostasis became a dividing wall which dominated the place of worship, especially in Russia, with the result that icon painting came to occupy a very special position within the general field of Church art.

Early prototypes of the iconostasis took the form of screens between the sanctuary and the nave of the church. These apparently existed even in the days of Paulus Silentiarius. In his poem in praise of the Hagia Sophia in Constantinople he mentioned that the columns between the altar and the nave, which were covered with silver, were decorated with pictures in relief. We are probably correct in assuming, on the basis of recent research, that these relief pictures did not appear on the actual columns, but were attached to the beams of the dividing screens. Pictures of Christ and a whole host of angels, prophets and apostles were given a place there. Previously the architrave had only been adorned with a cross. When the cross was replaced by an icon of Our Saviour, this was not necessarily hung on the architrave, but was also put up at the top, as the cross had been. The icons of Christ were painted on wooden panels which varied in size, depending on whether He was shown alone or with accompanying figures. The board was referred to in Greek as a 'templon', and was very broad if a large group had to be portrayed. The word *templon* would appear to have been used originally for the architrave, but was later transfered to the icon panel showing the holy pictures. Even today the term *templon* is currently used in Greece to mean the iconostasis.

The Deesis composition was to be found in the middle part of the architrave over the entrance customarily referred to as the Royal Door, or Holy Door, through which only the priest passed at certain times, as laid down in the liturgy, so giving the congregation a glimpse of the holy of holies. Very soon after the Deesis group had appeared on the architrave, a new tier of icons was added in Byzantine regions between the upper arch of the Royal Door and the bottom of the Deesis. These icons were portable, and depicted the main festivals of the Christian churches. They were generally referred to as 'worshipping icons', as the icon for the current festival was taken down from the architrave and set up in front of the iconostasis so that it could be worshipped. This custom appears to have been introduced in the 11th century, but was not generally adopted in all churches. This simplified Byzantine version of the iconostasis with only two rows of pictures, the top one representing an enlarged Deesis tier in which icons of the archangels, apostles, bishops, martyrs and ascetics were added symmetrically on both sides of Christ, the Virgin and John the Baptist, and a second tier, below the first, illustrating the Christian festivals,

has survived in a number of churches in the Western Ukraine. The iconostasis is often surmounted by a carved cross set up over the icon of Christ. But the vital part of every iconostasis has always been the Deesis, signifying the intercession made by the Mother of God, John the Baptist and all the saints to Christ, the Judge of the World, as they plead with Him to forgive the sins of mankind.

A different type of iconostasis appeared in Russia and was also introduced into the Balkan countries later on. Two further tiers of pictures showing the prophets and the patriarchs were added to the two containing the Deesis and the festivals of the Church. This increase in the number of pictures accentuated the symbolic character of the iconostasis still further. The tiers containing the patriarchs from Adam and Moses onwards and the prophets represent the Old Testament Church. The Prophets are often shown merely as half-length figures, holding scrolls in their hands. These unrolled sheets with writing on them contain prophecies referring to the coming of Christ as Redeemer of the World. A meaningful and important centrepiece has been incorporated in the two tiers of Old Testament pictures — a panel of the Trinity appears with the Patriarchs, and with the prophets there is a Mother of God of the Znamenie type (Our Lady of the Sign). This type of Mother of God was the most suitable for bridging the gap between the events of the Old and the New Testament, as the picture is based on the prophecy of Isaiah that a virgin would bring forth a child that would bear the name Emmanuel. Mary is shown here in an Orans pose, carrying the floating figure of the Holy Infant in an aureole in front of her breast. Under these two tiers of Old Testament pictures came the Festival tier, containing the twelve main festivals of the Christian Church. These included six festivals connected with Christ: Nativity, Presentation of Christ in the Temple, Baptism, Christ's Entry into Jerusalem, the Descent into Hell and the Ascension. There were also four festivals of the Mother of God: Nativity of Mary, Mary Being Led into the Temple, the Annunciation and the Dormition of the Mother of God, which in the iconography of the Eastern Church replaces the Feast of the Assumption. In addition to these ten festivals there is also the Pentecost icon, showing either the Trinity in the form of the Philoxenia, i. e., the Visit of the Three Angels to Abraham and Sarah in the Grove of Mamre, or the Descent of the Holy Spirit. The twelfth

67 Preliminary Sketch of an Icon of the Mirozhskaya Mother of God. Russian, 17th century

festival commemorates the Elevation of the Cross, intended as a reminder of the re-erection of the cross under the Emperor Heraclius. These twelve main festivals form the essential part of the Festival tier. But in really large churches we may find that further icons and pictures illustrating the life of Christ or the Mother of God have been added as well. The principal ones included are the Raising of Lazarus and the Crucifixion of Christ and, among the festivals of Mary, a picture illustrating her roles of protection and intercession (*Pokrov*), which is particularly common in Russia and goes back to a 'manifestation' of Mary in the Blachernae Church in Constantinople. The Festival tier is intended to show how Salvation has been brought about by Christ's sojourn on Earth, His sacrifice and His Resurrection. On Russian iconostases the Deesis comes underneath this Festival tier in an expanded form, with a great many figures. Where possible, if the church is large enough, the importance of this tier as the focal point of the whole structure is emphasised by the use of full-length figures. In this way the Deesis can immediately be identified as the immutable central feature of that entire wall of pictures. We have already mentioned the fact that the Deesis figures in the Cathedral of the Assumption in Moscow, on which Feofan Grek and Andrei Rublev both worked, were painted on icon panels over two metres tall and one metre broad.

A definite programme was also devised for the portion of the screen below the Deesis tier, with the three doors leading through it. The most important was the Royal Door, situated in the middle of the iconostasis and in a straight line below the figure of Christ in the Deesis. The Evangelists appeared on it in four separate rectangular compartments and occasionally pictures of certain of the venerated Church Fathers, and there was another picture of the Annunciation on the curved top portion of the door. The arch between the top of the door and the bottom of the Deesis tier was decorated with a picture of the Lord's Supper. It is not usually regarded as the last time that Christ and His Disciples were together, but is meant to show the institution of Our Lord's Supper as a sacrament. Christ is painted twice. On each occasion a group of six apostles can be seen approaching Him and He is offering them the wine and the bread. An icon of the Mother of God always hangs to the left of the Royal Door and on the right an icon of Christ. Beside this we generally find an icon representing the holy person or event to which the particular church is dedicated. In a church dedicated to the Beheading of John the Baptist a picture illustrating that subject is placed on the right of the Royal Door, and in a church dedicated to St Nicholas we would find a picture of the Bishop of Myra occupying that position. Pictures of archangels or holy deacons were usually chosen to decorate the two side doors, i. e., the north and south doors leading into the diakonikon and the prothesis. The rest of this portion of the iconostasis below the Deesis, also referred to as the worshipping tier because the pictures were at a suitable height for people visiting the church, did not have to follow such strict rules, so there was some scope for subjects of local interest. In addition to these pictures on the iconostasis there were others on lecterns, known as *proskynetaria*, between the iconostasis and the

Pl. XXII, p.139

207

congregation. These pictures were objects of special veneration. Believers kissed them and candles were placed in front of them.

So this expanded version of the picture screen that we find in Russia came to include all the subjects that had been used to adorn church interiors from the Middle Byzantine period onwards in the form of frescoes according to a definite pattern. The prophets and patriarchs were moved from the dome, the Christian Festivals from the walls and the vault area, and the Deesis from the apse, and the Eucharist, the Annunciation and the Evangelists were given a place on the Royal Door or in the space between it and the Deesis tier.

HOW ICONS WERE MADE AND DECORATED

Before embarking on the various technical processes, the icon-maker had to select a suitable type of wood. It had to be as free from resin as possible and preferably broad enough to avoid the necessity of joining several boards together. In Russia, oak, alder and birch were frequently used, and in Greece and the East another popular wood was cypress. The boards were trimmed with an axe in Russia and even today Russians wield that implement with great skill. They first of all prepared the ground of the picture by making a depression in the wood, but leaving a slightly raised edge all round. On old icons these margins were comparatively narrow, but became wider on the more recent panels. If the icon had to be made from several boards fitted together, warping was prevented by means of cross-pieces which were originally inserted in the boards at the top and bottom edge, but were later fitted into the back of the icon in the form of sliding bars.

As soon as the wood had been properly seasoned, the next stage was to provide a support for the paint. Canvas was often put on the ground area after it had been scraped and coated with size. This served a twofold purpose. It made the wood firmer and thus prevented warping of the panel to some extent, and it also provided the chalk ground with a more secure support than wood alone. Examination of the famous icon of the Virgin of Vladimir in the State Restoration Workshops in Moscow has disproved the theory that a canvas underlay was not introduced until the 14th century. Part of that picture is underlaid with canvas — in fact, the very part that has been found to belong to the original painting, i. e., the heads of the Virgin and the Christ Child. Here we have one good reason why these very important portions of the icon show the highest degree of preservation and the least damage. Parts of icons where the chalk ground was applied to the wood have deteriorated considerably, as the icons were faced with metal at various times; this decoration was torn off by looters and the parts in question had to be renewed on several occasions.

68 Preliminary Sketch of
an Icon of the
Unsleeping Eye.
Russian, 17th century

As the icon of the Vladimir Mother of God has already been shown by the Chronicle to have been in Russia as early as the middle of the 12th century, the use of canvas as an underlay for the paint ground must therefore go back to the beginning of the 12th century, always presupposing that the icon is, in fact, the orignal from Byzantium, as a great number of reputable investigators claim to be the case, and not a new 13th-century icon, painted to replace the old one that had been lost, as others would have us believe.

The chalk ground was applied to the wood or canvas in several very thin layers to provide a support, and then the actual painting was done in tempera. When a gold background was used, the gold leaf was put on first. In Russia the egg tempera was generally diluted with a kind of beer known as *kvass*.

The outlines for the figures or scenes were taken either from old icons which the painter chose as his model or, at a later date, from a painting-book, referred to as *hermeneia* in Greek and *podlinnik* in Russian. The use of preliminary sketches or cartoons (*perevody*) was also customary among icon painters in Russia in the 14th and 15th century, judging by the documentary evidence. We learn from the Chronicles and records that the painting of Feofan Grek attracted great attention among his contemporaries because he used no models, but took up his brush and painted his picture straight on to the support, with supreme confidence. He did not trouble

with models because he had a sure hand and did not need them. As for the pupils of Andrei Rublev, it is a well-known fact that they studied the models done by their master again and again and planned out the composition of their icons accordingly.

When the painting was complete, a layer of olive oil and various resins was applied to the whole icon. This was called the 'olifa' layer. It protected the picture from damp and at the same time gave it a touch of real warmth. But there was one disadvantage, of course. The 'olifa' layer collected dust and soot from the incense and candles, so giving the icon the dark appearance so common in uncleaned picture panels. This progressive darkening that occurs in icons is undoubtedly one of the reasons why the flesh tint became increasingly sombre as time went on. Painters copying a model tried to reproduce the colouring of a picture as it was in their day. As a result, they generally used a darker version of colours that had once been quite vivid and, as time went on, these dark tints became even more sombre, just like the prototype. This may well account for the existence of icons of the type known as the 'Black Mother of God'.

If the icon had lost its colour effect as a result of age or darkening, artists frequently put on new paint over the old. In old icons four or more paint layers have sometimes been found, one on top of the other. Before icons were subjected to careful cleaning and scrutiny in Russia, these attempts at repainting often led to mistakes in the dating, which have only been corrected quite recently, after the oldest paint layers had been exposed.

Another point to bear in mind in icon painting is that the panels were not necessarily the work of a single person. Groups of painters often shared out the work on individual icons. Some icon painters — usually the more competent among them — specialised mainly in making heads and others had to attend to the draperies and accessories. We find evidence of this policy of work-sharing both in individual icons and in series of pictures. Here, of course, it sometimes took a different form. The master of the group painted the most important figures — in a Deesis for example, the icons of the central characters and perhaps also those of the archangels — whilst the other members of the association were responsible for the apostles and the remaining saints in the composition.

A peculiarity we often find in icons, especially Russian ones, is the use of a metal covering. This was also a popular and well-known device in the Byzantine Empire, but was abandoned in the Greek area during the post-Byzantine era. Impressive examples of artistic chased metal surrounds from the Byzantine era, bearing inscriptions, are to be found on the decorated 14th-century icons preserved at Ochrid.

A number of changes took place in these decorations in Russia. Under the influence of Byzantium they very soon became an established indigenous feature. We know, for instance, from the Chronicle that the icon of the Vladimir Mother of God was adorned with precious metal and valuable stones when it was set up in the cathedral. Its decoration was wrenched off during the feuds among the local princes of the Kiev Rus and also when Vladimir was sacked by the Tartars. The purpose of this decoration consisting of metal and precious stones would

have been primarily to show honour to the icon and not, as later generations often supposed, to shield it from profane eyes.

Various types of covering were designed in Russia and there was a special term for each. A *basma* merely covered the edge of the picture. If, as more frequently happened from the 15th century onwards, this surround was extended over the picture ground until it reached the contours of the figure, it is referred to as a *riza*. The later type of covering, which left only the flesh tint exposed, whilst all the rest of the picture was concealed under the metal casing, is termed an *oklad*. The terms *riza* and *oklad* are actually interchangeable and are sometimes used indiscriminately for both these last types of casing. A special feature of what we have described here as an *oklad* is that the picture on the icon, which was now no longer visible, was repeated in the form of a relief on the covering. This type of decoration became more usual from the middle of the 17th century onwards. The haloes are often superimposed on the metal coverings and pearl hoods with precious or semi-precious stones have been added as well. In Russia, too, we often find decorative plates shaped like half-moons suspended between the figure's shoulders in front of his breast, and these in turn are frequently adorned with pendants containing precious stones.

In the 19th and 20th century the metal covering also came to have an effect on the painting, and a very negative one at that. During this late period there was a brisk trade in icons, in complete contrast to the old idea that icons could perhaps be exchanged, but certainly never sold. Artists no longer bothered to paint the whole picture. As most of it was concealed in any case by the metal covering and the *oklad* was already in position before the icons came up for sale, it seemed pointless to paint more than people could actually see. So, after removal of the oklad, we find that only the flesh tint was painted on many of these icons and the other parts of the wooden board were not even treated with a primer.

SCHOOLS OF PAINTING AND DATING OF ICONS

Icon painters, especially those from Russia, are generally not known to us by name. By a curious quirk of fate we are familiar with the names of many masters, but do not actually know any picture they have painted, whereas in the case of a great number of the works that have survived, we know the painting, but do not know the artist and have little hope of ever finding out his name. Icon painting was an anonymous branch of art because, when icons were at their peak, the painter regarded himself as a tool in the hands of God rather than as a creative artist. His name was therefore quite unimportant and not worth mentioning. He was not interested in enhancing his reputation and the whole procedure of dating or signing pictures seemed quite superfluous when viewed in that light.

This accounts for the difficult situation in which we find ourselves when we have no information at all about the date or origin of a particular icon. In the case of some pictures painted in the early days it is possible to fix certain time-limits because of the donor figures included in pictures of Christ or His Mother. In Greek icons this practice can occasionally be observed even in the post-Byzantine era. Exceptions occurring nowhere else in icon painting are to be found particularly in areas of Greece and her islands, e. g., Cyprus, that came under the control of Western princes as a result of the Crusades and were thus in contact with the art of France or Italy, or in Greek territory ruled by Venice.

When donors are shown, we can accurately place pictures within quite a narrow time-span and also a specific area. The clues we get from a study of their pictorial content are not nearly so precise. If the saints depicted did not belong to Early Christian times, the dates between which they lived enable us to determine the earliest possible point at which the picture could have been painted, but this does not usually help us very much, as quite a long interval of time might have elapsed since the saint died. And yet this makeshift device is often quite useful, because there is a general tendency when dating an icon to place it too early. This need not always mean that a person is trying to 'cash in on' these anonymous works of art in any way and make them appear more valuable than they really are. Wrong datings are usually made in good faith. The main reason why such errors occur is that old models were rigidly followed and icons were therefore archaic in character. As a result, people were misled into thinking that the antiquated style of painting must mean that the icon dated from an early period.

So the smallest clue we can find in a picture or its contents and the artistic form which it takes is of great importance. If a saint is portrayed, his dates will tell us the earliest year that the picture could have been painted. For other subjects we have to find a different method. We usually get a similar clue if we know the year when an icon of the Mother of God gave a manifestation; that is, when it first revealed the miraculous power that resided in it. In the case of the much painted Kazan Mother of God the operative year was 1579. The Kazan type stands out clearly and is not difficult to identify. So, if we are dealing with an icon of that type, it could hardly have been painted before the end of the 16th century. But it must be remembered that some of the 'transcriptions' or imitations of these miracle-working icons (if we want to avoid the word 'copy') quite often performed miracles too, and the imitations differed in minor details from the original. To quote the same example, nine copies of the Kazanskaya have been included in the Festival Calendar of the Russian Orthodox Church as miracle-working icons. In addition to the epithet Kazanskaya the place associated with the miracle-working 'copy' is generally added, e. g., the *Kazanskaya-Kaplunovskaya.* But that miracle-working transcription of the original work did not manifest itself until 1689, which means that iconographical differences between the nine miracle-working copies and the original can be of great assistance to us when we are trying to determine the date of origin.

We must also bear in mind that figures of Saints appearing along the edge of an icon need not necessarily have been painted at the same time as the actual picture. They were often added later and can only be of doubtful value when we are trying to date the main picture, if we are not absolutely certain that they were painted at the same time.

The iconography also provides some valuable pointers to the date of origin. Certain iconographical features did not appear in the early icons. The adoption of a new painting style, for example, the 'continuous' method, also gives us some idea where to set the lower time-limit.

The lettering on an icon should also be considered. Of course, it was quite often renewed and did not belong to the original painting, but even the knowledge that it was subsequently overpainted may provide us with some clues about the actual picture. In many old icons the lettering on the original has, however, been preserved and, by making a palaeographical examination, we can find the specific period when that particular type of lettering was in vogue. Other clues can also be traced in the lettering. Sometimes the superscriptions are not in the standard language or pure Church Slavonic, but display certain local peculiarities and dialect influences. From these we can, up to a point, determine the region where the icon was painted — or at least where the artist came from.

In late Russian icons the metal cases very often supply a further clue. A great number of workshops put a stamp mark and date on the metal. Although the icon need not, of course, have been painted at the same time as the surround was put on, even this seemingly unimportant point helps us to establish the final date. It tells us that the icon must have been painted by a certain year. Similar information can sometimes be found in the literature and in the Chronicles and accounts of the lives of the saints.

All these rather makeshift methods provide us with clues, but we still cannot be absolutely sure about anything. So we have to study the style in detail. This may tell us more about the icon and give us definite information about its provenance and period of origin. We have already mentioned signed icons when discussing the Stroganov painters, but these are very rare. They first appeared in considerable numbers in Greek areas, especially in Italo-Cretan painting from the 16th century onwards.

Analysis of style is closely bound up with the various school of painting. These present one of the most controversial problems in the whole vast subject of icon painting. In many cases we have no very clear or definite picture of the individual school. There have always been mixed styles, and absolutely pure examples of the style of a local school or a school formed by a particular master are far less common than icons containing a mixture of different features and based on a variety of models and styles. This is very true in the case of the earliest Russian icons. It is extremely difficult to decide whether they are Byzantine or Russian, so we cannot reach any final conclusion. As far as the Kiev School is concerned, we cannot reliably attribute any specific icon to it. The whole idea of a school is founded on the assumption (and it is, no doubt, correct) that there must have been a large number of icons in Kiev and special work-

shops would most probably have been established in Kiev at the court of the Grand Duke and the residence of the Metropolitan.

Little is known about the Vladimir-Suzdal and Yaroslavl School and the early days of painting in Moscow and even Novgorod. So we must be very cautious about listing new schools of painting and not be too ready to refer to the large number of separate groups that used to be picked out and labelled as schools, as long as we do not have any definite criteria enabling us to differentiate between the individual schools of painting. There have been many attempts to build up different schools of painting on the basis of their iconographical discrepancies. But we can hardly expect satisfactory results if the main emphasis is laid on the iconography and the various artistic details are ignored. The works of important painters like Feofan Grek, Andrei Rublev and Dionisi show that it was always the finest artists who managed to find pupils and in icon painting, as in other fields, artistic quality is the deciding factor, marking off one school from another.

It is quite true that certain saints or festivals were specially commemorated in particular towns and areas, but this does not necessarily mean that an icon illustrating that subject must have been produced in that area. The fact that pictures from Vladimir-Suzdal often show a Deesis, and that the Hetoimasia was popular in Novgorod does not really tell us anything definite about the schools of painting in those areas. They are interesting pieces of information, but we cannot attribute a work to a particular school merely on that basis. It is more useful if we make an exact note of the stylistic details, study features in the painting and drawing that are shared by particular groups and examine the ornamental forms and colour composition of the picture, rather than devote our attention to the subject matter. This is of more help with the dating, as iconographical changes are generally produced by spiritual influences running through all the schools simultaneously and altering the composition of all the pictures. Our only definite pointers or guides to the various schools of painting are the ways in which the individual groups of artists managed to set their own special stamp on a new picture. When tyring to attribute pictures to different schools of painting, our main criterion cannot be the subjects chosen for these pictures, but the artistic means used to express them.

The closer we come to modern times, the harder it is for us to find any schools of painting, except for the artist villages such as Palekh, and Kholuy, that made a name for themselves during the later period of icon painting. We do, of course, have a clearly defined picture of what Stroganov painting was like, in spite of the contradictions and discrepancies that emerge when we look at Stroganov painting as a whole, but in the other areas, for example, Novgorod, we can no longer speak in terms of an artistic peak or golden age. All this shows how extremely careful and circumspect we must be when trying to determine the origin of an icon and establish the existence of new schools of painting.

CENT.	EUROPE	RUSSIA	BALKANS	ITALY Byz. and Italo-Byz. Art	BYZANTIUM	CENT.
V				Ravenna: Mausoleum of Galla Placidia Rome: S Maria Maggiore	Constantinople: Imperial Palace Salonika: Hag. Georgios, Hag. Demetrios	V
VI	Under Byzantium, Italy, the Balkans and Russia, grey = mosaics, blue = frescoes, brown = icons			Ravenna: S Apollinare Nuovo; S Vitale Rome: SS Cosma e Damiano Mother of God from S Maria Nuova (Rome)	Sinai: Monastery of St Catherine Peter; Three Young Men	VI
VII				Rome: S Maria Antiqua	Salonika: Hag. Demetrios	VII
VIII				Rome: S Maria in Cosmedin	Damascus: Great Mosque	VIII
IX	Irish Book Illumination Carolingian Art			Rome: S Prassede	Constantinople: Hagia Sophia (Narthex) Salonika: Hag. Sophia	IX
X	St Gallen Book Illum. Romanesque Style	Kiev: Desyatinnaya Church	Preslav Ochrid: Cathedral of St Sophia	Castelseprio (?)		X
XI		Kiev: Cathedral of St Sophia Kiev: Mikhailovski Zlatoverkhi Monastery Kiev: Pecherskaya Lavra	Athos: Monasteries		Chios: Nea Moni Daphni: Hosios Lukas Mosaic Icon of 'Christ the Merciful'	XI
XII		Kirillov Monastery (nr. Kiev) Vladimir: Cathedral of St Demetrius Vladimir: Uspenski Cathedral Novgorod: Cathedral of St Sophia Arkazhi, nr. Novgorod Staraya Ladoga: Church of St George Bogoliubskaya Mother of God (Vladimir-Suzd.) Christ-Acheiropoietos (Novgorod) Nereditsa: Church of the Redeemer	Nerezi Studenica	Torcello: Basilica Cefalù: Cathedral Palermo: Cappella Palatina Festival Diptych (Mosaic Icon in Florence)	Constantinople: Hagia Sophia (South Tribune) Vladimir Mother of God (Moscow)	XII
XIII	Duccio and Giotto Gothic Book Illum.	Zvensk Mother of God Demetrius Enthroned (from Dmitrov) Znamenie (from Yaroslavl) Ustyug Annunciation (Novgorod) Royal Doors from Krivoi (Novgorod) Belozerskaya Mother of God (Novgorod) Painting Schools of Novgorod and Vladimir-Suzdal	Mileševa Sopoćani Boiana	Venice: San Marco		XIII
XIV	Pisano, Cimabue Bohemian workshop	Archangel Michael (Vlad.-Suzd.) Tolgo Mother of God I and II Boris and Gleb, Russ. Museum, Leningrad Novgorod Painting School Beginnings of Moscow Painting School Novgorod: Church of the Redeemer Novgorod: Feodor Stratilat Volotovo: Church of the Assumption	Gračanica Markov Monastery Dečani, Lesnovo Mother of God Lesnovo Ochrid Icons Athos: Chilandari		Constantinople: Kahrieh Djami Mistra: Peribleptos; Pantanassa Salonika: Church of the Twelve Apostles Philoxenia of Abraham (Athens, Benaki Museum) Synaxis of the Apostles (Moscow)	XIV
XV	Mantegna, Giorgione, Fra Angelico, Masaccio, Lochner, van Eyck	Kovalevo Deesis Icons from Cathedral of the Annunciation, Moscow (Feofan Grek) Vladimir and Moscow Icons by Andrei Rublev Master Dionisi Ferapontov Monastery	Manasiya Turnovo Crete	Andrea Riccio di Candia		XV
XVI	Raphael, Urbino, Correggio, Veronese, Titian, Dürer, Grünewald, El Greco, Holbein, Tiepolo, Caravaggio, Rembrandt	The Church Militant (Moscow) End of the Novgorod Painting School Godunov School Stroganov School Prokopi Chirin; Nikifor Savin; Istoma Savin Workshop of the Tsar in the Kremlin Simon Ushakov	Athos	Damaskinos		XVI
XVII				Tzanfournari; Tzanes; Moschos; Viktoros; Lampardos		XVII

NOTES

If journals or omnibus publications, etc., are mentioned more than once, the abbreviation used later on is printed in brackets after the name the first time that it appears, e. g., Dumbarton Oaks Papers (DOP).

IMAGES AND IMAGE WORSHIP IN THE EARLY CHRISTIAN WORLD (pp. 10—41)

1 Cf. W. Eichrodt, 'Religionsgeschichte Israels,' in *Historia Mundi*, vol. 2, 1953, pp. 377—448.

2 Tacitus, *Historiae*, V, 5.

3 Examples in A. Baumstark, pl. I (Jewish), in *Reallexikon für Antike und Christentum (RAC)*, vol. 2, 1954, Col. 289.

4 Du Mesnil du Buisson, 'Rapport sur la sixième campagne des fouilles à Doura-Europos,' in *Comptes rendus de l'Académie des inscriptions et belles-lettres (CRAI)*, 1933, pp. 193—203; id., *Les peintures de la synagogue de Doura-Europos*, 245—256 après J.-C. 1939; M. Rostovtzeff, 'Die Synagoge von Dura,' in *Röm. Quartalschrift* XLII, 1934, pp. 203—218; G. Wodtke, 'Die Malereien der Synagoge in Dura und ihre Parallelen in der christlichen Kunst,' in *Zeitschr. f. d. ntl. Wissensch.* XXXIV, 1935, pp. 51—62; C. H. Kraeling, *The Synagogue, The Excavations at Dura-Europos, Final Report* VIII/1, 1956.

5 M. P. Nilsson, *Geschichte der griechischen Religion*, 1941.

6 H. Diels, *Die Fragmente der Vorsokratiker*, 5th ed., 1934/37. Xenophanes B. 24,14,15.

7 Ibid., Heraclitus B 5.

8 Ibid., Empedocles B 133, 134.

9 Ibid., Protagoras B 4.

10 Plato, *Nomoi*, XI, 931a.

11 *RAC*, vol. 2, col. 289.

11a Cf. J. Moreau, *Die Christenverfolgung im Römischen Reich*, 1961.

12 H. Koch, *Die altchristliche Bilderfrage nach den literarischen Quellen*, 1917, p. 4 f.

13 Irenaeus, *Adversus haereses*, I, 25, 6.

14 Origenes, *Contra Celsum*, VII, 18; quoted here from W. Neuss, *Die Kunst der alten Christen*, 1926, p. 17.

15 Regarding interpretations, cf. Koch, op. cit., p. 31 ff.

16 Eusebius, *Hist. eccl.*, VII, 18; quoted here from W. J. A. Visser, *Die Entwicklung des Christusbildes in Literatur und Kunst in der frühchristlichen und frühbyzantinischen Zeit*, 1934, p. 146.

17 Cf. Koch, op. cit., p. 42 f.

18 *Asterii Amaseae episc. homilia de divite et Lazaro*, quoted here from K. Schwarzlose, *Der Bilderstreit, ein Kampf der griechischen Kirche um ihre Eigenart und ihre Freiheit*, 1890, p. 7.

19 Epiphanius, *Epistolae*, 51, 9.

20 Cf. A. Grabar, *Martyrium, Recherches sur le culte des reliques et l'art chrétien antique*, 2 vols., 1946.

21 Augustinus, *De mor. eccl. cath.*, I, 34, 75.

22 Basil, *Homil. in Barlaam Mart.*, 17, 3.

23 Basil, *Homil. in quadr. Mart.*, 19, 2.

24 Basil, *Liber de Spiritu Sancto*, cap. 18.

25 Examples in J. Kollwitz, pl. III (Christian), in *RAC*, vol. 2, col. 328.

26 Ibid., *Literature*, col. 325.

27 Gregory Nazianzen, *Carmina* (P. G., XXXVII, col. 737 f.), on picture of St Polemon.

28 Quoted here from Koch, op. cit., p. 71 f.

29 P. Toesca and M. Brion, *S. Vitale de Ravenna, Les Mosaïques*, 1952, pl. XXXI, XXXIV.

30 *Nili Epist.*, 61; quoted here from Koch, op. cit., p. 68.

31 Kollwitz, op. cit., col. 330 f.

32 Koch, op. cit., p. 73 f.

33 Cf. A. Stange, 'Deutsche romanische Tafelmalerei,' in *Münchner Jahrb. d. bildenden Kunst*, NF VII, 1930, p. 129 f.

34 Regarding interpretation, cf. Koch, op. cit., p. 78 f.

35 K. Holl, 'Der Anteil der Styliten am Aufkommen der Bilderverehrung,' in *Gesammelte Aufsätze zur Kirchengeschichte*, vol. 2, 1928, pp. 388—98.

36 For picture of Christ, cf. E. v. Dobschütz, *Christusbilder*, 1899; J. Kollwitz, 'Christusbild,' in *RAC*, vol. 3, 1955, cols. 1—24.

37 Cf. Dobschütz, op. cit.; K. Schneider, 'Acheiropoietos,' in *RAC*, vol. 1, 1950, cols. 68—71.

38 Such thank offerings were also customary in pre-Christian times, e. g., coins were stuck on with wax and parts of the images of the gods were gilded.

39 Johannes Damascenus, *De sacris imaginibus oratio*, III.

40 Ibid.

41 Ibid.

42 H. Menges, *Die Bilderlehre des hl. Johannes von Damaskus*, 1938, p. 23.

43 Cf. G. Ostrogorsky, *Geschichte des byzantinischen Staates*, 1940, p. 90.

44 Quoted from L. Ouspensky and V. Lossky, The Meaning of Icons, 1952, p. 30.

45 Ibid., p. 30.

46 J. Strzygowski, *Ursprung der christlichen Kirchenkunst, Neue Tatsachen und Grundsätze der Kunstforschung*, 1920, p. 24.

47 Quoted from W. Ellinger, 'Zur bilderfeindlichen Bewegung des 8. Jahrhunderts,' in *Forschungen zur Kirchengeschichte und zur christlichen Kunst*, in commemoration of the 70th birthday of Johannes Ficker, 1931, pp. 40—60.

48 For the Iconoclast Controversy, cf. L. Bréhier, *La querelle des images*, 1904; G. Ostrogorsky, *Studien*

zur Geschichte des byzantinischen Bilderstreites, 1929; id., 'Les débuts de la querelle des images,' in Mélanges Charles Diehl I, 1930, pp. 235–255; id., 'Rom und Byzanz im Kampf um die Bilderverehrung,' in Seminarium Kondakovianum VI, 1933, pp. 73–88; A. Grabar, L'iconoclasme byzantin, Dossier archéologique, 1957; G. B. Ladner, 'The concept of the image in the Greek Fathers and the Byzantine Iconoclastic Controversy', in Dumbarton Oaks Papers (DOP), III, 1953, p. 3 ff.; E. Kitzinger, 'The cult of images in the age before iconoclasm', in DOP, VIII, 1954, p. 83 ff.; H. G. Beck, Kirche und theologische Literatur im Byzantinischen Reich, 1959.

49 The earthquake devastated several of the Cycladic Islands.

50 For the political history of Byzantium, cf. A. Bailly, Byzance, 1939; J. B. Bury, A History of the Later Roman Empire from Arcadius to Irene (395–800), 2 vols., 1899; C. Diehl, Histoire de l'empire byzantin, 1924; G. Ostrogorsky, Geschichte des byzantinischen Staates, 2nd ed., 1952; A. Vasiliev, Histoire de l'empire byzantin, 2 Vols., 1932; H. W. Haussig, Kulturgeschichte von Byzanz, 1959.

51 Ostrogorsky, op. cit., p. 118 f.

52 C. Diehl, Histoire de l'empire byzantin, 1924, p. 65.

53 Ostrogorsky, op. cit., p. 119.

54 Ibid., p. 141.

55 Ibid., p. 146.

56 Menges, op. cit., p. 1 ff.

57 Quoted from Menges, op. cit., p. 163.

58 Ibid., p. 165.

59 This wording was used by the Emperor Leo III in his letter to the Pope.

60 Menges, op. cit., p. 134.

61 Ibid., p. 160 f.

62 Ibid., p. 35.

63 Ibid., p. 35.

64 Dionysius Areopagita, De divinis nominibus, I, 4; De ecclesiae hierarchia, I, 2.

65 Cf. K. Schneider, 'Acheiropoietos,' in RAC, vol. 1, 1950, Col. 70; also Dobschütz, op. cit.

66 Menges, op. cit., p. 63 ff.

67 Ibid., p. 79.

68 H. Schrade, Vor- und frühromanische Malerei, Die karolingische, ottonische und frühsalische Zeit, 1958, p. 119. For Nicephorus and his attitude to the Iconoclast Cointroversy, cf. also A. J. Visser, Nikephoros und der Bilderstreit, Eine Untersuchung über die Stellung des Konstantinopeler Patriarchen Nikephoros innerhalb der ikonoklastischen Wirren, 1952, and P. J. Alexander, The Patriarch Nicephorus of Constantinople, Ecclesiastical policy and image worship in the Byzantine Empire, 1958.

69 Cf. P. Meyer, Die Haupturkunden für die Geschichte der Athosklöster, 1894, p. 79.

70 Cf. F. X. Kraus, Geschichte der christlichen Kunst, 2 vols., 1896/97; here vol. 2, p. 2 ff.; G. Haendler, Epochen karolingischer Theologie, Eine Untersuchung über die karolingischen Gutachten zum byzantinischen Bilderstreit, 1958; Schrade, op. cit., chps. IV–VI.

71 Ibid.

72 The term 'Orthodox' is used here in its present-day meaning. In those days it did not imply opposition to the Western Church. For example, on Charlemagne's epitaph he is referred to as an 'imperator orthodoxus'.

THE BEGINNINGS OF CHRISTIAN ART (pp. 41–55)

1 W. Neuss, Die Kunst der alten Christen, 1920, p. 16; A. Grabar, Die Kunst des frühen Christentums, Munich, 1967.

2 Plato, Politeia, III, 401 b. c.

3 Cf. Historia Mundi, vol. IV, Römisches Weltreich und Christentum, 1956; F. Altheim, Gesicht vom Abend und Morgen. Von der Antike zum Mittelalter, 1955; id., Der unbesiegte Gott. Heidentum und Christentum, 1957.

4 L. Budde, Die Entstehung des antiken Repräsentationsbildes, 1957, p. 8.

5 Ibid., Plates 37, 38; J. H. Breasted, Oriental Forerunners of Byzantine Painting, 1924, Plates VIII–XIX.

6 E. Kitzinger, Early Mediaeval Art in the British Museum, 1955, Pl. 1.

7 Budde, op. cit., Pl. 36, 44.

8 Cf. K. Wessel, Koptische Kunst. Die Spätantike in Ägypten, 1963.

9 Cf. P. Buberl, Die griechisch-aegyptischen Mumienbildnisse der Sammlung Theodor Graf, 1922; H. Drerup, Die Datierung der Mumienporträts, 1933; H. Zaloscer, Porträts aus dem Wüstensand. Die Mumienbildnisse der Oase Fayum, 1961; Wessel, op. cit.; K. Parlasca, Mumienporträts und verwandte Denkmäler, 1966.

10 Kitzinger, op. cit., p. 9.

11 J. Myslivec, Ikona, 1947, p. 13.

12 For the technique, cf. K. Wehlte, 'Technik der Malerei,' in Das Atlantis-Buch der Kunst, 1952, pp. 78–80; R. Büll, Vom Wachs, Vols. 1/7, 1963, 'Wachsmalerei, Enkaustik und Temperatechnik unter besonderer Berücksichtigung antiker Wachsmalverfahren'.

13 O. Wulff and M. Alpatoff, Denkmäler der Ikonenmalerei in kunstgeschichtlicher Folge, 1925, p. 5.

14 A. Riegl, Spätrömische Kunstindustrie, 1927.

15 A. Hauser, Sozialgeschichte der mittelalterlichen Kunst, 1957, p. 10.

16 Ibid.

17 O. Wulff, Altchristliche und byzantinische Kunst, 2 vols., 1914; here vol. 1, p. 61 ff.

18 Animals were still used in Russian book illuminations of the Old Believers in the 18th and 19th century to personify passions; cf. D. Chizhevsky, *Paradies und Hölle. Russische Buchmalerei*, 1957.

19 Wulff, op. cit., p. 71.

20 Ibid., p. 72, Illust. 57.

21 Cf. L. Clausnitzer, *Die Hirtenbilder in der altchristlichen Kunst*, 1904; H. Leclerq, 'Pasteur (Bon),' in *Dictionnaire d'archéologie chrétienne et de liturgie (DACL)*, vol. XIII/2, 1938, Cols. 2272–2390; W. Jost, Poimen. *Das Bild vom Hirten*, 1939; T. Klauser, 'Studien zur Entstehungsgeschichte der christlichen Kunst,' I–V, in *Jahrbuch für Antike und Christentum*, 1 (1959) to 5 (1962).

22 The H-sound is only written as a rough breathing, or aspirate, in Greek, so the initial letter is Upsilon.

23 Neuss, op. cit., Illust. 28.

24 Ibid., Illust. 15.

25 Ibid., Illust. 39.

26 Ibid., Illust. 40 (Burial chambers of El Kargeh).

27 Ibid., Illust. 16 (Cappella Greca of the Priscilla Catacomb).

28 Ibid., Illust. 38 (Cubiculum of the Coemeterium Maius).

29 Ibid., Illust. 20 (S Callisto Catacomb, Rome).

30 Wulff, op. cit., Illust. 38 (Catacomb of S Gennaro dei poveri, Naples).

31 Ibid.

32 Ibid., Plate III (Priscilla Catacomb, Rome).

33 Neuss, op. cit., Illust. 35 (Priscilla Catacomb, Rome); Illust. 33 (S Callisto Catacomb, Chapel of the Sacrament A 3).

34 Ibid., Illust. 30 (Cubiculum of the Catacomb of SS Peter and Marcellinus, Rome).

35 Ibid., Illust. 38 (Cubiculum of the Coemeterium Maius, Rome).

36 Quoted from Neuss, op. cit., p. 30.

37 Ibid., Illust. 29 (Chapel of the Sacrament in the S. Callisto Catacomb, Rome).

38 Wulff, op. cit., Illust. 53 (Cappella Greca of the Priscilla Catacomb, Rome).

39 Ibid., Illust. 61 (Catacomb of SS Peter and Marcellinus, Rome).

40 Neuss, op.cit., Illust. 23 (Cappella Greca of the Priscilla Catacomb, Rome).

41 Ibid., Illust. 24 (Priscilla Catacomb, Rome).

42 Wulff, op. cit., Illust. 74.

43 Ibid., Illust. 76.

44 Cf. H. Leclerq, 'Alexandrie I' (Archéologie), in *DACL*, vol. I/1, 1924, Cols. 1098–1182.

45 Cf. B. C. Roth, *Die Kunst der Juden*, vol. 1, 1963, p. 64 ff.; B. Kanael, *Die Kunst der antiken Synagoge*, 1960.

46 For the various questions connected with the beginnings of Christian art, cf. R. C. Morey, *Early Christian Art*, 1953; W. F. Volbach and M. Hirmer, *Frühchristliche Kunst. Die Kunst der Spätantike in West- und Ostrom*, 1958; D. Talbot Rice, *Beginn und Entwicklung christlicher Kunst*, 1961; Klauser, op. cit.

47 F. Gerke, *Die christlichen Sarkophage der vorkonstantinischen Zeit*, 1940.

48 F. Gerke and E. Kitzinger, *Christus in der spätantiken Plastik*, 1940.

49 A. Grabar, *L'empereur dans l'art byzantin*, 1936.

50 Cf. H. Leclerq, 'Anges,' in *DACL*, vol. I/2, 1924, Cols. 2080–2161; A. Piolanti and R. Aprile, 'Angeli,' in *Bibliotheca Sanctorum*, vol. I, n. d. (1962), Cols. 1196 to 1225; M. Tatić-Djurić, *Das Bild der Engel*, 1962.

51 O. Demus, *Byzantine Mosaic Decoration*, 2nd ed., 1953; C. Ihm, *Die Programme der christlichen Apsismalerei vom vierten bis zur Mitte des achten Jahrhunderts*, 1960.

BYZANTIUM AND THE BALKANS (pp. 55–107)

1 H. Russack, *Byzanz und Stambul, Sagen und Legenden vom Goldenen Horn*, 1941, p. 156.

2 G. Ostrogorsky, 'Die wirtschaftlichen und sozialen Entwicklungsgrundlagen des byzantinischen Reiches,' in *Vierteljahresschrift für Sozial- und Wirtschaftsgeschichte*, XXII, 1929; S. Runciman, *Byzantine civilization*, 1933.

3 G. Ostrogorsky, *Geschichte des byzantinischen Staates*, 1940, p. 16.

4 J. Bidez, *Kaiser Julian, Der Untergang der heidnischen Welt*, 1956.

5 Kitzinger, op. cit., p. 17 ff.

6 Ibid., Pl. 7.

7 Ibid., p. 21 f.

8 A short article on the two cities, mentioning the most important literature, in *RAC*, vol. 1, 1950: W. Schubart, 'Alexandria', Cols, 271–283; J. Kollwitz, 'Antiochia am Orontes', Cols, 461–469.

9 C. Diehl, *Manuel d'art byzantin*, 2nd ed., 2 vols., 1925/26, p. 83 f.

10 H. Thiersch, *An den Rändern des römischen Reiches*, 1911, p. 55.

11 Cf. J. Orbeli and K. Trever, *Sasanidski metall*, 1935; K. Erdmann, *Die Kunst Irans zur Zeit der Sassaniden*, 1943; E. Diez, *Iranische Kunst*, 1944; R Ghirshman, *Iran. Parther und Sassaniden*, 1962.

12 Cf. the words of Bishop Porphyrius of Gaza (around 400), who compared the earthly pomp of the court and all the attention it attracted with the heavenly splen-

dour that is in store for the righteous; in Diehl, op. cit., p. 9.

13 Wulff, op. cit. p. 391.

14 P. Friedländer, *Johannes von Gaza und Paulus Silentiarius*, 1912.

15 Cf. V. Bénéschévitch, 'Sur la date de la mosaïque de la Transfiguration au Mont Sinaï,' in *Byzantion* I, 1924, p. 145 ff.; G. Soteriou, 'The mosaic of the Transfiguration of the church of the monastery of Sinaï,' in *Atti dello VIII congresso internazionale di studi bizantini, Palermo*, II, 1953, p. 246 ff.

16 H. Skrobucha, *Sinai*, 1959; G. Gerster, *Sinai*, 1961.

17 N. Petrov, *Albom dostroprimechatel'nostei tserkovno-arkheologicheskago muzeya pri Kievskoi Dukhovnoi Akademii, Vyp. I, Kollektsiya sinaiskikh i afonskikh ikon preozvyashchennago Porfiriya Uspenskago*, 1912; detailed discussion in German in Wulff and Alpatoff, op. cit., p. 8 ff.; W. Felicetti-Liebenfels, *Geschichte der byzantinischen Ikonenmalerei von ihren Anfängen bis zum Ausklange unter Berücksichtigung der maniera greca und der italo-byzantinischen Schule*, 1956, p. 22 f.

18 G. and M. Soteriou, *Les icônes du Mont Sinaï*, 2 vols., 1956/58.

19 Wulff and Alpatoff, op. cit., p. 16 f.; Wessel, op. cit., p. 187 ff.

20 Soteriou, op. cit., I, Pl. I, Nos. 1–3; Pl. II, Nos. 4–7.

21 Felicetti-Liebenfels,, op. cit., Plates 32 A and B.

22 Ibid., p. 24.

23 For Constantinople, see also E. Kitzinger, 'Byzantine art in the period between Justinian and inconoclasm,' in *Berichte zum XI. Internationalen Byzantinisten-Kongress*, Munich, 1958, p. 30 ff.

24 Felicetti-Liebenfels, op. cit., p. 28.

25 The entire icon is reproduced in Soteriou, op. cit., I, No. 17; in colour in H. Skrobucha, *Meisterwerke der Ikonenmalerei*, 1961, p. 57 ff., Pl. II.

26 Felicetti-Liebenfels, op. cit., p. 23.

27 Cf. reproduction from the Chludov Psalter in E. H. Gombrich, *Die Geschichte der Kunst*, 1953, Illust. 88.

28 Wulff, op. cit., p. 363.

29 Cf. J. Beckwith, *The Art of Constantinople*, 1961; D. Talbot Rice and M. Hirmer, *Kunst aus Byzanz*, 1959; K. Weitzmann, *Geistige Grundlagen und Wesen der Makedonischen Renaissance*, 1963.

30 K. Onash, 'Die Ikone der Gottesmutter von Vladimir in der Staatlichen Tretjakov-Galerie zu Moskau,' in *Wissenschaftliche Zeitschrift der Martin-Luther-Universität Halle-Wittenberg, Gesellschafts- und sprachwissenschaftliche Reihe*, V, 1, 1955, p. 52, Note 8.

31 A. J. Anisimov, *Our Lady of Vladimir*, 1928, p. 15; Onash, op. cit., p. 52 f.

32 Anisimov, op. cit., p. 16.

33 Ibid., p. 17.

34 Onash, op. cit., p. 54.

35 D. Ainalov, *Die Geschichte der russischen Monumentalkunst zur Zeit des Großfürstentums Moskau*, 1933, p. 85.

36 Anisimov, op. cit., p. 17.

37 Ainalov, op. cit., p. 86; Onash, op. cit., pp. 54, 56.

38 Ainalov, op. cit., Pl. 31.

39 Anisimov, op. cit., p. 31, Pl. II.

40 M. Alpatoff and V. Lazarev, 'Ein byzantinisches Tafelwerk aus der Komnenenepoche,' in *Jahrbuch der Preussischen Kunstsammlungen*, XLVI, p. 142.

41 Wulff and Alpatoff, op. cit., p. 66 f.; in colour in A. V. Bank, *Iskusstvo Vizantii v sobranii gosudarstvennogo Ermitazha*, 1960, Pl. 95.

42 Soteriou, op. cit., I, No. 47; dated to the 11th century.

43 Cf. M. Soteriou, 'Palaiologos eikon tou archangelou Michael,' in *Deltion tes Christianikes Archaiologikes Etairias*, vol. I, 4, 1960, pp. 80–86.

44 O. Demus, 'Byzantinische Mosaikminiaturen,' in *Phaidros*, 1947.

45 A. Grabar, *La peinture byzantine*, 1953, Pl. p. 191.

46 Wulff and Alpatoff, op. cit., p. 54.

47 Ibid., p. 53.

48 Catalogue of the Byzantine and Early Mediaeval Antiquities in the Dumbarton Oaks Collection: M. C. Ross, 'Metalwork, ceramics, glass, glyptics, painting', 1962 (Catalogue Dumbarton Oaks), No. 125, p. 104 f., Pl. LXI.

49 Ibid., No. 124, p. 102 f., Pl. LX.

50 P. Schweinfurth, *Die byzantinische Form*, 2nd ed., 1944, p. 33.

51 Felicetti-Liebenfels, op. cit., p. 68.

52 Cf. S. Radojčić, 'Die Entstehung der Malerei der paläologischen Renaissance,' in *Jahrbuch der Österreichischen Byzantinischen Gesellschaft*, VII, 1958, pp. 105–124; O. Demus, 'Die Entstehung des Paläologenstils in der Malerei,' in *Berichte zum XI. Internationalen Byzantinisten-Kongress*, Munich, 1958; H. Hunger, 'Von Wissenschaft und Kunst der frühen Paläologenzeit,' in *Jahrbuch der Österreichischen Byzantinischen Gesellschaft*, VIII, 1959, pp. 123–155.

53 In colour in Myslivec, op. cit., Pl. I; also in Talbot Rice and Hirmer, op. cit.

54 Wulff and Alpatoff, op. cit., p. 116.

55 In colour in *The Icons of Ochrid*, 1950; S. Radojčić, *Ikonen aus Serbien und Makedonien (Ikonen)*, 1962.

56 Cf. Radojčić, *Ikonen*, Plates 48, 49, 53–56.

57 G. Millet, *Recherches sur l'iconographie de l'Evangile aux XIVe, XVe, et XVIe siècles*, 1916, p. 630 ff.; C. Diehl, *Choses et gens de Byzance*, 1926, pp. 143–170.

58 A. Xyngopoulos *Thessalonique et la peinture macédonienne*, 1955.

59 V. N. Lazarev, 'Zhivopis XI–XII vekov v Makedonii,' in *Rapports du XIIe Congrès International des études byzantines, Ochrid*, 1961.

60 S. Pelekanides, *Kastoria, I, Byzantinai toichographiai*, 1953.

61 S. Pelekanides, *Byzantina kai metabyzantina Mnemeia tes Prepas*, 1960.

62 G. Millet, *Monuments byzantins de Mistra*, 1910.

63 Cf. M. H. L. Rabino, *Le Monastère de Sainte-Catherine du Mont Sinaï*, 1938.

64 In colour in Skrobucha, op. cit., p. 99 f., Pl. XIII.

65 Ibid., p. 95 f., Pl. XII.

66 Myslivec, op. cit., No. 15.

67 A. Xyngopoulos, *Katalogos ton eikonen, Sympleroma A*, 1939, pp. 109—115, Plates 54—57; in colour in Skrobucha, op. cit., p. 115 f., Pl. XVII.

68 Catalogue Dumbarton Oaks, No. 131, p. 110 f., Pl. LXIV.

69 M. Chatzidakis, *Ikônes de Saint-Georges des Grecs et de la collection de l'Institut*, n. d. (1963).

70 Ibid.

71 S. Radojčić, 'Die serbische Ikonenmalerei vom 12. Jahrhundert bis zum Jahre 1459,' in *Jahrbuch der Österreichischen Byzantinischen Gesellschaft*, V, 1956, p. 62; V. J. Djurić and S. Radojčić, *Icônes de Yougoslavie*, 1961; S. Radojčić, *Geschichte der serbischen Kunst von den Anfängen bis zum Ende des Mittelalters* (*Grundriß der slavischen Philologie und Kulturgeschichte*), 1969.

72 A. Grabar, *La Sainte Face de Laon*, 1931.

73 Cf. L. Karamon, 'Notes sur l'art byzantin et les Slaves catholiques de la Dalmatie,' in *L'art byzantin chez les Slaves*, vol. II/2, pp. 332—380.

74 Cf. Radojčić, Ikonen, p. XIV; Skrobucha, op. cit., p. 163, Pl. XXIX.

75 Radojčić, *Die serbische Ikonenmalerei*, p. 83.

76 Cf., for example, M. Čorović-Ljubinković, *Pećko-Dečanska ikonopisna škola od XIV do XIX veka*, 1953; *Katalog Galerija Matice Srpske*, 1958, Plates 1—4.

77 In colour in Radojčić, Ikonen, Pl. 69.

78 Cf. A. Grabar, *Boyanskata tsarkva*, 1924; id., *La peinture religieuse en Bulgarie*, 2 vols., 1928; P. Schweinfurth, *Die Wand-Bilder der Kirche von Bojana bei Sofia*, 1943; K. Mijatev, *Les peintures murales de Boiana*, 1961; A. Grabar and K. Mijatev, *Bulgarien. Mittelalterliche Fresken*, 1961.

79 B. D. Filov, *Die altbulgarische Kunst*, 1919; id., *Geschichte der bulgarischen Kunst im altbulgarischen Reich bis zu seiner Eroberung durch die Türken*, 1932; id., *Die Geschichte der bulgarischen Kunst unter der türkischen Herrschaft und in der neueren Zeit*, 1933; recent literature in V. Beševliev and J. Irmscher, *Antike und Mittelalter in Bulgarien*, 1960; K. A. Boschkov, *Die bulgarische Malerei von den Anfängen bis zum 19. Jahrhundert*, 1969.

80 Illustrated in Radojčić, Ikonen, and Tatić-Djurić, op. cit., Pl. p. 43.

81 Cf. Radojčić, Ikonen.

82 Cf. K. Krestev and V. Zachariev, *Stara blgarska zhivopis*, 1960; German edition, 1961.

83 N. Iorga, *Les arts mineurs en Roumanie*, 1934, vol. 1, p. 7 ff.

84 C. H. Wendt, *Rumänische Ikonenmalerei*, 1953, p. 23 ff.; G. Oprescu (ed.), *Istoria artelor plastice in România*, 1968.

85 Cf. Wendt, op. cit., Illusts. 25—30; D. Wild, *Ikonen. Kirchliche Kunst des Ostens*, 1946, Pl. XXII; C. Irimie and M. Focşa, *Rumänische Hinterglasikonen*, Bucharest, 1968.

86 J. Kłosińska, *Ikonen aus Polen, Ausstellungskatalog*, Recklinghausen, 1966; ANURSR (ed.), *Istoriya ukrainskogo mistetsva*, vols. I—III, 1966 ff.

RUSSIA (pp. 108—204)

1 A. M. Ammann, *Abriss der ostslavischen Kirchengeschichte*, 1950, p. 13.

2 Cf. F. Dvornik *Les Slaves, Byzance et Rome au IXe siècle*, 1926; F. Grivec, Konstantin und Method. *Lehrer der Slaven*, 1960.

3 V. N. Lazarev in *Istoriya Russkogo Iskusstvo* (*Istoriya*), Vol. I, 1953, p. 155.

4 Istoriya, I, p. 69 ff.

5 Ibid., p. 155 f.

6 W. Philipp, *Ansätze zum geschichtlichen und politischen Denken im Kiever Russland*, 1940; L. Müller (ed.), *Des Metropoliten Ilaron Lobrede auf Vladimir den Heiligen und Glaubensbekenntnis*, 1962.

7 M. D. Priselkov, *Ocherki po tserkovno-politicheskoi istorii Kievskoi Rusi X—XV vv*, 1913; cf. also L. Müller, *Zum Problem des hierarchischen Status und der jurisdiktionellen Abhängigkeit der russischen Kirche vor 1039*, 1959.

8 N. P. Sychev, *Drevneishi fragment russko-vizantiskoi zhivopisi*, in *Seminarium Kondakovianum*, II, 1928, pp. 92—104, Pl. XIII.

9 Ibid.

10 N. I. Kresalni, *Sofiski zapovidnik u Kievi. Arkhitekturno-istorichni naris*, 1960; V. N. Lazarev, *Mozaiki Sofii Kievskoi*, 1960.

11 Istoriya, I, p. 188 ff.

12 Ibid., p. 204 ff.; the legend appears in German translation in E. Benz (ed.), *Russische Heiligenlegenden*, 1953, pp. 200—209.

13 Istoriya, I, p. 206 f.

14 Cf. A. Zvirin, *Drevnerusskaya zhivopis v sobranii gosudarstvennoi Tretyakovskoi Galerie*, 1958, Pl. 1, 2, Istoriya, I, Pl. after p. 210.

15 Istoriya, I, p. 210.

16 Ibid., p. 214 f.

17 Ibid., p. 214.

18 I. Smolitsch, *Russisches Mönchtum. Entstehung, Entwicklung und Wesen. 988–1917*, 1953, p. 68.

19 In colour in Onash, *Ikonen*, 1961, Pl. 3.

20 Cf. Illust. in *Istoriya*, I, p. 445.

21 In colour in *Istoriya*, I, Pl. after p. 470.

22 P. Schweinfurth, *Geschichte der russischen Malerei im Mittelalter*, 1930, p. 146, speaks of the icon having a gold ground; *Istoriya*, I, p. 472, describes the picture ground as silver; cf. also colour plate in Onash, op. cit., Pl. 4.

23 *Istoriya*, I, p. 474 ff.

24 In colour in *UdSSR, Frühe russische Ikonen (UdSSR)*, 1958, Pl. III; Onash, op. cit., Pl. 6; *Istoriya*, I, p. 484.

25 D. Ainalov, *Geschichte der russischen Monumentalkunst der vormoskowitischen Zeit*, 1933, p. 67 f., Pl. 33 b.

26 *Istoriya*, I, p. 491.

27 Onash, op. cit., Pl. 8.

28 *Istoriya*, I, p. 499.

29 Ainalov, op. cit., Pl. 84.

30 Ainalov, op. cit., p. 88, refers to the figure in front of the Angel as Joshua.

31 In colour in Myslivec, op. cit., Pl. 2; *UdSSR*, Pl. XVII.

32 *Russian icons and objects of ecclesiastical and decorative arts from the collection of George R. Hann* (Hann), 1944.

33 H. Kjellin, *Ryska ikoner i svensk och norsk ägo*, 1956, Pl. XI.

34 Hann, No. 1.

35 *Istoriya*, II, p. 72 ff.

36 Cf. N. M. Chernyshev, *Iskusstvo freski v drevnei Rusi*, 1954; V. N. Lazarev, *Freski Staroi Ladogi*, 1960.

37 *Istoriya*, II, p. 96.

38 Ibid., p. 112 ff.

39 Onash, op. cit., Plates 15, 16.

40 K. Onash, 'Gross-Novgorod und Feofan Grek,' in *Ostkirchliche Studien*, III, 1954, pp. 179–192 and 287–306; V. N. Lazarev, *Feofan Grek i ego shkola*, 1961.

41 *Istoriya*, II, p. 177 ff.

42 Hann, No. 6.

43 Cf. *Istoriya*, II, Pl. after p. 366.

44 In colour in *UdSSR*, Pl. VI.

45 *Istoriya*, II, p. 194 ff.; Fig. p. 204.

46 V. N. Lazarev, *Iskusstvo Novgoroda*, 1947, Pl. 90.

47 Ibid., Pl. 89 b.

48 Ibid., Pl. 110.

49 Ibid., Pl. 120.

50 Ibid., Pl. 121.

51 Ibid., Pl. 124.

52 In colour in Skrobucha, op. cit., p. 191 ff., Pl. XXXVI.

53 In colour in T. Eckhardt, *Engel und Propheten*, 1959, p. 55 f., Pl. XI.

54 The entire icon is illustrated in the Extended Catalogue of the *Ikonenmuseum*, Recklinghausen, 1960, No. 317.

55 In colour in Skrobucha, op. cit., p. 235 ff., Pl. XLVII.

55a Kjellin, op. cit., p. 122, Pl. XLIII.

56 J. A. Lebedewa, *Andrei Rubljow und seine Zeitgenossen*, 1962, p. 24 ff.; *Istoriya*, III, p. 72 ff.

57 I. E. Grabar, 'Andrei Rublev,' in *Voprosi restavratsii*, I, 1926, p. 52 ff.; *Istoriya*, III, p. 102 ff.; I Ivanova, *Andrei Rublev, zhivopisets drevnei Rusi*, 1960; A. Yagodovskaya, *Andrei Rublev*, 1960; M. V. Alpatoff, *Andrei Rublev*, 1960; V. N. Lazarev, *Andrei Rublev*, 1960; J. A. Lebedewa, op. cit.

58 *Istoriya*, III, Pl. p. 123.

59 Ibid., p. 130.

60 Ibid., p. 102 ff.

60a M. Walicki, *Malowidla ścienne kościoła św. Trójcy na zamku w Lublinie*, 1930.

61 V. N. Georgievski, *Freski Ferapontova Monastyrya*, 1911.

62 Cf., for example, Smolitsch, op. cit., p. 119 ff.

63 E. Duchesne, *Le Stoglav ou les Cent Chapitres, recueil des décisions de l'assemblée ecclésiastique de Moscou 1551*, 1920.

64 N. E. Andreev, 'O dele dyaka Viskovatago,' in *Seminarium Kondakovianum*, V, 1932, pp. 191–242.

65 E. S. Ovchinnikova, *Portret v russkom iskusstve XVII veka*, 1955.

66 *Der Physiologus*, ed. O. Seel, 1960.

67 Schweinfurth, op. cit., p. 328 ff.; 453 ff.

68 Cf. also the icons of these two saints with the monastery in Skrobucha, op. cit., p. 269 ff., Pl. XL; D. Ainalov, *Geschichte der russischen Monumentalkunst zur Zeit des Grossfürstentums Moskau*, 1933, Pl. 61 b; and the sketch in N. Pokrovski, *Ocherki pamyatnikov khristianskoi ikonografii i iskusstva*, 2 izd., 1900, Fig. 288.

69 *Istoriya*, III, p. 641.

70 Ibid., p. 643 ff.

71 Ibid., p. 660.

72 Ibid.

73 Cf. O. Wulff, 'Der Ursprung des kontinuierenden Stils in der russischen Ikonenmalerei,' in *Seminarium Kondakovianum*, III, 1929, pp. 25–40.

74 *Istoriya*, III, p. 565 ff.

75 Cf. *Ikonopis* in *Russkoe narodnoe iskusstvo na vtoroi vserossiskoi kustarnoi vystavke v Petrograd v 1913*, 1914; D. K. Trenev, *Russkaya ikonopis i eya zhelaemoe razvitie*, 1902; recent discussion on Palekh by W. Kotow, *Die Volkskunst von Palech. Ein Museumsführer*, n. d.

SELECTED BIBLIOGRAPHY

Ainalov, D., *Geschichte der russischen Monumentalkunst der vormoskovitischen Zeit*, Berlin and Leipzig, 1932

Ainalov, D., *Geschichte der russischen Monumentalkunst zur Zeit des Grossfürstentums Moskau*, Berlin and Leipzig, 1933

Akrabova-Žandova, I., *Ikoni v Sofijskia Archeologičeski Muzej*, Sofia, 1965

Alpatov, M. V., *Altrussische Ikonenmalerei*, Dresden, 1958

Alpatov, M. V., *Andrei Rublev*, Moscow, 1959

Alpatov, M. V., *Pamyatnik drevnerusskoi zhivopisi kontsa XV veka: Ikona 'Apokalipsis' Uspenskogo Sobora Moskovskogo Kremlya*, Moscow, 1964

Alpatov, M. V., *Trésors de l'art russe*, Paris, 1966

Alpatov, M. V., and Brunov, N., *Geschichte der altrussischen Kunst*, 2 vols. Augsburg, 1932

Ammann, A., *La pittura bizantina*, Rome, 1957

Anisimov, A. I., *Our Lady of Vladimir*, Prague, 1928

Antonova, V. I., *Rostovo-Suzdalskaya shkola zhivopisi*, Moscow, 1967

Artamonov, M. I. (ed.), *Kultura i iskusstvo drevnei Rusi. Sbornik statei v chest professora M. K. Kargera*, Leningrad, 1967

Bank, A. V., *Byzantine Art in the Collections of the USSR*, Leningrad/Moscow, 1966

Beck, H. G., *Kirche und theologische Literatur im Byzantinischen Reich*, Munich, 1959

Beckwith, J., *The Art of Constantinople*, London, 1961

Beševliev, V., and Irmscher, J., *Antike und Mittelalter in Bulgarien*, Berlin, 1960

Blankoff, J., *L'art de la Russie ancienne*, Brussels, 1963

Bolshakova, L., and Kamenskaya, E., *State Tretyakov Gallery, Early Russian Art*, Moscow, 1968

Božkov, A., *L'école de peinture de Triavna*, Sofia, 1967

Boschkov, A., *Die bulgarische Malerei von den Anfängen bis zum 19. Jahrhundert*, Recklinghausen, 1969

Boschkov, A., *Monumentale Wandmalerei Bulgariens*, Mainz, 1969

Bocharov, G. N., *Prikladnoe iskusstvo Novgoroda Velikogo*, Moscow, 1969

Bröker, G., *Ikonen*, Leipzig, 1969

Coche de la Ferté, E., *L'antiquité chrétienne au Musée du Louvre*, Paris, 1958

Cultura moldovenească in timpul lui Ștefan cel mare, Bucharest, 1964

Dalton, O. M., *Byzantine Art and Archeology*, Oxford, 1911

Dalton, O. M., *East Christian Art*, Oxford, 1925

Delvoye, C., *L'art Byzantin*, Paris, 1967

Demus, O., *Byzantine Mosaic Decoration*, London, 1947

Demus, O., 'Die Entstehung des Paläologenstils in der Malerei,' *Reports: Der XI. Internationale Byzantinisten-Kongress*, Munich, 1958

Diehl, C., *Manuel d'art byzantin*, 2 vols., Paris, 1925/26'

Dombrovski, O. I., *Freski srednevekovogo Kryma*, Kiev, 1966

Drevnerusskoe iskusstvo, Khudozhestvennaya kultura Novgoroda, Moscow, 1968

Drevnerusskoe iskusstvo XVII vek, Moscow, 1964

Drevnerusskoe iskusstvo, Khudozhestvennaya kultura Pskova, Moscow, 1968

Ebersolt, J., *Les arts somptuaires de Byzance*, Paris, 1923

Ebersolt, J., *La miniature byzantine*, Paris, 1926

Embiricos, A., *L'école crétoise, dernière phase de la peinture byzantine*, Paris, 1967

Felicetti-Liebenfels, W., *Geschichte der byzantinischen Ikonenmalerei*, Olten-Lausanne, 1956

Filov, B., *Geschichte der altbulgarischen Kunst*, Berlin and Leipzig, 1932

Goldberg, T., Mishukov, F. et al., *Russkoe zolotoe i serebryannoe delo XV—XX vekov*, Moscow, 1967

Grabar, A., *La peinture religieuse en Bulgarie*, 2 vols., Paris, 1928

Grabar, A., *La Sainte Face de Laon*, Prague, 1931

Grabar, A., *Martyrium, Recherches sur le culte des reliques et l'art chrétien antique*, 2 vols. Paris, 1943/46

Grabar, A., *La peinture byzantine*, Geneva, 1953

Grabar, A., *L'iconoclasme byzantin, Dossier Archéologique*, Paris, 1957

Grabar, A., 'Byzanz,' in *Kunst der Welt*, Baden-Baden, 1964

Grabar, A., 'Die mittelalterliche Kunst Osteuropas,' in *Kunst der Welt*, Baden-Baden, 1968

Grabar, A., 'Die Kunst des frühen Christentums,' in *Universum der Kunst*, Munich, 1967

Grabar, A., 'Die Kunst im Zeitalter Justinians,' in *Universum der Kunst*, Munich, 1967

Grabar, A., *Christian Iconography, A Study of Its Origins*, New York, 1968

Grabar, I., *O drevnerusskom iskusstve*, Moscow, 1966

Grabar, I., Lazarev, V. N., and Kemenov, V. S., *Geschichte der russischen Kunst*, vols. 1—3, Dresden, 1957/60

Grabar, I., Lazarev, V. N., and Demus, O., *UdSSR, Frühe russische Ikonen* (UNESCO series on world Art), Munich, 1958

Hackel, A., *Das altrussische Heiligenbild, die Ikone*, Nijmegen, 1936

Hackel, A., *Ikonen*, Freiburg i. Br., 1950

Halle, F. W., *Altrussische Kunst*, Berlin, 1920

Hallensleben, H., *Die Malerschule des Königs Milutin*, Giessen, 1963

Hamann-MacLean, R., and Hallensleben, H., *Die Monumentalmalerei in Serbien und Makedonien vom 11. bis zum frühen 14. Jahrhundert*, Giessen, 1963

Hamilton, G. H., *The Art and Architecture of Russia*, London, 1954

Hare, R., *Tausend Jahre russische Kunst*, Recklinghausen, 1964; English edition entitled: *Art and Artists in Russia*, London, 1965

Haussig, H. W., *Kulturgeschichte von Byzanz*, Stuttgart 1959

Hendrix, P., Skrobucha, H., and Janssens, A. M., *Ikonen* (Elsevier Pocket A 18), Amsterdam/Brussels, 1960

Huber, P., *Athos, Leben — Glaube — Kunst*, Zurich, 1969

Hutter, I., 'Frühchristliche Kunst — byzantinische Kunst,' in *Belser Stilgeschichte* IV, Stuttgart, 1968

Iorga, N., *Les arts mineurs en Roumanie*, 2 Vols. Bucharest, 1934/36

Irimie, C., and Focşa, M., *Rumänische Hinterglasikonen*, Bucharest, 1968

Jamščikov (Yamshchikov), *Old Russian Painting, recent discoveries*, Moscow, 1965

Janssens, A. M., *Ikonen*, Bussum, 1960

Johnstone, P., *The Byzantine Tradition in Church Embroidery*, London, 1967

Kitzinger, E., 'Byzantine Art in the Period between Justinian and Iconoclasm,' in *Reports: Der XI. Internationale Byzantinisten-Kongress*, Munich, 1958

Kjellin, H., *Ryska ikoner i svensk och norsk ägo*, Stockholm, 1956

Kondakov, N. P., *Russkaja ikona*, 4 Vols., Prague, 1929/31

Kondakov, N. P., and Minns, E. P., *The Russian Icon*, Oxford, 1927

Kornilovich, K., *Okno v minuvshee*, Leningrad, 1968

Kornilowitsch, K., *Kunst in Russland von den Anfängen bis zum Ende des XVI. Jahrhunderts*, Munich-Geneva-Paris, 1968

Kovalevskij, P., *Atlas historique et culturel de la Russie et du monde slave*, Paris, 1961; German edition, Munich, 1964

Kresalni, M. I., *Sofiski zapovidnik u Kievi*, Kiev, 1960

Krestev, K., and Sachariev, V., *Alte bulgarische Malerei*, Dresden, 1960

Küppers, L., *Göttliche Ikone*, Düsseldorf, 1947

Küppers, L., *Ikone — Kultbild der Ostkirche*, Essen, 1964

Lange, R., *Die byzantinische Reliefikone*, Recklinghausen, 1964

Lassus, J., 'Frühchristliche und byzantinische Welt,' in *Schätze der Weltkunst*, vol. 4. Gütersloh, 1968

Lazarev, V. N., *Iskusstvo Novgoroda*, Moscow, 1947

Lazarev, V. N., *Istoriya vizantiskoi zhivopisi*, 2 Vols. Moscow, 1947/48

Lazarev, V. N., *Freski Staroi Ladogi*, Moscow 1960

Lazarev, V. N., *Mosaiki Sofii Kievskoi*, Moscow 1960

Lazarev, V. N., *Feofan Grek*, Moscow 1961; German edition entitled: *Theophanes der Grieche und seine Schule*, Vienna—Munich 1968

Lazarev, V. N., 'Zhivopis XI—XII vekov v Makedonii,' in *Reports: Le XIIe Congrès International des Etudes Byzantines*, Belgrade—Ochrid, 1961

Lazarev, V. N., *Old Russian Murals and Mosaics*, London, 1966

Lazarev, V. N., *Andrei Rublev*, Moscow, 1966

Lazarev, V. N., *Novgorodian Icon Painting*, Moscow, 1969

Lebedewa, J. A., *Andrei Rubljow und seine Zeitgenossen*, Dresden, 1962

Likhachev, N., *Materialy dlya istorii russkago ikonopisaniya*, 2 Vols. St. Petersburg, 1906

Mathew, G., *Byzantinische Malerei*, Berlin, 1960

Matthey, W. v., *Russische Ikonen*, Munich and Ahrbeck, 1960

Mazalić, D., *Slikarska umjetnost u Bosni i Hercegovini u tursko doba (1500—1578)*, Sarajevo, 1965

Michelis, P., *Aesthetic Approach to Byzantine Art*, London, 1955

Millet, G. (ed.), *L'art byzantin chez les Slaves*, 4 vols. Paris, 1930/32

Molè, W., *Ikona ruska*, Warsaw, 1956

Molè, W., *Sztuka Słowian południowych*, Wrocław—Warsaw—Cracow, 1962

Mongait, A. L. (ed.), *Kultura drevnei Rusi, Posvyashchaetsya 40 — letiyu nauchnoi deyatelnosti N. N. Voronina*, Moscow, 1966

Morey, C. R., *Early Christian Art*, Princeton, 1942

Mouratoff, P., *L'ancienne peinture russe*, Paris, 1925

Mouratoff, P., *Trente-cinq primitifs russes*, Paris, 1931

Mullock, C., and Teller Langdon, M., *The Icons of Yuhanna and Ibrahim the Scribe*, London, 1946

Myslivec, J., *Ikona*, Prague, 1947

Nekrasova, M., *Iskusstvo Palekha*, Moscow, 1966

Nemitz, F., *Die Kunst Russlands*, Berlin, 1940

Nickel, E., *Byzantinische Kunst*, Heidelberg, 1964

C. Nicolescu, C., *Argintaria laică si religioasă in tările Române (sec. XVI—XIX)*, Bucharest, 1968

Nikolaeva, T. V., *Drevnerusskaya melkaya plastika XI—XVI vekov*, Moscow, 1968

Nyssen, W., *Das Zeugnis des Bildes im frühen Byzanz*, Freiburg i. Br., 1962

Onasch, K., *Ikonen*, Gütersloh, 1961; French edition, Paris, 1961; English edition, London, 1961

Onasch, K., *Die Ikonenmalerei. Grundzüge einer systematischen Darstellung*, Leipzig, 1968

Ouspensky, L., *Essai sur la théologie de l'icone dans l'Eglise Orthodoxe*, vol. 1, Paris, 1960

Ouspensky, L., and Lossky, V., *Der Sinn der Ikonen*, Berne—Olten, 1952; English edition, *The Meaning of Icons*, 1952

Ovsyannikov, Yu., *Novo-Devichi monastyr*, Moscow, 1968
Panajotova, D., *Die bulgarische Monumentalmalerei im 14. Jh.*, Sofia, 1966

Papageorgiou, A., *Ikonen aus Zypern*, Munich—Geneva—Paris, 1969

Papaioannou, K., *La peinture byzantine et russe*, Lausanne, 1965

Petković, S., *Zidno slikarstvo na području Pećke Patrijaršije 1557—1614*, Novi Sad, 1965

Pomerantsev, N., *Russian wooden sculpture*, Moscow, 1967
Racz, I., *Ikonen*, Olten—Lausanne, 1964

Radojčić, S. *Majstori starog srpskog slikarstva*, Belgrade, 1961

Radojčić, S., *Icones de Serbie et de Macédoine*, Belgrade, 1961; German edition, Munich, 1962

Radojčić, S., 'Geschichte der serbischen Kunst von den Anfängen bis zum Ende des Mittelalters,' in *Grundriss der slavischen Philologie und Kulturgeschichte*, Berlin, 1969

Réau, L., *L'art russe*, 2 vols. Paris, 1921/22

Reformatskaya, M. A., *Severnye pisma*, Moscow, 1968

Restle, M., *Die byzantinische Wandmalerei in Kleinasien*, 3 vols. Recklinghausen 1967; English edition

Rothemund, H., *Ikonenkunst*, Munich, 1966²

Schäfer, G., *Das Handbuch der Malerei vom Berge Athos*, Trier, 1855; an unrevised reprint entitled: *Malerhandbuch des Malermönchs Dionysios vom Berge Athos*, Munich, 1960

Shchepkina, M. V., *Bolgarskaya miniatiura XIV veka, Issledovanie Psaltyri Tomicha*, Moscow, 1963

Schweinfurth, P., *Geschichte der russischen Malerei im Mittelalter*, The Hague, 1930

Schweinfurth, P., *Russian Icons*, Oxford, 1953

Skrobucha, H., *Die Botschaft der Ikonen*, Ettal, 1961; English edition entitled: *Icons*, London, 1963

Skrobucha, H., *Von Geist und Gestalt der Ikonen*, Recklinghausen, 1961; English edition, New York, 1965

Skrobucha, H., *Meisterwerke der Ikonenmalerei*, Recklinghausen, 1961; French edition entitled: *Merveilles des Icones*, Paris, 1969

Smirnova, E. S., *Zhivopis Obonezhya XIV—XVII vv*, Moscow, 1967

Smirnova, E. S. (ed.), *Kultura drevnei Rusi*, Leningrad, 1967

Soteriou, G. and M., *Les icones du Mont Sinai*, 2 Vols. Athens, 1956/58

Svirine, A., *La peinture de l'ancienne Russie, Collection de la Galérie Tretyakov*, Moscow, 1958

Svirin (Zvirin), A. N., *Drevnerusskoe shite*, Moscow, 1963
Talbot Rice, D., *The Icons of Cyprus*, London, 1937

Talbot Rice, D., *Beginn und Entstehung christlicher Kunst*, Cologne, 1961

Talbot Rice, D., *Byzantinische Kunst*, Munich, 1964

Talbot Rice, D., *Byzantine Painting, The Last Phase*, London, 1968

Talbot Rice, D., *Die Kunst im byzantinischen Zeitalter*, Munich—Zurich, 1968

Talbot Rice, D., and Hirmer, M., *Kunst aus Byzanz*, Munich, 1959

Talbot Rice, T., *Icons*, London n. d.

Talbot Rice, T., *Russische Kunst* (Phoenix Pocket 40), Zeist, 1960

Talbot Rice, T., *Die Kunst Russlands*, Munich, 1965

Theunissen, W., *Ikonen*, The Hague, 1938

Theunissen, W., *Ikonen* (Service Pocket 11), The Hague, 1960

Trubetzkoy, E. N., *Die religiöse Weltanschauung der altrussischen Ikonenmalerei*, Paderborn, 1927

Underwood, P. A., *The Kariye Djami*, New York, 1966

Volbach, W. F., and Hirmer, M., *Frühchristliche Kunst*, Munich, 1958

Volbach, W. F., and Lafontaine-Dosogne, J., 'Byzanz und der christliche Osten,' in *Propyläen Kunstgeschichte*, Vol. 3, Berlin, 1968

Voronin, N. N., Kostochkin, V. V. (ed.), *Troitse-Sergieva Lavra, khudozhestvennye pamyatniki*, Moscow, 1968

Voyce, A., *The Art and Architecture of Medieval Russia*, Norman/Oklahoma, 1967

Weidlé, W., *Les icones byzantines et russes*, Florence, 1950

Weitzmann, K., *Die byzantinische Buchmalerei des IX. und X. Jahrhunderts*, Berlin, 1935

Weitzmann, K., *Illustrations in Roll and Codex*, Princeton, 1947

Weitzmann, K., *Die geistigen Grundlagen der Makedonen-Renaissance*, Opladen, 1963

Weitzmann, K., Chatzidakis, M., Miatev, K., Radojčić, S., *Frühe Ikonen: Sinai, Griechenland, Bulgarien, Jugoslawien*, Vienna/Munich, 1967

Wendt, C. H., *Rumänische Ikonenmalerei*, Eisenach, 1953

Wessel, K., *Die byzantinische Emailkunst*, Recklinghausen, 1967; English edition

Wild, D., *Ikonen*, Berne, 1946

Wulff, O., *Altchristliche und byzantinische Kunst*, 2 Vols. Berlin, 1914

Wulff, O., and Alpatoff, M., *Denkmäler der Ikonenmalerei*, Hellerau, nr. Dresden, 1925

Wunderle, G., *Um die Seele der heiligen Ikonen*, Würzburg, 1937

Xyngopoulos, A., *Thessalonique et la peinture macédonienne*, Athens, 1955

Xyngopoulos, A., *Schediasma istorias tes threskeutikes zographikes meta ten alosin*, Athens, 1957

Zonova, O., *Khudozhestvennye sokrovishcha Moskovskogo Kremlya*, Moscow, 1963

Zventsitski-Zvyatitski, I., *Ikoni galitskoi Ukraini XV—XVI vikiv*, Lviv, 1929

IMPORTANT MUSEUM AND EXHIBITION CATALOGUES

ATHENS, Benaki Museum:
A. Xyngopoulos, *Katalogos ton eikonon*. Athens, 1936

PITTSBURGH, Carnegie Hall:
Russian Icons, Collection of Mr. George R. Hann. Pittsburgh, 1944

BALTIMORE, Museum of Art:
Early Christian and Byzantine Art. Baltimore, 1947

BELGRADE, National Museum:
M. Čorović-Ljubinković, *Pećko-Dečanska ikonopisna škola od XIV do XIX veka*. 1955
G. Tomić, *Bokokotorska ikonopisna škola XVII—XIX vek*, 1957

EDINBURGH, Festival 1958:
Masterpieces of Byzantine Art. Edinburgh, 1958

MOSCOW, State Tretyakov Gallery:
Vystavka, posvyashchennaya shestisotletnemu yubileyu Andreya Rubleva. 1960

OCHRID, XIIe Congrès International des Etudes Byzantines 1961:
V. J. Djurić and S. Radojčić, *Icônes de Yougoslavie*, Belgrade, 1961

RECKLINGHAUSEN, Städtische Kunsthalle:
Ikonen-Sammlung Amberg, Recklinghausen, 1962

WASHINGTON, Dumbarton Oaks Collection:
Marvin C. Ross, *Catalogue of the Byzantine and Early Mediaeval Antiquities in the Dumbarton Oaks Collection*, Vol. 1: Metalwork, Ceramics, Glass, Glyptics, Painting, Washington, 1962

VENICE, Istituto ellenico dei studi bizantini e postbizantini (Museum):
M. Chatzidakis, *Icones de Saint-Georges des Grecs et de la Collection de l'Institut*, Venice, 1962

MOSCOW, Tretyakov Gallery:
V. I. Antonova and N. E. Mneva, *Katalog drevnerusski zhivopisi XI — nachala XVIII vv.*, 2 Vols. Moscow, 1963

ESSEN, Villa Hügel:
Koptische Kunst — Christentum am Nil, Essen, 1963

ESSEN, Villa Hügel:
Kunstschätze in bulgarischen Museen und Klöstern, Essen, 1964

ATHENS, Zappeion Megaron:
Byzantine Art — A European Art, Athens, 1964 (also in French)

MOSCOW, State Historical Museum:
Vystavka russkoi derevyannoi skulptury i dekorativnoi rezby, 1964

MILWAUKEE, Art History Gallery of the University of Wisconsin:
A. Dean McKenzie, *Greek and Russian Icons and other Liturgical Objects in the Collection of Mr. Charles Bolles Rogers*, 1965

EDINBURGH, The Royal Scottish Museum:
Rumanian Art Treasures XV to XVIII centuries, 1965

LUCERNE, Sammlung W. Schweizer-Amsler:
Luzerner Ikonensammlung, 1965

PARIS, Palais du Louvre — Pavillon de Marsan:
Icones de Macédoine du XIe au XVIIe siècle, collections yougoslaves, 1965

PETROZAVODSK, Art Museum of the Karelian ASSR:
Zhivopis drevnei Karelii, 1966

MOSCOW, Korin Collection:
V. I. Antonova, *Drevnerusskoe iskusstvo v sobranii Pavla Korina*, Moscow, 1966

LENINGRAD, State Russian Museum:
Drevnerusskoe iskusstvo, vystavka 'Itogi ekspeditsi muzeev RSFSR po vyaleniyu i sobiraniyu prozvedeni drevnerusskogo iskusstva', 1966

RECKLINGHAUSEN, Ikonenmuseum:
J. Kłosińska, *Ikonen aus Polen*, 1966

RECKLINGHAUSEN, Ikonenmuseum:
H. Skrobucha, Sammlung Popoff, *50 russische Ikonen vom 15.—19. Jh.* 1967

BELGRADE, Collection of Milan Sekulić:
Zbirka ikona Sekulić, 1967

MOSCOW, Tretyakov Gallery:
V. I. Antonova, *Rostovo-suzdalskaya shkola zhivopisi*, 1967

PARIS, Grand Palais:
Trésors de musées soviétiques, l'art russe des Scythes à nos jours, 1967/68

RECKLINGHAUSEN, Ikonenmuseum:
Katalog (4th enlarged edition), 1968

BRATISLAVA, Slovenská Národná Galéria:
K. Vačulik and Š. Tkáč, *Ikony na Slovensku*, 1968

MUNICH, Stadtmuseum:
Schätze aus Zypern, Munich, 1968

GENEVA, Musée Rath:
M. Lazović et al., *Les icones dans les collections suisses*, 1968

BEIRUT, Musée Nicolas Ibrahim Sursock:
V. Cândeà, S. Agémian et al., *Icones melkites*, 1969

MUNICH, Haus der Kunst:
H. Skrobucha, *Ikonen: 13.—19. Jahrhundert*, 1969

INDICES

1 PERSONS

Abgar V Ukkama **26**
(King of Osroene, 4 B.C. – 7 A.D. and 13–50)
Adalbert **108**
St, Missionary Bishop in Russia, Archbishop of Magdeburg, 968–981)
Ainalov, D. **79, 89, 131**
Alexius I Comnenus **75, 113**
(Emperor, 1081–1118)
Alipy **120, 121, 122, 176**
(St, Monk in Kiev, Icon Painter, 11th century)
Alpatov, M. V. **79**
Anastasius of Chersonesus, see Nastas Korssunian **114**
Anastasius of Sinai **30**
(St, Abbot, Religious Writer, † after 700)
Andrei Bogoliubski **76, 125**
(Grand Duke of Kiev, 1157–1175)
Anisimov, A. I. **79**
Anna Comnena **75**
(Daughter of Alexius I, 1083–1148?)
Antoni Pecherski **120**
(St, Founder of Kiev Cave Monastery, † 1073)
Antoni Rimlyanin **143**
(St, Founder of Monastery in Novgorod, 1st half 12th century)
Apollonius of Tyana **18**
(Philosopher, 3–97?)
Areios (ca. 260–336) **23**
Aristotle **18, 75**
(Philosopher, 384/383–322/321 B.C.)
Arius, see Areios
Asterius of Amasia **19**
(St, Bishop, ca. 400)
Augustine **20**
(St, Religious Teacher, 354–430)
Augustus **13**
(Emperor, 63 B.C.–14 A.D.)
Avraami Smolenski **164**
(St, Monk, 12th century)

Barlaam (St, Martyr) **20**
Basil the Great **20, 21**
(St, Bishop of Caesarea, 330–379)
Basil I, the Macedonian **75**
(Emperor, 867–886)
Boris Godunov **186**
(Tsar, 1598–1605)

Caligula (Emperor, 37–41) **13**
Celsus (Philosopher, 2nd century) **18**
Charlemagne **41**
(Frankish King, Emperor, 768–814)
Chatzidakis, M. **92**
Chirin, Prokopi **194, 199**
(Icon Painter, 16th/17th century)
Clement of Alexandria **18**
(St, 140/150–215?)

Constantia **19**
(Sister of Constantine the Great)
Constantine the Great **19, 55, 64, 76**
(Emperor, 324–337)
Constantine V Copronymus **33, 34, 74**
(Emperor, 741–755)
Constantine VI **34**
(Emperor, 780–797)
Constantine **31**
(Bishop of Nacolia, 8th century)
Constantine XI Palaeologus **91**
(Emperor, 1449–1453)
Cyril **92**
(St, Patriarch of Alexandria, † 444)
Cyril **108**
(St, Apostle of the Slavs, 826/27–896)

Damaskinos, Michael **92**
(Icon Painter, 2nd half 16th century)
Daniel **170**
(Russian Icon Painter, 1st half 15th century)
Danilo, see Daniel
Decius (Emperor, 249–251) **43**
Demetrius (the 'False', † 1606) **186**
Diehl, C. **34**
Dionisi **175, 190**
(Icon Painter, ca. 1500)
Dionysius the Areopagite **39**
(St, Religious Writer, 5th/6th century)
Dmitri Donskoi **164**
(Grand Duke of Moscow, 1361–1389)

Empedocles **12**
(Philosopher, ca. 490–422 B.C.)
Epifani Premudri **150**
(Writer, 15th century)
Epiphanius **20, 31, 39**
(St, Bishop of Salamis, ca. 315–403)
Euphrasia **26**
Eusebius of Caesarea **19, 31**
(St, Church Historian, ca. 265–339)
Ezekiel **10**

Felicetti-Liebenfels, W. **68**
Feodosi Pecherski **120**
(St, Abbot of Kiev Cave Monastery, 1062–1079)
Feofan Grek (Icon and Fresco Painter, late 14th/early 15th century) **150, 153, 169, 170, 207, 209, 214**
Filov, B. **103**

Galla Placidia **64**
(Roman Empress, 389–450)
Germanus I **32**
(St, Patriarch of Constantinople, 715–730)
Godunov, see Boris Godunov
Grabar, I. E. **171**
Gregory I, the Great **25**
(St, Pope, 590–604)

Gregory II **32 f.**
(Pope, 715–731)
Gregory III **33**
(Pope, 731–741)
Gregory of Nazianzen **20**
(St, Bishop, 329–390)
Gregory of Nyssa **20**
(St, Bishop, ca. 334–394)
Gregory **25**
(St, Bishop of Tours, 538–594)

Hann, G. R. **132, 139, 153, 175**
Hauser, A. **47**
Heraclitus **12**
(Philosopher, ca. 500 B.C.)
Hippolytus **18**
(of Rome, † 235/36)
Homer **12**

Ilarion **113**
(Metropolitan of Kiev, 1051–1054)
Iorga, N. **104**
Irenaeus **18**
(St, Bishop of Lyons, † ca. 202)
Irene **34, 37**
(Empress, † 750)
Isaiah **53, 206**
Ivan I Kalita **164**
(Grand Duke of Moscow, 1328–1341)
Ivan IV Grozni **137, 164**
(Tsar, 1533–1584)

Joachim **203**
(Patriarch of Moscow, 1674–1690)
John Chrysostom **20, 24, 26**
(St, Patriarch of Constantinople, 354–407)
John VII Grammaticus **37**
(Patriarch of Constantinople, 837–843)
John of Damascus **26, 38 f., 40, 178**
(St, ca. 650 to ca. 750)
Josephus Flavius (37 to ca. 100) **10**
Julian the Apostate **23**
(Emperor, 361–363)
Justinian I **57, 64, 67, 75, 76**
(the Great, Emperor, 527–565)
Justinian II **29**
(Emperor, 685–695 and 705–711)

Kirill Belozerski **150**
(St, Founder of Monastery, 1337?–1427)
Kjellin, H. **137**
Kliuchevski, V. O. **76**
Kondakov, N. P. **67, 79**
Kyprios, John **91**
(Icon Painter, 2nd half 16th century)

Lampardos, Petros **92 f.**
(Icon Painter, 16th/17th century)
Lazarev, V. N. **79, 108, 110, 120, 125, 171**

Leo III (Emperor, 717—741) **32 f, 34 f**
Leo IV (Emperor, 775—780) 34
Leo V (Emperor, 813—820) 37
Leontius 30
 (St, Bishop of Neapolis, *ca.* 590 to *ca.* 650)
Likhachev, N. **189**
Longin 98
 (Icon Painter, mid-16th century)
Louis the Pious 40
 (Emperor, 813—840)
Luke **26, 39**

Mahomet 74
Manuel Disypatos 83
 (Archbishop of Salonika)
Martin of Tours 25
 (St, 316/17—397)
Maximus the Confessor **29**
 (St, 580—662)
Meletius, St
Methodius 108
 (St, Apostle of the Slavs, † 885)
Michael III 37
 (Emperor, 842—867)
Michael VIII Palaeologus 84
 (Emperor, 1259—1282)
Millet, G. **90**
Mitrofanović, Georgije 98
 (Icon Painter, 17th century)
Moschos, Elias **92**
 (Icon Painter, mid-17th century)
Mstislav I **76**
 (Grand Duke of Kiev, 1125—1132)
Muratov, P. **189**
Myslivec, J. **91**

Nastas Korssunian **114**
Nicephorus 40
 (St, Patriarch of Constantinople, 806—815)
Nicodemus 83
 (Bishop of Freising)
Nikon **200**
 (Patriarch of Moscow, 1652—1667)
Nikon **170**
 (St, Abbot of Troitse Sergiev Monastery, † 1428)
Nilus the Ascetic
 (also designated Sinaita, St, † 430)

Olga **108, 113**
 (St, Grand Duchess of Kiev, mid-9th century)
Olympiodorus 25
 (Eparch, early 5th century)
Origen (*ca.* 185—245) **18 f**
Ostrogorsky, G. **37**
Otto I (Emperor, 936—973) **108**
Ouspensky, L. **29 f.**

Paulinus of Nola 25
 (St, 353—431)
Paulus Silentiarius **64, 205**
Peter I, the Great **203**
 (Tsar, 1682—1725)

Petrovich **144**
 (Icon Painter, late 12th century)
Philip the Arab 43
 (Emperor, 244—249)
Photius **75, 108**
 (Patriarch of Constantinople, 858—867 and 877—886)
Pilate, Pontius **16, 18**
Plato 13
 (Philosopher, 427—348/47 B.C.)
Priselkov, M.D. **113**
Prokhor, of Gorodets **170**
 (Icon Painter, 15th century)
Protagoras 12
 (Philosopher, 480—410 B.C.)
Psellus, Constantine 75
 (Monastic Name Michael, 1018—1078)
Pythagoras 18
 (Philosopher, 580—500 B.C.)

Rublev, Andrei **80, 150, 170 f., 190, 207, 210, 214**
 (St, Icon Painter, *ca.* 1360 to *ca.* 1430)

Savin, Nasari **199**
 (Icon Painter, 17th century)
Savin, Nikifor **199**
 (Icon Painter, 17th century)
Schweinfurth, P. **79**
Secundinus 25
Severus Alexander 18
 (Emperor, 222—235)
Simeon Metaphrastes **75**
 (Hagiographer, 10th century)
Simeon the Stylite (St, † 459) **25**
Skouphos, Philotheos **97**
 (Icon Painter, 17th century)
Soteriou, G. **67**
Soteriou, M. **68**
Stephen 33
 (St, Abbot of Mount Auxentius, 8th/9th century)
Stroganov **189, 190, 194, 213**
 (Russian Merchant House)
Stroganov, Fedor **189**
Stroganov, Maxim **189**
Stroganov, Nikita **189, 194 f.**
Strzygowski, J. **30, 89**
Sulpicius Severus († *ca.* 420) **25**
Svyatoslav **108**
 (Grand Duke of Kiev, 946—972)
Sychev, N.P. **114 f**

Tacitus, Cornelius (*ca.* 55—115) **10**
Tamerlaine **79**
 (Mongol Khan, 1336—1405)
Tarasius 37
 (St, Patriarch of Constantinople, 784—806)
Tertullian 17
 (*ca.* 160 to after 220)
Theocritus 49
 (Poet, 310—250 B.C.)
Theodora 24
 (Empress, *ca.* 500—548)
Theodora 37
 (Byz. Regent, 9th century)

Theodore 37
 (Graptos) (St, Iconodule, 9th century)
Theodore the Studite **39, 74**
 (St, Abbot, 759—826)
Theodosius I, the Great **57, 64**
 (Emperor, 379—395)
Theophanes the Greek, see Feofan Grek
Theophilus (Emperor, 829—842) **37**
Thomas of Claudiopolis 31
 (Iconoclast, 8th century)
Tokhtamysh **169**
 (Khan of the Volga Tartars, 1381—1395)
Tzanes, Emmanuel **97**
 (Icon Painter, 1610—1690)
Tzanfournari, Emmanuel **91**
 (Icon Painter, born 1570/75)

Ushakov, Simon **200**
 (Painter, 1626—1686)
Uspenski, Porfiri **67**
 (Metropolitan of Kiev, 19th century)

Viktoros **92**
 (Icon Painter, 2nd half 17th century)
Viskovati, I.M. **181, 203**
Vladimir I, St Vladimir **108, 113, 114 f.**
 (Grand Duke of Kiev, 978—1015)
Vsevolod, the 'Big Nest' **125, 126, 132**
 (Grand Duke of Kiev, 1177—1212)

Weitzmann, K. **68**

Xenophanes 12
 (Philosopher, *ca.* 580—490 B.C.)

Yaroslav Mudri **113, 119**
 (the Wise, Grand Duke of Kiev, 1019—1054)
Yazid II 31
 (Caliph of Damascus, 720—724)

2 PLACES AND RACES

Aachen 83
Ain Duk 11
Akhmim 47
Alexandria **54, 58, 63, 68**
Anablatha 20
Antinoë **47, 73**
Antioch 58
Arabs **31, 32**
Arkazhi 143
Athens 83
Athos **83, 90, 98, 113**

Bačkovo 103
Balkans **90, 107, 113, 114 f., 122, 175**
Belgrade 103
Belozersk 149
Berende 103
Berlin 83
Bethlehem 64

Blachernae 207
Boboševo 104
Bohemia 175
Boyana 103
Bolshie Soli 131
Bosphorus 55
Bulgaria 98, 103, 104, 113, 114
Bulgars 34
Burtscheid 83
Byzantium, see also Constantinople 30, 33 f, 41, 54, 55 f, 63 f, 90 f, 97, 132

Caesarea 29
Cagliari 53
Camulia 26, 40
Cappadocia 26, 40, 73
Cargrad, see Constantinople
Carpathians 107
St Catherine, Monastery of, see Sinai
Caucasus 113, 143
Chalcedon 150
Chersonesus 114
Chilandari (Monastery) 90, 98, 104
Chios 76
Clermont 25
Constantinople 26, 31, 33, 34, 37, 40, 58, 64, 68, 76, 84, 89, 98, 103, 108, 113, 115, 120, 125, 132, 138, 143, 150, 169, 176, 205
Copenhagen 90, 92
Crete 91, 98
Crimea 114
Cyprus 91, 107

Dalmatia 98
Daphne 76, 121
Dečani 98, 104
Delphi 76
Dmitrov 127, 132
Dura Europos 11, 44, 54

Eastern Slovakia 107
Edessa 26
Egypt 47, 50, 73
Elvira 19
Ephesus 12
Epirus 84

Faiyum 47, 114
Feodosia 150
Ferapontov Monastery 175
Florence 83
Frankfurt/Main 41
Freising 83

Galata 150
Greece 26, 32, 76, 92, 137, 169

Hiereion 33
Hosios Lukas 76

Illyria 33
Italy 58, 98

Jericho 11
Jerusalem 11, 63

Jews 9, 10, 11, 14
Judaea 14

Kaffa 150
Kastoria 90
Kholuy 204, 214
Kideksh 125
Kiev 67, 76, 108, 110, 114 f, 121 f, 123 f, 137 f, 176, 213 f
Kirillov Monastery 122
Kolomna 164
Korssun 114
Kovalevo 153
Kulikovo Pole 169

Laon 97
Leningrad 80
Leptis Magna 44 f
Limoges 143
Lombards 32
Lublin 175
Lwów (Lemberg) 107
Lydda 186

Macedonia 91
Malta 53
Maramuresh 107
Mesopotamia 63
Milan 48, 57
Mistra 91
Moldavia 107
Morača 98
Moscow 79, 121, 132, 137, 150, 164, 169, 171, 176, 185, 186, 193, 194, 199, 200, 207, 214
Mstera 204

Naples 54
Nazareth 64
Nereditsa 120
Nerezi 76
Nessebar 104
Nicaea 37, 84, 89
Nizhni-Novgorod 150
Novgorod (on Lake Ilmen) 107, 132 f, 137 f, 153 f, 169, 185, 195, 214
Novodevichi Monastery 186

Ochrid 90, 103, 113, 119
Oslo 156

Pafnuti Borovski Monastery 186
Palekh 204, 214
Palestine 11, 20, 37
Palmyra 44
Panias 19
Panteleimon Monastery 113
Peć 98
Persia 63
Phocis 76
Poganovo 103
Poland 107
Prague 91
Prespa 91

Przemyśl 106
Pskov 107, 153, 164

Ravenna 24, 64
Rome 30, 33, 44, 49, 54, 57, 64, 68, 107
Rumania 104 f
Russia 76 f, 90

Salonika 67, 68, 83, 90, 119
Samokov 104
Sardinia 54
Sebastopol 114
Serbia 76, 98 f, 104, 122, 169
Sicily 53
Sinai 67, 74, 80, 83, 91
Skopje 76
Smederevo 97
Smolensk 164
Sofia 103 f
Solovetski Monastery 185
Solvychegodsk 189
Staraya Ladoga 143
Syria 89

Tartars 79
Therapontos Monastery, see Ferapontov Monastery
Tolgski Monastery 131
Transylvania 107
Trebizond 84
Trier 108
Tryavna 104
Troitse Sergiev Monastery 170, 171
Troy 12
Turnovo 103
Tver 164

Ukraine 107
Ustyug 144

Venice 91, 92
Vidubitski Monastery 122
Vladimir 76, 125, 126, 132, 171, 175, 204
Vladimir-Suzdal 125, 126, 132, 169, 214
Vologda 164
Volokolamsk 175
Volotovo 150
Vyshegorod 76

Washington (Dumbarton Oaks) 84, 92

Xilurgia (Monastery) 112

Yaroslavl 126, 132, 169, 214

Zvenigorod 170

3 ICONOGRAPHICAL AND SUBJECT INDEX

Acheiropoietic images 26, 40, 84
Adoration of the Cross 143
Akathistos 186

All Saints 132
Anastelosis 37
Angels 143
Archangel Gabriel 150, 153, 155
Archangel Michael 131, 153, 155, 182, 190, 193
Artemis 12
Athene 12

Basma 211
Bishops, Portrayal of 20
Byzas 55

Calendar Icons 156
Carpocratians 18
Catacombs, Jewish 11
Catacombs, Christian 48
Cherubim 10
Chludov Psalter 74
Christ Emmanuel 103, 125, 206
Christ the Merciful 83
Christ, the Unsleeping Eye 182
Christ — Life
 Nativity 73, 92 f, 156, 171
 Presentation in the Temple 171
 Baptism 171
 Passion 154
 Crucifixion 199
 Descent into Hell 153, 156, 164, 199
 Ascension 73
Christ — Miracles
 Raising of Lazarus 53, 156
 Healing of the Issue of Bloody 53
 Healing of the Palsy 53
Christ, Portrayals of 29, 181, 200
Councils
 Quinisextum (691/92) 29
 Hiereion (754) 33
 VIIth Ecumenical (787/88) 92
 Moscow, see Stoglav
Cross 182

Deesis 92, 125, 150, 153, 164, 172, 205, 207, 214
Descent of the Holy Spirit 73
Devil 163
Diana, see Artemis
Dove 40
Duck 49

Elvira, Synod of 19
Emperors, Portrayal of 13

Fish 50
Flesh Tint 150, 211

Genre Motifs 49
Gnosis 13, 18, 25

Holy Spirit 40

Ichthys 50
Icon Inscriptions 40, 143, 194
Iconoclast Controversy 20 f, 30, 32, 38

Iconoclasts 24
Iconostasis 205, 206 f
Images, Banning of 9, 31
Images, Consecration of 40
Images, Criticism of 31

Judas 58

Lamb 181
Last Judgement 164
Libri Carolini 41

Monophysites 31
Mother of God
 Eleousa 79, 104, 131, 149, 175
 S. Maria Nuova 68
 Vladimir 76, 126, 209
 Tolgskaya I and II 131
 Belozersk 149
 Enthroned, Recklinghausen 28, 77
 Enthroned, Pecherskaya 122
 Enthroned, Tolgskaya I 131
 Orans, Yaroslavl 126
 Bogoliubskaya 125
 Danskaya 150
 Hodigitria 104
 Petrovskaya 199
 Burning Thornbush 200
 The Whole of Creation 200
 Weep not for me 185
 Annunciation 79, 91, 126, 144, 153, 170
 Nativity of Mary 137
 Death of Mary 150
Mummy Portraits 47, 73

Neoplatonism 39
Nestorians 31
Nike 54

Oedipus 12
Oklad 211
Orpheus 18, 49

Painting-Books 39, 75, 156
Paulicians 31
Peacock 49
Perun 110
Physiologos 185
Portraits 182

Relics, Cult of 20
Riza 211

Saints
 Abraham 50, 206
 Abraham, Apa (Bishop) 67
 Adam and Eve 50, 153, 156, 164, 206
 Anastasia 153
 Basil the Great 150
 Blaise 153
 Boris 125, 132, 154, 186, 193
 Catherine 68, 80
 Chariton 68, 73
 Constantine and Helena 83
 Cosmas and Damian 26, 97

Cyril of Alexandria 92
Damian, see Cosmas and Damian
Daniel 50, 83
David 50
Demetrius of Salonika 80, 83
Dionysius the Areopagite 97
Elijah 154, 155
Felix, Martyr 25
Feodosi Pecherski 122
Florus 154
Forty Martyrs of Sebaste 97
George 68, 104, 155, 163
Gleb 125, 132, 154, 186, 193
Gregory the Miracle-Worker 80, 84
Helena, see Constantine and Helena
Isaac 23, 50
Ivan Rilski 104
Jesus Navin 132
John 103
John the Baptist 92, 125, 175, 197, 205
 Beheading of John the Baptist 211
John Chrysostom 24, 26, 84, 150
Jonah 50
Joshua 132
Laurus 154
Luke 26
Macarius 154
Mary of Egypt 200
Moses 50
Nestorius 83
Nicholas 155
Nikita 163
Nina 143
Noah 50
Onuphrius 154
Paraskeva-Pyatnitsa 153
Paul 19, 25, 150, 171, 172
Peter 19, 25, 53, 68, 172
Procopius 80, 83
Rhipsime 143
Savati Solovetski 185
Solomon 193
Sophia 193
Theodore Stratelates 68, 150
Theodosius 73
Thomas 98
Varlaam of Khutyn 163
Zechariah 90
Zosima Solovetski 185
Saints, Veneration of 20
Sarcophagi 54
Shepherds 49
Stoglav 176
Stylites 25
Sudarium, or Kerchief of St Veronica 185
Synagogue 11, 54

Tabernacle 10
Theodore, Martyr 23
Trinity 92, 132, 170, 172

Young Men in the Fiery Furnace 50, 67, 154

Zeus 12

LIST OF COLOURED ILLUSTRATIONS

I The Evangelist Luke. Russian (Novgorod),
16th century
Ikonenmuseum, Recklinghausen

II Mother of God and Child (detail). Santa Maria
Nuova, Rome, 6th/7th century 15

III The Three Young Men in the Fiery Furnace.
Palestine (?), 6th/7th century 15

IV Apa Abraham. Coptic, 7th century 21
Staatliche Museen, Berlin

V SS. Chariton and Theodosius. Palestine (?),
7th/8th century 27
Monastery of St Catherine, Sinai. Photograph: Allan

VI The Martyrs Procopius, Demetrius and
Nestorius. Byzantine, 11th/12th century 45
Monastery of St Catherine, Sinai. Photograph: Allan

VII Christ the Merciful. Byzantine, 12th century 51
Stiftung Preußischer Kulturbesitz, Staatl. Museen
(Sculpture Section, Early Christian-Byz. Collection)
Photograph: Allan

VIII The Mother of God Interceding. Byzantine,
1st half 13th century 59
Cathedral, Freising

IX The Martyr Catherine. Byzantine, 14th century 61
Monastery of St Catherine, Sinai. Photograph: Allan

X The Archangel Gabriel. Byzantine, late 14th
century 65
Chilandari Monastery, Athos (Museum)
Photograph: P. Chrysostomus Dahm, Maria Laach

XI Constantine and Helena. Byzantine,
12th/13th century 71
Monastery of St Catherine, Sinai. Photograph: Allan

XII The Forty Martyrs of Sebaste. Philotheos
Skouphos. 17th century 93
Dr Willy Flachsmann, Zurich (Switzerland)

XIII The Eleousa Mother of God. Double-Sided
Icon. Bulgarian, 13th/14th century 99
National Gallery, Sofia

XIV St George and the Dragon. Bulgarian, 1667 102
National Gallery, Sofia

XV Demetrius of Salonika. Rumanian (Moldavia),
16th century 105
Ikonenmuseum, Recklinghausen

XVI All Saints. Greek, 16th century 115
Sewickley/Penn., Collection of G. R. Hann
Collector's Photograph

XVII The Holy Trinity. Russian (Moscow),
15th century 117
Sewickley/Penn., Collection of G. R. Hann
Collector's Photograph

XVIII Christ's Resurrection (Descent into Hell).
Russian (Novgorod ?), 14th century 123
Sewickley/Penn., Collection of G. R. Hann
Collector's Photograph

XIX The Archangel Gabriel. Russian (Novgorod),
late 14th century 129
Sewickley/Penn., Collection of G. R. Hann
Collector's Photograph

XX George, Clement and Menas. Russian (Nov-
gorod), late 14th century 133
Stiftung Preußischer Kulturbesitz, Staatl. Museen
(Sculpture Section, Early Christian-Byz. Collection)

XXI Demetrius (detail). Russian (Novgorod),
15th century 135
Ikonenmuseum, Recklinghausen

XXII Royal Door from an Iconostasis. Russian
(Novgorod), late 15th century 139
Sewickley/Penn., Collection of G. R. Hann
Collector's Photograph

XXIII The Annunciation. Russian (Novgorod),
15th century 141
Ikonenmuseum, Recklinghausen

XXIV Nicholas Appearing to Mariners in Distress
(detail). Russian (Novgorod), 15th century 147
Ikonenmuseum, Recklinghausen

XXV Christ's Resurrection (Descent into Hell,
detail). Russian, early 16th century 158
Ikonenmuseum, Recklinghausen

XXVI The Apostle Peter. Russian (Moscow),
early 16th century 166
Ikonenmuseum, Recklinghausen

XXVII John the Baptist. Russian (Moscow),
early 16th century 166
Ikonenmuseum, Recklinghausen

XXVIII The Martyr George. Russian, 16th century 167
Ikonenmuseum, Recklinghausen

XXIX Deesis. Russian (Moscow), 16th century 173
Sewickley/Penn., Collection of G. R. Hann
Collector's Photograph

XXX Christ's Crucifixion and Burial. Russian
(Moscow), ca. 1600 179
Hans von Herwarth, former Secretary of State

XXXI The Eleousa Mother of God. Russian
(Moscow), late 16th century 183
Sewickley/Penn., Collection of G. R. Hann
Collector's Photograph

XXXII Christ, the Unsleeping Eye. Russian (Moscow),
ca. 1500 187
Ikonenmuseum, Recklinghausen

XXXIII The Archangel Michael. Russian (Stroganov
School), 17th century 191
Ikonenmuseum, Recklinghausen

XXXIV The Beheading of John the Baptist. Russian
(Stroganov School), 17th century 195
Ikonenmuseum, Recklinghausen

XXXV The Image of Christ Not Made by Human
Hands. Russian, late 17th century 201
Ikonenmuseum, Recklinghausen

LIST OF MONOCHROME ILLUSTRATIONS

1 Mummy Portrait. Faiyum, 2nd/3rd century 16
Gustav-Lübcke-Museum, Hamm. From Foto Wiemann

2 Mummy with Inset Portrait Panel.
Faiyum, 2nd century 16
British Museum, London. Courtesy the Trustees

3 Two Martyrs. Palestine (?), 6th/7th century
Municipal Museum of Eastern and Western
Art, Kiev 22
Photographic Collection of Ikonenmuseum,
Recklinghausen

4 The Mother of God Enthroned (Wall Mosaic).
Hagia Sophia, Constantinople, ca. 1000 28
Photographic Collection of Ikonenmuseum,
Recklinghausen

5 The Apostle Peter. Byzantine, 6th century 35
Photographic Collection of Ikonenmuseum,
Recklinghausen

6 The Ascension (detail). Palestine (?),
7th/8th century 36
Monastery of St Catherine, Sinai. Photograph: Allan

7 The Prophet Daniel. Byzantine, 12th century 46
Byzantine Museum, Athens. Photograph: Papahadjidakis

8 Gregory the Miracle-Worker. Byzantine,
12th century 52
Russian Museum, Leningrad.
Photographic Collection of Foto Marburg

9 The Eleousa Mother of God of Vladimir.
Byzantine, early 12th century 52
Tretyakov Gallery, Moscow.
Photographic Collection of Foto Marburg

10 Deesis and Saints. Greek, early 16th century 60
Dipl.-Ing. Hans Bibus, Zumikon (Switzerland)

11 John Chrysostom. Byzantine, 14th century 62
The Dumbarton Oaks Collection, Washington
Museum Photograph

12 The Annunciation. Byzantine, 14th century 66
National Museum, Ochrid
Photographic Collection of Ikonenmuseum,
Recklinghausen

13 The Forty Martyrs of Sebaste. Byzantine,
late 13th century 69
The Dumbarton Oaks Collection, Washington
Museum Photograph

14 The Murder of the Prophet Zechariah. Greek,
ca. 1500 70
Statens Museum for Kunst, Copenhagen
Museum Photograph

15 Cyril of Alexandria. Greek, late 16th century 72
The Dumbarton Oaks Collection, Washington
Museum Photograph

16 The Platytera Mother of God. Greek,
late 15th century 77
Ikonenmuseum, Recklinghausen. From Foto Wiemann

17 The Annunciation. Greek, 15th century 78
Ikonenmuseum, Recklinghausen. From Foto Wiemann

18 The VIIth Ecumenical Council. Greek,
17th century 81
Statens Museum for Kunst, Copenhagen
Museum Photograph

19 The Nativity. Viktoros, 17th century 82
Benaki Museum, Athens. Museum Photograph

20 Christ Pantocrator. Elias Moschos, 1653 85
Ikonenmuseum, Recklinghausen. From Foto Wiemann

21 John the Baptist. Petros Lampardos,
17th century 86
National Museum, Palermo. Photograph from
Soprintendenza alle Gallerie, Palermo

22 Cosmas and Damian. Emmanuel Tzanes,
17th century 87
National Gallery, London. Courtesy the Trustees

23 Dionysius the Areopagite. Emmanuel Tzanes,
17th century 88
National Gallery, Oslo. Museum Photograph

24 Doubting Thomas. Serbian (Peć-Dečani
School), 17th century 94
National Museum, Belgrade. Museum Photograph

25 Demetrius of Salonika. Serbian,
late 14th/early 15th century 95
Museum of Applied Art, Belgrade. Museum Photograph

26 Ivan Rilski. Byzantine, 14th century 96
Photographic Collection of Ikonenmuseum,
Recklinghausen

27 The Hodigitria Mother of God with Scenes
from the Life of Mary. Bulgarian, 16th century 100
Museum of Church History and Archaeology, Sofia

28 Demetrius of Salonika. Bulgarian, 17th century 101
Monastery of St Demetrius, Boboševo (Bulgaria)

29 The Martyr Paraskeva. Ruthenian, 16th century 106
Šarišké muzeum, Bardejov (ČSSR)
Photograph: M. Jurik, Bratislava

30 Demetrius of Salonika (Wall Mosaic).
Monastery of St Michael with the Golden
Roof, Kiev, late 12th/early 13th century 111
Tretyakov Gallery, Moscow.
Photographic Collection of Foto Marburg

31 Demetrius of Salonika. Russian (Vladimir-
Suzdal), late 12th/early 13th century 112
Tretyakov Gallery, Moscow.
Photographic Collection of Foto Marburg

32 The Archangel Michael. Russian (Yaroslavl),
late 13th/early 14th century 116
Tretyakov Gallery, Moscow.
Photographic Collection of Foto Marburg

33 The Image of Christ Not Made by Human
Hands. Russian (Novgorod), 12th/13th century 118
Tretyakov Gallery, Moscow.
Photographic Collection of Foto Marburg

34 The Adoration of the Cross. Russian (Novgo-
rod), 12th/13th century (reverse of Illust. 33) 118

35 Nicholas. Russian (Novgorod),
 12th/13th century 124
 Tretyakov Gallery, Moscow.
 Photographic Collection of Foto Marburg

36 The Archangel Gabriel. Russian,
 12th/13th century 127
 Russian Museum, Leningrad.
 Photographic Collection of Foto Marburg

37 The Eleousa Mother of Belozersk. Russian
 (Novgorod), mid-13th century 128
 Russian Museum, Leningrad.
 Photographic Collection of Foto Marburg

38 Christ's Resurrection (Descent into Hell).
 Russian (Pskov), 14th century 130
 Russian Museum, Leningrad.
 Photographic Collection of Foto Marburg

39 The Prophet Elijah. Russian (Novgorod),
 15th century 134
 Tretyakov Gallery, Moscow.
 Photographic Collection of Foto Marburg

40 St George and the Dragon. Russian
 (Novgorod), late 14th century 136
 Sewickley/Penn., Collection of G. R. Hann
 Collector's Photograph

41 Three Bishops. Russian (Novgorod),
 15th century 140
 Photographic Collection of Ikonenmuseum,
 Recklinghausen

42 St George and the Dragon. Russian
 (Novgorod), late 15th century 142
 Sewickley/Penn., Collection of G. R. Hann
 Collector's Photograph

43 The Prophet Elijah. Russian (Novgorod),
 15th century 145
 Ikonenmuseum, Recklinghausen. From Foto Wiemann

44 The Martyr George. Russian (Novgorod),
 15th century 146
 Museum, Novgorod. Photographic Collection of
 Foto Marburg

45 The Archangel Michael. Russian (Novgorod),
 late 15th century 148
 Sewickley/Penn., Collection of G. R. Hann
 Collector's Photograph

46 The Archangel Gabriel. Russian (Novgorod),
 late 15th century 148
 Sewickley/Penn., Collection of G. R. Hann
 Collector's Photograph

47 The Dormition of the Mother of God.
 Feofan Grek, late 14th century 151
 Tretyakov Gallery, Moscow.
 Photographic Collection of Foto Marburg

48 The Archangel Gabriel. Russian (Novgorod),
 late 15th century 152
 The Fogg Art Museum, Cambridge (Mass.)
 Museum Photograph

49 Nicholas. Russian (Novgorod), ca. 1500 157
 National Gallery, Oslo. Museum Photograph

50 Christ's Resurrection (Descent into Hell).
 Russian, early 16th century 159
 Ikonenmuseum, Recklinghausen. From Foto Wiemann

51 Calendar Panel of the Church Year
 (1. 9. to 14. 3.). Russian, late 16th century 160
 Ikonenmuseum, Recklinghausen. From Foto Wiemann

52 Calendar Panel of the Church Year
 (15. 3. to 31. 8.). Russian, late 16th century 161
 Ikonenmuseum, Recklinghausen. From Foto Wiemann

53 The Martyr Nikita. Russian, 16th century 162
 Photographic Collection of Ikonenmuseum,
 Recklinghausen

54 Varlaam of Khutyn. Russian, late 16th century 165
 Photographic Collection of Ikonenmuseum,
 Recklinghausen

55 Archangel. Fresco in the Castle Chapel,
 Lublin, 1418 168
 Photograph from Institute of the History of Art,
 Warsaw University

56 The Ascension (detail). Fresco in the Castle
 Chapel, Lublin, 1418 168
 Photograph from Institute of the History of Art,
 Warsaw University

57 Zosimus and Savati of the Solovetski
 Monastery. Russian (Moscow), ca. 1600 174
 Ikonenmuseum, Recklinghausen. From Foto Wiemann

58 Zosimus and Savati of the Solovetski
 Monastery. Russian (Moscow), late 16th/early
 17th century 180
 Hans von Herwarth, former Secretary of State

59 Zosimus and Savati of the Solovetski
 Monastery. Russian (Moscow), mid-17th century 184
 Ikonenmuseum, Recklinghausen. From Foto Wiemann

60 Christ's Resurrection (Descent into Hell).
 Russian, 17th century 188
 Ikonenmuseum, Recklinghausen. From Foto Wiemann

61 Sophia, Divine Wisdom. Russian (Stroganov
 School), 17th century 192
 Ikonenmuseum, Recklinghausen. From Foto Wiemann

62 Boris and Gleb. Russian, 17th century 196
 Ikonenmuseum, Recklinghausen. From Foto Wiemann

63 The Whole of Creation Rejoices over Thee.
 Russian, 17th century 197
 Ikonenmuseum, Recklinghausen. From Foto Wiemann

64 Two Wings of a Domestic Altar. Russian
 (Stroganov School), 17th century 198
 Ikonenmuseum, Recklinghausen. From Foto Wiemann

65 The Burning Thornbush Mother of God.
 Russian, late 17th century 202
 Ikonenmuseum, Recklinghausen. From Foto Wiemann

66 Preliminary Sketch of an Icon with the Image
 of Christ Not Made by Human Hands.
 Russian, 17th century 204

67 Preliminary Sketch of an Icon of the
 Mirozhskaya Mother of God. Russian,
 17th century 206

68 Preliminary Sketch of an Icon of the
 Unsleeping Eye. Russian, 17th century 209